MW00451003

Curves for the Mathematically Curious

18315337206697857941381316112026049056203
92616665711564966607842166814649870825958
26896046168627213434548372679840038786077
30520751834344363454057224837023166394849
10836103157729423210718408197217705622971
62281857627692632972691882708869450959589
82521973143488463804132789716989507981644
85545448327206383563337271761017072256202
02965299323169703097145697089728882897417
65584388291547542211329679431397905863491
72698057162551575897389997339630723041481
50107992987929819107147019732608436103300
51392488075309855197250616740126922709376

71266188410480659227201446263656645880093
18844197456940725207877835704534451970174
48862888925044952156233497248730061560706
67898686586113351446361025922643828994675
06037387814229999478145338879822045514918
98281495737692621835700841561758423731908
88117948110340670167576139867939940026365
08056189909652731801692183720033396299112
95568769154371794465470889182213946052760
07079940311919423102484304241791034442158
37192267825471649144600624995402793506701
79301774961489551329747583940212148274193
34231139279560498382250971644852273414144

Curves for
the Mathematically Curious

AN ANTHOLOGY OF THE
UNPREDICTABLE, HISTORICAL,
BEAUTIFUL AND ROMANTIC

Julian Havil

PRINCETON UNIVERSITY PRESS

PRINCETON AND OXFORD

Published by Princeton University Press,
41 William Street, Princeton, New Jersey 08540
6 Oxford Street, Woodstock, Oxfordshire OX20 1TR

press.princeton.edu

Library of Congress Control Number: 2019942340

ISBN: 978-0-691-18005-2
ISBN (e-book): 978-0-691-19778-4
British Library Cataloguing-in-Publication Data is available

Editorial: Vickie Kearn, Susannah Shoemaker, and Lauren Bucca
Jacket Design: Pamela L. Schnitter
Production: Jacqueline Poirier
Publicity: Matthew Taylor and Katie Lewis

This book has been composed in LucidaBright

Copy-edited and typeset by T&T Productions Ltd, London

Printed on acid-free paper ∞

Printed in the United States of America

1 3 5 7 9 10 8 6 4 2

Dedicated
to those
who shall come after
in memory
of those
who have gone before

A mathematical doodle

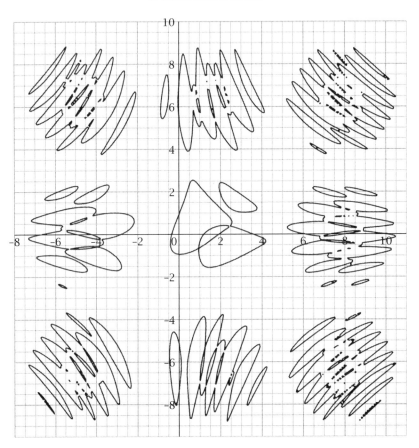

$$\sin(\sin x + \cos y) = \cos(\sin xy + \cos x)$$

Festina lente

Hâtez-vous lentement, et sans perdre courage
Vingt fois sur le métier votre ouvrage:
Polissez-le sans cesse, et le repolissez;
Ajoutez quelquefois, et souvent effacez.

Slowly Make Haste

Slowly make haste, and without losing courage
Twenty times redo your work:
Polish and re-polish endlessly;
And sometimes add, but often take away.

<div align="right">Nicolas Boileau-Despréaux (1636–1711)</div>

This place is wretched enough – a villainous chaos of din and drunkenness, nothing but Hazard and burgundy, hunting, mathematics, and Newmarket, riot and racing...

Lord Byron, in a letter to Miss Elizabeth Pigot describing
Trinity College, Cambridge, 26 October 1807.

Contents

Preface

I have gathered a posy of other men's flowers and nothing but the thread which binds them is my own.[1]

Michel de Montaigne

In 1943 the distinguished British soldier, Field Marshal the Earl Wavell, had published an anthology of poems under the title *Other Men's Flowers*. In doing so, this poetry-loving soldier of prodigious memory and great learning had observed that *anthology* derives from the Greek *anthos*, meaning "flower", and *legein* through to *logia*, meaning "a collection"; a collection of flowers, then. Perhaps a bouquet. This usage has flowers as a metaphor for choice examples of a type, usually but not always connected with poetry, compiled by an individual and, inevitably, exhibiting individual tastes. Lord Wavell required his posy to be gathered from nineteenth-century poetry; ours is from the long history of mathematics and, in particular, mathematical curves.

Any curve that has a name has a story, and it has been our purpose to tell that story for a few of them in a manner that we hope will appeal to the mathematically inclined reader. But which few, and why them? In compiling the original list of curves for inclusion we have rummaged through notes, papers, books and internet sites as a magpie, choosing any bright thing that pleased, afterwards to be forced to ignore the glint of some bright gem in favour of that of another. The result is these ten curves – different no doubt to the ten curves another might choose.

An anthologist at once enjoys a glorious freedom of personal choice, yet bears responsibility for its cohesion; that choice must not be random, but neither should it be wholly predictable, with the central

[1] In translation from *Essais*, 1580. Subsequently adopted by a variety of authors, including Lord Wavell and John Bartlett in his famous *Familiar Quotations*. And now by us.

ground made firm by the application of reasonable selection criteria. Our most significant filter has been that the curve exists in the two-dimensional Euclidean plane, which precludes space curves and curves that occupy parts of abstract mathematical worlds – perhaps those are for another time. It should also have a revealing history with its story, in our view, an interesting one, and perhaps surprising too, and it should be in its way important, by whatever criteria importance is judged. Its significance may lie in its shape or its slope, or the area under it, or it may be some characteristic of it that has been exploited to significant ends; or it may be that the curve was the first of its kind. And it might be beautiful too. As a bonus, fortune has sometimes shown favour, with the law of unintended consequences coming into play to reveal subsidiary curves of interest. One curve in particular, the Quadratrix of Hippias, found initial favour and survived refinement of selection because it provides an opportunity to revisit the world of ancient Greece, with its elegant straight edge and compass constructions – a skill that has largely fallen through the coarse mesh of secondary mathematics syllabuses. Through reading that chapter, we hope that some readers will be minded to revisit happy memories of these challenges, and perhaps embrace a few more of them.

Anthologies, though, are more judged by omission than inclusion, and we have omitted much that others might consider essential, with the conic sections standing as a prime candidate, given their long history and ubiquity. Yet we feel that so many others have written about them in such detail and in such a variety of ways, and that their story is so great, that our own contribution would have occupied either too many pages in slavish repetition of others' work or too few in a superficial treatment of them; anyway, not every anthology of poems contains works by Shakespeare. This said, conic sections are mentioned more than once in more than one chapter and in more than one way. Other glaring omissions we acknowledge and regret while hoping for readers' understanding.

It is characteristic of an anthology that its reading is unlikely to be sequential and so it is with this book. The chapters are meant to be read in any order and independently of each other, yet occasionally there is an overlap of a technique and we hope the reader will understand any consequent minor repetition. With no other sensible criterion coming to mind, the chapter order is in increasing magnitude of word count.

So, we invite the reader to join us in this particular and eclectic mathematical adventure, with the stories bringing us into glancing contact

with (among others) Pablo Picasso, George II, Queen Victoria's consort (Prince Albert), the Inquisition, the Holy Roman Emperor (Frederick II) and many mathematicians who have existed over millennia, and also one who didn't, in the person of Professor Onésime Durand. And, inescapably, we meet with Leonhard Euler. Save for one chapter, it was never our intention for this book to touch on the work of this eighteenth-century eclectic genius, but perhaps inevitably his name has forced itself onto more pages than we foresaw at the project's start. Where there are "E" references to him, these refer to the *Eneström index*, so named after the Swedish mathematician Gustav Eneström, who compiled the definitive list of Euler's most important works.

We claim sole ownership of any errors that have crept in, apologize for them and assure the reader that we have done all that is within our power to eliminate them. With this in mind, and with thoughts towards the poetic, p. vii of the front matter comprises a verse, in its original French for the Francophone and in English translation for the rest of us: it sums up the book-writing process rather well.

Acknowledgments

People talk about books that write themselves, and it's a lie. Books don't write themselves. It takes thought and research and backache and notes and more time and more work than you'd believe.

Neil Gaiman, *Smoke and Mirrors*, 2005, Headline Book Publishing

Just so. It also takes considerable input from others whose crucial contributions to the book's existence often remain largely anonymous; people whose names do not appear on the front cover but without whom the book that you, the reader, now hold simply would not exist. This small section provides an opportunity for me to redress the balance a little.

First, and above all, grateful thanks to Vickie Kearn, who has recently retired as Executive Editor for Mathematics and Computer Science at PUP. Vickie was the editor of this and my four previous books: unflappable, accommodating, inspiring and charming. May she enjoy the long and fulfilling retirement she deserves. Susannah Shoemaker has replaced her and has taken control of the final stages of production, ensuring the seamless transition that any author craves. And then there are the various and important contributions of Lauren Bucca, Pam Schnitter, Kathleen Cioffi and Jacqueline Poirier; and, no doubt, others whom I have forgotten to mention. Thanks to all.

Jon Wainwright and Sam Clark of T&T Productions Ltd have again weaved their magic wands, transforming the "finished" manuscript into a finished book, the difference between which is greater than I would like to admit. Thanks to them for their patience, civility and evident expertise as they coped with an author who knew what he wanted but not always how this was to be achieved. Or whether it was possible to achieve it at all.

Finally, to family and friends, whose principal contribution is "being there". It would need a page in itself to list them all, but the two component parts are headed by my wife, Anne, and my long-term friend

Colin. "No man is an island", as John Donne has observed, and they are all part of the continent on which I live – to my good fortune and great delight.

Curves for the Mathematically Curious

What is a curve? Everyone knows what a curve is, until he has studied enough mathematics to become confused through the countless number of possible exceptions.

Felix Klein (1958)

The Euler Spiral

Why This Curve?

It is a curve that attracts some particularly pleasing mathematics and also one that enjoys varied and surprising application. More than this, its shape is one of enduring elegance. And it is our favourite.

1.1　An Unusual Parametrization...

The standard practice of expressing a curve in parametric form $x = g(t), y = h(t)$ brings with it variants of formulae for its common characteristics: its slope, the area under it, its arc length and its curvature. In the usual notation:

- slope: $\dfrac{\mathrm{d}y}{\mathrm{d}x} = \dfrac{y'}{x'}$,

- area: $\displaystyle\int_{t_1}^{t_2} yx'\,\mathrm{d}t$,

- arc length s: $\displaystyle\int_{t_1}^{t_2} \sqrt{x'^2 + y'^2}\,\mathrm{d}t$,

- curvature κ: $\dfrac{x'y'' - y'x''}{(x'^2 + y'^2)^{3/2}}$,

where the prime indicates the derivative with respect to the parameter t. Given differentiable functions $g(t)$ and $h(t)$, the usual major concern is whether the resulting integrals can be evaluated in closed form.

Our interest lies in what might at first appear to be a most exotic example of a parametrization:

$$x = x(t) = \int \cos f(t)\, dt = \int_0^t \cos f(u)\, du,$$

$$y = y(t) = \int \sin f(t)\, dt = \int_0^t \sin f(u)\, du,$$

where we choose to start the parameter at 0 and $f(u)$ is any differentiable function of u. The potentially daunting appearance of the integral actually contributes to the simplification of all but the area under the curve, with

$$\begin{array}{ccc} x' = x'(t) = \cos f(t) & & x'' = -f'(t)\sin f(t) \\ & \text{and} & \\ y' = y'(t) = \sin f(t) & & y'' = f'(t)\cos f(t) \end{array}$$

which lead to

- $\dfrac{dy}{dx} = \dfrac{\sin f(t)}{\cos f(t)} = \tan f(t);$

- $s = \displaystyle\int_0^t \sqrt{\cos^2 f(u) + \sin^2 f(u)}\, du = t;$

- $\kappa(t) = \dfrac{f'(t)\cos^2 f(t) + f'(t)\sin^2 f(t)}{[\cos^2 f(t) + \sin^2 f(t)]^{3/2}} = f'(t).$

We see that the parameter value, t, is precisely the arc length, s, and the curvature at the point given by parameter t is $f'(t)$; or, put conversely,

$$f(t) = \int \kappa(t)\, dt = \int^t \kappa(u)\, du.$$

We can, therefore, replace the abstract parameter t with the curve's arc length, s, and rewrite the parametrization as

$$x = x(s) = \int_0^s \cos\left(\int^u \kappa(t)\, dt\right) du,$$

$$y = y(s) = \int_0^s \sin\left(\int^u \kappa(t)\, dt\right) du.$$

The reader may be reassured by the equations generating a straight line (the x-axis) when $\kappa(t) = 0$ and a circle $(x^2 + (y-1)^2 = 1)$ when $\kappa(t) = 1$. The next natural step is to take $\kappa(t) = t$, or equivalently $\kappa(s) = s$, which

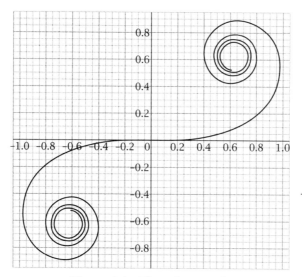

Figure 1.1. The Euler spiral.

leads to a curve whose curvature increases linearly with arc length, a
curve whose simplest parametric equations are

$$x = x(s) = \int_0^s \cos \tfrac{1}{2} u^2 \, du,$$

$$y = y(s) = \int_0^s \sin \tfrac{1}{2} u^2 \, du.$$

Such a curve must spiral inwards since the curvature becomes greater
as the curve develops, and does so to form the *Euler spiral,* shown in
figure 1.1 and the curve that is the subject of this chapter.

Figure 1.2. A chaise longue.

With a sympathetic curve plotter, considerable and enjoyable time
can be spent experimenting with other variants of $\kappa(t)$; for example,
figure 1.2 is generated by $\kappa(t) = t^2$ and figure 1.3 by $\kappa(t) = \cos t - t \sin t$
(and hence $f(t) = t \cos t$).

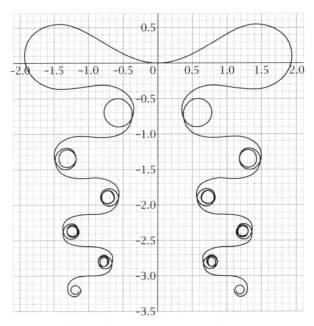

Figure 1.3. An elegant madness.

So, the curve of principal interest in this chapter appears as an example of what might at first appear to be a rather exotic parametrization involving arc length and curvature, but we will now see that such a construction is not at all strange. Quite the reverse, in fact.

1.2 ...Yet a Natural Parametrization

If a mathematical result is given a name, it is a clear indication of its perceived importance; if that name begins with the adjective "fundamental", that importance is magnified to the level where the result occupies a central role in the theory at hand or perhaps in mathematics more generally. Such is the case, then, for the *fundamental theorem of plane curves*, formal statements of which attract the abstraction necessary for mathematical precision, but its essence is that "curvature determines the curve". That is, if we are given a starting point in the plane and a curvature function, the curve is determined.

So, suppose that we are given a curvature function, $\kappa(s)$, parametrized in terms of arc length, s. With this, we have two quantities that are primitive, that is, ones that are not affected by external influences such as coordinate systems or frames of reference; they are termed *intrinsic* variables, and there is another too: the *tangential angle*, ψ.

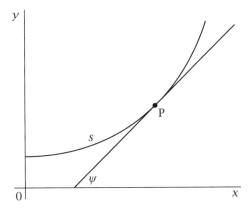

Figure 1.4. Intrinsic coordinates.

This is the angle that each of the tangents to the curve makes with a fixed direction, and it is reasonable and common to normalize matters so that $s = 0$ when $\psi = 0$ and take the direction as the positive x-axis. It is clear from figure 1.4 that $dy/dx = \tan\psi$. What is more – and it is a standard result easily gained – we have $d\psi(s)/ds = \kappa(s)$; indeed, this need not be thought of as a *result* but as a *definition* of curvature as the (normalized) rate at which the tangent to the curve turns.

Moreover, by definition,

$$\frac{ds}{dx} = \sqrt{1 + \left(\frac{dy}{dx}\right)^2} = \sqrt{1 + \tan^2\psi} = \sec\psi,$$

and so $dx/ds = \cos\psi$, and since

$$\frac{dy}{dx} = \frac{dy}{ds} \times \frac{ds}{dx} = \tan\psi,$$

it must be that $dy/ds = \sin\psi$.

We now have the necessary apparatus in place to achieve our goal of deriving the equation of a curve from a knowledge of its curvature.

Let the curve have a parametrization in terms of arc length as

$$x = g(s)$$
$$y = h(s)$$

and write

$$\frac{dx}{ds} = g'(s) \quad \text{and} \quad \frac{dy}{ds} = h'(s).$$

We have, then, the following set of differential equations defining the curve in terms of intrinsic coordinates:

$$\kappa(s) = \frac{d\psi(s)}{ds},$$
$$g'(s) = \cos\psi(s),$$
$$h'(s) = \sin\psi(s).$$

So, given $\kappa(s)$ we first find $\psi(s)$ and from this the parametric equations of the curve.

We have already danced between definite and indefinite integrals and we will continue to do so here, again using the variable as a limit and remembering any arbitrary constant. In these terms, the first equation has general solution

$$\psi(s) = \int \kappa(s)\,ds = \int_0^s \kappa(t)\,dt + \psi_0.$$

This means that

$$g'(s) = \cos\left(\int_0^s \kappa(t)\,dt + \psi_0\right) \quad \text{and} \quad h'(s) = \sin\left(\int_0^s \kappa(t)\,dt + \psi_0\right),$$

and these have the general solution

$$g(s) = \int \cos\left(\int_0^s \kappa(t)\,dt + \psi_0\right) ds = \int_0^s \cos\left(\int_0^u \kappa(t)\,dt + \psi_0\right) du + x_0,$$

$$h(s) = \int \sin\left(\int_0^s \kappa(t)\,dt + \psi_0\right) ds = \int_0^s \sin\left(\int_0^u \kappa(t)\,dt + \psi_0\right) du + y_0.$$

We now make explicit the influence of those arbitrary constants of integration, using the standard, elementary trigonometric identities

$$\cos(\theta + \varphi) = \cos\theta\cos\varphi - \sin\theta\sin\varphi,$$
$$\sin(\theta + \varphi) = \sin\theta\cos\varphi + \cos\theta\sin\varphi,$$

to obtain

$$g(s) = \int_0^s \cos\left(\int_0^u \kappa(t)\,dt + \psi_0\right) du + x_0$$
$$= \int_0^s \cos\left(\int_0^u \kappa(t)\,dt\right)\cos\psi_0 - \sin\left(\int_0^u \kappa(t)\,dt\right)\sin\psi_0\,du + x_0$$
$$= \cos\psi_0 \int_0^s \cos\left(\int_0^u \kappa(t)\,dt\right) du$$
$$\quad - \sin\psi_0 \int_0^s \sin\left(\int_0^u \kappa(t)\,dt\right) du + x_0,$$

$$h(s) = \int_0^s \sin\left(\int_0^u \kappa(t)\,dt + \psi_0\right) du + y_0$$

$$= \int_0^s \sin\left(\int_0^u \kappa(t)\,dt\right)\cos\psi_0 + \cos\left(\int_0^u \kappa(t)\,dt\right)\sin\psi_0\,du + y_0$$

$$= \cos\psi_0 \int_0^s \sin\left(\int_0^u \kappa(t)\,dt\right) du$$

$$+ \sin\psi_0 \int_0^s \cos\left(\int_0^u \kappa(t)\,dt\right) du + y_0,$$

which we can conveniently rewrite in matrix form as

$$\begin{pmatrix} g(s) \\ h(s) \end{pmatrix} = \begin{pmatrix} \cos\psi_0 & -\sin\psi_0 \\ \sin\psi_0 & \cos\psi_0 \end{pmatrix} \begin{pmatrix} \int_0^s \cos\left(\int_0^u \kappa(t)\,dt\right) du \\ \int_0^s \sin\left(\int_0^u \kappa(t)\,dt\right) du \end{pmatrix} + \begin{pmatrix} x_0 \\ y_0 \end{pmatrix}.$$

The pre-multiplying matrix represents an anticlockwise rotation about the origin by angle ψ_0 and the final vector a translation. We have shown that, up to these two isometries, our curve is uniquely determined by the parametric equations

$$x = g(s) = \int_0^s \cos\left(\int_0^u \kappa(t)\,dt\right) du,$$

$$y = h(s) = \int_0^s \sin\left(\int_0^u \kappa(t)\,dt\right) du,$$

with arc length as parameter. These equations are the embodiment of the fundamental theorem of plane curves and confirm that curvature does indeed determine the curve. With these thoughts, we have the Euler spiral as the curve naturally defined by the simplest non-trivial relationship possible between its curvature and arc length: $\kappa = s$. Yet, this is not the manner in which the curve came into existence – and Euler was not the first to consider it.

1.3 A Challenge

With two Jakobs, three Johanns, two Daniels and five Nikolauses, along with linguistic variants of their names, it is extremely easy to confuse one Bernoulli family member with another. The mathematical dynasty that spread over a century and comprised nine sons and sons-of-sons was singularly remarkable for the contribution it made to the various areas of mathematics and associated studies, but it is to James I (or Jakob I or Jacques I), by age the dynasty's mathematical patriarch,

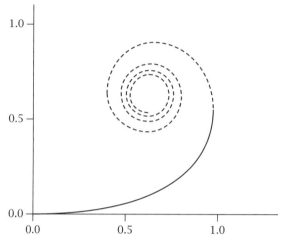

Figure 1.5. Bernoulli's curve.

whom we must look for the first appearance of our curve – although not the first real appreciation of it.

A seminal 1694 publication (Bernoulli 1694) formed the culmination of James Bernoulli's study of what we would now term the *cantilever problem*: a thin horizontal beam of negligible mass, fixed at one end and loaded at the other assumes a curved shape – but what shape? The answer he gave is what we now call the *elastica*: a curve that has its own considerable importance in various areas and that is closely related to our spiral. At the end of his work he had, characteristically, posed a number of challenges for the readers' consideration, one of which could be thought of as the converse to the one he had already answered:

> To find the curvature a lamina must have in order to be straightened out horizontally by a weight at one end.

The beam remains fixed at one end but now assumes a curved, upward shape that transforms to a horizontal line by the action of a weight placed at its other extremity. In a note dated that same year, Bernoulli showed that he had solved his own problem and gave the intrinsic equation of such a curve as $a^2 = sR$, where a is constant and R is the curve's radius of curvature, defined as the reciprocal of its curvature, κ; its nature is, then, that its curvature is proportional to its arc length. His argument is terse and more of a statement than a proof, and in consequence it is obscure – a view echoed in 1744 by his nephew, Nicholas I, when, in editing his uncle's work for publication,

Figure 1.6. Euler's argument.

he commented "I have not found this identity established". Referring
to figure 1.5, Bernoulli's curve is the solid line, drawn until it becomes
vertical. Beyond this, he would have had no interest, and it would be left
to the inimitable Leonhard Euler to provide the convincing arguments
which extended it to the dotted spiral.

It was in that same year of 1744 that Euler published a work (see
Euler 1744, (E65)) that, even by his lofty standards, is extraordinary in
its compass. There are two appendices, the first of which, *Additamen-
tum 1*, deals with elastic curves, and in sections 51 and 52 he considers
this problem. The mixture of pure mathematics and physics that Euler
uses is a clearer version of what was, apparently, Bernoulli's argument.

Referring to figure 1.6, suppose that the curvature of the beam at a
point S on it before and after the application of a bending force is $\kappa_1(s)$
and $\kappa_2(s)$ respectively. Also suppose that S is distant s along the beam
from the point of application of the force. In modern terms, the force's
influence is measured by the equation $M = \kappa EI$, where M, E and I are
the moment of the force, Young's modulus and the second moment of
area of the beam (about its neutral axis), respectively. With $M = Ps$ we
measure the contribution to the curvature of the beam as

$$\kappa = \frac{Ps}{EI} = \frac{s}{a^2},$$

as Euler did. This means that $\kappa_2(s) = \kappa_1(s) - \kappa$, and, since the final
shape of the beam is required to be a straight line, $\kappa_2(s) = 0$, and so

$$0 = \kappa_1(s) - \frac{s}{a^2} \quad \text{and} \quad \kappa_1(s) = \frac{1}{r} = \frac{s}{a^2}.$$

From this intrinsic equation Euler somewhat rapidly extracted the
curve's parametric equations[1]

$$x = \int \cos \frac{s^2}{2a^2} \, ds = \int_0^s \cos \frac{u^2}{2a^2} \, du$$

$$y = \int \sin \frac{s^2}{2a^2} \, ds = \int_0^s \sin \frac{u^2}{2a^2} \, du$$

[1] Actually, we have interchanged sin and cos to be consistent with modern usage.

with his largely implied argument being

$$\int \frac{1}{r}\,ds = \int \frac{s}{a^2}\,ds \quad \Rightarrow \quad \int \frac{d\psi}{ds}\,ds = \frac{s^2}{2a^2} \quad \Rightarrow \quad \psi = \frac{s^2}{2a^2}.$$

With

$$\frac{dx}{ds} = \cos\psi \quad \text{and} \quad \frac{dy}{ds} = \sin\psi,$$

the solution follows.

The parametric equations allow for the extension of the curve beyond our assumed bound: to the vertical and, beyond that, to the infinite spiral.

Euler acknowledged that neither integral can be evaluated in closed terms and he used series expansions and term-by-term integration to yield the still-useful infinite series forms:

$$x = s - \frac{s^5}{2! \times 5} + \frac{s^9}{4! \times 9} - \frac{s^{13}}{6! \times 13} + \cdots,$$

$$y = \frac{s^3}{1! \times 3} - \frac{s^7}{3! \times 7} + \frac{s^{11}}{5! \times 11} - \frac{s^{15}}{7! \times 15} + \cdots.$$

He also made the following observation.

> Now, from the fact that the radius of curvature continually decreases the greater the arc taken, it is manifest that the curve cannot become infinite, even if the arc is taken infinite. Therefore the curve will belong to the class of spirals, in such a way that after an infinite number of windings it will roll up a definite point as a centre, which point seems very difficult to find from this construction. Analysis therefore must be considered to gain no slight advantage if anyone should discover a method by the aid of which at least an approximate value can be assigned to the integrals in the case where s is taken as infinite. This seems not an unworthy problem upon which mathematicians may exercise their powers.

That is, the curve spirals towards its two limit points

$$x = \pm \int_0^\infty \sin\frac{u^2}{2a^2}\,du,$$

$$y = \pm \int_0^\infty \cos\frac{u^2}{2a^2}\,du.$$

Figure 1.7. The limit point.

Figure 1.7 is the plot (for an arbitrary value of $a = 0.7$)

$$x(t) = \int_0^t \sin \frac{u^2}{2a^2} \, du \quad \text{(dotted)},$$

$$y(t) = \int_0^t \cos \frac{u^2}{2a^2} \, du \quad \text{(full)},$$

for $t \geqslant 0$, and it leads the eye to a limit, the exact value of which would be very nice to know.

There appears to be no record of any contribution from other mathematicians, but 38 years later, in 1781, Euler published his own answer to his own question:[2]

$$x = \pm \frac{a}{\sqrt{2}} \sqrt{\frac{\pi}{2}},$$

$$y = \pm \frac{a}{\sqrt{2}} \sqrt{\frac{\pi}{2}}.$$

His approach exhibits typical Eulerian masterful symbolic manipulation, with a mixture of integrals, complex exponentials and the Gamma function (which he had already brought into existence in 1729): a method that he described as *singular*. This singular method yielded various other results and, most particularly,

$$\int_0^\infty \frac{\sin x}{x} \, dx = \frac{\pi}{2}.$$

Bernoulli's original question had been answered and the solution curve extensively investigated, with Euler's contribution comprising a tiny part of his vast output and seemingly lost within it.

1.4 One Curve, Many Names

And so the curve slumbered. That is, until 1814, when the French physicist Augustin Fresnel deduced an expression for the intensity of the

[2] On the values of integrals extended from the variable term $x = 0$ to $x = \infty$ (E675).

illumination at any point of a diffraction pattern, which has the form
(under certain simplifying assumptions)

$$I_v = \left[\int_0^v \cos \tfrac{1}{2}\pi t^2 \, dt \right]^2 + \left[\int_0^v \sin \tfrac{1}{2}\pi t^2 \, dt \right]^2.$$

So, if not the spiral itself, its components resurfaced, and in a note
to the French Academy of Science in 1818 Fresnel produced a table
of values of the two integrals for values of v, differing by 0.1, from
$v = 0.1$ to $v = 5.1$, later extended to $v = 5.5$, all to four decimal places.
More tables followed, of course, but these two defining components
of the Euler spiral are nearly universally known as *Fresnel integrals*.
The spiral itself reemerged in 1874, when the French scientist (Marie)
Alfred Cornu,[3] following Fresnel, plotted the curve and identified its
use as a computational device for problems involving diffraction. The
influence of this most eminent scientist's involvement caused his name
to be attached to the curve – the following comes from his 1902 funeral
oration by his former student, Henri Poincaré:

> Today, to predict the effect of an arbitrary screen on a beam of light,
> everyone makes use of the spiral of Cornu.

And from one of his obituaries (Ames 1902):

> and the method of studying problems of diffraction by the use of
> Cornu Spirals is familiar to everyone.

The *Cornu spiral* is a term still in common use. From the late nine-
teenth through to the twentieth century, the curve's further mathemat-
ical properties were investigated by the Italian mathematician Ernesto
Cesàro, to whom the curve resembled the shape that a length of thread
assumes as it is wrapped around a spindle. In 1886 and from this image,
Cesàro coined *clothoid(e)* for the spiral's name, after *Clotho*, the spinner
among the *Three Fates*, who spins the thread of human life by winding it
around a spindle. This Italian romance is balanced by Cesàro's geomet-
ric findings regarding the curve, which were many but whose nature is
somewhat remote from modern mathematics. As an indication, we pro-
vide the statements of two of them below, leaving the reader to make
use of the internet to identify such terms as are necessary:

[3] It is a nice coincidence that the French word *cornu* translates to *horned*, as with an
ibex, etc.

> When a clothoide rolls on a straight line, the locus of the centre
> of curvature corresponding to the point of contact is an equilateral
> hyperbola asymptotic to the line considered.

> The clothoide is the only curve enjoying the property that the centre
> of gravity of any arc is a centre of similitude of the circles osculating
> the extremities of the arc.

Again, the name *clothoid* remains in common use.

Meanwhile, trains moved faster. Modern model train sets can be equipped with a plethora of differently designed track pieces, but those that offer a change in direction are shaped as arcs of circles of various lengths and with various radii. These do not, as any serious model railway enthusiast will know, reflect the real world. A train travelling at a constant speed v along a straight section of track would encounter an instant change in its acceleration, from 0 to the centripetal acceleration of $v^2/r = \kappa v^2$, as it began to negotiate the change of direction afforded by a circular arc of radius r and, therefore, of curvature $\kappa = 1/r$. The resulting unpleasant experience, for the train and its passengers, is technically known as a *jerk* and is to be avoided. From the early days of the railway, this avoidance took the form of various *transition curves* of several types replacing the circular arc, yet best of all is one where the curvature, and so acceleration, increases linearly from 0 along the track – which is precisely the nature of the Euler spiral. It would appear to be in 1881 that the spiral was put to such use (Talbot 1890–91):

> The transition spiral was probably first used on the Pan Handle Rail-
> road in 1881, by Mr. Elliot Holbrook. The principal part of the treat-
> ment here given was made before the writer's attention was called to
> Mr. Holbrook's use of the curve, and it is believed that most of the
> formulas and methods appear here for the first time.

A visualization of things is provided by figure 1.8. Part (a) is the plan view of a track initially formed as two straights joined by two semicircular arcs, which has been amended at the right end with the replacement of the semicircular arc with two parts of an Euler spiral (shown dotted). Part (b) shows the train's acceleration as it first moves with constant speed along the top straight, then negotiates the Euler spirals, then returns along the bottom straight and finally completes the circuit along the semicircular arc: the jerk has been replaced by a linearly increasing acceleration, which will be slightly greater, but much preferable.

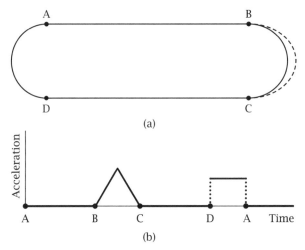

Figure 1.8. A transition curve in action.

Surprisingly, there appears to be no *Holbrook spiral*, although there is a *Glover spiral*, after one James Glover who trumpeted the curve's usefulness as a railway transition curve in 1900. In this usage, Americans may well know it as the *AREMA spiral*, and it remains in use to this day in any situation in which straight lines and curves need smooth joining – including road transitions and the vertiginous curves on roller coasters.

Whatever the context, whatever the theory or practice associated with it, and whatever name it is known by, the curve came into existence as a well-defined, well-understood entity through the omnipresent involvement of Leonhard Euler: it is surely the *Euler spiral*.

The Weierstrass Curve

Why This Curve?

It is the first everywhere-continuous but nowhere-differentiable curve, and as such it was to a significant extent responsible for the impetus behind the rigorous idea of a limit. It is also the first recognized example of what would later be called a fractal.

2.1 Naive Thoughts

We begin this chapter with an appeal to reasoned intuition. If we deem a curve to be something we can draw, it must reasonably satisfy the following criteria.

- It must be continuous, or at least comprise continuous sections, since a line drawn between any two points must necessarily pass through all points on the chosen path.
- It must have a determinate tangent at every point, since at every point of the path there is a determinate direction of motion.
- The path between any two points must be of finite length, since it is drawn in a finite time.

So we may think; and so thought the majority of mathematicians of the early nineteenth century, with the precise nature of "curve" very much a matter of debate. It might be such a path as we describe above;

Figure 2.1. (a), (b) Simple non-differentiability.

it might be the physical manifestation of a function, expressed as an analytic formula; it might be an infinite power series, devoid of immediate geometric appeal, and sometimes of questionable convergence. It was by then evident, though, that the comfortable, if naive, concept of *curve* that had served for so long was in urgent need of appraisal. The first of these assumptions was brought into question as early as 1829 when, at the end of a paper concerning Fourier series, Lejeune Dirichlet (1829) provided a description of the nowhere-continuous function for $c \neq d$:

$$f(x) = \begin{cases} c: & x \text{ rational} \\ d: & x \text{ irrational} \end{cases}$$

although its classification as a curve was then, and remains, questionable. It was, though, an attack on the second assumption that was to bring about the quite shocking curve that is the subject of this chapter.

Differentiation has as its purpose finding the gradients of tangents to curves. Yet, a tangent may be vertical: at the sides of a circle, for example, or \sqrt{x} at the origin, where in each case the tangent is palpable but the derivative is infinite. More profoundly, the simplicity of the two "curves" in figure 2.1 belies their significance as we try to ascribe a tangent to a point at which there is an instantaneous change of direction.

Figure 2.1(b) finds analytic expression in the modulus function

$$|x| = \begin{cases} x: & x \geqslant 0 \\ -x: & x < 0 \end{cases}$$

and with this we can easily generate an infinite number of awkward points using the periodicity of, for example, $|\sin x|$, as shown in figure 2.2. The misbehaviour of tangents to continuous curves is thus magnified, but the problematic points – exceptions between which the curve can be sectioned into well-behaved components – are at least isolated.

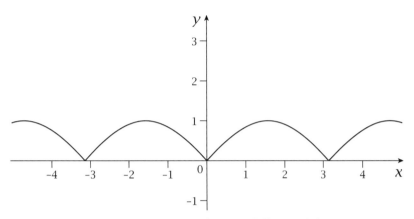

Figure 2.2. More complex non-differentiability.

Put succinctly, that continuity is a necessary prerequisite for differentiability was accepted from the outset of the differential calculus, but whether or not the condition is (largely) sufficient was an outstanding question. This admitted, there was a general conviction that such is the case, with the assertion "proved" in many leading texts of the time. André-Marie Ampère's important and lengthy memoir (with a far-from-pithy title – see Ampère (1806)) contained what many have deduced as his own "proof" of the result, and one on which others were built; the unfortunate vagueness of language, though, casts doubt on the precise nature of what he did infer from his calculations. Whatever Ampère thought he had proved or otherwise, there was widespread confidence that (save for questionable examples such as Dirichlet's) whatever a function was held to be, if it has a curve associated with it, that function cannot be so contrary that its curve cannot be drawn.

2.2 Profound Thoughts

The conviction that curves were born of accepted functions combined in reasonable ways clouded the territory that was the birthplace of what we now term real analysis. To investigate the terrain properly required less comfortable constructions:

Everyone understands the profound difference that exists between a fact obtained in circumstances constructed for the purpose, with no other point and having no other interest than to demonstrate the possibility, some sort of exhibit in a teratological museum, and the same fact encountered in the course of a theory that has all its roots in the most common and most essential problems of analysis.

These words are those of Jacques Hadamard (1921, p. 212) and they refer to what were by 1921 a slew of monsters of the mathematical deep, constructed for the purpose of making mathematicians question ideas that had long been taken for granted: Dirichlet's function and a variant of it, which is continuous on the irrationals yet discontinuous on the rationals; monotonic curves that have zero derivative almost everywhere; bounded functions that are not integrable, etc. Most outrageous of all, though, a curve that is continuous everywhere but differentiable nowhere. A curve that cannot be drawn by dint of there being no direction in which to guide the pen. For brevity, we will refer to such as a CND curve.

Although the first known attempt at producing a CND curve must be attributed to the Bohemian polymath Bernard Bolzano, his manuscript *Functionenlehre* of about 1830, in which his construct featured, was not published until 1930. Furthermore, his proof of continuity was deficient and he had established non-differentiability merely in a dense subset of the real line. Nevertheless, the infinite sequence of straight lines that constituted his construction was later shown to be a CND curve. A similar fate befell the contribution of the Swiss mathematician Charles Cellérier, who in about 1860 had proposed the function

$$\sum_{n=1}^{\infty} \frac{1}{a^n} \cos(a^n x)$$

as a CND curve, where $a > 1000$ is an even integer. Again, the manuscript remained unpublished and its appearance in 1890 rendered its significance slight, and yet its form is one that in other hands was to lead to the discovery of a curve that was widely and confidently believed not to exist: one that is everywhere-continuous but nowhere-differentiable.

On 18 July 1872, Karl Weierstrass was to imagine the unimaginable, and he succeeded in luring the truth towards it. It was then that he presented a paper to the Royal Academy of Science in Berlin, the second he had ever presented to the academy, in which he described his own example of a CND curve – and proved that it was such. In translation, from that presentation we have:

> Only recently it was generally believed that a continuous function of a real variable has a derivative the value of which is not defined or is infinite only at several isolated points. Even in the works of Gauss, Cauchy or Dirichlet, mathematicians who were rather critical of everything in their fields, we are unable – as far as I know – to find a mark

of a different opinion. I learned from Riemann's students that he was the first who expressed a conviction (in 1861 or even sooner) that this assertion is not valid, e.g., for a function expressed by infinite series

$$\sum_{n=1}^{\infty} \frac{1}{n^2} \sin(n^2 x).$$

Unfortunately, Riemann's proof of this has not been published, nor does it appear to have been preserved in his papers or by oral communication. It is more regrettable that I had not learned for sure what Riemann exactly said about the example. Those mathematicians who have concerned themselves with the problem after Riemann's conjecture became known in wider circles, seem to be of the opinion (at least a majority thereof) that it is enough to prove the existence of functions that have points in every interval of their argument, no matter how small, where they are not differentiable. That there are functions of this kind is unusually easy to prove, and I consequently believe that Riemann had in mind only those functions that have no determinate derivative for any value of their argument.

This appears to be the first reference to Riemann's function, and we may infer from it that Weierstrass had failed to find his own proof: small wonder, as it has subsequently been shown to be everywhere continuous but only "nearly" everywhere non-differentiable (it has a derivative (of $-\frac{1}{2}$) at the points of the form $x = (p/q)\pi$, where p, q are odd integers).[1] The function that Weierstrass provided in that lecture, and that is the subject of this chapter, is the *Weierstrass function*:

$$W(x) = \sum_{n=0}^{\infty} a^n \cos(b^n \pi x),$$

where $0 < a < 1$, $ab > 1 + \frac{3}{2}\pi$ and $b > 1$ an odd integer, is continuous everywhere but differentiable nowhere on the real line.

There are echoes of Cellérier with this strange function and the even stranger conditions attached to it. It was brought to the greater mathematical world through the efforts of the mathematician Paul du Bois-Reymond (1875) and once again published in the prestigious *Crelle's Journal*.[2] We can readily judge the impact of the function's existence by du Bois-Reymond's own comment on page 29 of that article:

[1] This combination of papers settles the matter: Gerver (1970, 1971) and Hardy (1916, pp. 322–25).

[2] The proper name of the journal is *Für die reine und angewandte Mathematik*. At this time it was known as *Borchardt's Journal*, after its then editor Carl Borchardt. It is the oldest mathematical periodical still in existence.

It appears to me that the metaphysics of Weierstrass's function still hides many riddles and I cannot help thinking that entering deeper into the matter will finally lead us to the limits of our intellect.

The motif at this chapter's start shows the Weierstrass curve with parameter values $a = 0.5$ and $b = 5$,[3] summed for the first few terms. A (very) rough idea of what lies behind the construction is that there is an infinite series of trigonometric terms with fast-diminishing amplitudes a^n (which will cause the curve to be continuous) but for which the term-by-term derivative has fast-increasing amplitudes of $(ab)^n$, making the series of derivatives divergent. An example of the type is $\sum_{n=0}^{\infty} (\frac{1}{2})^n \cos(4^n x)$, which has amplitudes the diminishing $(\frac{1}{2})^n$, whereas the series of term-by-term derivatives is $\sum_{n=0}^{\infty} -2^n \sin(4^n x)$, with amplitudes the diverging 2^n.

We should, though, seize the spirit of the construction: it was meant to embrace rigour, and rigour is what we must embrace.

2.3 Differentiability

Since we have at the heart of this chapter notions of continuity and differentiability, with history warning against vagueness, we provide some standard fare, together with an important variant, choosing to avoid the ε, δ formulation.

A function $f(x)$ is *continuous* at a point x_0 of its domain if

$$\lim_{x \to x_0} f(x) = f(x_0).$$

It is *differentiable* at x_0 if

$$\lim_{x \to x_0} \frac{f(x) - f(x_0)}{x - x_0}$$

exists, in which case this limit is called the *derivative* of $f(x)$ at $x = x_0$; it is defined to be the slope of the tangent to the curve at that point. In both cases the limit is required to be independent of the direction in which x_0 is approached.

For example, a standard exercise in elementary calculus is to show that our earlier awkward function

$$f(x) = |x| = \begin{cases} x: & x \geq 0 \\ -x: & x < 0 \end{cases}$$

[3] Note that the original conditions are not fully met, but more of that later.

although evidently continuous everywhere, is not differentiable at the origin, with the argument being

$$\lim_{x \to 0^+} \frac{|x| - |0|}{x - 0} = \lim_{x \to 0^+} \frac{x}{x} = 1,$$

whereas

$$\lim_{x \to 0^-} \frac{|x| - |0|}{x - 0} = \lim_{x \to 0^-} \frac{-x}{x} = -1;$$

the limits exist but are different.

There is, though, an equivalent formulation of both continuity and differentiability in terms of convergent sequences, and, in the case of differentiability, one that we shall soon have cause to use. We trouble, then, to include the following definition.

A function $f(x)$ is *differentiable* at a point x_0 if, for every sequence $\{x_n\} \to x_0$, the sequence

$$\left\{ \frac{f(x_n) - f(x_0)}{x_n - x_0} \right\}$$

converges, in which case this limit is called the *derivative* of $f(x)$ at $x = x_0$. We note that again implicit in this is the condition that the sequence may approach from the left or the right and that the limits must exist and be the same. To prove non-differentiability, we need only provide a sequence or sequences for which the limit is problematic.

Once again, we consider $f(x) = |x|$ and consider the two subsequences of the sequence

$$x_n = \frac{(-1)^n}{n} \xrightarrow[n \to \infty]{} 0,$$

one where n is held to be even, and so $y_n = 1/n$ and the other to be when n is held to be odd, and so $z_n = -1/n$. Then

$$\frac{f(y_n) - f(0)}{y_n - 0} = \frac{1/n}{1/n} = 1 \quad \text{and} \quad \frac{f(z_n) - f(0)}{z_n - 0} = \frac{1/n}{-1/n} = -1.$$

And the two limits once again exist, but are again unequal. We now look to sterner stuff to which to put this definition to use as we disassemble Weierstrass's proof of the non-differentiability of his infamous function.

2.4 Weierstrass's Proof

The Statement

The Weierstrass function

$$W(x) = \sum_{n=0}^{\infty} a^n \cos(b^n \pi x)$$

for $0 < a < 1$, $ab > 1 + \frac{3}{2}\pi$ and $b > 1$ an odd integer is continuous everywhere and differentiable nowhere on the real line.

The proof necessarily demands two components: establishing that the function is everywhere continuous and then that it is nowhere differentiable – and there is a marked contrast between the two approaches.

Continuity

This results from the interaction of three results from real analysis.

- The limit of a uniformly convergent sequence or series of continuous functions is itself continuous.
- The series of functions $\sum_{n=0}^{\infty} f_n(x)$ is uniformly convergent if there exist constants M_n such that $|f_n(x)| < M_n$ for each n and for all x, and for which $\sum_{n=0}^{\infty} M_n$ converges.
- $|f_n(x)| = |a^n \cos(b^n \pi x)| \leqslant a^n = M_n$, and the sum to infinity of the convergent geometric series $\sum_{n=0}^{\infty} a^n = 1/(1-a)$.

It is singularly appropriate that the middle result above is known as the *Weierstrass M test*.

Non-differentiability

We follow and expand upon the proof submitted by Paul du Bois-Reymond in 1875, which we have broken down into its component parts; it will, of course, expose why the remaining, rather strange, restrictions on the parameters are as they are. Although at first glance it may not seem so, the proof is elementary, using high school ideas of summation, geometric series and trigonometric facts, and the triangle inequality: there is much that is detail but little that is difficult. That said, it is also a proof for which a first read might seem daunting, but it is also one that yields to repeated, careful study. It is impressive to witness what a great mathematical practitioner can conjure up with such limited tools.

The Idea

Two sequences are constructed, each of which converges to an arbitrary fixed point x_0, one from above and the other from below, yet the limit of the difference quotients are different; indeed, this limit is on the one hand plus infinity and on the other minus infinity.

The Sequences

For a fixed positive integer b and an arbitrary positive integer m, choose $\alpha_m \in \mathbb{Z}$ such that $-\frac{1}{2} < b^m x_0 - \alpha_m \leqslant \frac{1}{2}$. This means that

$$\left| \frac{\alpha_m}{b^m} - x_0 \right| < \frac{1}{2b^m} \quad \text{and so} \quad \lim_{m \to \infty} \frac{\alpha_m}{b^m} = x_0.$$

Now define the interim sequence $x_{m+1} = b^m x_0 - \alpha_m$ (which means that $-\frac{1}{2} < x_{m+1} \leqslant \frac{1}{2}$) and also our two sequences of interest:

$$y_m = \frac{\alpha_m - 1}{b^m} \quad \text{and} \quad z_m = \frac{\alpha_m + 1}{b^m}.$$

Then,

$$y_m - x_0 = \frac{\alpha_m - 1}{b^m} - x_0 = \frac{\alpha_m - 1 - b^m x_0}{b^m} = -\frac{1 + x_{m+1}}{b^m} < 0,$$

which means that $y_m < x_0$; also,

$$z_m - x_0 = \frac{\alpha_m + 1}{b^m} - x_0 = \frac{\alpha_m + 1 - b^m x_0}{b^m} = \frac{1 - x_{m+1}}{b^m} > 0,$$

which means that $z_m > x_0$. Since $\lim_{m \to \infty} y_m = x_0$ from the left and $\lim_{m \to \infty} z_m = x_0$ from the right, we have the two convergent sequences we require.

The Tools

In part of the argument we shall have need of several standard elementary results, which we list in order of use.

1. $\cos x - \cos y = -2 \sin \frac{1}{2}(x + y) \sin \frac{1}{2}(x - y)$.
2. $|\sum_{r=1}^{n} a_r| \leqslant \sum_{r=1}^{n} |a_r|$ (the triangle inequality).
3. $|(\sin x)/x| \leqslant 1$.
4. $\sum_{n=0}^{m-1} r^n = (r^m - 1)/(r - 1)$.
5. $\cos(\theta + \varphi) = \cos \theta \cos \varphi - \sin \theta \sin \varphi$.

The Left Limit

The difference quotient is divided into two parts, which are dealt with separately:

$$
\frac{W(y_m) - W(x_0)}{y_m - x_0} = \sum_{n=0}^{\infty} a^n \frac{\cos(b^n \pi y_m) - \cos(b^n \pi x_0)}{y_m - x_0}
$$

$$
= \sum_{n=0}^{m-1} (ab)^n \frac{\cos(b^n \pi y_m) - \cos(b^n \pi x_0)}{b^n (y_m - x_0)}
$$

$$
+ \sum_{n=0}^{\infty} a^{m+n} \frac{\cos(b^{m+n} \pi y_m) - \cos(b^{m+n} \pi x_0)}{y_m - x_0}
$$

$$
= S_1 + S_2.
$$

Using (1) above,

$$
S_1 = \sum_{n=0}^{m-1} (ab)^n \frac{\cos(b^n \pi y_m) - \cos(b^n \pi x_0)}{b^n (y_m - x_0)}
$$

$$
= \sum_{n=0}^{m-1} (ab)^n \frac{-2 \sin(\frac{1}{2}(b^n \pi y_m + b^n \pi x_0)) \sin(\frac{1}{2}(b^n \pi y_m - b^n \pi x_0))}{b^n (y_m - x_0)}
$$

$$
= \sum_{n=0}^{m-1} (-\pi)(ab)^n \sin\left(\frac{b^n \pi (y_m + x_0)}{2}\right) \frac{\sin(\frac{1}{2}b^n \pi (y_m - x_0))}{\frac{1}{2}b^n \pi (y_m - x_0)}.
$$

Using (2) then (3) then (4) above,

$$
|S_1| = \left| \sum_{n=0}^{m-1} (-\pi)(ab)^n \sin\left(\frac{b^n \pi (y_m + x_0)}{2}\right) \frac{\sin(\frac{1}{2}b^n \pi (y_m - x_0))}{\frac{1}{2}b^n \pi (y_m - x_0)} \right|
$$

$$
\leqslant \pi \sum_{n=0}^{m-1} (ab)^n \left| \sin\left(\frac{b^n \pi (y_m + x_0)}{2}\right) \right| \left| \frac{\sin(\frac{1}{2}b^n \pi (y_m - x_0))}{\frac{1}{2}b^n \pi (y_m - x_0)} \right|
$$

$$
\leqslant \pi \sum_{n=0}^{m-1} (ab)^n = \pi \frac{(ab)^m - 1}{ab - 1} < \frac{\pi (ab)^m}{ab - 1},
$$

which means that we can write

$$
S_1 = (ab)^m \frac{\pi}{ab - 1} \varepsilon_1,
$$

where $\varepsilon_1 \in (-1, 1)$.

S_2 is dealt with differently, as the b^m cancels.

First, we look at the two component parts of its numerator:

$$\cos(b^{m+n}\pi y_m) = \cos\left(b^{m+n}\pi\frac{\alpha_m - 1}{b^m}\right)$$

$$= \cos(b^n(\alpha_m - 1)\pi) = (-1)^{b^n(\alpha_m - 1)}$$

$$= [(-1)^{b^n}]^{\alpha_m - 1} = (-1)^{\alpha_m - 1} = -(-1)^{\alpha_m},$$

where we use the fact that

$$\cos N\pi = \begin{cases} 1: & N \text{ even} \\ -1: & N \text{ odd} \end{cases}$$

$$= (-1)^N$$

and then that b is odd.

In the same way, using

$$x_{m+1} = b^m x_0 - \alpha_m \quad \Rightarrow \quad x_0 = \frac{\alpha_m + x_{m+1}}{b^m}$$

and (5) above,

$$\cos(b^{m+n}\pi x_0)$$

$$= \cos\left(b^{m+n}\pi\frac{\alpha_m + x_{m+1}}{b^m}\right) = \cos(b^n\pi\alpha_m + b^n\pi x_{m+1})$$

$$= \cos(b^n\pi\alpha_m)\cos(b^n\pi x_{m+1}) - \sin(b^n\pi\alpha_m)\sin(b^n\pi x_{m+1})$$

$$= [(-1)^{b^n}]^{\alpha_m}\cos(b^n\pi x_{m+1}) - 0 = (-1)^{\alpha_m}\cos(b^n\pi x_{m+1})$$

since $\alpha_m \in \mathbb{Z}$.

From these and the definition of y_m,

$$S_2 = \sum_{n=0}^{\infty} a^{m+n}\frac{-(-1)^{\alpha_m} - (-1)^{\alpha_m}\cos(b^n\pi x_{m+1})}{-(1 + x_{m+1})/b^m}$$

$$= (ab)^m(-1)^{\alpha_m}\sum_{n=0}^{\infty}a^n\frac{1 + \cos(b^n\pi x_{m+1})}{1 + x_{m+1}}.$$

But

$$\sum_{n=0}^{\infty}a^n\frac{1 + \cos(b^n\pi x_{m+1})}{1 + x_{m+1}} \geq \frac{1 + \cos(\pi x_{m+1})}{1 + x_{m+1}}$$

$$\geq \frac{1 + 0}{1 + \frac{1}{2}} = \frac{2}{3}.$$

The inequality merely reflecting the fact that the infinite sum of positive terms ($0 < a < 1$ and $-\frac{1}{2} < x_{m+1} \leqslant \frac{1}{2}$, so $-\frac{1}{2}\pi < \pi x_{m+1} \leqslant \frac{1}{2}\pi$) is at least as big as the first term of the series. So,

$$S_2 = (ab)^m (-1)^{\alpha_m} \times \tfrac{2}{3} \times \eta_1 \quad \text{for } \eta_1 > 1.$$

Combining the two results we can write

$$\frac{W(y_m) - W(x_0)}{y_m - x_0} = (ab)^m \frac{\pi}{ab - 1}\varepsilon_1 + (ab)^m (-1)^{\alpha_m} \times \frac{2}{3} \times \eta_1$$

$$= (-1)^{\alpha_m}(ab)^m \eta_1 \left(\frac{\pi}{ab - 1}\frac{\varepsilon_1}{\eta_1} + \frac{2}{3} \right).$$

The Right Limit

The argument is precisely the same and results in the almost identical but – with its leading minus sign – crucially different expression

$$\frac{W(z_m) - W(x_0)}{z_m - x_0} = -(-1)^{\alpha_m}(ab)^m \eta_2 \left(\frac{\pi}{ab - 1}\frac{\varepsilon_2}{\eta_2} + \frac{2}{3} \right),$$

where $\varepsilon_2 \in (-1, 1)$ and $\eta_2 > 1$.

The Denouement

First, note that $|\varepsilon_1/\eta_1| < 1$ (and the same is true for $|\varepsilon_2/\eta_2|$). The condition that $ab > 1 + \frac{3}{2}\pi$ is equivalent to $\pi/(ab-1) < \frac{2}{3}$, so it is guaranteed that the left and right difference quotients have different signs; they do not approach zero and, since $\lim_{m\to\infty}(ab)^m = \infty$, the function has no derivative at the arbitrary point x_0.

And so we have it: a curve that in theory can be plotted but in practice cannot be drawn.

2.5 The Aftermath

With the Weierstrass curve, the sought-after destination had been reached yet the journey was far from its end. With his choice of parameter values, Weierstrass had sought functionality not optimality and it fell to the inimitable mathematical aesthete G. H. Hardy to tidy matters, having commented (Hardy 1916):

These conditions are all obviously artificial. It would be difficult to believe that any of them really correspond to any essential feature of the problem under discussion. They arise merely in consequence of

the limitations of the methods involved. There is in fact only one condition which suggests itself naturally and seems obviously relevant, viz: $ab \geqslant 1$.

He had suppressed the necessity of $0 < a < 1$ – which allows for convergence of the trigonometric coefficients, guaranteeing continuity – to emphasize the need for the divergence of the derived series. Using far more advanced techniques than Weierstrass, he reached the following theorem.

Theorem 1.31. *Neither of the functions $C(x) = \sum a^n \cos(b^n \pi x)$, $S(x) = \sum a^n \sin(b^n \pi x)$, where $0 < a < 1$, with $b > 1$ and $ab \geqslant 1$, possesses a finite differential coefficient at any point in any case in which $ab \geqslant 1$.*

The reader may well have noticed that our own choice of parameters for this chapter's motif fail to satisfy Weierstrass's original conditions but do comply with those of Hardy.

Meanwhile, others had been busy populating Hadamard's teratological museum. Variants of the trigonometric series, variants of the range of parameter values and variants in the conclusions drawn had followed through individuals and years. For example:

- the Darboux function (1873, published 1875)

$$\sum_{n=1}^{\infty} \frac{1}{n!} \sin((n+1)!x)$$

- the class of Dini functions (1877–1878), an example of which is

$$\sum_{n=1}^{\infty} \frac{a^n}{1.3.5 \cdots (2n-1)} \cos(1.3.5 \cdots (2n-1)\pi x) \quad \text{for } |a| > 1 + \frac{3\pi}{2}$$

- the Hertz function (1879), $\sum_{n=1}^{\infty} a^n \cos^p(b^n \pi x)$, where $a > 1$, $p \in \mathbb{N}$ is odd, b is an odd integer and $ab > 1 + \frac{2}{3}p\pi$

were all shown to be CND functions. The discomfiture caused by these and other such curves was deeply felt – and deeply resented. Charles Hermite and Thomas Stieltjes were to exchange 432 letters over a twelve-year period, and in one, dated 20 May 1893, Hermite (1905, p. 318) wrote:

> But these elegant developments are stricken with malediction; their derivatives ... are series which have no meaning. The analysis removes

with one hand what it gives from the other. I turn with fear and horror at this lamentable plague of continuous functions which do not have derivatives.

In 1899 the man who is widely considered to be the last mathematical universalist,[4] Poincaré (1899), wrote:

> For half a century a multitude of bizarre functions appeared which were constructed to resemble as little as possible the honest functions which serve some purpose. No more continuity, or continuity, but no derivatives, etc., etc. In former times when one invented a new function, it was for a practical purpose; today one invents them purposely to show up defects in the reasoning of our fathers and one will deduce from them only that.

Time passed and yet the floodgates remained stubbornly open:

- the Takagi function (1903)

$$\sum_{n=1}^{\infty} \frac{1}{2^n} \inf_{m \in \mathbb{Z}} (2^n x - m)$$

- the Van der Waerden function (1930)

$$\sum_{n=1}^{\infty} \frac{1}{10^n} \inf_{m \in \mathbb{Z}} (10^n x - m)$$

- the Faber functions (1907, 1908)

$$\sum_{n=1}^{\infty} \frac{1}{10^n} \inf_{m \in \mathbb{Z}} (2^{n!} x - m) \quad \text{and} \quad \sum_{n=1}^{\infty} \frac{1}{n!} \inf_{m \in \mathbb{Z}} (2^{n!} x - m)$$

- the Knopp functions (1918)

$$\sum_{n=0}^{\infty} a^n \inf_{m \in \mathbb{Z}} (b^n x - m)$$

where $a \in (0, 1)$, $ab > 4$ and $b > 1$ is an even integer
- the McCarthy function (1953)

$$\sum_{n=1}^{\infty} \frac{1}{2^n} g(2^{2^n} x),$$

[4] In that his expertise embraced all of the mathematics known in his time.

where

$$g(x) = \begin{cases} 1 + x: & x \in [-2, 0] \\ 1 - x: & x \in [0, 2] \end{cases} \quad \text{and} \quad g(x + 4) = g(x), \quad x \in \mathbb{R}$$

- the Wen function (2002)

$$\prod_{n=1}^{\infty} (1 + a_n \sin(b_n \pi x)),$$

where

$$\sum_{n=1}^{\infty} a_n < \infty \quad \text{and} \quad b_n = \prod_{k=1}^{n} p_k$$

taken over even integers for which $\lim_{n \to \infty} 2^n / a_n p_n = 0$

are all CND functions. The list is hardly exhaustive, and if we add to it those curves for which the anomaly exists only in the unit interval, or those that are intrinsically defined geometrically, it lengthens still more.

2.6 Final Thoughts

We first note that the third of those *naive assumptions* at the start of this chapter is also brought into question by Weierstrass's curve. With a standard formula for arc length,

$$\int_a^b \sqrt{1 + \left(\frac{dy}{dx}\right)^2} \, dx,$$

it can hardly be surprising that a function for which there is no derivative is unlikely to have a well-defined length, but the fact is best seen as a consequence of more general theory, the fine details of which we will avoid. For our purposes, the following will be sufficient.

- *Bounded variation* has a precise formulation but, intuitively, a curve is of bounded variation if it cannot oscillate too often with amplitudes that are not too large.
- A curve is *rectifiable* if there is a meaningful concept of its length.
- A curve is rectifiable if and only if it is of bounded variation.
- If a function is of bounded variation, then it is differentiable almost everywhere.

The contrapositive of the final statement ensures the lack of defined arc length of the curve over any interval.

And the curve is a fractal. In 1977 Benoit Mandelbrot himself pointed out that its topological (Hausdorff) dimension, H, exceeds 1, the dimension of a standard curve in the plane: a condition which passes for a definition of a fractal curve. Matters are delicate, though, since there is another standard measure of dimension, usually referred to as the *box-counting* dimension, and this too categorizes the Weierstrass curve as fractal, with this dimension of the curve measured specifically as $D = 2 + \log a / \log b$, in which case, with the required restrictions on the curve's parameters, $0 < a < 1$ and $ab > 1$:

$$\log ab > 0 \Rightarrow \log a > -\log b \Rightarrow \frac{\log a}{\log b} > -1 \text{ and also } \frac{\log a}{\log b} < 0,$$

$$-1 < \frac{\log a}{\log b} < 0 \Rightarrow 1 < 2 + \frac{\log a}{\log b} < 2 \Rightarrow 1 < D < 2.$$

With our example, $a = 0.5$, $b = 5$, we have

$$D = 2 + \frac{\log 0.5}{\log 5} = 1.569\ldots.$$

The curve leaves us with a puzzle, though. It is known that for fractals $H \leqslant D$, with equality achieved very often but not always, and it is strongly believed that for the Weierstrass curve $H = D$; it is just that no one can prove it – not completely, anyway.

The Weierstrass curve lives on, most particularly, as a staple of introductory real analysis courses, reminding students that the transition from school to university mathematics brings with it a responsibility for rigour: intuition, though playing a crucial role in mathematical thought, having been firmly put in its place by those nineteenth-century mathematicians. It is, then, a cautionary construction and a fractal, but its modern role is broader still (Kolwankar and Gangal 1996):

> [T]he Weierstrass functions are not just mathematical curiosities but occur in several places. For instance, the graph of this function is known to be a repeller or attractor of some dynamical systems. This kind of function can also be recognized as the characteristic function of a Lévy flight on a one dimensional lattice, which means that such a Levy flight can be considered as a superposition of Weierstrass type functions. This function has also been used to generate a fractional Brownian signal by multiplying every term by a random amplitude and randomizing phases of every term.

Whatever these technical terms actually mean, the Weierstrass curve is, after all, more than that fantastic exhibit from Hadamard's teratological museum.

One last thing: it is only *just* not differentiable if we embrace the theory of fractional derivatives, since it has derivatives of all orders less than 1.

Bézier Curves

Why These Curves?

For their ubiquity and, in use, their simplicity. Every computer graphics package will include them, whether explicitly by name or not, since any reasonable curve can be closely, easily and quickly approximated by them. They can be combined to model profiles of, or curves in, manufactured goods, whether they be cars, aeroplanes, shoes, ..., and their two-dimensional variants fulfil the role for the surfaces themselves. They pervade the whole content of this and every book since all PostScript and Truetype fonts are designed using them – as is the dachshund above. His name was "Lump".

3.1 Bézier's Curve of Curves

The most famous mathematician never to exist is Nicolas Bourbaki, the pseudonym adopted by a group of nine young (mainly) French mathematicians in the mid 1930s. Bourbaki had, at least, existed as an individual, if not as a mathematician, as a general who fought in the Franco-Prussian war: Professor Onésime Durand was a brilliant mathematician who existed only in the mind of his creator, the French engineer and Head of Design at the motor company, Renault: Pierre Bézier. Modern day car design (and, indeed, the design of much else) is facilitated by sophisticated computer-aided design (CAD) and the cars are manufactured by computer-aided manufacturing (CAM) packages, both of

which require powerful computers – none of which were available in the 1960s, when Bézier plied his trade. The situation that prevailed is well summarized by the following quotation[1]:

> In addition to full-scale blueprints, Citroën's and other carmakers' design process relied largely on physical models for conceptual development, as well as preserving, translating, and sharing the automobile's geometry amongst various teams. The styling department began by crafting small-scale conceptual models of the new prototype. Curved surfaces had to be manually enlarged to full-scale by measuring points offset from these smaller clay mock-ups, then re-plotted onto a life-sized drawing board. The plotted points were interpolated using French Curves or flexible spline rulers to arrive at a best-fit approximation. Plywood cross sections would be cut out and assembled crosswise, creating an intersecting matrix formwork. The skeleton was fleshed out with clay and further sculpted to create a detailed master model of the car. In its final form, the master model would continue to undergo subtle shaping and refinement at the hands of skilled plasterers before being frozen in its final shape, ready for production.
>
> Designers, engineers and machinists could refer to the master model's geometry (or one of several copies of it) when designing parts and the tooling required to manufacture them. Extracting the relevant geometry and ensuring it fitted seamlessly within the overall assembly would entail similarly onerous techniques of translation. Several design iterations were required to finalize each part, relying greatly on the workers' skill, ingenuity and subjective judgement. However, the often-qualitative interpretation of the geometry introduced significant room for inconsistency, discrepancy and human error. The company needed a common geometrical language to store each part in terms of numbers, rather than relying on the time-consuming and error-prone process of manual replication.

French government initiatives began to make possible the introduction of early computers into industry, and Bézier brought his analytical skills to bear to harness the new (if limited) computational power available to help with the design of the curves and surfaces that would combine to form the elegant and aerodynamically efficient shape of a car. His insight was that the shape of a curve can be characterized by a dynamic polygonal line, shown dotted in figure 3.1, and that by manipulating this containing broken line one could also manipulate the curve itself.

[1] Alastair Townsend, On the spline: a brief history of the computational curve (http://www.alatown.com/spline-history-architecture/).

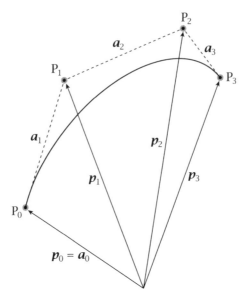

Figure 3.1. The Bézier initiative.

And this is where Professor Durand played an important role, as explained by Bézier (1990):

> For years, when I presented my work at the Régie Renault or else-where, I invoked the research of a mythical teacher whom I had called Durand. I had attributed to him the results of my own reflections, which gave people confidence. Because if I had said that it was polyno-mials defined by myself, I think I would have become an abomination for the house! So I was talking about Durand's functions and people were looking at the curves, very satisfied. I even taught these func-tions at the National Conservatory of Arts and Crafts. I was recently asked about Durand, three years ago at General Motors.

We will explain Bézier's approach by considering a polygonal line de-fined by four vertices (and, consequently, one with three segments). Figure 3.1 shows the vertices $\{P_0, P_1, P_2, P_3\}$ with position vectors $\{p_0, p_1, p_2, p_3\}$ and the (assumed independent) vectors along the seg-ments as

$$\{a_1 = p_1 - p_0, \ a_2 = p_2 - p_1, \ a_3 = p_3 - p_2\}.$$

In terms of the segments, the vector parametric equation of the curve will be of the form

$$r(t) = a_0 + f_{3,1}(t)a_1 + f_{3,2}(t)a_2 + f_{3,3}(t)a_3$$

with the persistent 3 appearing as a reminder that there are three sections; the range of the parametrization is assumed to be $0 \leqslant t \leqslant 1$.

These coefficient functions will be progressively identified as conditions are imposed on the curve's nature, the first of which is that it has as its end points P_0 and P_3; that is, $r(0) = a_0 = p_0$ and $r(1) = p_3$, from which we conclude that

$$f_{3,1}(0) = f_{3,2}(0) = f_{3,3}(0) = 0 \quad \text{and} \quad f_{3,1}(1) = f_{3,2}(1) = f_{3,3}(1) = 1,$$

where the latter arises by the use of vector addition.

The next requirement is that the first and last segments are tangent to the curve at P_0 and P_3, respectively; that is, the tangents at these points lie along a_1 and a_3, respectively. For this to be the case, we need to differentiate to get

$$r'(t) = f'_{3,1}(t)a_1 + f'_{3,2}(t)a_2 + f'_{3,3}(t)a_3,$$

and the conditions result in

$$\left. \begin{aligned} r'(0) &= f'_{3,1}(0)a_1 + f'_{3,2}(0)a_2 + f'_{3,3}(0)a_3 = ka_1 \\ r'(1) &= f'_{3,1}(1)a_1 + f'_{3,2}(1)a_2 + f'_{3,3}(1)a_3 = ka_3 \end{aligned} \right\}$$
$$\rightarrow f'_{3,2}(0) = f'_{3,3}(0) = f'_{3,1}(1) = f'_{3,2}(1) = 0.$$

The intermediate sections of the polygonal line are used to control the curve through their influence on its deeper geometry at these two end points; for this to be the case, the second derivative is used, with this determined by $\{a_1, a_2\}$ alone at P_0 and by $\{a_2, a_3\}$ alone at P_3. Taking the second derivative gives

$$r''(t) = f''_{3,1}(t)a_1 + f''_{3,2}(t)a_2 + f''_{3,3}(t)a_3,$$

and applying these conditions results in

$$\left. \begin{aligned} r''(0) &= f''_{3,1}(0)a_1 + f''_{3,2}(0)a_2 + f''_{3,3}(0)a_3 = ka_1 + la_2 \\ r''(1) &= f''_{3,1}(1)a_1 + f''_{3,2}(1)a_2 + f''_{3,3}(1)a_3 = ka_2 + la_3 \end{aligned} \right\}$$
$$\rightarrow f''_{3,3}(0) = f''_{3,1}(1) = 0.$$

If we tot up we see that we have twelve independent conditions to impose on whatever functions are chosen for the coefficients. Bézier's eventual (but not first) choice was cubic polynomials, three of which are needed, each having four coefficients: $4 \times 3 = 12$ variables. It

requires only elementary algebra to complete the identification, which we undertake below, with the polynomials written as

$$f_{3,i}(t) = \alpha_i t^3 + \beta_i t^2 + \gamma_i t + \delta_i \quad \text{for } 1 \leqslant i \leqslant 3,$$

and we then apply the conditions in turn to get

$$f_{3,1}(0) = f_{3,2}(0) = f_{3,3}(0) = 0 \to \delta_1 = \delta_2 = \delta_3 = 0,$$

$$f_{3,1}(1) = f_{3,2}(1) = f_{3,3}(1) = 1 \to \left.\begin{cases} \alpha_1 + \beta_1 + \gamma_1 + \delta_1 = 1, \\ \alpha_2 + \beta_2 + \gamma_2 + \delta_2 = 1, \\ \alpha_3 + \beta_3 + \gamma_3 + \delta_3 = 1, \end{cases}\right\} \to \begin{cases} \alpha_1 + \beta_1 + \gamma_1 = 1, \\ \alpha_2 + \beta_2 + \gamma_2 = 1, \\ \alpha_3 + \beta_3 + \gamma_3 = 1, \end{cases}$$

$$f'_{3,i}(t) = 3\alpha_i t^2 + 2\beta_i t + \gamma_i,$$

$$f'_{3,2}(0) = \gamma_2 = f'_{3,3}(0) = \gamma_3 = 0 \to \gamma_2 = \gamma_3 = 0,$$

$$f'_{3,1}(1) = f'_{3,2}(1) = 0 \to \left.\begin{cases} 3\alpha_1 + 2\beta_1 + \gamma_1 = 0, \\ 3\alpha_2 + 2\beta_2 + \gamma_2 = 0, \end{cases}\right\} \to \begin{cases} \gamma_2 = \gamma_3 = 0, \\ 3\alpha_1 + 2\beta_1 + \gamma_1 = 0, \\ 3\alpha_2 + 2\beta_2 = 0, \end{cases}$$

$$f''_{3,3}(0) = f''_{3,1}(1) = 0 \to \begin{cases} 2\beta_3 = 0 \to \beta_3 = 0, \\ 6\alpha_1 + 2\beta_1 = 0. \end{cases}$$

When these various equations are combined appropriately, the unique solution will be seen to be

$$\begin{pmatrix} \alpha_1 & \alpha_2 & \alpha_3 \\ \beta_1 & \beta_2 & \beta_3 \\ \gamma_1 & \gamma_2 & \gamma_3 \\ \delta_1 & \delta_2 & \delta_3 \end{pmatrix} = \begin{pmatrix} 1 & -2 & 1 \\ -3 & 3 & 0 \\ 3 & 0 & 0 \\ 0 & 0 & 0 \end{pmatrix},$$

all of which means that the vector parametric equation of the curve is

$$\boldsymbol{r}(t) = \boldsymbol{a}_0 + (t^3 - 3t^2 + 3t)\boldsymbol{a}_1 + (-2t^3 + 3t^2)\boldsymbol{a}_2 + t^3 \boldsymbol{a}_3, \quad 0 \leqslant t \leqslant 1.$$

A choice of vectors defining the polygonal line will define the curve, and dynamic alteration of them will dynamically alter the curve's shape as well. And, of course, the process generalizes to n segments and, therefore, $n+1$ vertices $\{P_0, P_1, P_2, \ldots, P_n\}$, where $\{\boldsymbol{a}_1 = \boldsymbol{p}_1 - \boldsymbol{p}_0, \boldsymbol{a}_2 = \boldsymbol{p}_2 - \boldsymbol{p}_1, \boldsymbol{a}_3 = \boldsymbol{p}_3 - \boldsymbol{p}_2, \ldots, \boldsymbol{a}_n = \boldsymbol{p}_n - \boldsymbol{p}_{n-1}\}$, with the curve's equation becoming

$$\boldsymbol{r}(t) = \boldsymbol{a}_0 + \sum_{i=1}^{n} f_{n,i}(t)\boldsymbol{a}_i \quad \text{for } 0 \leqslant t \leqslant 1.$$

The conditions become

$$f_{n,i}(0) = 0, \quad 1 \leqslant i \leqslant n,$$
$$f_{n,i}(1) = 1, \quad 1 \leqslant i \leqslant n,$$
$$f_{n,i}^{(m)}(0) = 0, \quad m \leqslant i \leqslant n, \ 1 \leqslant m \leqslant n - 1,$$
$$f_{n,i}^{(m)}(1) = 0, \quad 1 \leqslant i \leqslant n - m, \ 1 \leqslant m \leqslant n - 1.$$

Elementary algebra gives way to deeper analysis as Bézier extracted the coefficient functions to be the improbable

$$f_{n,i}(t) = \frac{(-1)^i}{(i-1)!} t^i \frac{d^{i-1}}{dt^{i-1}} \frac{(1-t)^n - 1}{t}$$
$$= \sum_{j=1}^{n} (-1)^{i+j} \binom{n}{j} \binom{j-1}{i-1} t^j.$$

This derivation is not quite as daunting as it may seem, but we choose not to reproduce it, in part for want of space and in part to avoid a complicated repetition of what has already been achieved. Most of all, though, because in practice the cubic polynomial is entirely sufficient for all purposes for which the Bézier construction is used. In fact, having just one control point and a quadratic approximation serves many purposes, and we leave it to the interested reader to supply the equivalent, though simpler, variant of our arguments above to finish with the curve's equation:

$$r(t) = a_0 + (-t^2 + 2t)a_1 + t^2 a_2.$$

Finally, we have mentioned that Bézier had experimented with forms of the coefficient functions other than polynomials; he through necessity, as we have done for curiosity. Once more we invite that interested reader to revisit the three-section polygonal line, but this time with the coefficient functions generated by

$$\{\sin \tfrac{1}{2}\pi t, \cos \tfrac{1}{2}\pi t, \sin^2 \tfrac{1}{2}\pi t, \cos^2 \tfrac{1}{2}\pi t\} \quad \text{for } 0 \leqslant t \leqslant 1,$$

and therefore having the form

$$f_{3,i}(t) = \alpha_i \sin \tfrac{1}{2}\pi t + \beta_i \cos \tfrac{1}{2}\pi t + \gamma_i \sin^2 \tfrac{1}{2}\pi t + \delta_i \cos^2 \tfrac{1}{2}\pi t.$$

The associated calculations are provided in appendix C.

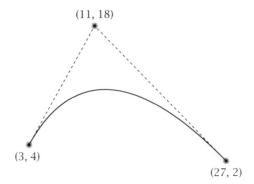

Figure 3.2. Forrest's quadratic amendment.

3.2 Bézier and Bernstein

Fortunately, Renault were not overly proprietorial regarding their employee's work: they allowed Bézier to publish his (or Professor Durand's) ideas, which thereby came to the attention of Professor Robin Forrest, then of the computing department of Cambridge University. It was he who argued that developing a formulation of Bézier's work using the vertices of the polygonal line rather than the line segments themselves would be more elegant and also more amenable to computation (Forrest 1972). In terms of the quadratic and cubic polynomial forms, the amendment takes the form

$$
\begin{aligned}
\boldsymbol{r}(t) &= \boldsymbol{a}_0 + (-t^2 + 2t)\boldsymbol{a}_1 + t^2\boldsymbol{a}_2 \\
&= \boldsymbol{p}_0 + (-t^2 + 2t)(\boldsymbol{p}_1 - \boldsymbol{p}_0) + t^2(\boldsymbol{p}_2 - \boldsymbol{p}_1) \\
&= (1 + t^2 - 2t)\boldsymbol{p}_0 + (-2t^2 + 2t)\boldsymbol{p}_1 + t^2\boldsymbol{p}_2 \\
&= (1 - t)^2\boldsymbol{p}_0 + 2t(1 - t)\boldsymbol{p}_1 + t^2\boldsymbol{p}_2
\end{aligned}
$$

and

$$
\begin{aligned}
\boldsymbol{r}(t) &= \boldsymbol{a}_0 + (t^3 - 3t^2 + 3t)\boldsymbol{a}_1 + (-2t^3 + 3t^2)\boldsymbol{a}_2 + t^3\boldsymbol{a}_3 \\
&= \boldsymbol{p}_0 + (t^3 - 3t^2 + 3t)(\boldsymbol{p}_1 - \boldsymbol{p}_0) + (-2t^3 + 3t^2)(\boldsymbol{p}_2 - \boldsymbol{p}_1) \\
&\quad + t^3(\boldsymbol{p}_3 - \boldsymbol{p}_2) \\
&= (1 - t^3 + 3t^2 - 3t)\boldsymbol{p}_0 + (3t^3 - 6t^2 + 3t)\boldsymbol{p}_1 \\
&\quad + (-3t^3 + 3t^2)\boldsymbol{p}_2 + t^3\boldsymbol{p}_3 \\
&= (1 - t)^3\boldsymbol{p}_0 + 3t(1 - t)^2\boldsymbol{p}_1 + 3t^2(1 - t)\boldsymbol{p}_2 + t^3\boldsymbol{p}_3,
\end{aligned}
$$

respectively.

With this we may express the curve and manipulate it in the somewhat more natural manner of a choice of two terminal points and one or

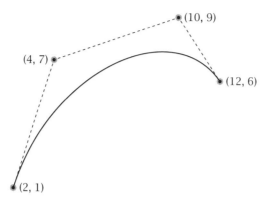

Figure 3.3. Forrest's cubic amendment.

two control points. The expressions are particularly amenable to plotting and, indeed, all curves in this chapter have been drawn accordingly. In figure 3.2 we have chosen two arbitrary points on a curve, $(3, 4)$ and $(27, 2)$, and an equally arbitrary control point, $(11, 18)$, to yield the quadratic vector equation

$$\begin{pmatrix} x \\ y \end{pmatrix} = (1 - t)^2 \begin{pmatrix} 3 \\ 4 \end{pmatrix} + 2t(1 - t) \begin{pmatrix} 11 \\ 18 \end{pmatrix} + t^2 \begin{pmatrix} 27 \\ 2 \end{pmatrix}$$

and the pair of quadratic parametrizations of the curve

$$x = 3(1 - t)^2 + 22t(1 - t) + 27t^2,$$
$$y = 4(1 - t)^2 + 36t(1 - t) + 2t^2.$$

For the cubic form, the points $(2, 1)$ and $(12, 6)$ are chosen to be on the curve, which is subject to the two control points $(4, 7)$ and $(10, 9)$. Again, in vector parametric form we have

$$\begin{pmatrix} x \\ y \end{pmatrix} = (1 - t)^3 \begin{pmatrix} 2 \\ 1 \end{pmatrix} + 3t(1 - t)^2 \begin{pmatrix} 4 \\ 7 \end{pmatrix} + 3t^2(1 - t) \begin{pmatrix} 10 \\ 9 \end{pmatrix} + t^3 \begin{pmatrix} 12 \\ 6 \end{pmatrix}$$

and the pair of cubic parametric equations

$$x = 2(1 - t)^3 + 12t(1 - t)^2 + 30t^2(1 - t) + 12t^3,$$
$$y = (1 - t)^3 + 21t(1 - t)^2 + 27t^2(1 - t) + 6t^3,$$

with the curve shown in figure 3.3.

With this formulation it is evident that the parametrizations are, respectively, of a parabola and a cubic curve; the first two (and quite the most practically useful) Bézier curves are these most elementary of

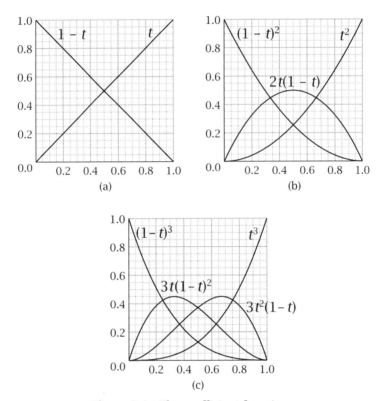

Figure 3.4. The coefficient functions.

polynomials – a fact that brings with it advantages (they are quick and easy to manipulate and compute) and disadvantages (they can never be manipulated to become, for example, transcendental curves). For completeness, we should include the degenerate form

$$r(t) = (1 - t)\boldsymbol{p}_0 + t\boldsymbol{p}_1, \quad 0 \leqslant t \leqslant 1,$$

containing no control points, which is of course nothing other than the vector parametric equation of the straight line segment with end points P_0 and P_1.

Figure 3.4 graphs the coefficient functions for the linear, quadratic and cubic variants of Bézier curves and exposes the influence of each of them in turn as the parameter t moves through its interval of $[0, 1]$. In the case of the cubic approximation, the $(1 - t)^3$ dominates for the first quarter of generation, in the second quarter $3t(1 - t)^2$ dominates, the third quarter $3t^2(1 - t)$ takes over to be replaced in its dominance by t^3 in the last quarter. These coefficient functions, usually called *blending*

functions, may be thought of as variable weightings attached to the respective vertices, the influence of which varies as suggested above.

And it is through these blending functions that mathematical ideas merge. First, they are the terms of the binomial expansion

$$1 = 1^n = (t + (1 - t))^n = \sum_{i=0}^{n} \binom{n}{i} t^i (1 - t)^{n-i} = \sum_{i=0}^{n} B_i^n(t).$$

The $B_i^n(t)$ notation reflects that they are also known as *Bernstein* polynomials,

$$B_i^n(t) = \binom{n}{i} t^i (1 - t)^{n-i}, \quad 1 \leqslant i \leqslant n, \ 0 \leqslant t \leqslant 1,$$

which gives appropriate recognition to Sergei Natanovich Bernstein (1880–1968), a Russian mathematician who used them as an alternative basis for polynomials of degree n in the single variable t: $\{1, B_0^n, B_1^n, B_2^n, \ldots, B_n^n\}$ rather than the usual $\{1, t, t^2, t^3, \ldots, t^n\}$.

It is of interest that their role as components of Bézier curves may be thought of as something of a reversal of their original purpose. Bernstein had set out to provide the first constructive proof of the *Weierstrass approximation theorem*. This celebrated result regarding the utility that polynomials bring to mathematics may be expressed in words as "polynomials of sufficiently high degree can (uniformly) approximate any continuous function over any finite interval", and in symbols as

$$|f(x) - p_n(x)| < \varepsilon \quad \text{for all } x \in [a, b].$$

The nth Bernstein polynomial was one component of the nth Bernstein polynomial function,

$$B_n(f, t) = \sum_{i=0}^{n} f\left(\frac{i}{n}\right) \binom{n}{i} t^i (1 - t)^{n-i},$$

for which he proved that

$$\lim_{n \to \infty} B_n(f, t) = f(t)$$

over the interval $t \in [0, 1]$. Since the transformation

$$t \to \frac{t - a}{b - a}$$

also transforms $[a, b] \to [0, 1]$, the general result is thereby achieved.

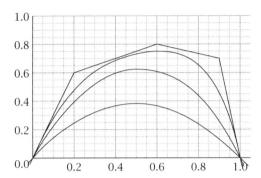

Figure 3.5. The Weierstrass approximation theorem.

We choose to illustrate the result when $f(x)$ is taken to be the polygonal line joining $(0,0)$, $(0.2, 0.6)$, $(0.6, 0.8)$, $(0.9, 0.7)$, $(1, 0)$, and figure 3.5 shows the comparison with the approximants (Davis 2014, p. 116):

$$B_2(f, t) = \tfrac{3}{2}(t - t^2),$$
$$B_4(f, t) = \tfrac{5}{2}t - 3t^2 + \tfrac{3}{2}t^3 - t^4,$$
$$B_{10}(f, t) = 3t - 30t^3 + 105t^4 - 189t^5 + 210t^6$$
$$\qquad\qquad - 160t^7 + 90t^8 - 35t^9 + 6t^{10}.$$

So, in this example of the Weierstrass theorem, curves defined in terms of Bernstein polynomials approximate a polygonal line; in the Bézier application, these same polynomials are used so that a polygonal line approximates a curve. Moreover, the rate of convergence of the curves to the polygonal line is glacially slow (Davis 2014, p. 116), which has no theoretical relevance but would, it would appear, have practical limitations:

> This fact seems to have precluded any numerical application of Bernstein polynomials from having been made. Perhaps they will find application when the properties of the approximant in the large are of more importance than the closeness of the approximation.

This remark was first published in 1963, when it was not yet public knowledge that $B_i^2(t)$ and $B_i^3(t)$ are quite enough for the very practical problem of curve approximation.

There is a final important aspect of the story of Bézier curves that would not become public knowledge until the mid 1970s. It is this we address next.

3.3 Bézier and Casteljau

Principally through the work of the young mathematician Paul de Faget de Casteljau, another French car giant, Citroën, had also been address-ing the problems of their antiquated design processes; unlike Renault, though, they were proprietorial about the fruits of their employees' labours. Casteljau had begun work at Citroën in 1959, and in a paper published in 1963, tellingly through the *Société Anonyme André Cit-roën*, he expounded his ideas within the organization. The paper's title, Courbes et surfaces à pôles (Curves and surfaces through poles), was to remain secret until 1975, when Wolfgang Boehm[2] discovered the work, which is now known as *Casteljau's algorithm*.

The *poles* in question are lines connecting certain points, according to his algorithm. It transpires that this is an entirely different but entirely equivalent formulation of Bézier curves – and one that is particularly amenable to computer calculation.

We take two points, P_0, P_2, which are to be the end points of the curve, and a third controlling point P_1, which is not on the curve but its position determines the shape of the curve. That is, the curve is defined initially by the set of points $\{P_0, P_1, P_2\}$ and then point-by-point in the following manner.

Suppose that a point Q moves along the pole P_0P_1 so that at time t, where $0 \leqslant t \leqslant 1$, its position vector has the form $\boldsymbol{q} = t\boldsymbol{p_0} + (1-t)\boldsymbol{p_1}$. Similarly, a second point Q moves along the pole P_1P_2 so that its posi-tion vector at time t is given by $\boldsymbol{q} = t\boldsymbol{p_1} + (1-t)\boldsymbol{p_2}$. Figure 3.6 demon-strates the situation when the point on P_0P_1 has reached Q_0 and that on P_1P_2 has reached Q_1. This defines the pole Q_0Q_1, and we imagine, simul-taneous with these two motions, a third in which the point Q moves from Q_0 to Q_1 to reach $\boldsymbol{r} = t\boldsymbol{q_0} + (1-t)\boldsymbol{q_1}$. The point R is a point on the defined curve.

All of this translates into symbols as follows:

$$\boldsymbol{q_0} = t\boldsymbol{p_0} + (1-t)\boldsymbol{p_1},$$
$$\boldsymbol{q_1} = t\boldsymbol{p_1} + (1-t)\boldsymbol{p_2},$$
$$\boldsymbol{r} = t\boldsymbol{q_0} + (1-t)\boldsymbol{q_1} = t[t\boldsymbol{p_0} + (1-t)\boldsymbol{p_1}] + (1-t)[t\boldsymbol{p_1} + (1-t)\boldsymbol{p_2}],$$
$$\boldsymbol{r} = t^2\boldsymbol{p_0} + 2t(1-t)\boldsymbol{p_1} + (1-t)^2\boldsymbol{p_2}.$$

And we have the quadratic Bézier curve constructed in a manner that is quite different to the use of Bernstein polynomials. Which is better for

[2] The 2017 recipient of the Pierre Bézier Award.

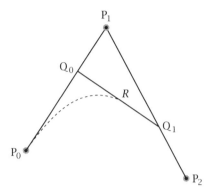

Figure 3.6. The Casteljau method.

purpose? That depends on circumstances; all the curves in this chapter have been drawn using the Bernstein polynomials, but this alternative can be a very attractive option because of a particular property of it – and because of the nature of the architecture of a computer's arithmetic-logic unit. To understand this we will continue with the quadratic variant and therefore refer to figure 3.6, freeze the dynamic process for some fixed value of t, and consider the two curves defined by their own three points: the first one by $\{P_0, Q_0, R\}$ and the second by $\{R, Q_1, P_2\}$. For an arbitrary point on the first curve we have

$$
\begin{aligned}
\boldsymbol{s} &= \lambda^2 \boldsymbol{p}_0 + 2\lambda(1 - \lambda)\boldsymbol{q}_0 + (1 - \lambda)^2 \boldsymbol{r} \\
&= \lambda^2 \boldsymbol{p}_0 + 2\lambda(1 - \lambda)[t\boldsymbol{p}_0 + (1 - t)\boldsymbol{p}_1] \\
&\quad + (1 - \lambda)^2 [t^2 \boldsymbol{p}_0 + 2t(1 - t)\boldsymbol{p}_1 + (1 - t)^2 \boldsymbol{p}_2] \\
&= [\lambda^2 + 2\lambda(1 - \lambda)t + (1 - \lambda)^2 t^2]\boldsymbol{p}_0 \\
&\quad + [2\lambda(1 - \lambda)(1 - t) + 2t(1 - t)(1 - \lambda)^2]\boldsymbol{p}_1 + (1 - \lambda)^2(1 - t)^2 \boldsymbol{p}_2.
\end{aligned}
$$

Now define the parameter T to be $T = \lambda + t(1 - \lambda)$. For any t, as λ varies, clearly $T \geqslant 0$. Also, since $(1 - \lambda)(t - 1) \leqslant 0$, it must also be that $T \leqslant 1$. So, $0 \leqslant T \leqslant 1$ and as $1 - T = (1 - \lambda)(1 - t)$ we may write

$$
\boldsymbol{s} = T^2 \boldsymbol{p}_0 + 2T(1 - T)\boldsymbol{p}_1 + (1 - T)^2 \boldsymbol{p}_2,
$$

which is a point on our original curve, that first part of which will be traced out. The procedure is called *curve splitting* and it can be implemented on Bézier curves of any degree and is one of a number of several operations that are routinely performed on them. For our purposes we take $t = 0.5$, meaning that Q_0, Q_1 and R are the centres of their respective poles. Now repeat to give another point on the

other half of the curve and then repeatedly perform this process, halving and locating a point on the original curve until the new point is within a pixel of the one before, with the mini-section of the original curve sufficiently flat for it to be drawn as a straight line. As far as the computer screen (or printer) is concerned, the curve is drawn. For a human this repetitive process is hardly attractive, but for a computer it is an excellent recursive procedure requiring only addition of point coordinates and division by two: operations that are extremely fast to perform.

In the final sections of this chapter we look to two applications of Bézier curves: the first frivolous, the second anything but.

3.4 The Story of Lump

Two years before Casteljau joined Citroën, Pablo Picasso played host to a friend, the acclaimed photographer David Douglas Duncan, at his Cannes mansion, the Villa La California. Accompanying Duncan was his dachshund, Lump (the German word for *rascal*, pronounced "Loomp"), who was immediately to win Picasso's heart and he became resident for the next six years. The relationships between Lump, Picasso's Boxer, Jan, and his goat, Esmerelda, were convivial and between Lump and Picasso extremely close:

> This was a love affair. Picasso would take Lump in his arms. He would feed him from his hands. Hell that little dog just took over. He ran the damn house!

Such was Duncan's view, expressed (in particular) in his book *Lump: The Dog Who Ate a Picasso* (2006). Unsurprisingly, Lump assumed the role of muse for the artist, and was included in numerous works, including Picasso's interpretation of Diego Velázquez's painting *Las Meninas*, in which the mastiff was replaced by this particular dachshund. Many quick sketches of the dog were made and the motif in the top matter of this chapter is our rendition of one of them, apparently drawn at a single stroke by Picasso but requiring nine cubic Bézier curves when created by us. We suppose that Picasso was concerned with simple continuity rather than a higher degree of smoothness at the joins (known in the jargon as *knots*), and our choice of curves reflects this. The data is given below, with the figure divided as has seemed natural and in the order in which we imagine a left-handed artist would produce it, starting where the mouth meets the ear and continuing clockwise round to finish at the front foot.

Figure 3.7. Lump as nine Bézier curves.

Figure 3.7 indicates the break points between the sections, which are defined as cubic Bézier curves by the coordinates

$$\{(55, 60), (40, 67), (15, 53), (1, 60)\},$$
$$\{(1, 60), (57, 96), (37, 86), (64, 110)\},$$
$$\{(64, 110), (85, 120), (83, 25), (68, 25)\},$$
$$\{(68, 25), (50, 35), (50, 106), (79, 95)\},$$
$$\{(79, 95), (105, 60), (225, 80), (290, 107)\},$$
$$\{(290, 107), (295, 104), (285, 93), (268, 90)\},$$
$$\{(270, 90), (275, 0), (265, 10), (255, 54)\},$$
$$\{(255, 54), (215, 70), (205, 56), (106, 56)\},$$
$$\{(106, 56), (101, 44), (98, 32), (95, 20)\},$$

with a discontinuity to account for the slight overlap as the tail meets the top of the hind leg.

Lump died on 29 March 1973, ten days before the death of Picasso himself.

3.5 The Story of O

This second use of Bézier curves is altogether more serious. Should the reader care to look at this book's front matter, the sentence "This book has been composed in LucidaBright" will be found (even though the typeface we used to create the work was Times Roman). Lucida from lucid: clear, easy to read. The font comprises an extended family of related typefaces and was designed by Charles Bigelow and Kris Holmes, initially to become available in 1984, yet it has undergone continued expansion through (at present) to 2012, when Lucida OpenType Math font was released by TUG (TeX Users Group). And what is an OpenType font? Before this question is answered, we must consider PostScript and TrueType fonts.

Electronic fonts are extremely involved structures and yet, as with so much technicality that attaches itself to computers, knowledge (much

less understanding) of the detail is mercifully unnecessary. We see a *glyph* on the keyboard, press its key to transmit the appropriate *character* to the CPU, to appear as a glyph on the screen in our chosen *typeface* from a particular *font*. And if we decide to print to paper, we expect no great surprises in the hard copy. As for the font itself, the software will typically offer us many alternatives, and we may download many, many more – sometimes for free, other times at a price. So we press a key and confidently expect the glyph under our finger to appear on the screen in our chosen font, size and colour, the software having called up the necessary information through the computer's operating system. What information? Put another way, how can a symbol (or, for that matter, a command code) be stored so that it can be retrieved quickly, faithfully and repeatedly as we demand?

The earliest electronic solution was that fonts were stored as bitmaps, with the glyphs (in particular) described by rectangular arrays of white and black pixels: the higher the resolution, the more pixels were required, with Donald Knuth designing METAFONT as a powerful compression system for bitmap fonts as part of his T_EX system in 1978, its further development remaining the primary way of typesetting technical information.

The second solution was notably adopted by John Warnock, founder of Adobe, in 1985. He developed a programming language called *PostScript*, through which the page can be accessed with the use of certain mathematical constructs. In particular, the PostScript language includes a font format that remains one of the most common in the world: *Type 1 fonts*, which are examples of *vector fonts*.

With the success of PostScript and the Type 1 fonts, Adobe flourished and Apple and Microsoft moved to break Adobe's monopoly. Their joint contribution as a competitor to Type 1 fonts was called *TrueType*. Apple and Microsoft separately began to work on improving the TrueType fonts, with Apple producing *TrueType GX* (later renamed as AAT, "Apple Advanced Typography"). Microsoft combined with its former competitor, Adobe, and together they brought out a competitor to TrueType GX: *OpenType*. One final complication is that OpenType fonts were then divided into two categories: *OpenType-TTF* (which are TrueType with a few extra features) and *OpenType-CFF* (which are Type 1 fonts extended and integrated into TrueType structures).

The PostScript language, through its interpreter *Ghostscript*, can therefore be used to describe symbols and letters with all of their component parts: *stem, ascender, descender, bowl, counter, arm, bar, serif* and *terminal*. The associated commands are *moveto, lineto, curveto*

and *closepath*, each of which accesses its own parameters from the data stack. It is the curveto command that has within it the drawing procedure for the cubic Bézier curve, and we can exemplify its use through the Ghostscript/Times Roman font access to the encoding of the letter O.

Each row of the data-set

$$\left\{ \begin{pmatrix} 0.360998541 \\ 0.673999 \end{pmatrix}, \begin{pmatrix} 0.169997558 \\ 0.673999 \end{pmatrix}, \begin{pmatrix} 0.039997559 \\ 0.530835 \end{pmatrix}, \begin{pmatrix} 0.039997559 \\ 0.33099854 \end{pmatrix} \right\},$$

$$\left\{ \begin{pmatrix} 0.039997559 \\ 0.33399854 \end{pmatrix}, \begin{pmatrix} 0.039997559 \\ 0.236999512 \end{pmatrix}, \begin{pmatrix} 0.0697631836 \\ 0.145998538 \end{pmatrix}, \begin{pmatrix} 0.119995117 \\ 0.0879980475 \end{pmatrix} \right\},$$

$$\left\{ \begin{pmatrix} 0.119995117 \\ 0.0879980475 \end{pmatrix}, \begin{pmatrix} 0.177995607 \\ 0.0249975584 \end{pmatrix}, \begin{pmatrix} 0.266994625 \\ -0.0140014645 \end{pmatrix}, \begin{pmatrix} 0.354995131 \\ -0.0140014645 \end{pmatrix} \right\},$$

$$\left\{ \begin{pmatrix} 0.354995131 \\ -0.0140014645 \end{pmatrix}, \begin{pmatrix} 0.551994622 \\ -0.0140014645 \end{pmatrix}, \begin{pmatrix} 0.689997554 \\ 0.125998542 \end{pmatrix}, \begin{pmatrix} 0.689997554 \\ 0.326999515 \end{pmatrix} \right\},$$

$$\left\{ \begin{pmatrix} 0.689997554 \\ 0.326999515 \end{pmatrix}, \begin{pmatrix} 0.689997554 \\ 0.425998539 \end{pmatrix}, \begin{pmatrix} 0.660305202 \\ 0.510998547 \end{pmatrix}, \begin{pmatrix} 0.603996575 \\ 0.570998549 \end{pmatrix} \right\},$$

$$\left\{ \begin{pmatrix} 0.603996575 \\ 0.570998549 \end{pmatrix}, \begin{pmatrix} 0.540996075 \\ 0.639997542 \end{pmatrix}, \begin{pmatrix} 0.456999511 \\ 0.673999 \end{pmatrix}, \begin{pmatrix} 0.360998541 \\ 0.673999 \end{pmatrix} \right\}$$

provides the anchor points and the two intermediate control points for the outer curve of the letter, and each row of the data set

$$\left\{ \begin{pmatrix} 0.360998541 \\ 0.63399905 \end{pmatrix}, \begin{pmatrix} 0.406997085 \\ 0.63399905 \end{pmatrix}, \begin{pmatrix} 0.452998042 \\ 0.618159175 \end{pmatrix}, \begin{pmatrix} 0.488999 \\ 0.58999753 \end{pmatrix} \right\},$$

$$\left\{ \begin{pmatrix} 0.488999 \\ 0.58999753 \end{pmatrix}, \begin{pmatrix} 0.542998075 \\ 0.540998518 \end{pmatrix}, \begin{pmatrix} 0.58 \\ 0.44699952 \end{pmatrix}, \begin{pmatrix} 0.58 \\ 0.328000486 \end{pmatrix} \right\},$$

$$\left\{ \begin{pmatrix} 0.491999507 \\ 0.0750024393 \end{pmatrix}, \begin{pmatrix} 0.4569999511 \\ 0.0400024429 \end{pmatrix}, \begin{pmatrix} 0.411999524 \\ 0.0260009766 \end{pmatrix}, \begin{pmatrix} 0.358999 \\ 0.0260009766 \end{pmatrix} \right\},$$

$$\left\{ \begin{pmatrix} 0.491999507 \\ 0.0750024393 \end{pmatrix}, \begin{pmatrix} 0.456999511 \\ 0.0400024429 \end{pmatrix}, \begin{pmatrix} 0.411999524 \\ 0.0260009766 \end{pmatrix}, \begin{pmatrix} 0.358999 \\ 0.0260009766 \end{pmatrix} \right\},$$

$$\left\{ \begin{pmatrix} 0.358999 \\ 0.0260009766 \end{pmatrix}, \begin{pmatrix} 0.312998056 \\ 0.0260009766 \end{pmatrix}, \begin{pmatrix} 0.26799804 \\ 0.04253418 \end{pmatrix}, \begin{pmatrix} 0.232998043 \\ 0.0710034147 \end{pmatrix} \right\},$$

$$\left\{ \begin{pmatrix} 0.232998043 \\ 0.0710034147 \end{pmatrix}, \begin{pmatrix} 0.180998534 \\ 0.117004395 \end{pmatrix}, \begin{pmatrix} 0.15 \\ 0.218005374 \end{pmatrix}, \begin{pmatrix} 0.15 \\ 0.329006344 \end{pmatrix} \right\},$$

$$\left\{ \begin{pmatrix} 0.15 \\ 0.329006344 \end{pmatrix}, \begin{pmatrix} 0.15 \\ 0.431005865 \end{pmatrix}, \begin{pmatrix} 0.177197263 \\ 0.528005362 \end{pmatrix}, \begin{pmatrix} 0.217988043 \\ 0.575004876 \end{pmatrix} \right\},$$

$$\left\{ \begin{pmatrix} 0.217998043 \\ 0.575004876 \end{pmatrix}, \begin{pmatrix} 0.256997079 \\ 0.618005395 \end{pmatrix}, \begin{pmatrix} 0.30599609 \\ 0.63399905 \end{pmatrix}, \begin{pmatrix} 0.360996097 \\ 0.63399905 \end{pmatrix} \right\}$$

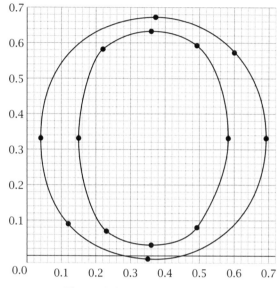

Figure 3.8. Times Roman O.

does the same for its inner curve. The plot of the resulting figure is shown in figure 3.8, with the outer curve traced anticlockwise and the inner curve traced clockwise from the top, and the dots inserted to designate the transition from one curve to the next.

From which we see that it is much harder to draw the o of dog than to draw the dog itself.

Finally, we have mentioned the Euler spiral in connection with transition curves. It has also been utilized in more general curve drawing, and most particularly in font construction, as an alternative to Bézier curves: Bézier curves deal with tangents, whereas *Spiro curves* deal with the more powerful notion of curvature (Levien 2009). Alas, this connection between our chapters 1 and 3 must remain undeveloped by us, fascinating though it is.

The Rectangular Hyperbola

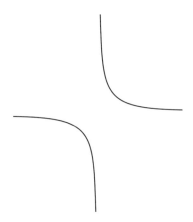

Why This Curve?

It is the curve that brought logarithms (that is, tables of numbers invented to aid calculation) into calculus. And through this came the exponential function. The ubiquity of what we now write as $\ln x$ and e^x in differential and integral calculus is evident to anyone who has studied upper high school mathematics and beyond, and their role in the theoretical investigation of innumerable real-world problems has long been considered to be central. And it all began with the rectangular hyperbola.

4.1 Old Logarithms

The original form of the calculative device known as *logarithms*, which were to serve civilization as the principal means of computation for four centuries, was the product of twenty years of solitary work by the Scottish nobleman John Napier, eighth Baron of Merchiston. The

Table 4.1. Briggs's examples of logarithms.

	A	B	C	D
1	1	5	5	35
2	2	6	8	32
4	3	7	11	29
8	4	8	14	26
16	5	9	17	23
32	6	10	20	30
64	7	11	23	17
128	8	12	26	14
Number in proportion	Log	Log	Log	Log

name "logarithm" was Napier's second choice for his invention, with *artificial numbers* being the first. They comprised a table of numbers conceived from the interrelationship between the kinematics of two linked one-dimensional motions. These numbers and instructions for their use were the subject of his 1614 book *Mirifici logarithorum canonis descriptio* ("Description of the Wonderful Canon of Logarithms"), which was to be translated into English in 1616, principally through the influence of the English mathematician and cartographer Edward Wright. Their utility was immediately improved upon in the last years of Napier's life through interaction between Napier and the English mathematician Henry Briggs. Briggs's 1624 book *Arithmetica Logarithmica* contained the first comprehensive tables of what became widely known as *Briggsian logarithms*, which comprised the logarithms of the integers from 1 to 20,000 and from 90,000 to 100,000, each to fourteen digits of accuracy. By then, the notion of the nature of logarithm had evolved, with the work containing a precise, non-kinematical definition of what a logarithm was then held to be. The opening line of *Arithmetica Logarithmica*'s chapter 1 reads: "Logarithms are numbers which, adjoined to numbers in proportion, maintain equal differences." There is no mention of kinematics, neither is there any mention of a base.

Happily, Briggs elaborated on his definition with the use of a table, which is reproduced as our table 4.1.

The numbers in *(continuous) proportion* are the powers of 2 in the first column and four sets of numbers associated with them, and which *maintain equal differences*, are provided in the remaining columns. The concept of continuous proportion is embodied in the notion that the sequence of numbers $\alpha, \beta, \gamma, \delta, \ldots$ are so if $\alpha/\beta = \beta/\gamma = \gamma/\delta = \cdots$: that is, if $\beta = \sqrt{\alpha\gamma}$ is the geometric mean of α and γ, $\gamma = \sqrt{\beta\delta}$ is the geometric mean of β and δ, and so on. In modern terms, the numbers form

a geometric sequence A, Ar, Ar^2, \ldots. The numbers that are adjoined to these and that maintain a constant difference are $\alpha', \beta', \gamma', \delta', \ldots$, wherein $\beta' - \alpha' = \gamma' - \beta' = \delta' - \gamma' = \cdots$; in modern terms, an arithmetic sequence $a, a + d, a + 2d, \ldots$. The association is, then, the correspondence $Ar^n \leftrightarrow a + nd$ as an infinite number of possible logarithms $a + nd$ of numbers that can be written in the form Ar^n; here, Briggs chose $A = 1, r = 2$ and the four parings $(a, d) = (1, 1), (5, 1), (5, 3), (35, -3)$. A clear consequence of the definition is that, for any four numbers from a sequence in continuous proportion, it must be the case that

$$\frac{p}{q} = \frac{r}{s} \leftrightarrow L(p) - L(q) = L(r) - L(s),$$

where $L(\cdot)$ denotes the logarithm. In particular, if we consider

$$pq{:}q = p{:}1 \leftrightarrow L(pq) - L(q) = L(p) - L(1),$$

for the familiar multiplicative property of logarithms to pertain, it must be that $L(1) = 0$. Between them, Napier and Briggs had eventually made that choice and, with the opening statement of *Arithmetica Logarithmica*'s chapter 3, their logarithms were determined:

> With the Logarithm of unity decided, in order that we may look for another number, it is the nearest one which will be the most frequently used and certainly the most necessary, and to that number we may assign some convenient logarithm, which shall be both easily remembered and copied out as often as necessary. Now from all the numbers, none seem to be more outstanding or adapted to this task than 10, of which the logarithm shall be 1,00000,00000,0000.

This final vast integer avoids decimals, and Briggsian logarithms – what we would now call base 10 logarithms and the tool that stood as the essential aid to calculation until the mid 1970s and beyond – came into being. The reader unfamiliar with logarithmic calculation might seek information on their use through the various books and internet sources available, if only to appreciate what labour was required and how wonderful is the electronic calculator. In turn, we should appreciate how wonderful the calculative aid of logarithms must have been when, for the most part, the alternative was to perform long, tedious, repeated and error-strewn calculations.

Logarithms are no longer a tool for calculation but they continue to occupy a central place in mathematical analysis through their surprising role as the solution to a problem remote from calculation but central to analysis.

4.2 A Thorny Problem

Quadrature is an historical mathematical term for the ambiguous process of determining area. Which areas are being determined and by what means are questions that bestow the ambiguity, with the original Greek interpretation being the use of a straight edge and compass to construct a square equal in area to the figure in question or to some area associated with it (thereby "squaring" the figure): the quadrature of the circle (or the squaring of the circle) provides mathematical history with one of its most enduring challenges and opportunities for error (see chapter 5). Archimedes had advanced the means considerably with the use of *Eudoxus's method of exhaustion* in the squaring of the parabola; in effect, he had summed an infinite geometric series with common ratio $\frac{1}{4}$ to establish, in figure 4.1, that the segment area ABC is $\frac{4}{3}$, the area of the triangle ABC, where C is the point of tangency of the line parallel to the chord.

With the segment area made commensurate with a triangle, it was a trivial matter to make the triangle commensurate with a square, and so the parabola was squared: the result is not, though, what we would now mean if we talked about "finding the area under a parabola", and we move forward 1,800 years to gain familiar ground. In the 1640s Pierre de Fermat, with work remote from his famed "Last Theorem", investigated the quadrature of what were termed *higher parabolas* and *higher hyperbolas*, which take the modern forms $y^m = x^n$ and $y^m = x^{-n}$, respectively. His results languished until 1659, to appear in the compilation

<div align="center">

On the Transformation
and the On the Transformation
and the
Simplification of Equations of Loci,
for the Comparison under all forms
of Curvilinear Areas, be it among them, be it with Rectilinear Areas,
and at the Same Time
On the Use of the Geometric Progression
for the Quadrature of Parabolas and Hyperbolas to Infinity.

</div>

Titles were seldom pithy.

The first sentence of the work gives due acknowledgement to Archimedes for the use of infinite geometric series to achieve the quadrature of the parabola in those ancient terms, and Fermat adapted the method to establish his far more wide-reaching results in the

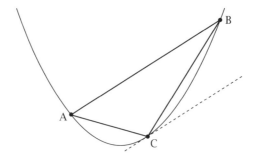

Figure 4.1. Archimedes' squaring of the parabola.

then-contemporary terms, which we give in modern, familiar form as

$$\int_0^a x^{n/m} \, dx = \frac{a^{n/m+1}}{n/m + 1} \quad \text{and} \quad \int_a^\infty x^{-n/m} \, dx = \frac{a^{-n/m+1}}{-n/m + 1}.$$

Apart, that is, for the second case, where $m/n = 1$, which he acknowledged with

> ...it is only for the primary hyperbola, that is to say the simple hyperbola or the hyperbola of Apollonius,[1] that the method is deficient.

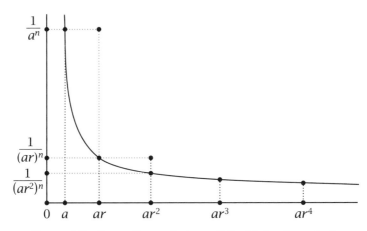

Figure 4.2. Fermat's quadrature of the higher hyperbola.

As to the method (for the higher hyperbola, using modern symbolism rather than Fermat's rhetoric), the curve's horizontal asymptote –

[1] Who, through his eight-book work *Conics*, and among much else, introduced the now-familiar names of the conic sections. Fermat means the hyperbola that is a conic section, rather than a higher hyperbola.

or, for us, an infinite part of the x-axis – is divided into intervals the length of which are not uniform but which form an infinite geometric sequence. Referring to figure 4.2, the x-axis from $x = a$ to infinity is segmented by the geometric sequence $a, ar, ar^2, ar^3, \ldots$, where $r > 1$, to delineate the bases of the overestimating rectangles, and, with the curve's equation $y = 1/x^n$, the corresponding heights are

$$\frac{1}{a^n}, \quad \frac{1}{(ar)^n}, \quad \frac{1}{(ar^2)^n}, \quad \frac{1}{(ar^3)^n}, \quad \ldots$$

The sum of the areas of these rectangles is, then,

$$\sum_{i=1}^{\infty} (ar^i - ar^{i-1}) \times \frac{1}{(ar^{i-1})^n} = \sum_{i=1}^{\infty} \frac{ar^{i-1}(r-1)}{a^n(r^{i-1})^n}$$

$$= \frac{r-1}{a^{n-1}} \sum_{i=1}^{\infty} \frac{1}{(r^{i-1})^{n-1}}$$

$$= \frac{r-1}{a^{n-1}} \sum_{i=1}^{\infty} \left(\frac{1}{r^{n-1}}\right)^{i-1}$$

$$= \frac{r-1}{a^{n-1}} \times \frac{1}{1 - 1/r^{n-1}}$$

$$= \frac{r-1}{a^{n-1}} \times \frac{r^{n-1}}{r^{n-1} - 1}$$

$$= \frac{r^{n-1}}{a^{n-1}} \times \frac{1}{r^{n-2} + r^{n-3} + \cdots + 1},$$

where the factorization of $r^{n-1} - 1$ is used in the last stage of simplification.

With the $r - 1$ eliminated, take the limit as r approaches 1 (and so put $r = 1$) to achieve that familiar

$$\int_a^{\infty} \frac{1}{x^n} \, dx = \frac{1}{a^{n-1}} \times \frac{1}{n-1},$$

which of course fails for $n = 1$.

Again, in Fermat's words:

> The reason for this is that the parallelograms DH, EI, LK are always equal. The terms making up the progression, insofar as they are now equal to each other, give no difference, and it is precisely the difference which is the key to the whole matter. I do not add the demonstration that, in the common hyperbola, the parallelograms in question are always equal. This is seen immediately and is instantly derived from this property of this type that always has GD:HE = HA:GA. The same

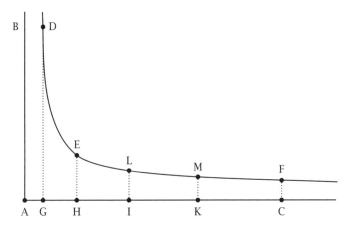

Figure 4.3. Geometric intervals generate arithmetic areas.

means can be used to square all the (higher) parabolas, except that again, as for the hyperbolas, there is one which escapes our method.

For us, these will constitute Fermat's last words on the subject, with the letters referring to figure 4.3, which is a relabelling of his own figure to that of the next contributor of note: the Flemish Jesuit Gregory of Saint-Vincent. During the years in which Fermat's arguments languished, the problem of the quadrature of the rectangular hyperbola had also been considered by others, notably Saint-Vincent and also his former student and then colleague Alfonso Antonio de Sarasa.

Forced to flee Prague by the turmoil of the Thirty Years' War, Saint-Vincent left behind his mathematical papers, which were later regathered and collated as his most significant mathematical legacy: the 1250 folio pages that constitute *Geometricum Quadraturae Circuli Sectionum Coni*, dated 1647. The title reveals it to be a book of geometry and conic sections and, to the detriment of its reputation, of the claimed successful quadrature of the circle; yet within it lies what appears to be the resolution of Fermat's (and others) difficulty: the first connection between the hyperbola of Appolonius and the logarithms of Napier. Book VI is dedicated to a comprehensive study of the hyperbola, the ample nature of which we can judge from our interest in Proposition 109 and those around it.

Proposition 109. *Let* AB *and* AC *be the asymptotes of a hyperbola* DEF. *Divide* AC *so that* AG, AH, AI, AK, AC *are in continuous proportion. Set*

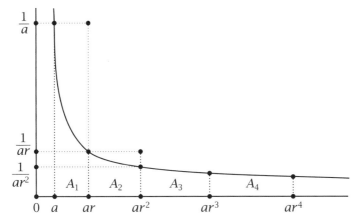

Figure 4.4. The quadrature of the rectangular hyperbola.

DG, EH, LI, MK, FC *equidistant*[2] *to* AB. *I say that* HD, IE, KL, CM *are equal segments.*

So, of course, said Fermat, with a characteristic dismissal of the need for justification, whereas Saint-Vincent offered two proofs, the essence of one of which we give below.

First, we restate the result in modern terms: for the rectangular hyperbola with points A, G, H, I, K, C taken on the x-axis so that they delineate a geometric sequence of distances

$$\frac{AG}{AH} = \frac{AH}{AI} = \frac{AI}{AK} = \frac{AK}{AC},$$

then the corresponding areas under the hyperbola, EHGD, LIHE, MKIL, FCKM are equal.

Referring to figure 4.4, the statement becomes one of taking a sequence of x coordinates $a, ar, ar^2, ar^3, \ldots$ and thereby delineating the areas $A_1, A_2, A_3, A_4, \ldots$ under the hyperbola $xy = 1$, with the conclusion that for the areas under it, $A = A_1 = A_2 = A_3 = A_4 = \cdots$.

To see this, we locate each A_i between the areas of the two obvious rectangles to conclude that

$$(ar - a)\frac{1}{ar} < A_1 < (ar - a)\frac{1}{a},$$

$$(ar^2 - ar)\frac{1}{ar^2} < A_2 < (ar^2 - ar)\frac{1}{ar},$$

$$\vdots$$

[2] In this context, the word means parallel.

and so

$$\frac{r-1}{r} < A_1 < r - 1, \quad \frac{r-1}{r} < A_2 < r - 1, \quad \ldots$$

Since r is arbitrary, it must be that the areas are equal. So, at least in discrete terms, as interval length increases geometrically, so areas under the rectangular hyperbola increase arithmetically – the defining behaviour of logarithms.

As we pass by this seminal result, let us measure the area from $a = 1$ and consider a fixed interval $[1, b]$ divided geometrically by the x coordinates $1, r, r^2, r^3, \ldots, r^n = b$. We know from above that each of the equal components of area is subject to $(r - 1)/r < A < r - 1$, and the total area therefore satisfies $n(r-1)/r < \sum A < n(r - 1)$, where $r^n = b$ and so $r = b^{1/n}$. This means that

$$n\frac{b^{1/n} - 1}{b^{1/n}} < \sum A < n(b^{1/n} - 1).$$

Since, as $n \to \infty$, $b^{1/n} \to 1$, the extremes converge to the same limit (given that it exists) and we have the result that the area function takes the form

$$L(b) = \sum A = \lim_{n \to \infty} n(b^{1/n} - 1).$$

Of course, logarithms were not then functions and this result had to wait for Euler, to whom we will soon refer.

For explicit mention of the logarithmic connection we must look to a subsequent publication by another author, and before that to the French polymath Father Marin Mersenne, a principal repository for significant areas of mathematical and scientific debate of his day.

His 1647 publication *Reflexiones Physico-mathematicae* – which, as the title suggests, comprises his thoughts on a number of physical and mathematical concepts – contains a guardedly critical assessment of Saint-Vincent's quadrature of the circle. It also contains the following challenge:

> Given three arbitrary magnitudes, rational or irrational, and given the logarithm of two of them, to find the logarithm of the third geometrically.[3]

[3] Here the word "geometrically" should be interpreted as "with mathematical precision".

The problem was one of moment. With the prevailing association between a geometric sequence of numbers and an arithmetic sequence of their logarithms, knowledge of the logarithms of a and ar determines the whole system: whether that third number could be found in that geometric sequence or any including it was, then, the essence of the question. Here we should realize that, although any two members of a geometric sequence do specify that sequence, it can be thought of as part of an infinite number of associated geometric sequences: for example, $a, ar, ar^2, ar^3, \ldots$ is a primary sequence but one embedded in the more dense sequence $a, a\sqrt{r}, ar, ar\sqrt{r}, ar^2, ar^2\sqrt{r}, \ldots$. Our sought-after third number might not lie within the original sequence but may belong to one that includes it: an observation made by the second Jesuit mathematician of interest to us, Alfonso Antonio de Sarasa. Sarasa, a Flemish product of Spanish parents, had been a student of Saint-Vincent and was at this time colleague to him in Ghent. In 1649 he published both a defence of his old tutor's work and an answer to Mersenne's question in the publication *Solvito Problematis A R P Marino Mersenno Minimo....* Setting aside his defence of the circle's quadrature, we find Sarasa's resolution to the logarithmic problem with his statement:

> From all this it will be clear that if quantities A and C are given, and their logarithms, and in the same way a third quantity L is given, which cannot be in any series [of continued proportion] containing the quantities A and C, however much that series is extended or divided or multiplied (which may be shown to be possible); in this case, it is not possible to find the logarithm of the quantity L, and therefore the problem has been badly formulated. But apart from this limitation we may find what is required in the problem, and to reduce the problem to a geometrical construction we apply what may be seen to be legitimate possibilities.

And for his proof about this problem regarding logarithms, he referenced the rectangular hyperbola, with the first sentence of a Scholion included in the work:

> But you say, I do not want these digressions. Yet I will lead you to logarithms, however distant this may seem from our purpose. Briefly then I explain how to understand the teaching on logarithms.

And also the last:

> For this reason you see that the nature of logarithms with its continu-
> ation and excess of terms is adapted exactly to the hyperbola, so that
> in place of the numbers, you may take the parts of the hyperbola or
> the given ratio of the lines.

And later still:

> Whence these areas (under the rectangular hyperbola) can fill the place
> of the given logarithms.

Logarithms began as a comparison between the continuous motion of
two points and developed into a relationship between discrete arith-
metic and geometric sequences and, through this, to a partial answer
to a thorny problem of quadrature. With logarithms identified as areas
under the rectangular hyperbola, the rectangular hyperbola could be
used to calculate logarithms.

4.3 Computation

Whatever logarithms were deemed to be, they needed calculating, and
Briggs's computation of his table of logarithms relied on a number of
methods. A principal one among them, already mentioned by Napier,
was to utilize the fact that the logarithm of the geometric mean of two
numbers was the arithmetic mean of their individual logarithms. That
is,

$$L(\sqrt{ab}) = \tfrac{1}{2}(L(a) + L(b)).$$

So, using our familiar decimals, with $L(1) = 0$, $L(10) = 1$, it must be
that $L(\sqrt{10}) = 0.5$, $L(\sqrt[4]{10}) = 0.25$, $L(\sqrt[8]{10}) = 0.125, \ldots, L(\sqrt[2^{54}]{10}) =$
2^{-54}, with Briggs reaching this level of subdivision, astonishingly with
the powers of 10 computed to (the equivalent of) 32 decimal places
and the logarithms to 40 decimal places. To this add his observation
that, for small α, $L(1 + \alpha) \approx k\alpha$, where his estimated value for $k =$
0.434294481903251804 (which is $\ln 10$ accurate in all but its last two
places) and two of the computational procedures are in place. There
are others too, but we hope that the point is made that this much-
sought-after table of numbers was at once hard to define and at the
same time hard to realize. And yet they could be realized in terms of
the quadrature of the rectangular hyperbola.

In volume 10 of the *Transactions of the Royal Society* (1668) we find
several important articles relating to logarithms and the quadrature of
the hyperbola. There is a detailed review of James Gregory's tract *Vera*

Circuli et Hyperbolae Quadratura, in which he had used exhaustion to compute areas under the rectangular hyperbola, which resulted in infinite series summing to logarithms. An article entitled "The Squaring of the Hyperbola, by an Infinite Series of Rational Numbers, Together with Its Demonstration, by that Eminent Mathematician, the Right Honourable the Lord Viscount Brouncker" also appears. Brouncker, the inaugural and then-current president of the Royal Society had finally published a result that, the preamble reminds us, John Wallis had attributed to him some years earlier. Using another of those ingenious infinite and exhaustive subdivisions, the principal result was that the area under the standard rectangular hyperbola between the x values 1 and 2 can be expressed as the infinite series

$$\frac{1}{1\times2} + \frac{1}{3\times4} + \frac{1}{5\times6} + \frac{1}{7\times8} + \cdots$$
$$= (1 - \tfrac{1}{2}) + (\tfrac{1}{3} - \tfrac{1}{4}) + (\tfrac{1}{5} - \tfrac{1}{6}) + (\tfrac{1}{7} - \tfrac{1}{8}) + \cdots$$
$$= 1 - \tfrac{1}{2} + \tfrac{1}{3} - \tfrac{1}{4} + \tfrac{1}{5} - \cdots .$$

Measuring the area from $a = 1$, thereby making the logarithm of 1 equal to 0, the result tells us that the logarithm of 2 is 0.693147.... The above review also mentions the Dane Nicolas Mercator and his book *Logarithmotechnia* (published the previous year), the first two parts of which were devoted to a method of constructing Briggsian logarithms. The third part, in contrast, contains a generalization of Brouncker's result, with his clumsily expressed Proposition 17 now formulated as the famous series

$$\ln(1 + x) = x - \frac{x^2}{2} + \frac{x^3}{3} - \frac{x^4}{4} + \cdots .$$

The hyperbola had been translated one unit to the left to $1/(1+x)$ and this expression divided out into the power series $1 - x + x^2 - x^3 + \cdots$; the area under the curve of each power of x was calculated using the methods of Cavalieri and the right-hand side results. John Wallis's review of the result improved the notation and contained the proviso that $x < 1$; he also established, again in modern notation, that

$$\ln(1 - x) = -x - \frac{x^2}{2} - \frac{x^3}{3} - \frac{x^4}{4} - \cdots .$$

Finally, in a further contribution in the same volume of the *Transactions*, Mercator combined the above to

$$\ln\frac{1 + x}{1 - x} = 2\left(x - \frac{x^3}{3} + \frac{x^5}{5} - \cdots\right),$$

thereby computing the logarithms of 2, 3, 10 and 11. Furthermore, he multiplied by 0.43429 (~1/ ln 10) to change natural to common logarithms.

With this last series, the natural – and therefore the Briggsian – logarithms of any numbers can be computed, since for its interval of convergence, $-1 < x < 1$, the number $(1 + x)/(1 - x)$ assumes all positive values. We have used functional notation in expressing matters to allow the arguments and results to occupy notational territory familiar to the modern reader, yet this advance was yet to be made, with the clear association of a logarithm as the power of a base and of the exponential function and its inverse yet to be openly recognized.

4.4 New Logarithms

One who did recognize logarithms in modern terms remains an obscure figure, with his name remembered solely for an unconnected and trivial matter: he adopted the symbol π for the ratio of the circumference to the diameter of a circle. This notational evolution appeared in the work *Synopsis Palmariorum Mathesios* of 1706, authored by one William Jones. Far more significant and far less well known is the fact that the work also contains a discussion of Halley's approach to logarithms, and, in a further tract likely to have been written soon after (with his death in 1749 the extreme date), we can identify him as one of the first men to understand the relationship between logarithms and exponents, and also that any number may be taken as the base of logarithms. Himself a member of the Royal Society, it was long after his death that his paper was prepared and read to the Society by its librarian, John Robertson, on 5 December 1771, and which had been communicated to him many years since. Logarithms were identified in the paper without equivocation, with the opening two paragraphs sufficient for our purpose:

1. Any number may be expressed by some single power of the same radical number. For every number whatever is placed somewhere in a scale of the several powers of some radical number r, whose indices are $m - 1, m - 2, m - 3, \ldots$ where not only the numbers $r^m, r^{m-1}, r^{m-2}, \ldots$ are expressed; but also any intermediate number x is represented by r, with a proper index z. The index z is called the Logarithm of the number x.

2. Hence, to find the logarithm z of any number x, is to find what power of the radical number r, in that scale, is equal to the number x; or to find the index z of the power, in the equation $x = r^z$.

We have passed by the contributions of Newton (who, of course, tarried publishing them) and his great rival Leibniz. Also of Roger Cotes and several members of the Bernoulli family and numerous others whose contributions were of varying importance, to make one final landfall with the man who cemented the ideas into a coherent theory with a recognizable notation.

All roads may lead to Rome, but all mathematical avenues pass by the inimitable Leonhard Euler. The loose strands that together formed the perception of logarithms were permanently knitted together in Book 1 of a two-volume textbook of 1748 entitled *Introductio in analysin infinitorum* ("Introduction to the Analysis of the Infinite"). It is a textbook, not a research document, and one that reads much as one we might refer to today (albeit in Latin). It is also a masterpiece of insight and exposition. Its 18 chapters are divided into 381 numbered sections, with parts of Chapters VI and VII of relevance here.

First, the precise nature of logarithm is identified in Section 102 of chapter VI:

> Just as, given a number a, for any value of z, we can find the value of y, so, in turn, given a positive value for y, we would like to give a value for z, such that $a^z = y$. This value of z, insofar as it is viewed as a function of y, is called the logarithm of y. The discussion of logarithms supposes that there is some fixed constant to be substituted for a, and this number is the base for the logarithm. Having assumed this base, we say the logarithm of y is the exponent in the power a^z such that $a^z = y$. It has been customary to designate the logarithm of y by the symbol ly. If $a^z = y$, then $z = ly$. From this we understand that the base of the logarithms, although it depends on our choice, still should be a number greater than 1. Furthermore, it is only of positive numbers that we can represent the logarithm with a real number.

To be followed by Section 103, which begins as follows:

> Therefore, whatever number may be agreed for the logarithmic base a, it will always be $l1 = 0$; for, if in the equation $a^z = y$ or its equivalent $z = ly$, on putting $y = 1$, it becomes $z = 0$.

And from these observations pour the familiar laws of logarithms, which are put to use in the calculation of $l5 = \log_{10} 5$. And, as with all good textbooks, motivational examples follow, whether it be in the calculation of $2^{7/12} = 1.498307\ldots$ or, with greater novelty, his take on compound interest:

Example 3
Since the human race shall have propagated from six people after
the Flood, if we may put the number of people 200 years later to
have increased now to 1.000.000, it is sought by how great a part the
number of people must increase in a year.

For which his solution is

$$6\left(1 + \frac{1}{x}\right)^{200} = 10^6 \rightarrow 1 + \frac{1}{x} = \left(\frac{1000000}{6}\right)^{1/200}$$

$$\rightarrow l\left(1 + \frac{1}{x}\right) = \frac{1}{200} l \frac{1000000}{6} = 0.0261092$$

$$\rightarrow 1 + \frac{1}{x} = 1.06196$$

$$\rightarrow x \approx 16.$$

He continued:

Therefore it may be sufficient [for the population] to multiply to so
great a number of people, if the number has increased by its sixteenth
part per annum; which multiplication, on account of the long life of the
inhabitants, may not be considered especially large. But if moreover
the number of people might have gone on to increase in the same ratio
through an interval of 400 years, then the number of people must rise
to
$$1000000 \times \frac{1000000}{6} = 166666666666$$
with which requiring to be supported, the whole orb of the earth would
by no means be equal.

Reasoning that we expand as

$$\left(1 + \frac{1}{x}\right)^{400} \times 6 = \left[\left(1 + \frac{1}{x}\right)^{200} \times 6\right] \times \left(1 + \frac{1}{x}\right)^{200}$$

$$= 1000000 \times \left(1 + \frac{1}{x}\right)^{200} = 1000000 \times \frac{1000000}{6}.$$

We move to chapter VII, which begins with Section 114 and the approx-
imation $a^x \sim 1 + kx$ of the exponential function by its tangent at
$x = 0$ where, of course, k depends on a. From this, in Section 116,
Euler weaves a mathematical tapestry to the end that

$$a^z = 1 + \frac{kz}{1} + \frac{k^2 z^2}{1 \times 2} + \frac{k^3 z^3}{1 \times 2 \times 3} + \frac{k^4 z^4}{1 \times 2 \times 3 \times 4} + \cdots$$

for any value of z.
 Move to Section 122 and we have:

Since we are free to choose the base a for our logarithms, we now choose a in such a way that $k = 1$, then the series above found in 116,

$$1 + \frac{1}{1} + \frac{1}{1 \times 2} + \frac{1}{1 \times 2 \times 3} + \frac{1}{1 \times 2 \times 3 \times 4} + \cdots,$$

is equal to a. If the terms are represented as decimal fractions and summed, we obtain the value for $a = 2.71828182845904523536028\ldots$. When this base is chosen, the logarithms are called natural or hyperbolic. The latter name is used since the quadrature of a hyperbola can be expressed through these logarithms. For the sake of brevity, for this number $2.718281828459\ldots$ we will use the symbol e, which will denote the base for the natural hyperbolic logarithm, which corresponds to the value $k = 1$ and e represents the number

$$1 + \frac{1}{1} + \frac{1}{1 \times 2} + \frac{1}{1 \times 2 \times 3} + \frac{1}{1 \times 2 \times 3 \times 4} + \cdots.$$

Euler had already used several letters as alternatives to the letter e, with e itself appearing in a letter to Christian Goldbach, dated as early as 25 November 1731. Others used alternative letters too, but such was Euler's overwhelming influence that the nomenclature soon became the standard. As the German mathematician Edmund Landau (2001) commented:

The letter e may now no longer be used to denote anything other than this positive universal constant.

Logarithms had become functions, with the exponential functions their inverse. And they were each given independent definitions, with

$$e^x = \lim_{n \to \infty} \left(1 + \frac{x}{n}\right)^n \quad \text{and} \quad \ln x = \lim_{n \to \infty} n(x^{1/n} - 1),$$

with the second limit having been foretold on page 58.

Briggsian logarithms continued their life as the servants of calculation until the advent of the microchip and, following that, the electronic calculator; with the successful quadrature of this simple curve, the hyperbolic logarithm and its inverse took on their own characters as the mainstay of analysis that remains with us today. The closing sentence of chapter VII of Euler's book rather sums up matters:

The remaining use of hyperbolic logarithms will be shown in more detail in the integral calculus.

The Quadratrix of Hippias

Why This Curve?

It "solved" two problems and created others. A clever construction from a clever man two and a half millennia ago resulted in a curve that could not possibly be understood at the time but that served as a driving force for more of its kind, and predated others that we now consider comparatively elementary. A largely forgotten curve, justly remembered.

5.1 Problems of Antiquity

The Babylonians and the Egyptians of antiquity bequeathed to the ancient Greeks a rich legacy of basic geometrical concepts. The storehouse of results was, though, intended for practical use by their surveyors, builders and astronomers and was not intended to be a repository for the systematic, deductive science developed by the Greeks. Indeed, if our mathematical thoughts stray to Ancient Greece, they will naturally stray to pure geometry: Euclidean geometry, with Euclid's *Elements* the obvious focus, even though the work also contains significant material on number theory. This collection of thirteen books stands as the most famous, most influential, most reprinted mathematical work ever to have been produced, from its inception at some time around 300 BCE

to the present day.[1] Yet the many geometric constructions within it are restricted to those that can be achieved using only a straight edge and compass. A straight edge, not a ruler with its marks allowing the comparison of lengths. The straight line and the circle were the fundamental geometric figures, and the straight edge and compass their physical manifestations through which – and only through which – new figures could be created.

With all of the success enjoyed over many centuries, three problems persisted in their stubbornness, resisting all attempts to establish their truth; so much so that eventually their truth was to be open to suspicion, although proof of their falsehood proved equally elusive.

These three great geometric problems of antiquity – listed below – have become justly famous even in modern times.

Trisecting the angle. Since any angle can be bisected using straight edge and compass (see later), it was natural to question angle trisection, particularly as methods for the trisection of some angles $(90°, 72°, 27°, \ldots)$ had already been established. The question at issue was, then, a natural one: can *every* angle be trisected by straight edge and compass techniques?

Squaring the circle. The ancient Greek idea of determining area was, by modern standards, strange. Area was not a numeric quantity to be determined from some figure, measured in some agreed units, but rather a property associated with it, to be compared with a most fundamental of figures: the square. To establish that some area relating to some figure was the same as that of some square of an appropriate size was to determine the figure's *quadrature*: from the latin *quadrates*, meaning four-sided, and from this a square. It was well known that the quadrature of any rectilinear figure was amenable to straight-edge and compass construction; the question at issue was whether the same was true of the most fundamental of curvilinear figures. The Presocratic Ionian philosopher Anaxagoras of Clazomenae, who lived in the approximate period 500–428 BCE, is the first name to be associated with the problem. His stated belief that the sun was a "red-hot stone as large as all of the Peloponnesus" rather than a deity led to his imprisonment in 434 BCE for impiety, and during his incarceration he attempted to square the circle.[2] Many, many others followed. For the best of reasons, none succeeded.

[1] Abraham Lincoln carried a copy with him and studied it, certainly the first six books (Carpenter 1995).

[2] Plutarch, *De Exilio*, chapter 17.

Doubling the cube. The problem is a matter of legend: the dissatisfaction of Minos, King of Crete and son of Zeus, with the size of the cubical tomb that had been erected for the prophetic sea god Glaucus,[3] or the better-known legend of the inhabitants of the island of Delos who suffered plague and to assuage it sought advice from the oracle at Delphi. The oracle's response was that Apollo should be placated by constructing a similar altar twice the volume of the one already erected to him; its shape was that of a cube.

The central curve of this chapter "solved" two of these three problems and we will soon move to its definition and from this its role in geometric history. First, though, part as a preliminary, part because of the sense of enjoyment extracted from them, we will consider some of those straight-edge and compass constructions. We should note that our compass is not the "collapsible" type; that is, once opened, it will remain opened at that distance and not collapse to its closed form until we cause it to do so.

5.2 Some Greek Constructions

We hope that some readers will be encouraged to dust off the compass hidden away in some drawer and attempt what follows, and perhaps even to seek out other, more demanding, constructions. All those below have relevance to this chapter, and some of them we will call upon in later sections (those referenced by "construction *X*").

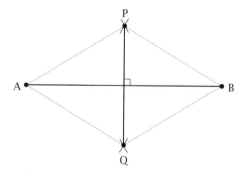

Figure 5.1. Bisecting a line segment.

Construction 1: Bisect a given line segment

[3] Who was immortal anyway, although born human; he became immortal after eating a magical herb.

Setup

Refer to figure 5.1. Draw the line segment AB.

Method

- Open the compass to a distance greater than half AB.
- Place the compass point at A and strike two arcs, one above the line and one below it.
- Place the compass point at B and strike two arcs, one above the line and one below it to determine points P, Q.
- Join the points P, Q to achieve the result.

Explanation

The figure APBQ is a rhombus with the given segment and the constructed line its diagonals; the diagonals of a rhombus are mutually perpendicular.

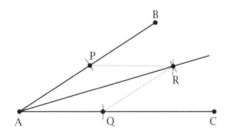

Figure 5.2. Bisecting an angle.

Construction 2: Bisect a given angle

Setup

Refer to figure 5.2. Construct the angle to be bisected by drawing the lines AB and AC.

Method

- Place the compass point at A, open it to a convenient distance, and strike arcs to determine the points P, Q.
- Leave the compass as it is or open it to a convenient distance.
- Place the compass point at P and strike an arc.
- Place the compass point at Q and strike an arc to determine the point R.
- Draw the line AR, the bisector of angle A.

Explanation

The triangles APR and AQR are congruent.

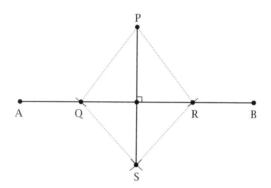

Figure 5.3. Exterior perpendicular.

Construction 3: Draw a perpendicular line to a given line from a given point not on the line

Setup

Refer to figure 5.3. Draw the line AB and locate the point P not on the line and through which the perpendicular must pass.

Method

- Open the compass to a reasonable distance, place its point on P and strike two arcs to intersect the line at points Q, R.
- Open the compass to a distance greater than half QR.
- Place the compass point at Q and strike an arc.
- Place the compass point at R and strike an arc to determine point S.
- Join S to P to achieve the line.

Explanation

The quadrilateral PQRS is a kite, so its diagonals are mutually perpendicular.

Construction 4: Draw a perpendicular line to a given line from a given point on the line

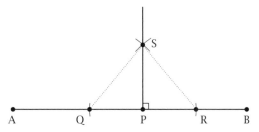

Figure 5.4. Interior perpendicular.

Setup

Refer to figure 5.4. Draw the line AB and locate the point P on the line.

Method

- Open the compass to a convenient distance, place the compass point at P and strike an arc either side of P to locate points Q, R.
- Open the compass to a convenient distance greater than PR.
- Place the compass point at Q and strike an arc.
- Place the compass point at R and strike the intersecting arc, locating the point S.
- Join P to S to achieve the required line.

Explanation

Triangles PQS and PRS are congruent and QPR is a straight line.

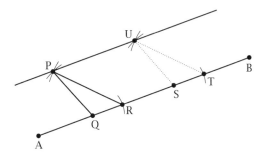

Figure 5.5. Drawing a parallel line.

Construction 5: Draw a line through a given point parallel to a given line

Setup

Refer to figure 5.5. Draw the line AB and locate the point P through which the parallel line is to pass.

Method

- Mark two arbitrary points Q, R on the given line and join each of them to the given point P to form the triangle PQR.
- Mark an arbitrary point S on the given line and at a convenient distance away.
- Place the compass point at Q and strike off the distance QR.
- Place the compass point at S and strike off this same distance to locate point T.
- Place the compass point at Q and strike off the distance QP.
- Place the compass point at S and strike an arc.
- Place the compass point at R and strike off the distance RP.
- Place the compass point at T and strike an arc and so determine point U.
- Draw the line through U and P to achieve the parallel line.

Explanation

The two triangles are congruent.

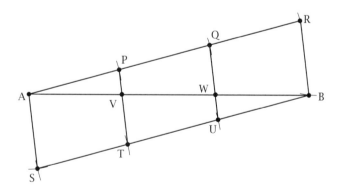

Figure 5.6. Trisecting a line segment.

Construction 6: Trisect a given line segment

Setup

Refer to figure 5.6. Draw the line segment AB.

Method

- Draw the line segment AR at a convenient angle to AB and of a convenient length.
- Place the compass point at A, open it to a convenient distance and strike to locate point P.
- Place the compass point at P and with the compass fixed open at this distance, strike to locate point Q.
- Place the compass point at Q and with the compass open at this distance, strike to locate point R.
- Place the compass point at R and open it to the distance RB.
- Place the compass point at A and strike an arc below AB.
- Place the compass point at R and open it to the distance RA.
- Place the compass point at B and strike an arc below AB to locate the point S and draw line BS.
- Place the compass point at A and open it to the distance AP.
- Place the compass point at S and strike an arc to locate point T.
- Place the compass point at T and strike an arc to locate point U.
- Draw the line segments PT and QU to locate points V, W, the points of trisection of AB.

Explanation

- AR and SB are parallel lines.
- AS, PT, QU, RB are parallel lines.
- Triangles AVP, AWQ, ABR are similar with sides in the ratio 1:2:3.

The construction can easily be generalized to the division of the line segment into any number of equal parts.

Construction 7: Trisect any given angle

Ahh … if only.

Of course, in general this is impossible but it took until 1837 for the Frenchman Pierre Wantzel to show it to be so.

To emphasize how delicately matters are balanced, we refer to *The Book of Lemmas*, a collection of fifteen propositions relating to circles. It appeared first in Arabic and then, in 1661, was translated into Latin; following this, Sir Thomas Heath translated it into English as *The Works of Archimedes* (although the authorship is somewhat questioned, it is commonly held that Archimedes is its author). Proposition 8 demonstrates how any angle can be trisected with compass and a *marked* rather than our unmarked straight edge, and it becomes our construction 8.

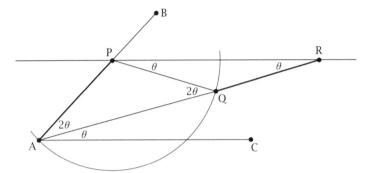

Figure 5.7. Archimedes trisection.

Construction 8: Archimedes trisection

Setup

Refer to figure 5.7. Construct the angle to be trisected by drawing the lines AB and AC. Take a straight edge that will admit a single mark.

Method

- Locate a point P conveniently on line AB.
- Construct a line through P and parallel to AC (see construction 5).
- Place the compass point at P and open it to distance AP, striking a large arc as shown.
- Place the straight edge along AB, with one end at A, and mark off the distance AP.
- Arrange the straight edge so that it pivots about A, crosses the circular arc at Q and meets the parallel line at R, where AP = QR (marked bold in the figure).
- The line AR trisects ∠BAC.

Explanation

PQ = AP = QR, and the two lines are parallel. The angles are, then, as in the figure.

Of course, the rules have been changed by a single mark on our straight edge, and with the ground thus prepared, we move to a different relaxation of the rules of the game and in consequence another solution of the problem – a solution that involves the curve of this chapter.

5.3 The Quadratrix and Trisection

When we think of the modern Olympic Games we naturally think of the remarkable skills, competitiveness and athleticism exhibited by the contestants; or perhaps our minds turn to the opening and closing ceremonies, which appear to compete across Games as ferociously as the athletes themselves within them. Tradition dates the event to 776 BCE, and in its ancient form it was to continue quadrennially until 393 CE; its location was the modern "regional unit" of Elis, on the western side of Greece's Peloponnese peninsula, with Olympia lying within its boundaries. And Hippias of Elis, as his name suggests, was a native of the region. Much of what is known about him with any degree of certainty derives from three works of Plato, and from these he appears to have been born in about 460 BCE and to have died in about 400 BCE, overlapping with Plato, and not to their mutual delight: Plato characterized Hippias as vain, arrogant and of limited intellect.[4] Hippias would appear to have been wealthy, much travelled, and possessed of a prodigious memory, and he appears to have lectured on a wide range of theoretical and practical subjects – including mathematics. As to his connection with the Olympic Games, he appears to have regularly attended them, he was the first to compile a list of victors, and he was noted for his public orations in the course of them, a skill that has not transmitted to their modern form. As to his connection with this chapter, he is accredited with the invention of the curve, later to be called the quadratrix, for the initial purpose of trisecting an arbitrary angle.

Hippias's route to success was again by the extension of the available tools, not to a marked ruler, but to this new curve; a "mechanical" curve that was to be the first new curve to be studied after the straight line and the circle and which predated the other conic sections by some 60–70 years.

His definition was subtle – and controversial. The curve is the locus of the intersection of two moving straight lines, where we refer to figure 5.8. Draw the square OXYZ of side 1 unit, which also defines the x- and y-axes and the origin for later coordinates. At time $t = 0$ the side YZ begins to move vertically downwards at one constant speed and, simultaneously, the side OY begins to rotate clockwise about O at another constant speed. Two speeds are chosen so that both lines reach side OX at the same instant. The curve is the locus of all points of

[4] See, for example, Platos Hippias Minor and Hippias Major.

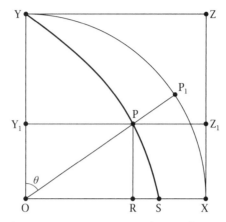

Figure 5.8. Constructing the quadratrix.

intersection, P, of these two lines. Evidently, it starts at Y and continues downwards to "meet' OX at some (mysterious) point S.

The construction itself attracted criticism. Through a commentary of Pappus of Alexandria we know that he and the scientist Sporus of Nicaea had commented that the synchronized motion necessary for the curve's construction would require the ratio of the side of the square to the circumference of the quadrant to be precisely known; that is, the ratio of the radius to the circumference of a quarter circle to be precisely known, which means that π is precisely known and the circle squared: more of this later. Nonetheless, the trisection of an arbitrary angle was effected as follows.

Let the angle be $\angle POQ$ in figure 5.9, where we have suppressed the quarter circle. Referring to the constructions of the previous section, the process is as follows.

- Construct the perpendicular from P to OQ to form the line segment PU (see construction 3).
- Trisect this line segment at the point S (see construction 6).
- Draw the horizontal line RST (see construction 5).
- Draw the line OT.
- The angle $\angle TOQ = \frac{1}{3}\angle POQ$.

And why? We could disseminate any of the early proofs but instead we take the opportunity to move centuries ahead to find the curve's Cartesian equation and from this identify the curve in modern terms, deduce this result and prepare for another.

We refer back to figure 5.8 with the square of side 1 unit. Suppose that the rotating line has reached position OP_1, having traversed an

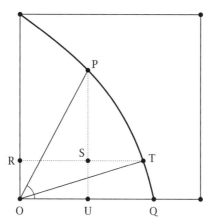

Figure 5.9. The quadratrix and angle trisection.

angle θ, and the descending line has reached position $Y_1 Z_1$; this makes the point $P(x, y) = P(\text{OP} \sin \theta, \text{OP} \cos \theta)$ a point on the curve. Since the motions are uniform, $\theta = \alpha t$ and $OY_1 = 1 - \beta t$ for some constants α, β. The parametric equations of the curve are given by

$$y = OY_1 = 1 - \beta t$$
$$x = \text{OP} \sin \theta = \text{OP} \tan \theta \cos \theta = (\text{OP} \cos \theta) \tan \theta,$$
$$= y \tan \theta = (1 - \beta t) \tan \alpha t.$$

So,

$$x = (1 - \beta t) \tan \alpha t,$$
$$y = 1 - \beta t.$$

And the equation of the curve may initially be rewritten as $x = y \tan \alpha t$.

To eliminate t from the equation we note that, since the two lines must each reach the base of the square simultaneously, at some time $t = T$, there must be a connection between the speeds of the two lines, that is, between α and β, which we now expose.

We have, then,

$$\theta = \alpha t \rightarrow \tfrac{1}{2}\pi = \alpha T,$$
$$OY_1 = 0 \rightarrow 1 - \beta T = 0 \rightarrow \beta T = 1,$$

which connect the constants by $\alpha = \tfrac{1}{2}\pi\beta$.

So, $x = y \tan \tfrac{1}{2}\pi\beta t = y \tan \tfrac{1}{2}\pi(1 - y) = y \cot \tfrac{1}{2}\pi y$ is the Cartesian equation of our curve, which involves a simple trigonometric function

and which generalizes the curve beyond its maximal physical genera-
tion process, $0 \leqslant \theta \leqslant \pi$, $\theta \neq \frac{1}{2}\pi$, to (nearly) all θ and which is shown
as the motif at this chapter's start.

With this we can easily see why the trisection is effected, since, with
$\angle POQ = y$ and $\angle TOQ = \varphi$ and $P(x, y)$, $T(x_1, y_1)$ as in figure 5.9, we
have

$$\tan y = \frac{y}{x} = \tan \tfrac{1}{2}\pi y \quad \text{and} \quad \tan \varphi = \frac{y_1}{x_1} = \tan \tfrac{1}{2}\pi y_1.$$

So

$$y = \tfrac{1}{2}\pi y \quad \text{and} \quad \varphi = \tfrac{1}{2}\pi y_1 = \tfrac{1}{2}\pi(\tfrac{1}{3}y) = \tfrac{1}{3}(\tfrac{1}{2}\pi y) = \tfrac{1}{3}y.$$

Of course, with the full generality of construction 6, we can divide an
angle into any number of equal parts.

The quadratrix had served its original purpose, if controversially, in
answering a question that has a somewhat different flavour to the other
two famous problems of antiquity. As we have mentioned, some angles
can be trisected – 90°, 72°, 27°, ..., for example – and what was sought
was a determination that no *general* process existed for doing so using
only the allowed tools of a straight edge and compass. No so the dou-
bling of the cube or the squaring of the circle; no cube can be doubled,
no circle squared. Yet no proof existed. Once more, relaxing the rules,
just as they were relaxed with the marked straight edge, changed mat-
ters entirely, and the quadratrix was again at the centre of things – since
it could be used to square the circle.

5.4 The Quadratrix and Circle Squaring

Finally, we provide justification for the name of this chapter's curve,
the quadratrix, named not by its discoverer, Hippias, but by a contem-
porary in one Hippocrates of Chios 470–410 BCE. The designation dis-
tinguishes between this lesser known ancient figure and the far more
famous Hippocrates of Kos, the "Father of Medicine", from whom the
Hippocratic Oath derives. Chios was our Hippocrates' island of birth (a
neighbouring island to Samos, of Pythagorean fame), although he was to
live in Athens for perhaps twenty years, during which time he acquired
his reputation as a mathematician of significance. As we mentioned
earlier, it was by that time well known that any rectilinear figure could
be squared, but it fell to Hippocrates to be the first person to square
a curvilinear figure; not a circle, of course, but a *lune*: more precisely,
three of them.

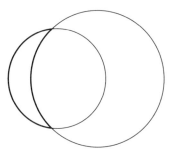

Figure 5.10. A lune.

We shall take as our definition of a lune the shape that is formed by the intersection of two unequal circles, as shown in bold in figure 5.10.

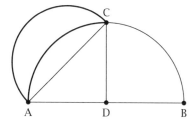

Figure 5.11. Squaring a particular lune.

Figure 5.11 displays the original lune considered by Hippocrates, formed as the figure between the larger quarter circle of radius 1 unit and the smaller semicircle with diameter the chord AC. It bears description as the *right-angled, isosceles triangle lune*, shown in bold, and is readily constructed with straight edge and compass using constructions 1 and 4. Its squaring places central reliance on the result that has been preserved for us as proposition 2 of book XII of Euclid's *Elements*:

Circles are to one another as the squares of their diameters.

That is, the ratio of the areas of two circles is the square of the ratio of their diameters.

With this and with D the centre of the larger semicircle we have

- AD = 1 → AB = 2, AC = $\sqrt{2}$
- $\dfrac{\text{area of semicircle on AC}}{\text{area of semicircle on AB}} = \left(\dfrac{\sqrt{2}}{2}\right)^2 = \dfrac{1}{2}$
- area of semicircle on AC = $\frac{1}{2}$ area of semicircle on AB = area of quarter circle on AD

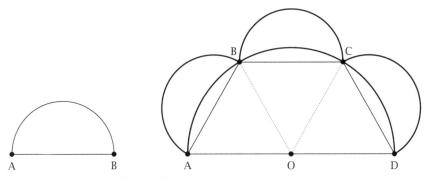

Figure 5.12. Squaring another lune.

- area of lune + common area = common area + area of triangle ADC
- area of lune = area of triangle ADC.

And this particular lune is squared. Hippocrates also managed to square two more such lunes: one based on a regular trapezium inscribed in a semicircle whose longest side is $\sqrt{3}$ times the length of the equal shorter sides, and another based on an irregular but symmetric pentagon. Details may be extracted from, for example, Sir Thomas Heath (1981, pp. 183–200).

He made other significant observations too, one of which comes tantalisingly close to the circle's squaring and which relies on figure 5.12, a variant of one of the two lunes just mentioned above. Here, the length of the longest side of the trapezium is twice that of its shortest side, and the three equal lunes are contained within the respective semicircles and arcs of circles. The left part of the figure is a copy of one of these smaller semicircles and all can be constructed with straight edge and compass. The associated reasoning is

$$AD = 2AB \to AD^2 = 4AB^2 = AB^2 + AB^2 + BC^2 + CD^2.$$

Since, again, the areas of circles are in the ratio of the squares of their diameters, we have

area of the large semicircle

= area of the small semicircle

+ sum of the areas of the small semicircles on the sides,

which may be rewritten as

area of the trapezium + the sum of the areas of the three segments
= area of the small semicircle
+ sum of the areas of the three segments
+ sum of the areas of the three lunes.

Cancelling results in

area of the trapezium = area of the small semicircle
+ the sum of the areas of the three lunes.

If these lunes could be squared, this would result in squaring the semi-circle and hence the circle. But the three lunes cannot be squared. It took until 1766 for other squareable lunes to be discovered, when one Martin Johan Wallenius discovered two more and, independently, Euler did the same in 1771.[5] It had to wait until 1934 when the Russian mathematician N. G. Tschebatorev came close, and in 1947 his student A. W. Dorodnov (1947) finished a proof that Hippocrates' three and the latter two are the only five lunes that are squareable with straight edge and compass, none of which suits purpose.

What, then, is the role of the quadratrix in the quadrature of the circle? For this we have to wait a century beyond Hippocrates when the Greek mathematician Dinostratus proved a particular theorem which still bears his name. Referring back to figure 5.8, the theorem states that the side of the square is the *mean proportional* (see later) between OS and arc \widehat{YX}: that is,

$$\frac{\widehat{YX}}{OX} = \frac{OX}{OS} \quad \text{and so} \quad \frac{\frac{1}{2}\pi}{1} = \frac{1}{OS},$$

which means that OS $= 2/\pi$. The proof is, of course, geometric and uses contradiction. We do not produce it here but rather utilize more modern methods, making use of the equation of the curve. We require $\lim_{y \to 0} y \cot \frac{1}{2}\pi y$, with evaluation at $y = 0$ of course leading to an indeterminant result, providing a modest challenge to a symbolic calculator or a candidate for l'Hôpital's rule with

$$\lim_{y \to 0} y \cot \tfrac{1}{2}\pi y = \lim_{y \to 0} \frac{y}{\tan \frac{1}{2}\pi y} = \lim_{y \to 0} \frac{1}{\frac{1}{2}\pi \sec^2 \frac{1}{2}\pi y} = \frac{2}{\pi}.$$

[5] Arguments are available in, among many alternatives, Sir Thomas Heath (1981, pp. 183-200).

The quadratrix meets the horizontal at a distance $2/\pi$ along the bottom side of the square – given that it actually *does* meet that side. A second criticism of Pappus was that the curve's definition causes the two line segments to be coincident at the end of the motion, which means that the final point S is not geometrically feasible. Put another way, in its original role as a mechanical curve, stop the motion at any point near its end and there is no way to extrapolate precisely the remainder of the curve, since it does not yet exist. A fair criticism, but one we shall ignore since with this result the quadratrix has performed the heavy lifting in the task of squaring the circle. Having "constructed" the length $2/\pi$, we use construction 1 to halve this to $1/\pi$ and then construct its reciprocal with construction 9.

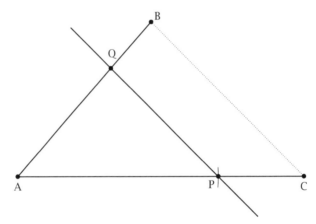

Figure 5.13. Constructing the reciprocal.

Construction 9: Given a length and a unit, construct the reciprocal of that length

Setup

Refer to figure 5.13. The already-constructed length is AC, and at a convenient angle draw the line AB of length 1 unit.

Method

- Place the compass point on A and open it to AB, striking an arc to meet AC at P.
- Construct the line through P parallel to BC (construction 5) to meet AB at Q.
- The line AQ has length the reciprocal of the length of AC.

Explanation

Triangles AQP and ABC are similar, so

$$\frac{AQ}{AB} = \frac{AP}{AC} \rightarrow \frac{AQ}{1} = \frac{1}{AC}.$$

We now have π constructed and to finish the job we invoke construction 10.

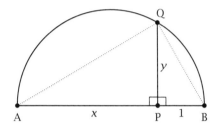

Figure 5.14. Constructing the square root.

Construction 10: Given a length and a unit, construct the square root of that length

Setup

Refer to figure 5.14. The already-constructed length is AP = x and this line is continued to the right so that PB = 1 is the unit.

Method

- Bisect AB to locate the centre of the semicircle passing through A, B (construction 1).
- Construct the perpendicular to AB through P to meet the semicircle at Q (construction 4).
- The length PQ = y = \sqrt{x}.

Explanation

- Pythagoras in $\triangle APQ \rightarrow AQ^2 = x^2 + y^2$
- Pythagoras in $\triangle BPQ \rightarrow BQ^2 = y^2 + 1^2$
- Pythagoras in $\triangle ABQ \rightarrow AB^2 = AQ^2 + BQ^2 \rightarrow (x+1)^2 = (x^2 + y^2) + (y^2 + 1^2) \rightarrow y = \sqrt{x}$

And we have constructed the side of a square of length $\sqrt{\pi}$. With this, the circle has been squared.

The third classic construction problem is not amenable to an approach using the quadratrix and so is not of central concern to us. It was Hippocrates, though, who showed that a cube can be doubled if two *mean proportionals* can be determined between a number and its double. This term has already been mentioned and has long ago been replaced by the geometric mean: to place a single mean proportional x between two numbers a and b, $x = \sqrt{ab}$. The method of construction of the geometric mean using straight edge and compass is precisely that of construction 10, with AP = a, PB = b and y the sought-after geometric mean. The idea easily generalizes if we rewrite the geometric mean as the solution of the equation $a/x = x/b$, in that we may seek two mean proportionals for which $a/x = x/y = y/b$; x being the geometric mean of a and y, and y that of x and b. Hippocrates required this to be amended to $a/x = x/y = y/2a$, with the associated algebra $x^2 = ay$, $y^2 = 2ax$, and so $x = 2^{1/3}a$ and the problem is transformed to the construction by straight edge and compass of a segment of length $x = 2^{1/3}a$ given a segment of length a, which would double the volume of the associated cube. As with trisecting a given angle, we must look to the efforts of Pierre Wantzel (and again in 1837) when the problem was to be shown to be impossible, in that the length $\sqrt[3]{2}$ was shown not to be constructible using a straight edge and compass.

And so came about the conic sections, somewhat later than the quadratrix. Menaechmus, brother of Dinostratus, in himself attempting to duplicate the cube by finding the two proportionals, brought about the first appearance of the conic sections with $a/x = x/y = y/b$, implying that $x^2 = ay$, $y^2 = bx$, $xy = ab$, and we are investigating what we recognize as the intersection of a parabola with a hyperbola. His own approach was, of course, entirely geometric.

With this, our story of the quadratrix is at an end.

We have mentioned the conics and there are many other curves, the names of some of which invoke a sense of mystery: the Cissoid of Diocles, the Conchoid of de Sluze, the Conchoid of Dürer, the Conchoid of Nicomedes, the Folium of Descartes, the Kampyle of Eudoxus, the Lemniscate of Bernoulli, the Pearls of Sluze, the Trisectrix of Maclaurin, the Trident of Newton, the Witch of Agnesi, etc.

Some relate to the three great construction problems, others justify their existence in different ways. Whatever names they are known by, whatever their use, in terms of the genesis of mathematical curves, the list begins straight line, circle, quadratrix of Hippias,

Two Space-Filling Curves

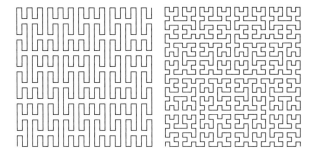

Why These Curves?

The first, as a function, paved the way for the second, as a curve. A space-filling curve, which helped to bring into sharp focus the dangers hidden within the first two definitions of Book I of Euclid's *Elements*, in which "a point has no part" and "a line is a breathless length". The nature of curve and the dimension of the space in which it lives were finally and urgently revisited, later helping spawn the vast subject of topology and in particular topological dimension theory.

6.1 Je Le Vois, Mais Je Ne Le Crois Pas

The latter part of the nineteenth century was not a happy time for mathematical intuition. We have seen in chapter 2 that in 1872 Weierstrass produced his everywhere-continuous but nowhere-differentiable curve. In 1873 the Russian-German Georg Cantor proved that the rational numbers and the algebraic numbers are each only as numerous as the natural numbers, and so are *countable*; later in the same year he proved that the real numbers were not countable, which meant that almost all real numbers were *transcendental*, which was particularly hard to

accept as transcendentals were proving extremely hard to find.[1] Add to these dilemmas Cantor's counterintuitive and controversial theory of transfinite numbers, published between 1879 and 1884, and we have an accurate picture of the widespread mathematical torment that prevailed during this period. Here we are interested in one particular instrument from Cantor's mathematical torture chamber: one which questions the concept of dimension.

> Can a surface (say a square that includes the boundary) be uniquely referred to a line (say a straight line segment that includes the end points) so that for every point on the surface there is a corresponding point of the line and, conversely, for every point of the line there is a corresponding point of the surface? I think that answering this question would be no easy task, despite the fact that the answer seems so clearly to be "no" that proof appears almost unnecessary.

The quotation is taken from a letter dated 5 January 1874 from Cantor to his frequent correspondent Richard Dedekind, with its subject matter striking deeply at the heart of long-embedded intuition – so deeply that Cantor himself felt the necessity to question his own question. It was an unspoken assumption, foolish to question, that the least number of coordinates needed to designate a point in a space determined the dimension of that space. For example, points in the plane require two independent coordinates to specify them, which makes the plane two dimensional and which makes the representation of its points by a single number on the number line quite unthinkable. Dedekind was Cantor's sounding board. Fourteen years his senior, more eminent and much esteemed by Cantor, Dedekind's opinion was paramount, and his approbation regularly sought in an exchange of letters that was to last for a decade beginning in 1872, when Cantor was 27 years old. Cantor had married in August 1874, with the honeymoon spent in the beautiful Swiss city of Interlaken; it says much that Dedekind was holidaying at the same time in the same place and it is known that the two spent much of the honeymoon exchanging mathematical ideas, one hopes to the new Mrs Cantor's approval.

Notwithstanding these verbal exchanges, there appears to be no record of a written reply from Dedekind to that 1874 question, and we move to another letter from Cantor to him dated 20 June 1877:

[1] In 1844 Joseph Liouville had exhibited his eponymous transcendental and in 1873 Charles Hermite had proved that e is transcendental. The transcendence of π had to wait for Ferdinand von Lindemann in 1882.

I should like to know whether you consider an inference-procedure that I use to be arithmetically rigorous. The problem is to show that surfaces, bodies, indeed even continuous structures of ρ dimensions can be correlated one-to-one with continuous lines, i.e., with structures of only one dimension – so that surfaces, bodies, indeed even continuous structures of ρ dimensions have the same power as curves. This idea seems to conflict with the one that is especially prevalent among the representatives of modern geometry, who speak of simply infinite, doubly, triply, ..., ρ-fold infinite structures. (Sometimes you even find the idea that the infinity of points of a surface or a body is obtained as it were by squaring or cubing the infinity of points of a line.)

Cantor had, he believed, answered his own question. That inference procedure can be representatively explained when it is applied to the unit square and the unit interval, thereby bringing about a one-to-one correspondence between them; such a correspondence demonstrates that the two sets have the same *power*, in Cantor's terminology. First he removed the ambiguity inherent in the decimal representation of finitely represented rationals: for example, taking the form $0.1999\ldots$ rather than 0.2.[2] With this, his simple argument was that the point $(x, y) = (0.a_1 a_2 a_3 \ldots, 0.b_1 b_2 b_3 \ldots)$ of the unit square is associated with $z = 0.a_1 b_1 a_2 b_2 a_3 b_3 \ldots$ of the unit interval. Such a correspondence is clearly one-to-one but, as Dedekind immediately pointed out, is not *onto* the interval. A quick reply of 22 June 1877 contained Dedekind's exposure of a difficulty that he had immediately noticed: there is an infinity of numbers in the unit interval the decimal pattern of which would prevent them being reached by Cantor's construction – his example, $z = 0.120101010101\ldots$, which would correspond to $x = 0.100000\ldots$ and $y = 0.21111\ldots$, with the former coordinate, by design, inadmissible. In Dedekind's words, "I do not know if my objection goes to the essence of your idea, but I did not want to hold it back", to which Cantor responded (by postcard the following day) "Alas, you are entirely correct in your objection; but happily it concerns only the proof, not the content. For I proved somewhat more than I had realised."

Cantor's association had brought into one-to-one correspondence the unit square with an infinite subset of the unit interval rather than the unit interval itself. A result that indeed appears to be stronger than the one intended – but it is in the nature of the infinite that intuition is regularly confounded. Cantor, though, wanted Dedekind to be convinced of his original proposal of the equivalence of the unit square

[2] A nice application of infinite geometric series.

with the whole of the unit interval, and on 25 June 1877 he continued the energetic correspondence with a far more complicated argument that involved continued fractions and infinite sequences of irrationals converging to 1, together with a graphical demonstration of the equivalence of the intervals $[0, 1]$ and $(0, 1]$. The argument suits purpose, yet it is disconcertingly cumbersome and also quite unnecessary since his correspondence can be readily adapted to suit his original purpose, as follows.

If, for example, $z = 0.12030045600007809\ldots$, then break the number into "atoms", α_i, which are integer patterns either without zeros or including all preceding zeros; in this case, $\alpha_1 = 1$, $\alpha_2 = 2$, $\alpha_3 = 03$, $\alpha_4 = 004$, $\alpha_5 = 5$, $\alpha_6 = 6$, $\alpha_7 = 00007$, $\alpha_8 = 8$, $\alpha_9 = 09$, ..., and associate these with the point in the unit square having coordinates $x = 0.\alpha_1\alpha_3\alpha_5\ldots$ and $y = 0.\alpha_2\alpha_4\alpha_6\ldots$. In this case, $x = 0.10350000709\ldots$ and $y = 0.200468\ldots$. Dedekind's problematic example generates $\alpha_1 = 1$, $\alpha_2 = 2$, $\alpha_3 = 01$, $\alpha_4 = 01$, $\alpha_5 = 01$, $\alpha_6 = 01$, $\alpha_7 = 01$, $\alpha_8 = 01$, $\alpha_9 = 01$, ..., and would be associated with $x = 0.101010101\ldots$ and $y = 0.201010101\ldots$, and all is well. The reverse process, from the unit square to the unit interval, works in the obvious manner and the correspondence is not only one-to-one but onto.

This argument and Cantor's own are readily extended to higher dimensions, and with them the foundations of geometry seemed under threat. Dedekind had not replied by 29 June and so Cantor pressed with yet another letter to him, an extract from which is:

> Please excuse my zeal for the subject if I make so many demands upon your kindness and patience; the communications which I lately sent you are even for me so unexpected, so new, that I can have no peace of mind until I obtain from you, honoured friend, a decision about their correctness. So long as you have not agreed with me, I can only say: *je le vois, mais je ne le crois pas*. And so I ask you to send me a postcard and let me know when you expect to have examined the matter, and whether I can count on an answer to my quite demanding request.

And we have the appearance of the most famous of Cantor's quotations, and arguably one of the most famous in all mathematics: *je le vois, mais je ne le crois pas* – I see it but I do not believe it.[3] All of

[3] "Voir, c'est croire" translates to "seeing is believing". This is part of the full idiom "seeing is believing, but feeling is the truth", coined by the seventeenth-century English scholar and preacher Thomas Fuller (who should not be confused with Thomas Fuller, the mental calculator of the eighteenth century).

the letters between them were, understandably, originally written in German, but Cantor used French for the quotation, the reasons for which remain speculative. He had acknowledged the shortcoming of his first proof and was not entirely confident of the veracity of this second one and needed the highly tutored eye of Dedekind to pass across it. The opening sentence of Dedekind's reply of 2 July was "I have examined your proof once more, and I have discovered no gap in it; I am quite certain that your interesting theorem is correct, and I congratulate you on it." The unit square could be squashed to the unit interval, and it was no great step for the plane to be squashed to the line. Yet the cataclysmic confusion of dimension that resulted was not (fortunately) to destroy the mathematical structure of space; as with so many paradoxes and contradictions, the uncomfortable was to lead to the inevitable, and in this case to a reassessment of the assumptions and definitions underlying measures of the size of space. So came into being a whole new branch of mathematics, now called *topological dimension theory*. The immediate reconciliation between Cantor's correspondence connecting spaces and the idea of their dimension lies, as Cantor observed and as Dedekind emphasized, with the concept of continuity: in Dedekind's words referring to Cantors letter, "… a frightful, dizzying discontinuity in the correspondence, which dissolves everything to atoms, so that every continuously connected part of one domain appears in its image as thoroughly decomposed and discontinuous". From the seeming wreck of the idea of dimension, Dedekind then proposed a resolution:

> For the time being I believe the following theorem: "If it is possible to establish a reciprocal, one-to-one, and complete correspondence between the points of a continuous manifold A of a dimensions and the points of a continuous manifold B of b dimensions, then this correspondence itself, if a and b are unequal, is necessarily utterly discontinuous."

That general reciprocal one-to-one and complete (onto) correspondence was quickly found by Cantor (1878) when he showed that any two finite-dimensional smooth "manifolds", no matter what their dimensions, have the same cardinality (or power). The three important, intrinsic qualities of any such correspondence are its injectivity (one-to-one), its surjectivity (onto) and its continuity, and, according to the shared wisdom of Cantor and Dedekind, it cannot possess all three: Cantor's correspondence must, therefore, be discontinuous and all such like it, yet establishing this to be the case in every case proved elusive. In

that same year, four mathematicians managed (with varying degrees of conviction and through extremely complex arguments) to show that, for dimensions no greater than three, a continuous function between spaces of different dimensions cannot be one-to-one, and Cantor provided his own variant in the following year. The result for higher dimensions proved more resistant, with several fallacious "proofs" appearing, including one of 1899 from Cantor himself, the errors in which took twenty years to uncover. It would have to wait for L. E. J. Brouwer in 1911 for the general result to be rigorously established.

So, a bijective correspondence between the unit interval and the unit square cannot be continuous, and hence a continuous correspondence cannot be bijective, and so if it is surjective, it cannot be injective. The obvious next step was to find an example of a surjective, necessarily non-injective, continuous correspondence from the unit interval to the unit square. The game was set but proved surprisingly difficult to play, as the first such correspondence was two decades in coming. In 1890 an Italian mathematician, logician and priest was to provide what was required – but in a most peculiar manner.

6.2 Peano's Function

The name of Giuseppe Peano is most readily perpetuated through the *Peano axioms*, which underpin the arithmetic of natural numbers (although he attributed these to Dedekind). His contribution to mathematics is wider, though, through various results of analysis, the provision of counterexamples and notation (he introduced the inclusion symbol \in of set theory, which we use below, and its reflection \ni for the phrase "such that"). He was also the first to provide that most-sought-after continuous function that maps the unit interval surjectively but necessarily non-injectively to the unit square (Peano 1890), and it is this that will occupy the next few pages. Gifted though the man was in producing telling and often surprising examples and counterexamples, it is extremely difficult to grasp how his imagination conceived this particular construction, the details of which we consider below.

Peano's Construction

An operator k is defined by $kt = 2 - t$ for $t \in \{0, 1, 2\}$, and the nth iteration of this denoted by k^n. In particular, $k^2 t = k(kt) = k(2 - t) = 2 - (2 - t) = t$, which means that $k^{2n} t = t$ and $k^{2n-1} t = kt = 2 - t$, and with this, if $k^n t = x$ then $t = k^n x$.

Now represent numbers $t \in I$ in base 3 (ternary) notation, so $t = 0_3 t_1 t_2 t_3 t_4 t_5 t_6 \ldots$, where all $t_i \in \{0, 1, 2\}$.

The function $f: I \to S$ is defined as having the x component's digits of the image the cumulative even-numbered iterations of the ternary expansion of the odd-numbered places of t and the y component's digits the cumulative odd-numbered iterations of the tertiary expansion of the even-numbered places of t. Specifically,

$$f(t) = (0_3 t_1 (k^{t_2} t_3)(k^{t_2+t_4} t_5)(k^{t_2+t_4+t_6} t_7) \ldots,$$
$$0_3 (k^{t_1} t_2)(k^{t_1+t_3} t_4)(k^{t_1+t_3+t_5} t_6) \ldots)$$
$$= (f_x(t), f_y(t)),$$

all of which is made far more transparent by examples.

First, we calculate the image of an arbitrary point

$$t = 0_3 1102100212 \cdots = 0.4736405\ldots,$$

where $t_1 = 1$, $t_2 = 1$, $t_3 = 0$, $t_4 = 2$, $t_5 = 1$, $t_6 = 0$, $t_7 = 0$, $t_8 = 2$, $t_9 = 1$, $t_{10} = 2$, ..., to be

$$f_x(t) = 0_3 1(k^1 0)(k^3 1)(k^3 0)(k^5 1) \cdots = 0_3 1(k0)(k1)(k0)(k1)$$
$$= 0_3 12121 \cdots = 0.62139\ldots,$$
$$f_y(t) = 0_3 (k^1 1)(k^1 2)(k^2 2)(k^3 2) = 0_3 (k1)(k2)(2)(k2)$$
$$= 0_3 1020 \cdots = 0.4074\ldots.$$

In base 10 the correspondence is

$$0.4736405 \cdots \to (0.62139\ldots, 0.4074\ldots).$$

And second, the much less arbitrary point $0_3 1000 \cdots = \frac{1}{3}$. Here we have $t_1 = 1$ and $t_i = 0$ otherwise, which results in

$$f_x(t) = 0_3 1(k^0 0)(k^0 0)(k^0 0)(k^0 0) \cdots = 0_3 10000 \cdots = \frac{1}{3},$$
$$f_y(t) = 0_3 (k^1 0)(k^1 0)(k^1 0)(k^1 0) = 0_3 2222 \cdots = 1.$$

As decimal fractions, the correspondence is $\frac{1}{3} \to (\frac{1}{3}, 1)$. But are we certain? We recall that Cantor's original correspondence relied on taking the infinite decimal form of a finite decimal; in this case, we may write $\frac{1}{3} = 0_3 0222\ldots$ in its infinite ternary form. Happily, all is well since applying the function to this form yields $(0_3 0222\ldots, 0_3 2222\ldots) = (\frac{1}{3}, 1)$ once again. The reader may wish to check that such is always

the case and that this ambiguity of representation has no effect on the function's definition; that is, it is well defined.

With this, we have a well-defined function and one given in explicit (if somewhat exotic) analytic form. Now we need it to satisfy the required two properties – and for it necessarily to fail to satisfy the third.

Surjectivity

For any given point

$$s = (0_3 x_1 x_2 x_3 x_4 x_5 x_6 \ldots, 0_3 y_1 y_2 y_3 y_4 y_5 y_6 \ldots) \in S,$$

we need to exhibit a $t = 0_3 t_1 t_2 t_3 t_4 t_5 t_6 \cdots \in I$ such that $f(t) = s$. For this we require that

$$(0_3 t_1 (k^{t_2} t_3)(k^{t_2+t_4} t_5)(k^{t_2+t_4+t_6} t_7) \ldots,$$
$$0_3 (k^{t_1} t_2)(k^{t_1+t_3} t_4)(k^{t_1+t_3+t_5} t_6) \ldots)$$
$$= (0_3 x_1 x_2 x_3 x_4 x_5 x_6 \ldots, 0_3 y_1 y_2 y_4 y_4 y_5 y_6 \ldots).$$

Comparing coordinates we must have

$$t_1 = x_1,$$
$$k^{t_1} t_2 = y_1 \rightarrow t_2 = k^{t_1} y,$$
$$k^{t_2} t_3 = x_2 \rightarrow t_3 = k^{t_2} x_2,$$
$$k^{t_1+t_3} t_4 = y_2 \rightarrow t_4 = k^{t_1+t_3} y_2,$$
$$k^{t_2+t_4+t_6} t_7 = x_3 \rightarrow t_7 = k^{t_2+t_4+t_6} x_3,$$
$$k^{t_1+t_3+t_5} t_6 = y_3 \rightarrow t_6 = y_3 k^{t_1+t_3+t_5},$$
$$\vdots$$

and we have the ternary expansion of t.

Continuity

We show that the Peano function is continuous by showing that its x coordinate function, f_x, is continuous at an arbitrary point, with the argument for the y coordinate, *mutatis mutandis*, the same: alternatively, we could approach the result for the y coordinate by use of the relationship $f_y(t) = 3 f_x(\frac{1}{3} t)$.

So, let our arbitrary point be written

$$a = 0_3 a_1 a_2 a_3 \cdots a_n a_{n+1} a_{n+2} a_{n+3} \cdots,$$

and let

$$b = 0_3 a_1 a_2 a_3 \cdots a_n \beta_{n+1} \beta_{n+2} \beta_{n+3} \cdots$$

be close to a, agreeing with it over the first n digits of its ternary expansion, where we assume n to be even. It is clear, then, that $|a - b| < 1/3^{n+1}$. We will apply f_x to a and b and consider the modulus of the difference between these two images, concentrating on the first and subsequent places in which they differ. To this end, we convert the ternary expansion of the images to infinite series of fractions.

Recall that

$$f_x(a) = 0_3 a_1 (k^{a_2} a_3)(k^{a_2 + a_4} a_5)(k^{a_2 + a_4 + a_6} a_7) \cdots$$
$$\cdots (k^{a_2 + a_4 + a_6 + \cdots + a_n} a_{n+1})(k^{a_2 + a_4 + a_6 + \cdots + a_n + a_{n+2}} a_{n+3}) \cdots$$

and that

$$f_x(b) = 0_3 a_1 (k^{a_2} a_3)(k^{a_2 + a_4} a_5)(k^{a_2 + a_4 + a_6} a_7) \cdots$$
$$\cdots (k^{a_2 + a_4 + a_6 + \cdots + a_n} \beta_{n+1})(k^{a_2 + a_4 + a_6 + \cdots + a_n + \beta_{n+2}} \beta_{n+3}) \cdots .$$

Convert these to the appropriate fractions and subtract and we have

$$|f_x(a) - f_x(b)|$$
$$= \left| \frac{k^{a_2 + a_4 + a_6 + \cdots + a_n} a_{n+1} - k^{a_2 + a_4 + a_6 + \cdots + a_n} \beta_{n+1}}{3^{(n/2)+1}} \right.$$
$$+ \left. \frac{k^{a_2 + a_4 + a_6 + \cdots + a_n + a_{n+2}} a_{n+3} - k^{a_2 + a_4 + a_6 + \cdots + a_n + \beta_{n+2}} \beta_{n+3}}{3^{(n/2)+2}} + \cdots \right|$$
$$\leq \left| \frac{k^{a_2 + a_4 + a_6 + a_n} a_{n+1} - k^{a_2 + a_4 + a_6 + \cdots + a_n} \beta_{n+1}}{3^{(n/2)+1}} \right|$$
$$+ \left| \frac{k^{a_2 + a_4 + a_6 + \cdots + a_n + a_{n+2}} a_{n+3} - k^{a_2 + a_4 + a_6 + \cdots + a_n + \beta_{n+2}} \beta_{n+3}}{3^{(n/2)+2}} \right| + \cdots$$
$$\leq \frac{2}{3^{(n/2)+1}} + \frac{2}{3^{(n/2)+2}} + \frac{2}{3^{(n/2)+3}} + \cdots$$
$$= \frac{2}{3^{(n/2)+1}} \left(1 + \frac{1}{3} + \frac{1}{3^2} + \cdots \right)$$
$$= \frac{2}{3^{(n/2)+1}} \times \frac{3}{2} = \frac{1}{3^{n/2}}$$

since the absolute difference between any pair of ternary digits is at most 2. As $b \to a$, so $f_x(b) \to f_x(a)$ and the function f_x is indeed continuous.

So, the Peano function is surjective and continuous: it cannot, then, be injective, and this is easy to establish.

Table 6.1. Possible numerators.

a_i	0	1	2
β_i	1	0	1
$k^{\text{even}}a, k^{\text{even}}\beta$	0,1	1,0	2,1
$k^{\text{odd}}a, k^{\text{odd}}\beta$	2,1	1,2	0,1

Non-injectivity

Suppose that $f(s) = f(t)$, where $s = 0_3 s_1 s_2 s_3 \ldots$, $t = 0_3 t_1 t_2 t_3 \ldots$, then

$$0_3 s_1 (k^{s_2} s_3)(k^{s_2+s_4} s_5)(k^{s_2+s_4+s_6} s_7) \cdots$$
$$= 0_3 t_1 (k^{t_2} t_3)(k^{t_2+t_4} t_5)(k^{t_2+t_4+t_6} t_7) \cdots .$$

So, $s_1 = t_1$ but (for example) $k^{s_2} s_3 = k^{t_2} t_3 \rightarrow s_3 = k^{s_2+t_2} t_3$, which means that these may be different and the same image point can originate from more than one object point.

Non-differentiability

The last line of Peano's paper is a statement without proof: that the two coordinate functions, although everywhere continuous, are nowhere differentiable. Perhaps we shall never know how he convinced himself of the fact and the mathematical world had to wait ten years for the first proof to appear, when, in 1900, E. H. Moore approached matters in a novel manner – the details of which we shall reserve for the next section. Here we choose to take a more direct but equally elegant approach (Sagan 1994). To establish this non-differentiability, we only need, for any arbitrary point $a \in I$, to manufacture a sequence that approaches a but for which the differential quotient has no limit (as we did with Weierstrass's curve in chapter 2). To this end, we take a fixed point $a = 0_3 a_1 a_2 a_3 \cdots a_{2n} a_{2n+1} a_{2n+2} \cdots \in I$ and a variable point $b = 0_3 a_1 a_2 a_3 \cdots a_{2n} \beta_{2n+1} a_{2n+2} \cdots \in I$, where $\beta_{2n+1} = (a_{2n+1} + 1) \bmod 2$. That is, the two points differ only in the $(2n+1)$st place, resulting in $|a - b| = 1/3^{2n+1}$ and $b \xrightarrow{n \to \infty} a$. Again, consider the modulus of the difference between f_x applied to a and to b, which is the expression

$$|f_x(a) - f_x(b)| = \frac{|k^{a_2+a_4+a_6+\cdots+a_{2n}} a_{2n+1} - k^{a_2+a_4+a_6+\cdots+a_{2n}} \beta_{2n+1}|}{3^{n+1}}$$
$$= \frac{1}{3^{n+1}}.$$

This last step is justified by table 6.1, which shows that the numerator is always 1.

Consequently,

$$\left| \frac{f_x(a) - f_x(b)}{a - b} \right| = \frac{1}{3^{n+1}} \times 3^{2n+1} = 3^n \xrightarrow[n\to\infty]{} \infty,$$

and we have our required result.

6.3 Hilbert's Curve

We have reached the third section of a chapter of a book devoted to curves without the word "curve" appearing. Peano's paper contains no curve and hints at none, with his approach concentrating solely on the analytic argument we have provided, yet that paper was read by a German prince of mathematics in the person of David Hilbert. We are wise not to attempt a representative thumbnail sketch of the man whom G. H. Hardy considered worthy of 80/100 on his informal scale of natural mathematical ability, in which he graded himself 25/100.[4] Hilbert penetrated the detail of Peano's paper and in 1891 exposed its essential geometric nature through his own variant, which he defined entirely geometrically and which carries the name of the *Hilbert curve*: the first ever space-filling curve to be explicitly given. Actually, his approach began with a drawing of the curve, or, more precisely, the first three iterations of it, as part of a two-page article in which he contrasted his methods with those of Peano (Hilbert 1891). Figure 6.1 reproduces his diagram from this article, and it is our purpose to develop it into modern form.

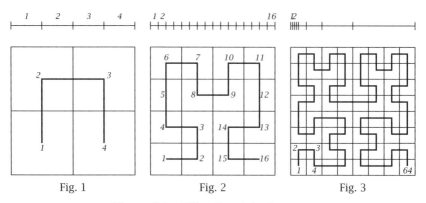

Fig. 1 Fig. 2 Fig. 3

Figure 6.1. Hilbert's original curves.

[4] His long-term collaborator, J. E. Littlewood, was given 30/100, and the genius Ramanujan, with whom they so famously worked, 100/100.

Hilbert's methodology may be summarized as follows. Suppose that the unit interval *I can* be mapped onto the unit square *S*, then the partition of *I* into four congruent subintervals and *S* into four congruent subsquares allows such a mapping to be recursed, moreover, with adjacent subintervals mapped to adjacent subsquares in a manner to ensure continuity. The process may be repeated indefinitely, and in the limit the continuous curve fills the square, joining $(0,0)$ to $(1,0)$. The procedure repeatedly joins the centres of ever-smaller subsquares by straight lines of ever-smaller lengths, oriented to ensure continuity at each stage. Once started, this continuity requirement renders the process unique. We will follow Hilbert and consider the first three stages of the curve's propagation in detail, with the trend then (we hope) clear.

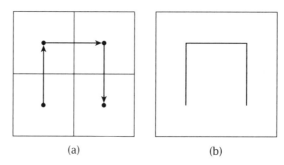

(a) (b)

Figure 6.2. The first stage of the Hilbert curve.

Stage 1

Divide the square into four congruent subsquares, locate their centres and join them in the order shown in figure 6.2(a), to yield the first iteration of the curve that is figure 6.2(b).

We have a simple route joining the centres of the four subsquares, beginning and ending as required. Now we elaborate on it, moving the extreme points ever closer to the bottom corners.

Stage 2

Divide the bottom-left subsquare into four further congruent subsquares, locate their centres and, beginning with the bottom-left subsquare (thereby moving the centre closer to the point $(0,0)$), join these centres in the only way possible to ensure that each is visited once and that the route leaves at the top, to ensure continuity, as indicated in figure 6.3(a). Repeat this for the other three subsquares in turn, starting

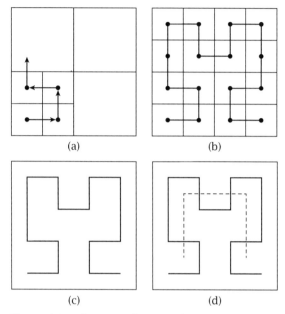

Figure 6.3. The second stage of the Hilbert curve.

as one must and leaving to ensure continuity. The result is figure 6.3(b), which is tidied to figure 6.3(c), the second stage of the Hilbert curve, with figure 6.3(d) being this stage with the previous stage superimposed as a dotted line.

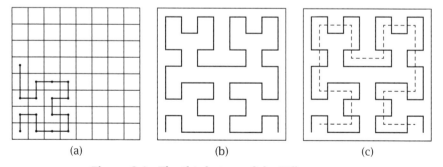

Figure 6.4. The third stage of the Hilbert curve.

Stage 3

The bottom-left subsquare is divided into four congruent subsquares, their centres located and the route from the bottom-left of them exits right to the next subsquare, which exits up to the next, which exits left

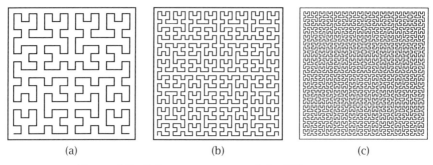

Figure 6.5. Subsequent stages of the Hilbert curve.

to the next, which exits up to the new subsquare, shown in figure 6.4(a). Complete this to generate figure 6.4(b), the third stage of the Hilbert curve, with figure 6.4(c) once again this stage with the previous stage superimposed.

We hope that the process is now clear and that parts (a)-(c) of figure 6.5, which show the subsequent three stages of the curve, come as no surprise.

We have, then, a purely geometric process that generates an ever more densely packed curve that is progressively expanding to the edges of the original square. Where, though, is that function from the unit interval to that unit square? Hilbert's own explanation (in translation and referring to his original figures above) is as follows:

> We take a line segment of length 1 and divide it up into 4 pieces of equal length. We then take a unit square and divide it by means of two perpendicular lines into 4 equal quadrants marked 1, 2, 3, 4 (Fig. 1). Next, we divide each piece on the line segment into four equal pieces, yielding 16 pieces; at the same time, we also divide each of the quadrants into equal quadrants, and write the numbers $1, 2, 3, \ldots, 16$ in the 16 resulting quadrants, where the ordering of the quadrants is to be chosen so that each quadrant shares a side with its predecessor (Fig. 2). If we take this process further – Fig. 3 illustrates the next step – it can easily be seen that to each point on the line, we can assign a singular point in a quadrant. All we need to do is to mark the piece of the segment that contains the point. The quadrants with the same numbers lie necessarily within each other and enclose in the limit a point of the unit square.

Hilbert's phraseology demands more faith than understanding from the reader, and we look to the contribution of E. H. Moore (1900) and his presentation to the American Mathematical Society on 25 August 1899 for illumination. For clarity we divide his approach into two parts.

Construction

Let $I = \{t: 0 \leqslant t \leqslant 1\}$ be the unit interval and let $S = \{(x,y): 0 \leqslant x, y \leqslant 1\}$ be the unit square. For each positive integer n we partition I into 4^n equal subintervals each of length 4^{-n} and S into 4^n equal subsquares each of side 2^{-n}. First, for each n we construct a one-to-one correspondence between the subintervals of I and the subsquares of S, which is subject to two conditions.

Adjacency. Adjacent subintervals correspond to adjacent subsquares (that is, squares with a side in common).

Nesting. If, on the nth partition, the interval I_n corresponds to the square S_n, then on the $(n + 1)$st partition of I, the four subintervals of I_n correspond to the four subsquares of S_n.

Conclusion

The above correspondence determines a unique function $f: I \rightarrow S$, which we now prove.

If $t \in I$ is never an end point of any of the subintervals, then t belongs to a nested sequence of closed subintervals $\{J_1 \supset J_2 \supset J_3 \supset \cdots\}$ the lengths of which approach 0. The corresponding sequence of closed, nested squares $\{T_1 \supset T_2 \supset T_3 \supset \cdots\}$ have diameters which also approach 0 and therefore approach a unique point $s \in S$: define $f(t) = s$.

The end points of I, where $t = 0$ and $t = 1$, are associated with the bottom left corner and the bottom right corner of S, respectively.

If $t \in I$ is an internal point common to two adjacent subintervals J_n and J_n^1 for some n, then it is common to two adjacent subintervals J_m and J_m^1 for all $m \geqslant n$ and must therefore belong to two nested subinterval sequences $\{J_n \supset J_{n+1} \supset J_{n+2} \supset \cdots\}$ and $\{J_n^1 \supset J_{n+1}^1 \supset J_{n+2}^1 \supset \cdots\}$, which correspond to two nested sequences of squares both of which determine the same point $x \in S$ (the squares are adjacent and their diagonals approach 0): define $f(t) = s$.

This, then, is the Hilbert curve defined as a function from the unit interval to the unit square. Next, we address those properties of it.

Surjectivity

We have produced a single-valued function $f: I \rightarrow S$. We must show that this function is onto. Each $s \in S$ lies in (at least) one sequence of closed nested squares that shrink to the point s. The corresponding sequence of nested closed intervals shrink to a point $t \in I$ for which $f(t) = s$.

Continuity

We take two points of I that are arbitrarily close and make this precise by requiring that $|t_1 - t_2| < 4^{-n}$. It must be the case that t_1 and t_2 lie in the same subinterval or in two adjacent subintervals of the nth partition. The corresponding images must at worst lie in two adjacent squares forming a rectangle having sides of length 2^{-n} and 2×2^{-n}, which means that $|f(t_1) - f(t_2)| < \sqrt{5} \times 2^{-n}$; the corresponding image points are therefore arbitrarily close and the function is continuous.

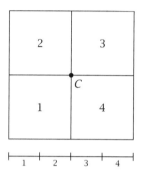

Figure 6.6. Non-injectivity.

Non-injectivity

Suppose in the nth partition that a subsquare S_n with centre C corresponds to a subinterval I_n. Now move to the $(n + 1)$st partition of this subsquare and its corresponding subinterval, as shown in figure 6.6, where the numbers indicate the order of the correspondence of the resultant subsquares and subintervals. There is a nested sequences of subsquares all lying in subsquare 1 that shrink to P, and the corresponding sequence of subintervals are shrinking to a point t in subinterval 1 of I_n. There is also a nested sequences of subsquares lying in squares 3 and 4 that shrink to C, with the corresponding sequence of subintervals shrinking to points t_3 and t_4, neither of which can equal t. This means that there are at least two distinct points in I that map to C, and with this argument holding in every square in every partition, the curve has infinitely many multiple points.

We can also easily deal with the curve's non-differentiability.

Non-differentiability

Once again, the proof is for the x coordinate function $f_x(t)$, with the y coordinate dealt with in exactly the same manner. For an arbitrary

$t \in I$, we manufacture a sequence $t_n \in I$ so that $|t - t_n| \xrightarrow[n \to \infty]{} 0$, yet the difference quotient diverges. To this end, consider a sequence of sixteen contiguous subintervals of I (each of length 4^{-n}) that contain t and that map to the 4×4 subsquare composed of sixteen subsquares each of side 2^{-n}. Wherever t is located in I, and therefore whichever subsquare $f(t)$ is located in, t_n may be chosen so that $f(t_n)$ lies in a subsquare so that they are separated by at least one subsquare of side 2^{-n}; consequently,

$$|f_x(t) - f_x(t_n)| > 2^{-n}$$

and

$$\left| \frac{f_x(t) - f_x(t_n)}{t - t_n} \right| > \frac{2^{-n}}{16 \times 4^{-n}} = \frac{2^n}{16} \xrightarrow[n \to \infty]{} \infty.$$

Our treatment of Hilbert's space-filling curve and the function that generates it is complete. This book is, though, about curves, and we lack the geometric form of Peano's space-filling function – something that Hilbert surely extracted from that abstract construction to form the basis of his own. It is this geometric form that will attract our final attention.

6.4 Peano's Curve

As a problem in curve plotting we are dealing with a rather complicated example. Referring back to Peano's construction, our first step identifies the curve's end points: since $f(0) = (0,0)$ and $f(1) = f(0_3 2222\ldots, 0_3 2222\ldots) = (1,1)$; the curve starts at the bottom left and finishes at the top right of the unit square.

Now observe that, for arbitrary values of the letters,

$$f(0_3 00 t_3 t_4 t_5 \cdots) = \begin{pmatrix} 0_3 0 \alpha_2 \alpha_3 \alpha_4 \cdots \\ 0_3 0 \beta_2 \beta_3 \beta_4 \cdots \end{pmatrix},$$

which means that the function maps the subinterval $[0, \frac{1}{9}]$ to the subsquare $[0, \frac{1}{3}] \times [0, \frac{1}{3}]$.

Similarly, since

$$f(0_3 01 t_3 t_4 t_5 \cdots) = \begin{pmatrix} 0_3 0 \alpha_2 \alpha_3 \alpha_4 \cdots \\ 0_3 1 \beta_2 \beta_3 \beta_4 \cdots \end{pmatrix},$$

the subinterval $[\frac{1}{9}, \frac{2}{9}]$ is mapped onto the subsquare $[0, \frac{1}{3}] \times [\frac{1}{3}, \frac{2}{3}]$ and the subinterval $[\frac{2}{9}, \frac{3}{9}]$ is mapped to the subsquare $[0, \frac{1}{3}] \times [\frac{2}{3}, 1]$, etc. In

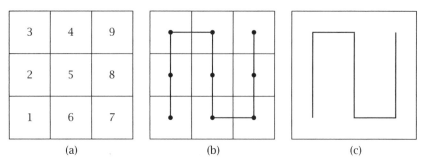

Figure 6.7. Constructing Peano's curve.

general, the subinterval $[\frac{1}{9}(n-1), \frac{1}{9}n]$ is mapped onto the subsquare n in figure 6.7(a). Since the curve is continuous, passes through each subsquare and starts and finishes as it does, the route must be as indicated in figure 6.7(b) with the first iteration as shown in figure 6.7(c).

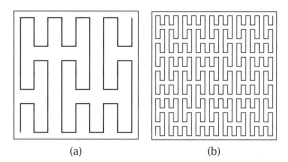

Figure 6.8. Developing Peano's curve.

The inevitable subdivision of the subintervals leads, in the same manner as the Hilbert construction, next to figure 6.8(a) and then figure 6.8(b), etc. And so the curve is recursively generated.

The initial horror that was felt by many mathematicians as the concept of dimension was called into question by Cantor's results and these curves was, as we have mentioned, to bring about a rigorous appraisal of some naively accepted ideas, and through this the new tools of topology were added to the mathematical chest. Vilenkin (1995) puts matters rather nicely:

> Everything had come unstrung! It's difficult to put into words the effect that Peano's result had on the mathematical world. It seemed that everything was in ruins, that all the basic mathematical concepts had lost their meaning.

In that they existed, these curves had served their mathematical purpose. Modern technology, though, has found modern uses for them, as it is inevitable that a space-filling curve has infinite length. In the case of the Hilbert curve, its length after the nth iteration may easily be seen to be $H_n = 2^n - 1/2^n$, and that of the Peano curve $P_n = 3^n - 1/3^n$. Since they are each contained in the unit square, they manifest themselves as a very efficient way of systematically packing a very long curve into a very small space: with $n = 10$, the Hilbert curve is over 1,000 times the length of the side of the containing square and the Peano curve nearly 60,000 times. And the nature of their continuity is special too. The essence of continuity of a function lies with the images of arbitrarily close points themselves being arbitrarily close; it is the nature of the Hilbert and Peano curves (and other such too) that points that are *quite* close in the unit interval also have their images *quite* close (mostly) in the square. In more technical language, *spacial locality* is preserved; that is, the curve "clusters". If we think of the visible light spectrum encoded in order along the unit interval, at any iteration the corresponding image may be seen as a skeletal path to which may be attached small squares shaded in the appropriate colour; squares that are contiguous would mostly have like colours. This property has manifold uses: building indexes for spacial databases, image processing, load balancing in parallel processing, numerical solution of partial differential equations, mapping chromosomes, etc., etc. All of which we must leave to the interested reader.

Curves of Constant Width

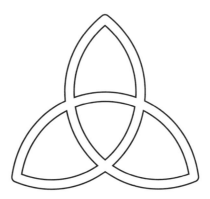

Why These Curves?

At first thought it is a surprise that they exist at all. The circle seems unique, yet it is merely the epitome of curves having constant width; in fact, there are an infinite number of essentially distinct examples of them. And they can be surprisingly useful and sometimes very beautiful: the above figure is a variant of the *triquetra* and derives from one of their kind. Furthermore, the study of curves of constant width naturally involves otherwise-disparate mathematical ideas: convex curve theory (including the addition of them), envelopes of curves and Fourier series. And they are naturally represented by a novel form of parametric equations. They also draw a surprising distinction between a roller and a wheel. For us, the only aspects of their story that do not elicit any surprise are that they were first studied by Leonhard Euler in the eighteenth century and that they were brought to popular attention by Martin Gardner (1991, chapter 18) two centuries later.

7.1 The Reuleaux Triangle ...

On 28 January 1986 the NASA space shuttle *Challenger* exploded
73 seconds into its flight, killing all seven crew members. The result-
ing Presidential Commission into the disaster included the late Nobel-
winning physicist Richard Feynman, who was to provide the world's
media with his famous "O-ring" demonstration of the catastrophic
effects of cold on a small but vital rubber component of the spacecraft.
His second autobiographical volume (Feynman 1988) includes much
detail relating to that commission and the role he played in it, and
below we have culled from it his thoughts relating to another possible
reason for the explosion:

> Then I investigated something we were looking into as a possible con-
> tributing cause of the accident: when the booster rockets hit the ocean,
> they became out of round a little bit from the impact. At Kennedy
> they're taken apart, and the sections – four for each rocket – are sent
> by rail to Thiokol in Utah, where they are packed with new propel-
> lant. Then they're put back on a train to Florida. During transport,
> the sections (which are hauled on their side) get squashed a little bit
> – the softish propellant is very heavy. The total amount of squash-
> ing is only a fraction of an inch but when you put the rocket sec-
> tions back together, a small gap is enough to let hot gases through:
> the O-rings are only a quarter of an inch thick, and compressed only
> two-hundredths of an inch!
>
> I thought I'd do some calculations. NASA gave me all the numbers on
> how far out of round the sections can get, so I tried to figure out how
> much the resulting squeeze was, and where it was located – maybe
> the minimum squeeze was where the leak occurred. The numbers
> were measurements taken along three diameters, every 60°. But three
> matching diameters won't guarantee that things will fit; six diameters,
> or any other number of diameters, won't do, either.
>
> For example, you can make a figure something like a triangle with
> rounded corners, in which three diameters, 60° apart, have the same
> length.
>
> I remembered seeing such a trick at a museum when I was a kid.
> There was a gear rack that moved back and forth perfectly smoothly,
> while underneath it were some noncircular, funny-looking, crazy-
> shaped gears turning on shafts that wobbled. It looked impossible, but
> the reason it worked was that the gears were shapes whose diameters
> were always the same.
>
> So the numbers NASA gave me were useless.

The young Feynman had evidently been shown the figure that is the
subject of this chapter and probably generalizations of it. Martin

Gardner (1991) laid emphasis on this dangerous aspect of misguided assumption with his own example:

> To give one example, it might be thought that the cylindrical hull of a half-built submarine could be tested for circularity by just measuring maximum widths in all directions. As will soon be made clear, such a hull can be monstrously lopsided and still pass such a test. It is precisely for this reason that the circularity of a submarine hull is always tested by applying curved templates.

Measuring equal diameters of a closed curve does not, they suggest, guarantee its circularity – nor does it: the circle is indeed the epitome of all curves of constant width, but the *Reuleaux triangle* is that of the non-circular variety.

Figure 7.1. Constrained rotational motion.

Franz Reuleaux's French surname is a reflection of his paternal Belgian heritage, and his German forename is a consequence of his birth in a German-speaking area close to what Germans would call Aachen and the French and English Aix la Chapelle. He was to personify a new type of scientist in the Victorian industrial age, that of the *engineer–scientist*, and one who was to rise to great eminence and influence, attracting the epithet "the father of modern kinematics". Yet, his name lingers only as an adjective describing a special curvilinear triangle: the Reuleaux triangle. The construction appears in chapter 3 of his 1875 book *The Kinematics of Machinery*, in which he considers restraints of turning, having earlier discussed restraints of linear motion. Using a simple diagram not unlike figure 7.1, he argued that the two pairs of parallel lines that touch the curve each determine its width in the direction mutually perpendicular to them, and unless this width is constant, the lines constrain rotational movement. Morph the random curve into a circle and the parallelogram into a rhombus or a square, and the constraints

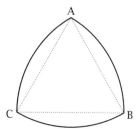

Figure 7.2. The basic Reuleaux triangle.

disappear, precisely because a circle has constant width. Yet he commented that "figures of constant breadth can easily be constructed of circular arcs", and he proceeded to do just that.

The construction was, of course, the now well-known Reuleaux triangle, which is formed from an equilateral triangle with three arcs of circles constructed on it, each centred on one vertex and passing through the other two, as shown in figure 7.2: a curve he called an *equilateral curve-triangle*.

That such a shape has constant width may either be deemed as obvious or can be made so by reasoning as follows.

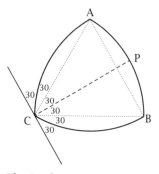

Figure 7.3. The Reuleaux triangle's constant width.

Hold the Reuleaux triangle stationary. The rigid T-shaped part of figure 7.3, which comprises the line passing through vertex C together with the dotted line perpendicular to it, can be imagined to rotate about C through an arc of 30° anticlockwise, to bring the points A and P into coincidence; starting again in its original position, it can then rotate through an arc of 30° clockwise to bring P into coincidence with B. For each position of P between these two extremes, the tangent to the arc of the circle AB at P will be perpendicular to the radius CP and so parallel to the line passing through C. This tangent and this line form the

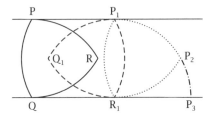

Figure 7.4. The Reuleaux roller.

pair of containing lines for the curve, the width between them being the constant radius of the circle. When this curvilinear triangle rolls, one of its vertices is always in contact with one of the two parallel lines containing it.

It is a curve whose elegant shape had attracted Leonardo da Vinci, since a world map comprising the eight octants of the globe, each flattened into the shape of a Reuleaux triangle, was found among his papers.[1] The shape appears frequently in architecture, both ancient and modern, both as a detail in stone and as a window or door. In some American cities, fire hydrant valves have been sealed by nuts in its shape to prevent unauthorised access, with ordinary spanners merely slipping around them – and guitar plectrums are routinely so shaped, as is this author's wife's ancient Hancock's tailors' marking chalk. All matters of interest, yet that elegant and useful shape assumes an essential importance when it is caused to move.

Transporting the great sarsen stones, each weighing about 25 tonnes, from the Marlborough Downs to the site of Stonehenge (about 20 miles distant) 2,500 years ago could only have been accomplished by use of felled trees acting as rollers, but the Bronze Age da Vinci might have contrived the shaping of the trunks into curvilinear cross-sections and Stonehenge would still have been built since, of its nature, such a roller would preserve constant distance between the level ground and the sarsen lying on top of it.

To reveal the kinematics of the motion, we track a vertex as the Reuleaux triangle rolls without slipping along a horizontal line, with the motion shown in figure 7.4. As we follow the path of the point $P \rightarrow P_1 \rightarrow P_2 \rightarrow P_3$ as the curvilinear wheel turns, it moves along the horizontal straight line from $P \rightarrow P_1$ since it is the centre of the circular arc QR; it moves in a circular arc from $P_1 \rightarrow P_2$ since the triangle is rotating about $R = R_1$; finally, it moves in a cycloidal arc from $P_2 \rightarrow P_3$ since

[1] To be found in the Royal Library, Windsor Castle. It is a matter of high controversy whether or not it was the work of da Vinci himself or of one of his students.

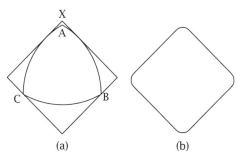

(a) (b)

Figure 7.5. Rotation within a square.

it is now a point on the circumference of a circle rolling on a straight line. The centre of mass, and all other points, will move in circular arcs as the triangle rotates on one of its vertices and in cycloidal arcs as it rolls along one of its circular arcs.

So, at once the motion is simple, just like a circle, but at the same time it is rather more complex and draws a distinction between a roller and a wheel: those sarsen stones would have moved just as readily on top of Reuleaux triangular rollers, but a flat-bed transporter with its four Reuleaux wheels would have its axles moving up and down as they turned, causing those great stones to be repeatedly raised and lowered.

So much, then, for the triangle's linear motion. If we refer back to Reuleaux's comment about constrained rotational motion, and consider figure 7.5(a), we have the Reuleaux triangle enclosed within a square of side the triangle's width within which it can rotate, keeping two vertices always in contact with the square's sides. The path of a vertex now comprises most of the four sides of the square, these joined together by what can be shown to be elliptic arcs as a vertex approaches the square's corners, as shown in figure 7.5(b). An unreached area therefore exists in all four corners, which, with a square of side 1 unit, can be shown to be of size $1 - \frac{\sqrt{3}}{2} - \frac{1}{24}\pi$, so the area covered by the rotating Reuleaux triangle is

$$1 - 4\left(1 - \frac{\sqrt{3}}{2} - \frac{\pi}{24}\right) = 2\sqrt{3} + \frac{\pi}{6} - 3 = 0.9877\ldots,$$

which means that 98% of the area of the unit square is traversed compared with the same calculation for the rotating circle, which of course occupies $\frac{1}{4}\pi = 0.7853\cdots = 79\%$ of the square. With this the reader will see that the Panasonic company has a point with its design of the *Rulo* robotic vacuum cleaner.

For what is surely the most surprising use to which the revolving Reuleaux triangle has been put we should look to an advertising leaflet:

> We have all heard about left-handed monkey wrenches, fur-lined bath-
> tubs, cast-iron bananas. We have all classed these things with the
> ridiculous and refused to believe that anything like that could ever
> happen, and right then along comes a tool that drills square holes.

The advertisement was on behalf of the Watts Brothers Tool Works
since, in 1917, Harry Watts, an English engineer living in Turtle Creek
Pennsylvania, patented[2] a drill bit he had invented in 1914: one which
drills square holes, using a modified Reuleaux triangle for its shape.
Some engineering perspicuity was needed to deal with the elliptic gap
mentioned earlier, which is easily measured by AX = $h(\sqrt{2} - \frac{1}{2} - \frac{\sqrt{3}}{2})$ in
figure 7.5(a); also, the roaming centre of mass, tracing the path of four
identical elliptical arcs, had to be overcome. Overcame these problems
were and square holes were drilled – and still are.

This paradigm of curves of constant width may be thought of as an
extreme case: its vertex angle is $120°$ and no curve of constant width
can have a vertex angle less than this, and of all curves of a particular
constant width, the circle has the largest area and the Reuleaux triangle
the smallest (of $\frac{1}{2}w^2(\pi - \sqrt{3})$ for a width of w).

With this, we leave this principal curve of constant width, admirable
for its simplicity, elegance and usefulness, and without considering the
many other areas in which it appears. Manhole covers are often cited
as a sound use of them since, like the circular disc, they are safe from
falling into the space they protect; the unlikely-sounding Cambridge
Soundworks OontZ speakers are in their shape; dream catchers are
formed in their shape; film advance mechanisms use their rotational
properties; they appear in fiction[3] and in chemical research (Ng and
Fan 2014). And a pencil on this author's desk is shaped as a Reuleaux
triangle to discourage it falling off, with its centre of mass rising higher
than the hexagonal non-circular alternative, should it be caused to roll.
We finish, though, with a common misnomer: just as a pure Reuleaux
triangle cannot drill square holes, so the design of the Wankel rotary
motor does not include it precisely, but in a slightly flattened form.

7.2 ...And Its Generalizations

With the idea of constructing circular arcs on the sides of an equilateral
triangle in place, the obvious extension (as Reuleaux pointed out) is to

[2] US patent "Drill or Boring Member", numbers 1,241,175/6/7, dated 25 September
1917.

[3] See, for example, Poul Anderson, *Three Cornered Wheel.*

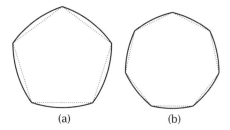

Figure 7.6. Two further curves of constant width.

repeat the process with further regular polygons, necessarily having odd numbers of sides. Figure 7.6(a) shows the result for the pentagon and 7.6(b) the heptagon, respectively, and for the same reason as before the curves are each of constant width.

The British 20 and 50 pence pieces, the Irish 50 pence piece, the Jamaican dollar and the 50 fils coin of the UAE are each in the shape of the heptagonal Reuleaux figure; the shape of the Canadian loonie is its 11-sided variant (so, based on the regular hendecagon).

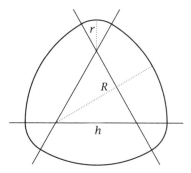

Figure 7.7. An extended equilateral Reuleaux triangle.

Furthermore, we can amend the basic construction: using the equilateral triangle that is part of figure 7.7, for example.

We start once more with an equilateral triangle of side h and extend its sides to form containing lines for its exterior angles. At each vertex we draw a major arc of some chosen fixed radius R between the two corresponding containing lines. Again, for each vertex draw a minor arc of radius $r = R - h$ between the corresponding containing lines. The arcs must join, and we have a curve of constant width $R + r$, since a tangent at any point carried through the figure to the opposite arc must travel a distance of $R + r$.

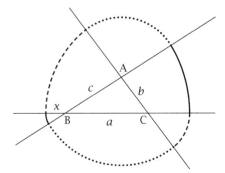

Figure 7.8. A scalene Reuleaux triangle.

If we are content to abandon symmetry, we can start with a scalene triangle as in figure 7.8 and draw circular arcs at each vertex, again between the containing lines, according to a prescription for radii that is easily derived and that generates a curve of constant width $a+c-b+2x$, where the first arc has radius x and we have taken it to be centred at vertex B:

$$
\begin{array}{llll}
\text{A:} & r = a + x - b, & R = c + x, \\
\text{B:} & r = x, & R = a + c - b + x, \\
\text{C:} & r = c + x - b, & R = a + x.
\end{array}
$$

And this is no more than a special case of multiply intersecting straight lines. Figure 7.9 has four such intersecting at five points, four of which are numbered; the fifth will not, for us, be needed. The two intersecting lines that generate each numbered intersection point enclose two regions that are labelled with the same number. We start at point 1 and draw a circular arc of any chosen radius between the two lines. Continue to points 2, 3, 4 in order, drawing circular arcs so that the lengthening curve is continuous. Repeat the procedure, drawing the arcs in the opposite regions.

If we let the lengths of the three parts of line L be x, y, z, it takes no more than a little length-chasing (and a few temporary labellings of other segment lengths) to show that all four line segments are of length $x + y + z$ and so the curve is necessarily of that constant width.

Finally, we discuss what is almost certainly their first appearance as a mathematical entity and in Euler's shortest publication: an anonymous entry of eight lines in the journal *Nova Acta Eruditorum* entitled

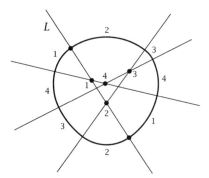

Figure 7.9. The general case.

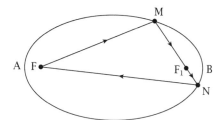

Figure 7.10. A catoprix.

"A problem of geometry proposed publicly by an anonymous geometer" (Euler 1745, p. 523, E79).[4] The Latin original bears the translation, where we refer to figure 7.10:

> Given a point F, to find all curves $AMBN$ such that any ray starting from F, after two reflections at M and N will return to the point F. The first among such curves are ellipses with a focus at F. Yet, there are innumerable other curves which possess this property the study of which extends the limits of analysis.

The reflective property of the ellipse makes evident that they are indeed examples of such curves: let F be one focus and M an arbitrary point on the ellipse, the ray emanating from F and reaching M will reflect through the second focus, F_1, with its continuation meeting the ellipse at N and necessarily reflecting back to F. Euler was to term a curve having this property a *catoprix*, with its plural of *catoptrices* (from the Greek for mirror).

To whatever extent the challenge was met by others, it succumbed to Eulerian analysis through a series of papers,[5] the third of which

[4] Probably posed to Euler by Christian Goldbach.
[5] E85, 106, 513.

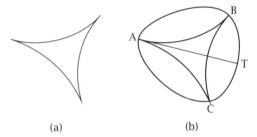

(a) (b)

Figure 7.11. The deltoid and its construction.

brought his interest into coincidence with ours. Almost precisely a century before Reuleaux published his book containing a study of his triangle (and much more besides), Euler had, on 12 May 1774, read *De curvis riangularibus* ("On triangular curves") to the St Petersburg Academy, later to be published[6] as the third paper mentioned above. The triangular curves to which Euler referred are the likes of figure 7.11(a), known as *tricuspoid astroids* or more simply *deltoids*, and he used them to generate curves of constant width, not as an end in itself, but as a staging post in his search for catoptrices. And for this he utilized the *involute* of a curve.

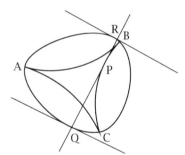

Figure 7.12. An orbiform.

A standard way of visualizing a curve's involute is to imagine attaching a piece of cotton of length arc AB to cusp A in figure 7.11(b) and cause it to lie along that arc. Keeping the cotton taught, unwind it and trace the path of its free end as it unwinds; that path is the curve's involute. In the figure, the arc BT of the involute will have been traced, to complete to the arc BC as we reverse the process by progressively wrapping the cotton along arc AC. Repeat with the other two cusps and

[6] In 1778, first in *Acta Acedmiae Scientarum Petropolitinae*, pp. 3–30.

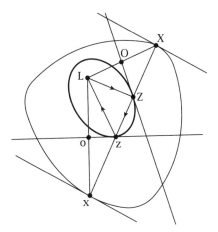

Figure 7.13. An orbiform constructed.

the involute is complete, with Euler coining another term for this partic-
ular involute: an *orbiform*, since, like the circle, he recognized that they
have constant width. The justification for which is reasonable enough.
Referring to figure 7.12, as the cotton unwinds from two vertices, each
point P on the deltoid determines two points Q and R on the orbiform,
with the straight line distances equal to the curved distances and so
PQ = PC and PR = PB. Since at any instant the straight line portion
of unwinding cotton is tangent to the deltoid, line QPR is straight and
tangent at P and, consequently, distance QR = PQ + PR is the length
of the cotton and so constant. Since PQ and PR are instantaneous radii
of rotation, centre P, the line QPR is perpendicular to both enclosing
tangents to the orbiform and so QR is the curve's width.

With the orbiform thus established, Euler now provided what we
believe is the first application of a curve of constant width: they gener-
ate catoptrices. His brief comments are confined to the few lines of the
paper that are its section 5, accompanied by a diagram of which our
figure 7.13 is a variant but which uses his nomenclature.

The rather complicated-looking collection of lines can be dissected
into the orbiform with its two opposite tangents and diameter together
with an arbitrary point L contained within it: this is the focal point from
which the light is emitted and, after two reflections in the constructed
catoprix, received back. Of the detail of the construction, Euler is at
pains with his clarity, and we provide the following bulleted translation.

- Join L to the two opposite points X, x on the orbiform.
- Form the perpendicular bisector of LX at O and similarly Lx at o.

- Label the points where these lines meet Xx as Z and z, respectively. These are two points on the catoprix, which is shown bold in our figure.
- Form the triangle LZz to determine the required path.

Of the justification, he is very much more sanguine, commenting that the proof is not difficult but that he hoped to be forgiven for not including it since he did not want consideration of the matter to be excessively drawn out. Yet, there *is* much to prove. First, that a smooth closed curve is generated at all; second, that the lines OZ and oz are tangents to it – all of which we leave to the interested reader.

We are now done with these purely geometric ways of generating curves of constant width but before we leave this section, those curves that we have generated can be used to generate further such curves by the process of the "addition" of convex regions, since there is a particular notion for their sum, attributed to the Russian–German mathematician Hermann Minkowski and so termed *Minkowski sums*; they are formed as follows.

Take two convex regions in the plane, R_1, R_2, which include their bounding convex curves C_1, C_2. Relative to an arbitrary origin O consider the position vector r_1 of an arbitrary point in R_1 and similarly r_2 in R_2; form the vector sum $r_1 + r_2$, the position vector of the sum of the two points, and define

$$R_1 + R_2 = \{\text{set of points in the plane with position vectors } r_1 + r_2\}.$$

In other words, find the sum of the two regions by taking each point in R_1 and adding its position vector to that of every point of R_2. The sum is the set of parallel translates of one region by position vectors of every point in the other region. From this, define the sum of the two convex curves $C_1 + C_2$ to be the bounding curve of $R_1 + R_2$. It is wise to note that this is not the same as adding the two bounding curves, for example, adding two line segments emanating from the origin would result in a parallelogram, not a curve. The general theory underlying this addition has three results that are of interest to us.

- The sum of two convex figures is convex.
- The sum remains invariant under change of origin and parallel displacement of the summands, which merely bring about a parallel displacement of the resulting figure. (Rotation of the summands is quite a different matter.)

- The width of the sum of two curves is the sum of the widths of the individual curves in the same direction.

So, if two curves have constant width, then their sum also has constant width, and we can use this fact to generate new constant-width curves from those we have already constructed; in fact, the example that is figure 7.7 actually adds a Reuleaux triangle to a circle.

With all of this discussion we have generated an infinite number of curves of constant width through geometry; we can generate still more by approaching matters analytically.

7.3 And Their Generalization …

We begin this section with a problem in elementary coordinate geometry: what is the equation of the straight line that is perpendicular to a given line segment and that passes through its end point? Figure 7.14 sets up the problem, where the segment has one end at the origin and the other at the point $P(p \cos \theta, p \sin \theta)$; its length is, therefore, p, and it is inclined at an angle θ to the positive x-axis.

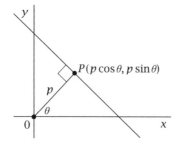

Figure 7.14. Elementary geometry.

The slope of the line segment is $\tan \theta$ and so that of the required line is $-\cot \theta$, which makes its equation $y - p \sin \theta = -\cot \theta (x - p \cos \theta)$, which simplifies to $x \cos \theta + y \sin \theta = p$.

If we now allow p to vary with θ, we have the functional relationship $x \cos \theta + y \sin \theta = p(\theta)$ and a family of straight lines parametrized by θ.

Next, we move to the curves that are given the broad name of "ovals", for which the image of an egg is useful, although, as we shall see, not always accurate. Figure 7.15 serves as a generic picture of such a curve, which is necessarily closed and convex; that is, for any two points contained within it (or on it), the straight line joining them is also contained

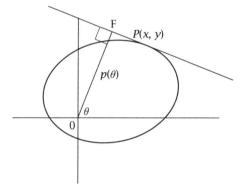

Figure 7.15. An oval.

within it. It is also sufficiently smooth to have a well-defined tangent at each point. Without loss of generality, we will assume that the origin is contained within it.

The role of our earlier line is that of a tangent to the curve, with the length of the perpendicular line segment, $p(\theta)$, given the name of the *support function* of the curve: a function of θ that is periodic with period 2π. It is in terms of this support function that we can devise a novel form of parametric equations for such a curve.

The curve is the envelope of its tangents (see appendix D), and to derive its equation we consider

$$F(\theta, x, y) = x \cos \theta + y \sin \theta - p(\theta)$$

and differentiate with respect to θ to get

$$\frac{\partial F}{\partial \theta} = -x \sin \theta + y \cos \theta - p'(\theta) = 0.$$

The equations of the envelope are, then,

$$-x \sin \theta + y \cos \theta = p'(\theta),$$
$$x \cos \theta + y \sin \theta = p(\theta),$$

which readily solve to the parametric form

$$x = p(\theta) \cos \theta - p'(\theta) \sin \theta,$$
$$y = p(\theta) \sin \theta + p'(\theta) \cos \theta.$$

Any choice of a differentiable $p(\theta)$ will yield a curve, which in general will hardly be expected to be convex and, unless it is periodic, not

(a) (b)

Figure 7.16. A bow tie and an asteroid.

closed. For example, $p(\theta) = \cos^2 \theta$ yields the bow tie of figure 7.16(a) and $p(\theta) = \sin \theta \cos 2\theta$ the curvilinear triangle of figure 7.16(b), which we know is at least a generator of a curve of constant width.

Of course, the support function relates to the width of our oval, defined (as ever) as the perpendicular distance between two parallel tangents and so by the function

$$w(\theta) = p(\theta) + p(\theta + \pi),$$

and if this width is constant, we seek support functions for which

$$p(\theta) + p(\theta + \pi) = \alpha$$

for some positive constant width α.

A little detective work results in a little progress. The support function should be differentiable of period 2π and so sin and cos continue to suggest themselves and, with a little imagination, in their role in the most famous of trigonometric identities: $\cos^2 \theta + \sin^2 \theta = 1$. With this motivation, we take $p(\theta) = \alpha \cos^2(k\theta)$ for some constant k. We require $p(\theta + \pi) = \alpha \cos^2(k\theta + k\pi) = \alpha \sin^2(k\theta)$, and so

$$\cos(k\theta + k\pi) = \pm \sin(k\theta) \rightarrow k = \tfrac{1}{2}(2n + 1), \quad n = 0, 1, 2, \ldots.$$

If we begin with $n = 0$ and so $p(\theta) = \alpha \cos^2 \tfrac{1}{2}\theta$, we have a form highly reminiscent of our bow-tie generator, yet that factor of $\tfrac{1}{2}$ has considerable influence, since

$$x = \alpha \cos^2 \tfrac{1}{2}\theta \cos \theta + \alpha \sin \tfrac{1}{2}\theta \cos \tfrac{1}{2}\theta \sin \theta$$
$$= \tfrac{1}{2}\alpha(1 + \cos \theta) \cos \theta + \tfrac{1}{2}\alpha \sin^2 \theta = \tfrac{1}{2}\alpha(1 + \cos \theta),$$
$$y = \alpha \cos^2 \tfrac{1}{2}\theta \sin \theta - \alpha \sin \tfrac{1}{2}\theta \cos \tfrac{1}{2}\theta \cos \theta$$
$$= \tfrac{1}{2}\alpha(1 + \cos \theta) \sin \theta - \tfrac{1}{2}\alpha \sin \theta \cos \theta = \tfrac{1}{2}\alpha \sin \theta.$$

Scaling by α, the Cartesian equation is that of the circle:

$$(x - \tfrac{1}{2})^2 + y^2 = \tfrac{1}{4}.$$

Not much progress, then, but undaunted we try the next case with $n = 1$ and so $p(\theta) = \alpha \cos^2 \frac{3}{2}\theta$ to yield the excellent curve that is figure 7.17, which challenges the very idea of width and is hardly convex.

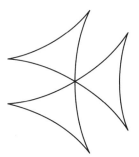

Figure 7.17. A curious curve.

The key to progress lies with our restrictive form of the support function, which could just as well be the more flexible $p(\theta) = \alpha \cos^2((n + \frac{1}{2})\theta) + \beta$, and experimenting with parameter values does indeed yield what we require: $n = 1$ with $\alpha = 2, \beta = 8$ or $\alpha = 10, \beta = 35$, etc., result in what we seek, with figure 7.18(a) and (b) respectively showing these two cases.

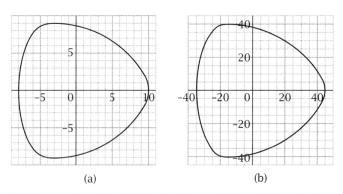

Figure 7.18. (a) $n = 1$, $\alpha = 2$, $\beta = 8$; (b) $n = 1$, $\alpha = 10$, $\beta = 35$.

Varying n varies the number of vertices: $n = 2$, $\alpha = 2$, $\beta = 25$ yields figure 7.19(a) and $n = 7$, $\alpha = 1$, $\beta = 25$ figure 7.19(b). They are all Reuleaux look-a-likes, and they are all imposters.

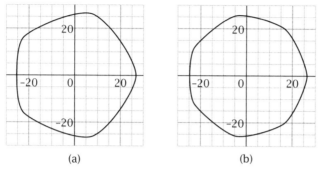

Figure 7.19. (a) $n = 2$, $\alpha = 2$, $\beta = 25$; (b) $n = 7$, $\alpha = 1$, $\beta = 25$.

The general case is approached using the double angle formula $\cos 2\theta = 2\cos^2 \theta - 1$, both to eliminate the fraction and also to convert a square to a multiple:

$$p(\theta) = \alpha \cos^2((n + \tfrac{1}{2})\theta) + \beta$$
$$= \tfrac{1}{2}\alpha[1 + \cos((2n + 1)\theta)] + \beta$$
$$= \tfrac{1}{2}a\cos((2n + 1)\theta) + \tfrac{1}{2}a + \beta.$$

In which case the parametric equations become

$$x = [\tfrac{1}{2}a\cos((2n + 1)\theta) + \tfrac{1}{2}a + b]\cos\theta$$
$$+ \tfrac{1}{2}(2n + 1)a\sin((2n + 1)\theta)\sin\theta,$$
$$y = [\tfrac{1}{2}a\cos((2n + 1)\theta) + \tfrac{1}{2}a + b]\sin\theta$$
$$- \tfrac{1}{2}(2n + 1)a\sin((2n + 1)\theta)\cos\theta,$$

which, after some wholesome if tedious trigonometric manipulations, take the form

$$x = \tfrac{1}{2}(n + 1)a\cos 2n\theta - \tfrac{1}{2}na\cos 2(n + 1)\theta + (\tfrac{1}{2}a + b)\cos\theta,$$
$$y = -\tfrac{1}{2}(n + 1)a\sin 2n\theta - \tfrac{1}{2}na\sin 2(n + 1)\theta + (\tfrac{1}{2}a + b)\sin\theta.$$

And we have the general form for a class of curves of constant width (for appropriate values of the parameters).

And that support function is special of its kind. Consider

$$p(\theta) = \sum_r a_r \cos((2r + 1)\theta) + b,$$

then

$$p(\theta) + p(\theta + \pi)$$
$$= \sum_r a_r \cos((2r+1)\theta) + b + \sum_r a_r \cos(2r+1)(\theta+\pi) + b$$
$$= \sum_r a_r \cos((2r+1)\theta) + b + \sum_r a_r \cos[(2r+1)\theta + (2r+1)\pi] + b$$
$$= \sum_r a_r \cos((2r+1)\theta) + b - \sum_r a_r \cos((2r+1)\theta) + b = 2b.$$

A curve of constant width (although not necessarily convex). We could have chosen the sine function instead, for which the above argument again holds, and then we could combine the two forms, for which the above argument once more holds, and so generate the form of support function

$$p(\theta) = \sum_r a_r \cos((2r+1)\theta) + \sum_r b_r \sin((2r+1)\theta) + b. \qquad (7.1)$$

In doing so we are taking a shallow dip into the deep theory of Fourier series: the support function is periodic and continuous, and if we require that its derivative is also continuous, the theory of Fourier series tells us that it can be represented as a (finite or infinite) sum of sines and cosines: that sum is precisely the above.

One last observation can be extracted and to this end we return to one of the cases above (where $n = 1$, $\alpha = 2$, $\beta = 8$). We have

$$x = 9\cos\theta + 2\cos 2\theta - \cos 4\theta = -3 + 9\cos\theta + 12\cos^2\theta - 8\cos^4\theta,$$
$$y = 9\sin\theta - 2\sin 2\theta - \sin 4\theta = \sin\theta(9 - 8\cos^3\theta).$$

The latter form of each equation once again resulting from standard trigonometric identities. Squaring the y equation brings in $\sin^2\theta$ and so $\cos^2\theta$ and we have a parametrization in the variable $\cos\theta$, which can in principle (and with a computer, in practice) be eliminated to yield a Cartesian equation, which in this case is the degree-8 polynomial

$$y^8 + 4x^2y^6 - 48xy^6 - 45y^6 + 6x^4y^4 - 80x^3y^4 + 441x^2y^4$$
$$+ 16632xy^4 - 41283y^4 + 4x^6y^2 - 16x^5y^2 - 519x^4y^2$$
$$+ 11088x^3y^2 - 82566x^2y^2 - 799146xy^2 + 7950960y^2$$
$$+ x^8 + 16x^7 + 19x^6 - 5544x^5 - 41283x^4 + 266382x^3$$
$$+ 7950960x^2 - 373248000 = 0,$$

which was generated in the blink of an eye: the skeptical but patient reader may choose to type the equation into a graph plotter – to achieve figure 7.18(a) once more. Of course, more complex choices of the support function, in terms of the number of trigonometric terms it involves in equation (7.1), yield even more complex polynomial forms. The simplest, in terms of degree, is the one we give above, with degree 8: it is known (Bardet and Bayen 2018) that if the last non-vanishing term has its multiple of θ in either the sin or cos term as $2N + 1$, the degree of the polynomial will be $4N + 4$.

7.4 A Circle in All but Name?

This last section is dedicated to a single property enjoyed by curves of constant width, which is also a fundamental characteristic of the circle: their circumference is π times their diameter (or width). The result is obvious in the special case of the Reuleaux figures: if such is generated by a regular polygon of n sides each of length r, the figure's circumference will be $n \times r \times 2\pi/n = 2\pi r$. It is the general nature of the result that is compelling, and to establish this we need a little more mathematical apparatus.

The name attached to the result we need is that of the tragic figure who was the Frenchman Joseph-Émile Barbier, a man who was to relinquish a promising position at the Paris Observatory, divorce himself from his friends and associates, and was later to be found, after fifteen years absence, as a patient in an asylum. His contribution to constant-width curves was achieved in 1860, long before his mental troubles were to emerge, and in the year in which he passed from being an outstanding student at a Paris lycée to being an entirely unsuccessful professor in another in Nice. His result, *Barbier's theorem*, can be stated as follows: a closed convex curve of constant width $w \geqslant 0$ has a perimeter of πw.

There are now various proofs available and we will choose one close to the original, which requires the support function parametrization and a little advanced high school calculus. We remind the reader of the parametrization

$$x = p(\theta) \cos \theta - p'(\theta) \sin \theta,$$

$$y = p(\theta) \sin \theta + p'(\theta) \cos \theta$$

and of the standard parametric expression for arc length of a curve:

$$s = \int_{\theta_1}^{\theta_2} \sqrt{\left(\frac{dx}{d\theta}\right)^2 + \left(\frac{dy}{d\theta}\right)^2}\, d\theta.$$

With these, we proceed quite naturally with

$$\frac{dx}{d\theta} = p'(\theta)\cos\theta - p(\theta)\sin\theta - p''(\theta)\sin\theta - p'(\theta)\cos\theta$$
$$= -(p(\theta) + p''(\theta))\sin\theta,$$
$$\frac{dy}{d\theta} = p'(\theta)\sin\theta + p(\theta)\cos\theta + p''(\theta)\cos\theta - p'(\theta)\sin\theta$$
$$= (p(\theta) + p''(\theta))\cos\theta,$$
$$\left(\frac{dx}{d\theta}\right)^2 + \left(\frac{dy}{d\theta}\right)^2 = (p(\theta) + p''(\theta))^2\sin^2\theta + (p(\theta) + p''(\theta))^2\cos^2\theta$$
$$= (p(\theta) + p''(\theta))^2.$$

Our limits are 0 and 2π and we notice that

$$w = p(\theta) + p(\theta + \pi) \rightarrow p(\theta + \pi) = w - p(\theta),$$
$$0 = p'(\theta) + p'(\theta + \pi),$$
$$0 = p''(\theta) + p''(\theta + \pi) \rightarrow p''(\theta + \pi) = -p''(\theta),$$

which means that

$$s = \int_0^{2\pi} p(\theta) + p''(\theta)\, d\theta$$
$$= \int_0^{\pi} p(\theta) + p''(\theta)\, d\theta + \int_{\pi}^{2\pi} p(\theta) + p''(\theta)\, d\theta,$$

and we let $u = \theta - \pi$ in the second integral to yield

$$s = \int_0^{\pi} p(\theta) + p''(\theta)\, d\theta + \int_0^{\pi} p(u + \pi) + p''(u + \pi)\, du$$
$$= \int_0^{\pi} p(\theta) + p''(\theta)\, d\theta + \int_0^{\pi} w - p(u) - p''(u)\, du$$
$$= \int_0^{\pi} p(\theta) + p''(\theta) + w - p(\theta) - p''(\theta)\, d\theta = \int_0^{\pi} w\, d\theta = \pi w.$$

We have Barbier's theorem proved. It is proper to note that the literature might also refer to it as *Mellish's theorem*, after the young Canadian mathematician Arthur Preston Mellish whose own life was also a tragedy, in that it was so short: he died in 1930, at the age of 25. After

his death his colleagues at Brown University examined his mathematical notes and prepared a paper based on them, which was published in the *Annals of Mathematics* in 1931 (Mellish 1931). These contain not only another proof of the result but also the equivalence of the following statements about an oval.

- It is of constant width.
- It is of constant diameter.[7]
- All of the normals are double.[8]
- The sum of the radii of curvature at opposite points is constant.

We have finished with a theorem of great beauty, which has shown itself susceptible to advanced high school mathematics, yet if we embrace Minkowski's addition of ovals it is quite obvious: it is not difficult to show that the sum of a curve of constant width with the same curve rotated through 180° is a circle of radius that width. The result is immediate.

[7] The *width* is the smallest distance between parallel tangents and the *diameter* the largest.

[8] That is, when there is meaning, a normal to the curve at one point meets the curve again at the opposite point, where it is again the normal to the curve.

The Normal Curve

Why This Curve?

Although the question "What is the most important statistical distribution?" should probably be avoided, if it is engaged the only reasonable answer is the *normal distribution*. It is of fundamental importance in its own right and the port of first call as an approximant to other distributions, both continuous and discrete, with the *central limit theorem* ensuring its ubiquity. Whether its curve reminds the reader of the cross-section of a bell, as it did the artillery officer, actuary and mathematician Esprit Pascal Jouffret in 1872, or the bicorne hat of the nineteenth-century French gendarmerie, as it did the statistician Francis Ysidro Edgeworth in 1888, it is a shape of fundamental importance in the vast and frequently vastly complicated world of statistical analysis. Its story has a natural separation into three parts and it is this observation that has guided our approach.

8.1 A Fruitful Question

The Scotsman Sir Alexander Cumming, 2nd Baronet of Culter (1690–1775), was at one time both a member of the Scottish bar and a captain in the Russian army; at another, the self-proclaimed and accepted king of the Cherokee nation, who enjoyed an audience with King George II at Windsor Castle, accompanied by seven Cherokee chiefs; at another, a defrauder of American settlers of large sums of money; then an

alchemist hoping to transmute base metals into gold; penultimately an inmate of London's debtors' prison of the Fleet; and finally, a poor brother of the charitable trust of the Charterhouse, wherein he died aged 85. He was also a Fellow of the Royal Society. Until, that is, he was ejected from the Fellowship for non-payment of its annual fee, at the time the only prerequisite for the aristocracy to have claim to the prestigious FRS appellation. The Society's *Transactions* are silent with regard to any scientific contribution from Cumming but it is clear that his contact with some of its membership was more than cursory: in particular, in 1721, the year after he was elected, he posed the following question on probability to one of its members:

> A and B playing together, and having an equal number of Chances to win one Game, engage to a Spectator S that after an even number of Games n is over, the Winner shall give him as many Pieces as he wins Games over and above one half the number of Games played, it is demanded how the Expectation of S is to be determined.

It is not unusual for clarity of meaning to be sacrificed as we travel back over the centuries; however, the problem is unraveled by considering the repeated tossing of a fair coin, with player A making the permanent selection of heads and player B tails. The deviation from the theoretical average of half heads and half tails over an even number of tosses is itself a random variable, the expected value of which is the goal. We have, then, a somewhat unfamiliar question concerning the very familiar binomial probability distribution. Through such luminaries as Pascal, Fermat, Huygens and Jacob I Bernoulli, the study of games of chance provided the means to advance the fledgling subjects of probability and statistics, and what are now referred to as Bernoulli or binomial trials were comparatively well understood and comparatively amenable to analysis. They are today the stuff of high school probability courses, with the most fundamental question associated with them the determination of the probability of any given number of successes in a fixed number of trials. Using modern notation, if the random variable X is the number of successes in n repetitions of the experiment, we write $X \sim B(n, p)$, where p is the constant probability of success in a single trial, and it was then known that

$$P(X = r) = \binom{n}{r} p^r (1 - p)^{n-r} \quad \text{for } r = 0, 1, 2, \ldots, n,$$

with

$$\binom{n}{r} = \frac{n!}{r!(n-r)!}$$

the entries of the famous Pascal's triangle.

In this variant, the winner may be either A or B (with equal probability), and so the expected gain to S is calculated as:

probability that A wins \times expected gain if A wins

\quad + probability that B wins \times expected gain if B wins.

The probabilities are each equal (to $\frac{1}{2}$) and the expected gains are each equal to the other: if A wins, we are interested in subtracting from $\frac{1}{2}n$ his winnings, ignoring the loss of B; and similarly the other way around. We can deal with the whole issue at one time using a modulus sign and as the following question:

If $X \sim B(n, \frac{1}{2})$, then what is the value of $E[S] = E[|X - \frac{1}{2}n|]$?

So, with the questioner and question and identified and the latter reframed in modern terms, we look to the identity of who was questioned, and to his elegant answer.

8.2 An Answer but Not a Solution

That Royal Society member to whom the question was posed was Abraham de Moivre, and in asking the question of him, Cumming could not have chosen a more fitting expert. Although contemporary study most readily links his name to the important staple of advanced high school mathematics known as *de Moivre's theorem*, that $(\cos\theta + i\sin\theta)^n = \cos n\theta + i\sin n\theta$, he was one of the pioneers of probability theory. His book *The Doctrine of Chance*, particularly in its (posthumous) third and final edition, is seminal to the early theory of probability, and in itself justifies de Moivre's high reputation in the subject's early development. In the view of the respected Isaac Todhunter (1865, p. 193):

> It will not be doubted that the Theory of Probability owes more to him than to any other mathematician, with the sole exception of Laplace.

Although de Moivre's approach to the Cumming's problem was to appear in the second and third editions of *The Doctrine of Chance*, the first written mention of it is in the 1730 summary of his research

over the preceding decade, a 250-page compilation entitled *Miscellanea Analytica de Seriebus et Quadraturis and Miscellaneis Analyticis Supplementum*: the miscellanea. It is at the start of chapter II of book V of this work that we learn that Cumming had posed the question to de Moivre back in 1721, and with the problem listed as problem 1, de Moivre developed his solution to it, which we reproduce below in modern, more complete, terms.

His result was that

$$E[S] = E[|X - \tfrac{1}{2}n|] = \frac{1}{2^n} \frac{n}{2} \binom{n}{\frac{1}{2}n},$$

and it was achieved first by a readjustment of the question and then through use of what we now call the *method of differences* for summing a series. To start,

$$E[|X - \tfrac{1}{2}n|] = \sum_{r=0}^{n} |r - \tfrac{1}{2}n| \times P(X = r)$$

$$= \sum_{r=0}^{n} |r - \tfrac{1}{2}n| \times \frac{1}{2^n} \binom{n}{r}$$

$$= \frac{1}{2^n} \times \sum_{r=0}^{n} |r - \tfrac{1}{2}n| \times \binom{n}{r}.$$

The readjustment was made by recalling that n is even and that the series, by dint of the modulus sign and the symmetry of the binomial coefficients, can be reduced to isolating the centre term and doubling the sum of the first half of the values to conclude that

$$E[|X - \tfrac{1}{2}n|] = 0 \times \binom{n}{\frac{1}{2}n} + 2 \times \frac{1}{2^n} \times \sum_{r=0}^{(n/2)-1} (\tfrac{1}{2}n - r) \times \binom{n}{r}$$

$$= 2 \times \frac{1}{2^n} \times \sum_{r=0}^{(n/2)-1} (\tfrac{1}{2}n - r) \times \binom{n}{r}.$$

The resulting series looks unpromising, but it can be summed by repeated use of the identity

$$(n - r + 1) \binom{n}{r - 1} - r \binom{n}{r} = 0$$

for $r = \tfrac{1}{2}n, \tfrac{1}{2}n - 1, \tfrac{1}{2}n - 2, \ldots, 1$ to arrive at

$$(n + 2) \binom{n}{\frac{1}{2}n - 1} - n \binom{n}{\frac{1}{2}n} = 0,$$

$$(n + 4) \binom{n}{\frac{1}{2}n - 2} - (n - 2) \binom{n}{\frac{1}{2}n - 1} = 0,$$

$$(n + 6) \binom{n}{\frac{1}{2}n - 3} - (n - 4) \binom{n}{\frac{1}{2}n - 2} = 0,$$

$$\vdots$$

$$(2n - 2) \binom{n}{1} - 4 \binom{n}{2} = 0,$$

$$2n \binom{n}{0} - 2 \binom{n}{1} = 0.$$

Repeatedly adding diagonally in pairs (top-left and bottom-right) results in

$$2 \left\{ 2 \binom{n}{\frac{1}{2}n - 1} + 4 \binom{n}{\frac{1}{2}n - 2} + 6 \binom{n}{\frac{1}{2}n - 3} + \cdots \right.$$

$$\left. + (n - 2) \binom{n}{1} + n \binom{n}{0} \right\} - n \binom{n}{\frac{1}{2}n} = 0$$

or

$$\frac{1}{2} n \binom{n}{\frac{1}{2}n} = 2 \binom{n}{\frac{1}{2}n - 1} + 4 \binom{n}{\frac{1}{2}n - 2} + 6 \binom{n}{\frac{1}{2}n - 3}$$

$$+ \cdots + (n - 2) \binom{n}{1} + n \binom{n}{0}$$

$$= 2 \times \sum_{r=0}^{(n/2)-1} (\tfrac{1}{2}n - r) \times \binom{n}{r}.$$

With this, the summation is completed and we may replace it in the expression for the expectation.

Pleasant though the result is, its application was necessarily limited to small values of n since, for large n, the expression involves the product of the immensely small $1/2^n$ and the immensely big

$$\binom{n}{\frac{1}{2}n},$$

the calculation of which at the time would have been infeasible. In his own words, de Moivre chose $n = 10{,}000$ and commented that the calculation "is not possible without labour nearly immense, not to say

impossible". We move forward, though, several pages, to a paragraph that in translation (Diaconis and Zabell 1991) reads:

> Because of this, the man I praised above asked me whether it was not possible to think of some method by which that term of the binomial could be determined without the trouble of multiplication or, what would come to the same thing in the end, addition of logarithms. I responded that if he would permit it, I would attempt to see what I could do in his presence, even though I had little hope of success. When he assented to this, I set to work and within the space of one hour I had very nearly arrived at the solution to the following problem.

We now look to the rather impressive fruits of de Moivre's hour of thought.

8.3 Approximating the Impossible

The man praiseworthy in de Moivre's eyes was, of course, Cumming, who, in 1730, would publicly be perceived worthy of praise; he had just returned from a visit to the Cherokee people of South Carolina, having brought those chiefs with him, and had been granted that audience with the king; by this time, though, his creditors were in ever closer pursuit. And it was as problem III of book V in the *Miscellanea* that de Moivre provided the unlikely statement that, for even n,

$$\frac{1}{2^n} \binom{n}{\frac{1}{2}n} \approx 2\frac{21}{125}\left(1 - \frac{1}{n}\right)^n \frac{1}{\sqrt{n-1}}.$$

His proof nestled among a number of analytical results in book VI and we present it again in a modern form. It is rather detailed and requires several techniques that, while unsurprisingly being known to de Moivre, would also have been quite new. It will be convenient to write $n = 2m$. So, we require an expression for

$$p_m = \frac{1}{2^{2m}} \binom{2m}{m}$$

$$= \frac{1}{2^{2m}} \frac{2m(2m-1)(2m-2)\cdots(2m-(m-2))(2m-(m-1))}{m(m-1)(m-2)\cdots 3.2.1}$$

$$= \frac{1}{2^{2m-1}} \frac{(m+1)(m+2)(m+3)\cdots(m+(m-2))(m+(m-1))}{(m-1)(m-2)\cdots 3.2.1}$$

$$= \frac{1}{2^{2m-1}} \frac{m+1}{m-1} \frac{m+2}{m-2} \cdots \frac{m+(m-2)}{m-(m-2)} \frac{m+(m-1)}{m-(m-1)}$$

$$= \frac{1}{2^{2m-1}} \prod_{i=1}^{m-1} \frac{m+i}{m-i}$$

$$= \frac{1}{2^{2m-i}} \prod_{i=1}^{m-2} \frac{m+i}{m-i} \times \frac{2m-1}{1}$$

$$= \frac{2m-1}{2^{2m-1}} \prod_{i=1}^{m-2} \frac{1+i/m}{1-i/m}.$$

The seemingly unnecessary step we have taken of stripping off the last term of the product will be crucial in ensuring later convergence.

Take the natural logarithm of both sides to achieve

$$\ln p_m = \ln(2m-1) - (2m-1)\ln 2 + \sum_{i=1}^{m-2} \ln \frac{1+i/m}{1-i/m}$$

$$= \ln(2m-1) - (2m-1)\ln 2 + 2 \sum_{i=1}^{m-2} \sum_{k=1}^{\infty} \frac{1}{2k-1} \left(\frac{i}{m}\right)^{2k-1}$$

$$= \ln(2m-1) + (-2m+1)\ln 2 + 2 \sum_{k=1}^{\infty} \frac{1}{(2k-1)m^{2k-1}} \sum_{i=1}^{m-2} i^{2k-1},$$

where the second summation arises from Newton's logarithmic series

$$\ln \frac{1+x}{1-x} = 2 \sum_{k=1}^{\infty} \frac{x^{2k-1}}{2k-1}.$$

The final step isolates the component that is the sum of powers of consecutive positive integers, which is dealt with using the famed result of Jakob I Bernoulli, which provides an explicit expression for such and which in our terms may be written

$$2k \sum_{i=1}^{m-2} i^{2k-1} = \sum_{j=0}^{2k-1} \binom{2k}{j} B_j (m-1)^{2k-j},$$

where $B_0 = 1$, $B_1 = -\frac{1}{2}$, $B_2 = \frac{1}{6}$, $B_3 = 0$, $B_4 = -\frac{1}{30}$, ..., are the *Bernoulli numbers*, with all subsequent odd-numbered of them zero. Expanding

the summation our expression becomes

$$\ln p_m = \ln(2m - 1) + (-2m + 1)\ln 2$$

$$+ 2\sum_{k=1}^{\infty} \frac{1}{(2k-1)m^{2k-1}} \left\{ \frac{1}{2k} B_0(m-1)^{2k} + \frac{B_1}{1!}(m-1)^{2k-1} \right.$$

$$+ \frac{B_2}{2!}(2k-1)(m-1)^{2k-2}$$

$$\left. + \frac{B_4}{4!}(2k-1)(2k-2)(2k-3)(m-1)^{2k-4} + \cdots \right\}$$

$$= \ln(2m - 1) + (-2m + 1)\ln 2$$

$$+ 2mB_0 \sum_{k=1}^{\infty} \frac{1}{2k(2k-1)} \left(\frac{m-1}{m} \right)^{2k}$$

$$+ 2B_1 \sum_{k=1}^{\infty} \frac{1}{2k-1} \left(\frac{m-1}{m} \right)^{2k-1} + \frac{2B_2}{2!m} \sum_{k=1}^{\infty} \left(\frac{m-1}{m} \right)^{2k-2}$$

$$+ 0 + 2\frac{B_4}{4!}\frac{1}{m^3} \sum_{k=1}^{\infty} (2k-2)(2k-3)\left(\frac{m-1}{m} \right)^{2k-4} + \cdots .$$

Now tidy the series by writing $t = (m-1)/m$ to arrive at

$$\ln p_m = \ln(2m - 1) + (-2m + 1)\ln 2 + 2mB_0 \sum_{k=1}^{\infty} \frac{1}{2k(2k-1)} t^{2k}$$

$$+ 2B_1 \sum_{k=1}^{\infty} \frac{1}{2k-1} t^{2k-1} + \frac{2B_2}{2!m} \sum_{k=1}^{\infty} t^{2k-2} + 0$$

$$+ 2\frac{B_4}{4!}\frac{1}{m^3} \sum_{k=1}^{\infty} (2k-2)(2k-3)t^{2k-4} + \cdots .$$

We consider the series individually, with the first of them requiring a development of the Newton series, achieved using integration by parts:

$$\int_0^t \ln\frac{1+x}{1-x} dx = \left[x\ln\frac{1+x}{1-x} \right]_0^t - \int_0^t x\frac{2}{1-x^2} dx$$

$$= t\ln\frac{1+t}{1-t} + \ln(1-t^2)$$

$$= (1+t)\ln(1+t) + (1-t)\ln(1-t)$$

$$= \int_0^t 2\sum_{k=1}^{\infty} \frac{x^{2k-1}}{2k-1} dx = 2\sum_{k=1}^{\infty} \frac{t^{2k}}{(2k-1)2k},$$

which means that

$$2mB_0 \sum_{k=1}^{\infty} \frac{t^{2k}}{(2k-1)2k} = m\{(1+t)\ln(1+t) + (1-t)\ln(1-t)\}$$

$$= m\left\{ \frac{2m-1}{m} \ln \frac{2m-1}{m} + \frac{1}{m} \ln \frac{1}{m} \right\}$$

$$= (2m-1)\ln \frac{2m-1}{m} - \ln m.$$

The second is straightforward:

$$2B_1 \sum_{k=1}^{\infty} \frac{1}{2k-1} t^{2k-1} = B_1 \ln \left(\frac{1+t}{1-t} \right) = -\tfrac{1}{2}\ln(2m-1).$$

These two divergent components are succeeded by an infinite series of convergent terms, with the first of them

$$\frac{2B_2}{2!m} \sum_{k=1}^{\infty} t^{2k-2} = \frac{2}{2m} \times \frac{1}{6} \frac{1}{1-t^2}$$

$$= \frac{m^2}{6m(2m-1)} = \frac{m}{6(2m-1)}$$

$$\xrightarrow[m\to\infty]{} \frac{1}{12}$$

and the second

$$2\frac{B_4}{4!} \frac{1}{m^3} \sum_{k=1}^{\infty} (2k-2)(2k-3)t^{2k-4}$$

$$= \frac{2}{4!} \times -\frac{1}{30} \times \frac{1}{m^3} \sum_{k=1}^{\infty} \frac{d^2}{dt^2} t^{2k-2}$$

$$= -\frac{1}{360m^3} \frac{d^2}{dt^2} \sum_{k=1}^{\infty} t^{2k-2} = -\frac{1}{360m^3} \frac{d^2}{dt^2} \frac{1}{1-t^2}$$

$$= -\frac{1}{360m^3} \frac{2+6t^2}{(1-t^2)^3} = -\frac{1}{360m^3} m^4 \frac{2m^2+6(m-1)^2}{(2m-1)^3}$$

$$= -\frac{1}{360} \frac{m(2m^2+6(m-1)^2)}{(2m-1)^3}$$

$$\xrightarrow[m\to\infty]{} -\frac{1}{360}.$$

We take the pattern no further (although de Moivre included two further terms) and so write

$$\ln p_m = \ln(2m - 1) + (-2m + 1)\ln 2 + (2m - 1)\ln \frac{2m - 1}{m} - \ln m$$
$$- \tfrac{1}{2}\ln(2m - 1) + \frac{1}{12} - \frac{1}{360} + \left(\frac{1}{1260} - \frac{1}{1680} + \cdots\right)$$
$$= \ln(2m - 1) - 2m\ln 2 + \ln 2 + (2m - 1)\ln(2m - 1)$$
$$- (2m - 1)\ln m - \ln m - \tfrac{1}{2}\ln(2m - 1)$$
$$+ \frac{1}{12} - \frac{1}{360} + \left(\frac{1}{1260} - \frac{1}{1680} + \cdots\right)$$
$$= -\tfrac{1}{2}\ln(2m - 1) + 2m\ln(2m - 1) - 2m\ln 2 + \ln 2 - 2m\ln m$$
$$+ \frac{1}{12} - \frac{1}{360} + \left(\frac{1}{1260} - \frac{1}{1680} + \cdots\right)$$
$$= (2m - \tfrac{1}{2})\ln(2m - 1) - 2m\ln 2m + \ln 2$$
$$+ \frac{1}{12} - \frac{1}{360} + \left(\frac{1}{1260} - \frac{1}{1680} + \cdots\right).$$

Writing the non-logarithmic part as a logarithm results in

$$\ln p_m = (2m - \tfrac{1}{2})\ln(2m - 1) - 2m\ln 2m + \ln 2$$
$$+ \frac{1}{12} - \frac{1}{360} + \frac{1}{1260} - \frac{1}{1680} + \cdots$$
$$= (2m - \tfrac{1}{2})\ln(2m - 1) - 2m\ln 2m + \ln 2 + \ln A,$$

where $\ln A = \frac{1}{12} - \frac{1}{360} + \frac{1}{1260} - \frac{1}{1680} + \cdots$ and so $A = \exp(\frac{1}{12} - \frac{1}{360} + \frac{1}{1260} - \frac{1}{1680} + \cdots)$.

Removing the logarithm results in

$$p_m = 2A(2m - 1)^{2m-1/2}(2m)^{-2m}$$
$$= \frac{2A}{\sqrt{n - 1}}\left(1 - \frac{1}{n}\right)^n \approx 2\frac{21}{125}\frac{1}{\sqrt{n - 1}}\left(1 - \frac{1}{n}\right)^n,$$

where his rational approximation resulted from him taking the progressively more accurate estimates of $2A$, given as 2.1738, 2.1676, 2.1695 and 2.1682, as he included more terms of the series expansion. He settled on 2.168 and its fractional form $2\frac{21}{125}$.

Furthermore, he calculated an expression that approximates probabilities of outcomes remote from the central one; to be precise, at a distance l from it. His approach capitalized on the above method to

establish the nicely symmetric

$$\ln \frac{p_{m+l}}{p_m} = (m + l - \tfrac{1}{2}) \ln(m + l - 1) + (m - l + \tfrac{1}{2}) \ln(m - l + 1),$$

which we leave to the interested reader to pursue. Pleasant though the expression is, it is not needed for our purpose since, if we consider only the first term of each expansion, we have by definition

$$\ln \frac{p_{m+l}}{p_m}$$

$$= \ln \frac{1}{2^{2m}} \binom{2m}{m+l} \times \frac{2^{2m}}{\binom{2m}{m}} = \ln \frac{(2m)!}{(m+l)!(m-l)!} \times \frac{m!m!}{(2m)!}$$

$$= \ln \frac{m!m!}{(m+l)!(m-l)!} = \ln \frac{m(m-1)\cdots(m-l+1)}{(m+l)(m+l-1)\cdots(m+1)}$$

$$= -\ln \frac{(m+l)(m+l-1)\cdots(m+1)}{m(m-1)\cdots(m-l+1)}$$

$$= -\ln \frac{m+l}{m} \frac{m+l-1}{m-1} \cdots \frac{m+l-1}{m-l+1}$$

$$= -\ln \left(1 + \frac{l}{m}\right)\left(\frac{1+1/m}{1-1/m}\right)\left(\frac{1+2/m}{1-2/m}\right)\cdots\left(\frac{1+(l-1)/m}{1-(l-1)/m}\right)$$

$$= -\left\{\left(\frac{l}{m} + \cdots\right) + 2\left(\frac{1}{m} + \cdots\right) + 2\left(\frac{3}{m} + \cdots\right)\cdots 2\left(\frac{l-1}{m} + \cdots\right)\right\}$$

$$\approx -\left\{\frac{l}{m} + \frac{2}{m}(1 + 2 + 3 + \cdots + (l-1))\right\}$$

$$= -\left\{\frac{l}{m} + \frac{2}{m}\frac{l}{2}(l-1)\right\}$$

$$= -\frac{l^2}{m} = -\frac{2l^2}{n}.$$

All of which means that

$$p_{m+l} \approx p_m e^{-2l^2/n}.$$

And we have a suspicion of a hint of the function e^{-x^2}, the defining form of the normal curve. The hint becomes a little more pronounced when the original expression for p_m is replaced by something more natural, and for this we look to 12 November 1733, when de Moivre presented a paper of just seven pages privately to a group of friends; its title was "Approximato as Summam Terminorum Binomii $(a + b)^n$ in Series Expansi". It is extremely rare, with only two original copies known to be extant, and, as its title suggests, it is devoted to the same problem and

tidies up his expression of 1730; the material reappears in the second and third editions of *The Doctrine of Chance*. The adjustment was made using the limit form of the constant e and with A changed to B, where $AB = e$, which results in

$$p_m = \frac{2e}{B\sqrt{n-1}}\left(1 - \frac{1}{n}\right)^n$$
$$\approx \frac{2e}{B\sqrt{n}} \times e^{-1} = \frac{2}{B\sqrt{n}},$$

where $\ln B = 1 - \frac{1}{12} + \frac{1}{360} - \frac{1}{1260} + \cdots$, which, de Moivre commented, his "learned friend James Stirling" had identified as $B = \sqrt{2\pi}$. Finally, then,

$$p_m \approx \frac{2}{\sqrt{2\pi n}} \quad \text{and} \quad p_{m+l} \approx \frac{2}{\sqrt{2\pi n}}e^{-2l^2/n}.$$

Finally, back in the *Miscellanea*:

> If the terms of the Binomial are thought of as set upright, equally spaced at right angles to and above a straight line, the extremities of the terms follow a curve. The curve so described has two inflection points, one on each side of the maximum term.

He found those inflection points to be (approximately and for large n) where $l = \pm\frac{1}{2}\sqrt{n}$, and in doing so he had found the natural measure of dispersion of a random variable; what he termed its *modulus*, defined as \sqrt{n}. If we take the standard normal approximation to the symmetric binomial random variable, we have the distribution $N(\frac{1}{2}n, \frac{1}{4}n)$ with its standard deviation $\frac{1}{2}\sqrt{n}$: his modulus is a variant of our standard deviation. The principal matter left outstanding was to put to use the relationship between the discrete and the continuous in performing otherwise-intractable calculations such as

$$P(\tfrac{1}{2}n - d \leqslant X \leqslant \tfrac{1}{2}n + d) \approx \sum_{l=-d}^{d} \frac{2}{\sqrt{2\pi n}}e^{-2l^2/n} \approx \frac{4}{\sqrt{2\pi n}}\sum_{l=0}^{d}e^{-2l^2/n}$$

using the approximation

$$\frac{4}{\sqrt{2\pi}}\int_0^{d/\sqrt{n}} e^{-2y^2}\, dy,$$

obtained by setting $y^2 = l^2/n$ in the summation. Of course, the exponential is not susceptible to integration and so he took the two avenues open to him (and to us today): use Taylor expansions and integrate

term-by-term or, alternatively, use an approximation formula for the area under a curve. The latter he termed the "Artifice of Mechanical Quadratures, first invented by Sir Isaac Newton" and his choice is what we would more likely call *Simpson's* $\frac{3}{8}$ *rule* (when it is referred to at all):

$$\int_a^b f(x)\,dx \approx \tfrac{3}{8}h\{f(x_0) + f(x_1) + f(x_2) + f(x_3)\}, \quad \text{where } h = \frac{b-a}{3}.$$

With these, de Moivre performed calculations for $n = 3600$ and $l = \frac{1}{2}\sqrt{n}$ to show that, if $X \sim B(3600, \frac{1}{2})$, then

$$P(1800 - \tfrac{1}{2}\sqrt{3600} \leqslant X \leqslant 1800 + \tfrac{1}{2}\sqrt{3600})$$
$$= P(1770 \leqslant X \leqslant 1830) \approx 0.682688.$$

That is, 68% of the distribution lies within one standard deviation of the mean; furthermore, he calculated that $0.95428 = 95\%$ lies within the boundaries $l = \pm 2\frac{1}{2} \times \sqrt{n}$ (two standard deviations of the mean) and that $0.99874 = 99^+\%$ lies within the boundaries $l = \pm 3\frac{1}{2} \times \sqrt{n}$ (three standard deviations of the mean). The reader will, we imagine, be impressed by the accuracy of these calculations and their prescient nature.

 With these calculations, the importance of the curve with equation e^{-x^2} was exposed and with this exposure the embryonic stage of the normal curve as the dominant statistical curve had been reached. The second stage in the evolutionary process was markedly different.

8.4 Error Curves

Given a collection of measurements that have been accumulated to approximate some value, we would naturally seek a strategy of how best to put them to use. Do we choose the one among them which, through dint of the conditions under which it was taken, as the most likely to be most accurate and so be the "best" approximant to the unknown value, or do we consider all measurements to have equal status and take their median or, if there is repetition, their mode; or do we calculate their mean? Or do we choose some process that involves multiple applications of the above ideas? Or do we do something completely different? Such questions have troubled scientists since science became such, and it is with the astronomers, the first scientists for whom repeated accurate measurement was crucial, that we find the first serious attempts to confront what was a most grave and limiting conundrum. The Ancients

through to Kepler and Brahe had their respective approaches – a mixture of ad hoc appeals to reason – but it is with Galileo that we first see a systematic approach to the study of errors. In his *Dialogue* (to which we will refer in the next chapter) he stated the following reasonable assumptions.

- There is only one number that gives the distance of the star from the centre of the earth: the true distance.
- All observations are encumbered with errors, due to the observer, the instruments and the other observational conditions.
- The observations are distributed symmetrically about the true value; that is, the errors are distributed symmetrically about zero.
- Small errors occur more frequently than large errors.
- The calculated distance is a function of the direct angular observations such that small adjustments of the observations may result in large adjustments of the distance.

Upon this minimal foundation was built the great edifice that is today a comprehensive theory of errors and that constitutes the second stage in the evolution of the normal curve. In general terms, the fundamental question is: whatever number is forged from the observational data, what level of confidence can we justify in using it as the true value of what we have been trying to measure? In more quantitative terms, what is the probability that our chosen estimate lies within an acceptable tolerance of the real value being measured? And should that estimate be the mean of the data items?

> It is well known to your Lordship, that the method practiced by astronomers, in order to diminish the errors arising from the imperfections of instruments, and of the organs of sense, by taking the Mean of several observations, has not been generally received, but that some persons, of considerable note, have been of opinion, and even publickly maintained, that one single observation, taken with due care, was as much to be relied on as the Mean of a great number.

So wrote the English mathematician Thomas Simpson (of Simpson's rule fame) to the then President of the Royal Society in 1755, and so thought, for example, the influential Robert Boyle (of Boyle's law fame). It was in that letter that Simpson promoted the use of the mean of several "observations", taking into account their relative frequency. His example was contrived to allow the mathematics to be tractable, with a discrete error distribution in which the errors take the values

$-v, \ldots, -3, -2, -1, 0, 1, 2, 3, \ldots, v$ for some v, first with probabilities proportional to $r^{-v}, \ldots, r^{-3}, r^{-2}, r^{-1}, r^0, r^1, r^2, r^3, \ldots, r^v$ and then proportional to $r^{-v}, 2r^{1-v}, 3r^{2-v}, \ldots, (v+1)r^0, \ldots, 3r^{v-2}, 2r^{v-1}, r^v$ for some r. The dots of figure 8.1 demonstrate his error distribution in the second case, with $r = 1$. His structure allowed him the use of geometric series and with it he was able to derive expressions for the probability that the mean of the observations would fall within specified limits of the real value being measured, and from this he presented an example in which this probability was greater than the corresponding probability for a single observation. A point made, then, but later he went further. In a second paper only two years later,[1] his perception of the mean's acceptability had altered. It starts with

> Although the method practiced by Astronomers in order to diminish the errors arising from the imperfections of instruments and of the organ of sense, by taking the mean of several observations is of great utility, and almost universally followed, yet it has not, that I know of, been hitherto subjected to any kind of demonstration.

What followed was a rehash of the previous paper but with one important addition, for which he provided a figure from which the continuous line in figure 8.1 derives, accompanied by the following words:

> But I shall now show how the chances may be computed when the error admits any value whatever, whole or broken, … Let, then, the line AB represent the whole extent of the given interval, within which all the observations are supposed to fall; and conceive the same to be divided into an exceeding great number of very small, equal particles.

With this he had all but constructed the first continuous error distribution, but the race was far from run. The baton was taken up by Lagrange in his first memoir concerning probability, which was published in the fifth volume of his *Miscellanea Taurinesia*, covering the years 1770–73. The ten problems that constitute the paper are much reminiscent of Simpson's work, predominantly dealing with conveniently constructed discrete error distributions, but the final part moves to the continuous. The culmination is a discussion of the two error distributions with probability density functions the ellipse $\varphi(x) = K\sqrt{c^2 - x^2}$ for $-c \leqslant x \leqslant c$ and $\varphi(x) = K \cos x$ for $-\frac{1}{2}\pi \leqslant x \leqslant \frac{1}{2}\pi$, the quadrature of both of which was susceptible to the calculus. With these the treatment of errors had moved to the continuous but not yet to the practical. How

[1] Dated 1757 and part of his *Miscellaneous Tracts*.

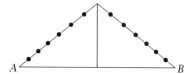

Figure 8.1. Simpson's error distribution with $r = 1$.

can the combination of human and machine failure be harnessed into a natural error distribution? What would be its exact form? Should this form vary according to circumstance?

It was to be left to Pierre-Simon Laplace to provide the first significant attempt at an answer with his *first error distribution*. Although his approach began in 1772, we see it more clearly as problem 3 of a 1774 paper (Laplace 1986), wherein he asked for the best estimate of an unknown value when just three differing observations of it had been made. His approach may be summarized as follows.

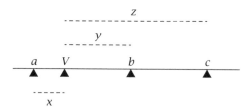

Figure 8.2. Laplace's approach to estimation.

Referring to figure 8.2, the true value, V, is estimated by the three observations a, b, c; writing $p = b - a$ and $q = c - b$, the errors in each case are x, y, z, where $y = p - x$ and $z = p + q - x$ and which are subject to the unknown error distribution $\varphi(x)$. Assuming independence, the probability of what has occurred in fact occurring is written as the product $\varphi(x)\varphi(p - x)\varphi(p + q - x)$, and we seek the value of x (and hence the value of V) that maximizes this. But, as Laplace commented: "It is necessary to know $\varphi(x)$. But of an infinite number of possible functions, which choice is to be preferred?"

Whatever its form, the error curve must arise as a consequence of an acceptable set of assumptions, with those of Galileo setting the standard: symmetry about 0 and decreasing either side of it. It should also have a total area of 1. What other condition could be attached that would result in an acceptable argument leading to a natural curve? For this, Laplace was to adopt a *principle of indifference* or, put otherwise, of *insufficient reason:*

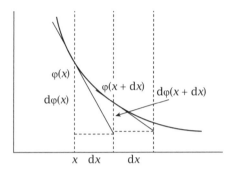

Figure 8.3. Laplace's principle of indifference.

Thus, not only the ordinates of the curve, but also the differences of these ordinates must decrease as they become further (away)...Now, as we have no reason to suppose a different law for the ordinates than for their differences, it follows that we must, subject to the rules of probabilities, suppose the ratio of two infinitely small consecutive differences to be that of the corresponding ordinates. We thus will have

$$\frac{d\varphi(x + dx)}{d\varphi(x)} = \frac{\varphi(x + dx)}{\varphi(x)}$$

and therefore

$$\frac{d\varphi(x)}{dx} = -m\varphi(x) \quad \text{which gives } \varphi(x) = \tfrac{1}{2}me^{-mx}.$$

We can fill in the small gaps in the argument with the use of figure 8.3 with its two tangents at two points incrementally distant apart yielding $d\varphi = (d\varphi/dx)\,dx = \varphi'(x)\,dx$ at any given point, and so his principle of indifference yields

$$\frac{d\varphi(x + dx)}{d\varphi(x)} = \frac{\varphi(x + dx)}{\varphi(x)} \rightarrow \frac{\varphi'(x + dx)\,dx}{\varphi'(x)\,dx} = \frac{\varphi(x + dx)}{\varphi(x)}$$

$$\rightarrow \frac{\varphi'(x)}{\varphi(x)} = \frac{\varphi'(x + dx)}{\varphi(x + dx)}.$$

This means that $\varphi'(x)/\varphi(x) = -m$, a constant, and $\varphi(x) = Ae^{-mx}$. The requirement of symmetry and the whole area to be 1 mean that

$$\frac{1}{2} = \int_0^\infty Ae^{-mx}\,dx = -\frac{A}{m}[e^{-mx}]_0^\infty = \frac{A}{m},$$

and so $\varphi(x) = \tfrac{1}{2}me^{-mx}$. This is the right part of the curve, and again symmetry requires its continuation to be $\varphi(x) = \tfrac{1}{2}me^{-m|x|}$, which is figure 8.4.

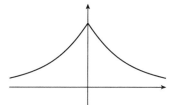

Figure 8.4. The Laplace distribution.

The curve survives today as the visualization of the *Laplace distribution*. With the tool at hand he was able to derive an expression

$$V \sim p + \frac{1}{m} \ln(1 + \tfrac{1}{3}e^{-mp} - \tfrac{1}{3}e^{-mq})$$

subject to the assumption $p > q$ and where p, q and the unknown, m, are interdependent. Even the formidable manipulative skills of Laplace were insufficient to apply his methods to arbitrarily large data sets, and in 1777 he moved to a second attempt at an error curve, with his arguments having a degree of complexity far exceeding the one above. In fact, much of his mathematical output up to 1781 was devoted to discussion of these ideas, with the full story defying a brief and representative analysis: we content ourself with his conclusion that the new error curve would have the equation

$$\varphi(x) = \frac{1}{2a} \ln \frac{a}{|x|},$$

with $-a \leqslant x \leqslant a$ the bound of the magnitude of the errors. Its graph is figure 8.5 and the difficulties associated with it are not helped by its vertical asymptote at 0.

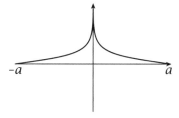

Figure 8.5. Laplace's second distribution.

For all its complexity, this last attempt constituted a retrograde step in the evolution of the error curve, with the final development requiring yet more thought on the part of Laplace – and the intervention of arguably mathematics's greatest practitioner.

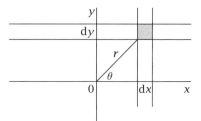

Figure 8.6. Error estimation.

8.5 *The* Error Curve

That mathematician is the inimitable Carl Friedrich Gauss, but before we look to his contribution we develop the normal curve as the natural error curve in the context of what we hope is a natural environment.

Consider repeated expert attempts at hitting a target 0 in figure 8.6. Those attempts which are unsuccessful result in horizontal errors, measured as x, and vertical errors, measured as y. These errors are subject to a continuous probability distribution $\varphi(x)$ and an assumed identical distribution $\varphi(y)$.

Three natural assumptions are made in that errors

- in the two perpendicular directions are independent,
- do not depend on orientation,
- decrease as we move further from the origin.

The probability that the vertical error lies in the elemental vertical strip is $\varphi(x)\,dx$, and similarly $\varphi(y)\,dy$ for the horizontal strip. By virtue of our assumption of independence, the probability that the attempt on the target is located in the shaded box is, therefore, $\varphi(x)\,dx \times \varphi(y)\,dy = \varphi(x)\varphi(y)\,dx\,dy$. Yet, this does not depend on the orientation of the box and so this probability could be written $g(r)\,dx\,dy$, which means that $g(r) = \varphi(x)\varphi(y)$. We have, then, $\varphi(x)\varphi(y) = g(\sqrt{x^2 + y^2})$. Setting $y = 0$ results in $\varphi(x)\varphi(0) = g(x)$, and so $\varphi(x)\varphi(y) = \varphi(\sqrt{x^2 + y^2})\varphi(0)$, which can be rewritten as

$$\frac{\varphi(x)}{\varphi(0)} \times \frac{\varphi(y)}{\varphi(0)} = \frac{\varphi(\sqrt{x^2 + y^2})}{\varphi(0)}.$$

Write $P(x) = \ln(\varphi(x)/\varphi(0))$ and we have $P(x) + P(y) = P(\sqrt{x^2 + y^2})$, a functional equation for $P(x)$ that (up to constants) will determine it, although the form is hardly an encouraging one. It becomes far more friendly if we define yet another function $Q(x) = P(\sqrt{x})$, which provides the new functional equation $Q(x) + Q(y) = P(\sqrt{x}) + P(\sqrt{y}) =$

Table 8.1. Piazzi's measurements for Ceres.

1801	Longitude	Latitude
1 January	53°23′06.38″	3°06′45.16″
22 January	53°39′11.58″	1°42′28.80″
11 February	56°26′28.20″	0°35′55.02″

$P(\sqrt{x+y}) = Q(x+y)$. $Q(x)$ is therefore a linear function and we can proceed by recognizing that it must therefore be of the form $Q(x) = kx$ (since $Q(0) = 0$). More rigorously, repeatedly take $y = x$ to yield $Q(nx) = nQ(x)$ and argue as follows (recalling that $\varphi(x)$ and therefore $P(x)$ and therefore $Q(x)$ are continuous):

• $x = 1 \to Q(n) = nQ(1) = kn$ and so $Q(x) = kx$ for $x \in \mathbb{N}$;

•

$$x = \frac{p}{q} \to qQ\left(\frac{p}{q}\right) = Q\left(q \times \frac{p}{q}\right) = Q(p) = kp \to Q\left(\frac{p}{q}\right) = k\frac{p}{q}$$

and so $Q(x) = kx$ for $x \in \mathbb{Q}^+$;

• if $x \in \mathbb{R}^+$, let $\{x_i\}$ be a sequence of rational numbers such that $x_i \xrightarrow[i \to \infty]{} x$, then, since $Q(x)$ is assumed to be continuous,

$$Q(x) = Q\left(\lim_{i \to \infty} x_i\right) = \lim_{i \to \infty} Q(x_i) = \lim_{i \to \infty} kx_i = k \lim_{i \to \infty} x_i = kx.$$

We conclude, again, that $Q(x) = kx$ for all positive x and by symmetry for all x. Either way, $P(\sqrt{x}) = kx$, which means that $P(x) = kx^2$, with k an arbitrary constant. We have, then, $\varphi(x) = p(0)e^{kx^2}$; also, since errors diminish as x increases, $k < 0$ and we may write $\varphi(x) = Ae^{-kx^2/2}$. Recognizing that the total probability is 1 and using standard techniques, we find $A = \sqrt{k/2\pi}$ and so $\varphi(x) = \sqrt{k/2\pi}e^{-kx^2/2}$, and we have a natural appearance of the normal curve in the context of error management; it is, though, not the manner in which it made its first appearance.

On 1 January 1801, while working from his observatory in Palermo, the Italian priest and well-regarded astronomer Giuseppe Piazzi had sighted a new heavenly body in the constellation of Taurus – which moved. It was not a star, then, so it might be a comet, but it could also be a new planet lying between Mars and Jupiter, long suspected and predicted by the law of Titius–Bode. Piazzi named the object *Ceres Ferdinandea*, after the Roman goddess of agriculture and the Sicilian king, its name soon to lose its royal connection for political reasons

and be truncated to Ceres. Nineteen complete observations were made by Piazzi, the last on 11 February, when the object disappeared behind the sun; partly to appreciate the level of attempted accuracy, we list in table 8.1 the essential parts of the first, middle and last of Piazzi's measurements.

Crucially missing, of course, are the object's distances away from the earth or sun. The obvious problem, and one that was feverishly pursued by many distinguished astronomers of the time, was to predict where in the celestial sphere Ceres would reappear and so be available for further examination of its planetary credentials. Various predictions were made by astronomers of varied distinction, but Ceres stubbornly remained "a fugitive to observation". These last words are those of Gauss, who in 1801 was 24 years old. That September he had come by the data, and by November he had completed his first determination of Ceres's orbit, to be published in the December issue of *Monatliche Correspondenz*, the monthly journal of astronomy. On 7 December the journal's founder, the Hungarian astronomer Franz Xaver von Zach, rediscovered Ceres in almost the exact position that Gauss had predicted, which was far removed from the many predictions of others; on 31 December the German astronomer Wilhelm Olbers confirmed matters with his own sighting made according to Gauss's predictions. The year 1801 was to prove an *annus mirabilis* for Gauss; years later he was to comment that so many important ideas had occurred to him that he could not control them. His seminal work on number theory, *Disquisitiones Arithmeticae*, had appeared, with its remarkable law of quadratic reciprocity and also his much-favoured result of the constructibility of a regular 17-sided polygon with straight edge and compass – and much else besides. With this latest success he was catapulted into the exalted class of genius, with this epithet appropriate to this day. It was with those three observations given in table 8.1 that Gauss initially made his calculations, using Kepler's laws and a good deal of spherical trigonometry; his computations provide a compelling example of the distinction mathematicians make between a matter being "elementary" and "simple":[2] the work may well be classified as *elementary*, but it is hard to make a case for it being *simple*. Fortunately, the details are not of concern to us other than to observe that, having made this first prediction of the orbit using three data items, he successively used the remaining observations to refine matters, never achieving an exact fit but ever

[2] Elementary: not much mathematical knowledge is needed to read the work. Simple: not much mathematical ability is needed to understand it.

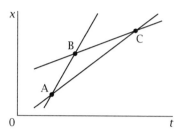

Figure 8.7. A line of best fit.

achieving a better one; rather like a carpet fitter adjusting the position of a carpet of one size to a room of another. With Ceres located and subsequently tracked, more data became available to Gauss to refine his estimates, and he did so by refining his methods:

> But when we have a longer series of observations, embracing several years, more normal positions can be derived from them; on which account, we should not insure the greatest accuracy, if we were to select three or four positions only for the determination of the orbit, and neglect all the rest. But in such a case, if it is proposed to aim at the greatest precision, we shall take care to collect and employ the greatest possible number of accurate places. Then, of course, more data will exist that are required for the determination of the unknown quantities: but all these data will be liable to errors, however small, so that it will generally be impossible to satisfy all perfectly. Now as no reason exists, why, from among those data, we should consider any six as absolutely exact, but since we must assume, rather, upon the principles of probability, that greater or less errors are equally possible in all, promiscuously; since, moreover, generally speaking, small errors oftener occur than large ones; it is evident, that an orbit which, while it satisfies precisely the six data, deviates more or less from the others, must be regarded as less consistent with the principles of the calculus of probabilities, than one which, at the same time that it differs a little from those six data, presents so much the better an agreement with the rest.

Gauss's point can be made with the three data items shown in figure 8.7. We will suppose that an object's "orbit" is a straight line and that the three measured positions have been plotted: would we wish to take the orbit to be the line AB or BC or AC - or none of them? The answer, of course, is none of them, since the third data point would have no influence on matters. A line that is appropriately influenced by all points, even though it passes through none of them, is far preferable. But what exactly do we mean by appropriate?

Let us suppose that the three points have coordinates

$$\{(t_1, x_1), (t_2, x_2), (t_3, x_3)\},$$

where the $\{t_i\}$ are times presumed measured to comparatively high accuracy and the $\{x_i\}$ positions subject to observational errors. The linear orbit's equation would have the form $x = a + bt$ with consequent errors

$$\{(a + bt_1 - x_1), (a + bt_2 - x_2), (a + bt_3 - x_3)\},$$

and we seek the values of the parameters that maximize the probability of these three errors, which did occur, occurring, which means that first of all we require a probability distribution for these errors. To this end Gauss sided with the *mean* as the most representative statistic:

> The hypothesis is in fact wont to be considered as an axiom that, if any quantity has been determined by several direct observations, made under similar circumstances and with equal care, the arithmetical mean between all the observed values presents the most probable value, if not with absolute rigour, at least very nearly so, so that it is always safest to adhere to it.

With this conviction he provided his first argument that the normal curve was the natural choice for an error curve that, if tentative, is also formative. We may paraphrase it as follows. Suppose that the true value we are trying to measure and will never know is v and that we take n measurements $x_1, x_2, x_3, \ldots, x_n$ to estimate it. The respective errors of measurement are, then, $(x_1 - v), (x_2 - v), (x_3 - v), \ldots, (x_n - v)$, and we suppose that these are subject to an unknown error distribution given by the differentiable function $\varphi(x)$. From this we construct what we would now call the *likelihood function* (as did Laplace)

$$\Omega = \varphi(x_1 - v)\varphi(x_2 - v)\varphi(x_3 - v) \cdots \varphi(x_n - v) = \prod_{i=1}^{n} \varphi(x_i - v)$$

as a function of v, which reflects the probability of the set of values independently occurring. We are, of course, trying to establish the identity of $\varphi(x)$ and we make the usual assumptions about it: small errors less likely than large errors, so $\varphi(0)$ is its maximum; errors either side of the true value are equally likely, so $\varphi(-x) = \varphi(x)$; and since it must account for all possibilities, the total area under it is 1.

The assumption that, having taken several measurements of the same quantity, the most likely value of that quantity is the average of them was interpreted to mean that Ω assumes its maximum value when

$$v = \bar{v} = \frac{1}{n} \sum_{i=1}^{n} x_i.$$

The natural next step is to differentiate Ω with respect to v and set this to zero, and to achieve this it is easiest to take logs:

$$\ln \Omega = \ln \prod_{i=1}^{n} \varphi(x_i - v) = \sum_{i=1}^{n} \ln \varphi(x_i - v)$$

and so

$$\frac{1}{\Omega} \frac{d\Omega}{dp} = \sum_{i=1}^{n} \frac{-\varphi'(x_i - v)}{\varphi(x_i - v)},$$

which means that

$$\sum_{i=1}^{n} \frac{\varphi'(x_i - \bar{v})}{\varphi(x_i - \bar{v})} = 0.$$

Write $f(x) = \varphi'(x)/\varphi(x)$, necessarily an odd function, and we have $\sum_{i=1}^{n} f(x_i - \bar{v}) = 0$.

Since the x_i are arbitrary, we may take their values to be what we wish, and if we take $x_1 = a$ and $x_2 = x_3 = x_4 = \cdots = x_n = a - nb$, for arbitrary a and b, we have

$$\bar{v} = \frac{1}{n}\{a + (n-1)(a - nb)\} = a - (n-1)b,$$
$$x_1 - \bar{v} = a - \{a - (n-1)b\} = (n-1)b,$$
$$x_i - \bar{v} = (a - nb) - \{a - (n-1)b\} = -b.$$

So,

$$\sum_{i=1}^{n} f(x_i - \bar{v}) = f(x_1 - \bar{v}) + \sum_{i=2}^{n} f(x_i - \bar{v})$$
$$= f((n-1)b) + (n-1)f(-b) = 0.$$

And, since $f(x)$ is odd,

$$f((n-1)b) = -(n-1)f(-b) = (n-1)f(b).$$

And we return to the earlier functional equation, which means that $f(x) = \varphi'(x)/\varphi(x) = kx$, which solves by separation of variables to $\varphi(x) = Ae^{kx^2}$ and, using the fact that the total area is 1, may be rewritten in the form $\varphi(x) = (h/\sqrt{\pi})e^{-h^2x^2}$, where h is a positive constant that Gauss referred to as the *precision of the measurement process*.

With the aid of this error distribution we can measure the probability of the above three errors occurring independently as

$$\Omega = \left(\frac{h}{\sqrt{\pi}}\right)^3 \exp\left(-h^2 \sum_{i=1}^{3} (a + bt_i - x_i)^2\right),$$

which we desire to be maximal, meaning that $\sum_{i=1}^{3}(a + bt_i - x_i)^2$ is minimal and we have the embodiment of the method now known as *least squares* – the story of which is long and complex, and one that we will sidestep. If we consider the expression as a function of the two variables a and b and differentiate and equate to zero, we obtain two equations that can be written neatly in the matrix form

$$\begin{pmatrix} \sum 1 & \sum t_i \\ \sum t_i & \sum t_i^2 \end{pmatrix} \begin{pmatrix} a \\ b \end{pmatrix} = \begin{pmatrix} \sum x_i \\ \sum x_i t_i \end{pmatrix}$$

and that are easily solved: in the literature, these are the *normal* equations. The normal equations that Gauss dealt with were very much more challenging, but through them the orbit of Ceres was ever more precisely established, as was its proper celestial role: rather than being the new fifth planet, it became the first asteroid. This component of the story completes with the further intercession of Laplace, who, having seen Gauss's derivation, produced his own, more rigorous, alternative. The normal curve as the curve of choice for error measurement was established and the associated theories developed.

The last of the three evolutionary stages of the normal curve links with our first derivation of the error curve above. This originates (in narrative form) on pages 19 and 20 of an extensive 1850 review of a book – a review which occupies the first 57 pages of an edition of the journal *The Edinburgh Review*, with the reviewer the famous English astronomer and physicist Sir John Herschel (1850). The reviewed book was destined to become greatly influential, both through the positive nature of this review from its prestigious reviewer and also because of the singular influence of its author. It is also rather out of the ordinary.

8.6 The Normal Distribution

If we were to hope to present a representative account of the ubiquitous influence of the normal curve in our everyday lives, we would require vastly more pages than we have available and we would needfully discuss the contributions of Messrs Fisher, Pearson, Yates, Turkey, Gosset, etc., but we will be content with the contribution of the Belgian polymath Lambert Adolphe Jacques Quetelet (pronounced Kettle-lay) (1796–1874), whose seminal studies regarding the normal curve provided the exemplar for names now far more famous than his, including Florence Nightingale, Charles Darwin and the omni-talented Francis Galton, Darwin's cousin.

The modern body mass index (BMI), interest in which has escalated with the increasing girth of prosperous Western populations, is not very modern at all. It has another name, not much used today: the *Quetelet index*,[3] after Adolphe Quetelet, who was at once astronomer, mathematician, statistician and sociologist (see Eknoyan 2008). The BMI is but one of his quantifications of human characteristics, and it is through him and his singular skill-and-interest set that we find the first written recognition that the error curve of the nineteenth century could bear amendment to the normal curve of today. That is, the law that determined the frailty of human observation could, in particular, be called into service to model characteristics of humans themselves: their weights, their heights and a combination of the two, their index of obesity. And all manner of other characteristics associated with human development too: crime rates and types, ages at marriage and at death, etc., etc. His analysis of Parisian crime figures caused him to suggest that the perpetrator of an illegal act "who is a well-educated female over thirty, appearing voluntary to answer a crime against persons" was most likely to avoid being charged or otherwise successfully convicted. In fact, it is small exaggeration to suggest that Quetelet saw the shape of the normal curve of errors everywhere in nature, as it is no exaggeration to suggest that he appreciated the novelty and difficulty linked to his ideas:

> I do not disguise from myself the many difficulties which attach to the employment of mathematical methods in the analysis of phenomena. This study, as yet new, has I know alarmed many readers, who have fancied they have seen in it a tendency to materialise that which belongs to the noble facilities of man.

[3] It became the BMI in 1972: a term coined by Ancel Keys.

His influence, both through its wide expanse and the identity of some who were subject to it, was great and largely positive, and he stands as the undisputed founder of the quantitative social sciences. His most famous publication, a collation of his studies to date, is the 1835 book *A Treatise of Man and the Development of His Aptitudes*, and it is here where we find that BMI, as well as much else. We will, though, look elsewhere for some detail of his contribution to this chapter.

Nestled among an impressive array of responsibilities, appointments and honours, he was at one time a teacher at the Royal Athenaeum of Brussels and, following this, in the 1830s, tutor to the teenage brothers the princes Ernest and Albert of Saxe-Coburg and Gotha; the younger brother, Albert, was to marry queen Victoria in 1840, and in 1844 Ernest was to succeed his father to become the Grand Duke. When the boys returned to Germany to complete their education the lessons continued by correspondence, and many of them were later to be incorporated into a book of 1846 entitled *Letters Addressed to H.R.H. The Grand Duke of Saxe-Coburg and Gotha, On the Theory of Probabilities as Applied to the Moral and Political Sciences.*[4] It is this book from which the previous quotation comes and that Herschel reviewed at such length, and it is in this unlikely place that we find specific mention of the use of the error curve in a context other than measuring errors.

Of the 46 letters that constitute most of the book, it is letters XX and XXI that are most pertinent to us; the former bears the title "To discover whether the arithmetical mean is the true mean-type of the human size". Quetelet's device for explaining to the young (but scientifically minded) prince his thoughts was to have him consider a sculpture, which is referred to as *The Gladiator*, and to consider its principal dimensions and, in particular, its chest measurement. *The Gladiator* represents the perfect form and any attempt to measure the chest is subject to error; measure it a thousand times and the mean of the measurements would be very near to the perfect dimension being measured. Also, the measurements differing least from the mean would constitute the most numerous group, with the other groups becoming less numerous as they become more remote from the mean: "If the succession of groups were traced by a line, this line would be the curve of possibility." Now segue to the careful reproduction of *The Gladiator* by a thousand different sculptors, wherein the measurements would again conform to the law of possibility.

[4] We rely on the 1849 translation of Olinthus Gregory Downes.

Table 8.2. Chest measurements of Scottish militia.

Measurement of chest	33	34	35	36	37	38	39	40
Number of men	3	18	81	185	420	749	1073	1079
Measurement of chest	41	42	43	44	45	46	47	48
Number of men	934	658	370	92	50	21	4	1

With this intermediate step taken, Quetelet's denouement required a lurch more than a segue into the world of Scottish soldiers. Any statistician needs data and Quetelet mined his own from various government records, as well as many other sources, and he was also the grateful recipient of many and varied data collections, sent to him by his contacts. He was particularly attracted to military records, which he considered a source of consistent and reliable data, and somehow came into possession of volume 13 of the *Edinburgh Medical Journal* of 1817. There among the various articles (many of which make very harrowing reading) are listed on page 260 eleven tables giving the chest measurements (correlated by height) of each of the regiments of the local Scottish militia; 5,731 measurements in all, but according to Quetelet the number was 5,738. His table is our table 8.2 and from it he commented:

> I now ask if it would be exaggerating to make an even wager that a person little practised in measuring the human body would make a mistake of an inch in measuring a chest of more than 40 inches in circumference? Well, admitting this probable error, 5,738 measurements made on one individual would certainly not group themselves with more regularity, as to the order of magnitude, than the 5,738 measurements made on the Scotch soldiers; and if the two series were given to us without there being particularly designated, we should be much embarrassed to state which series was taken from the 5,738 different soldiers, and which was obtained from one individual with less skill and ruder means of appreciation.
>
> The example which I have cited merits, I think, great attention: it shows us that the results really occur, as though the chests which have been measured have been modelled from the same type from the same individual, an ideal one if you will, but whose proportions we ascertain by a sufficiently long trial. If such were not the laws of nature, the measurements would not (spite of their imperfections) group themselves with the astonishing symmetry which the law of possibility assigns them.

The move from the equivalence of single measurements of 5,738 soldiers to 5,738 measurements of one soldier is awkward and scarcely believable, even though the latter be obtained "by an individual with less skill and ruder means of appreciation". The ideal *Gladiator* had

been replaced by *l'homme moyen*, the ideal or average man as a funda-
mental theoretical construct, the perfect individual who was the social
centre of gravity and who has become an enduring paradigm for stat-
istical and social reasoning. Not a single average man, but a theoret-
ical ideal in each context; here, the Scottish soldier and his chest mea-
surement. The idea permeates our language today: the *average man*
needs 250 grammes of carbohydrates each day, the *average family*
has 2.4 children, In letter XXI the young prince was induced to
consider the possible fraud in the published statistics of the heights
of 100,000 French conscripts; in the data set there were too many of
recorded height less than 5 feet 2 inches to fit Quetelet's approxima-
tion to the normal distribution "and the authorities are indulgent in
the cases where men of a more suitable size are substituted for small
men".

Quetelet's enthusiasm infected many of wide-ranging influence, and
the normal curve quickly became the principal model for the charac-
teristics of nature in general and man in particular. The various contri-
butions of those many other names we have not considered have com-
bined to justify the normal curve's preeminent place among statistical
distributions. The approximant to the binomial distribution remains
as one of its uses, and it still measures errors too. Recognizing the
hopelessness of any attempt to provide a proper perspective for the
importance of the normal curve, we finish with the artistically pre-
sented words of W. J. Youden, from his book *Experimentation and Mea-
surement*, which was published by the American National Bureau of
Standards in 1984. He wrote that he owned his own printing press –
and here he put it to good use.

<div align="center">
THE

NORMAL

LAW OF ERROR

STANDS OUT IN THE

EXPERIENCE OF MANKIND

AS ONE OF THE BROADEST

GENERALISATIONS OF NATURAL

PHILOSOPHY ♦ IT SERVES AS THE

GUIDING INSTRUMENT IN RESEARCHES

IN THE PHYSICAL AND SOCIAL SCIENCES AND

IN MEDICINE AGRICULTURE AND ENGINEERING ♦

IT IS AN INDISPENSABLE TOOL FOR THE ANALYSIS AND THE

INTERPRETATION OF THE BASIC DATA OBTAINED BY OBSERVATION AND EXPERIMENT

</div>

The Catenary

Why This Curve?

First, it may have deceived Galileo and certainly did deceive many before and after him. Second, it was an important test case in the early development of the new calculus. Third, drawn on a vertical wall, it can be used to compute logarithms. Fourth, it is a ubiquitous architectural shape and a fundamental one in construction. Fifth, it was named by a future president of the United States. And last, it makes a fascinating road surface.

9.1 A Matter of Symmetry

There are two particular symmetries associated with curves that, in terms of a determining function $f(x)$, take the form $f(-x) = f(x)$ or $f(-x) = -f(x)$ wherever the function is defined: the former condition ensures reflective symmetry in the y-axis and the latter 180° rotational symmetry about the origin. Since even powers of x satisfy the former condition and odd powers the latter, the terms *even* and *odd*, respectively, are used to describe such behaviour: beyond these, $\cos x$ is even and $\sin x$ is odd, etc. It is evident that by no means all curves enjoy such symmetry, yet there is a nice construction that extracts what we may

reasonably term the even and odd parts of a curve. Let $f(x)$ be arbitrary but have an appropriate domain and let $g(x) = \frac{1}{2}(f(x) + f(-x))$ and $h(x) = \frac{1}{2}(f(x) - f(-x))$.

Then $g(x)$ is guaranteed to be even and $h(x)$ odd; what is more, $f(x) = g(x) + h(x)$, and so we may reasonably term $g(x)$ to be the even part and $h(x)$ the odd part of $f(x)$. Put another way, any function that itself is neither odd nor even and that has an appropriate domain can be expressed as the sum of an odd function and an even function. For example, taking

$$f(x) = x^2 + x + 1 = (x^2 + 1) + x = g(x) + h(x)$$

results in figure 9.1, where the offset solid-line parabola is replaced by the one as a dotted line, symmetric about the y-axis, and the compensating dotted straight line with its rotational symmetry.

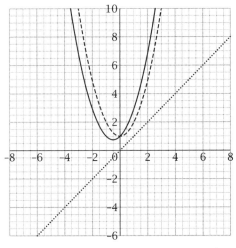

Figure 9.1. Even and odd parts of $f(x) = x^2 + x + 1$.

The game can be played with myriad functions but, unsurprisingly, the exponential function, $f(x) = e^x$, yields results of significance, where we arrive at figure 9.2. The compensating curve now rather looks like the tan function but of course it isn't, and the symmetric one rather like another parabola but it is equally clear that this is not the case either, with their defining equations $g(x) = \frac{1}{2}(e^x + e^{-x})$ and $h(x) = \frac{1}{2}(e^x - e^{-x})$. In modern terms, these define the two fundamental hyperbolic functions, $\cosh x$ and $\sinh x$, respectively, and it is $\cosh x$ that will attract our attention in this chapter; more than this, the

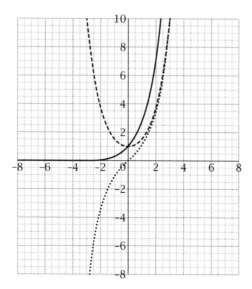

Figure 9.2. Even and odd parts of $f(x) = e^x$.

more general form $a\cosh(x/a) = \frac{1}{2}a(e^{x/a} + e^{-x/a})$ for $a > 0$ will be of interest to us, as with this we have the curve's most general form: the *catenary*. If we were deceived into thinking that shape to be parabolic, we would be in good company: Galileo seems to have thought so, and others before and after him certainly believed so. Not, though, in connection with odd or even functions; not in fact in connection with functions at all, but in the context of an extrapolation from a dynamical observation that is true to a statical one that isn't.

9.2 Historical Errors

In 1633 the Roman Inquisition consigned Galileo's *Dialogue Concerning the Two Chief World Systems* to the "Index of Forbidden Books", and in doing so committed the great error of denying the Copernican while favouring the Ptolemaic system: the earth was undeniably the centre of the universe and it was heresy to say otherwise; a belief to which Galileo was forced to accede even though the comment "and yet it moves" (referring to the earth) was afterwards attributed to him. Small wonder his subsequent and final publication, *Discourses and Mathematical Demonstrations Relating to Two New Sciences* (the *Discorsi*) of 1638, was published in Holland, remote from the Inquisition's influence. Both works took the form of a dialogue between characters (not

a new form and not at all an unusual one) and between them they contain some of the foundations of scientific principles and conclusions upon which we rely today: it is not for nothing that Galileo is multiply referred to as the *father of ...*, with the ellipsis replaced by some scientific noun. In these early struggles with modern scientific method and deep ideas, we cannot be surprised at the appearance of misjudgements, as Galileo himself was aware. At the end of Day Three in the *Discorsi*, and after theorem VI, Galileo had his character Salviati comment rather poetically:[1]

> Salviati: But profound considerations of this kind belong to a higher science than ours. We must be satisfied to belong to that class of less worthy workmen who procure from the quarry the marble out of which, later, the gifted sculptor produces those masterpieces which lay hidden in this rough and shapeless exterior.

Since Salviati represents the then-contemporary Galileo, one wonders who, compared with him, might justly be described as gifted. Still, he had erred in Day Two, after he had correctly argued that the path of a projectile subject to negligible air resistance is a parabola, when Salviati is caused to comment:

> Salviati: There are many ways of tracing these curves; I will mention merely the two which are the quickest of all. One of these is really remarkable; because by it I can trace thirty or forty parabolic curves with no less neatness and precision, and in a shorter time than another man can, by the aid of a compass, neatly draw four or six circles of different sizes upon paper. I take a perfectly round brass ball about the size of a walnut and project it along the surface of a metallic mirror held in a nearly upright position, so that the ball in its motion will press slightly upon the mirror and trace out a fine sharp parabolic line. ...
> ... The other method of drawing the desired curve upon the face of the prism is the following: Drive two nails into a wall at a convenient height and at the same level; make the distance between these nails twice the width of the rectangle upon which it is desired to trace the semi-parabola. Over these two nails hang a light chain of such a length that the depth of its sag is equal to the length of the prism. This chain will assume the form of a parabola, so that if this form be marked by points on the wall we shall have described a complete parabola which can be divided into two equal parts by drawing a vertical line through a point midway between the two nails.

[1] Throughout, we rely on the 1914 version of the authoritative translation by Henry Crew and Alfonso de Salvio.

The first part of the dialogue is, of course, correct; the second part is wrong. Not significantly wrong, certainly not in any practical way, but there is a discrepancy between the parabola and the shape of the associated hanging chain, as we see in figure 9.3. The aspect ratio Galileo has imposed is 2:1, and if we take an interval $-1 \leqslant x \leqslant 1$, the equation of the parabola is $y = x^2$, which is shown as the dotted line; the shape that the hanging chain would assume given the same constraint is shown as a solid line. At once a tiny difference, but also a world of difference. Yet, Galileo hedged. The same ideas were taken up once more at the end of Day Four with the following dialogue:

> Salviati: Besides I must tell you something which will both surprise and please you, namely, that the chord stretched more or less tightly assumes a curve which closely approximates the parabola. The similarity is clearly seen if you draw a parabolic curve on a vertical plane and then invert it so that the apex will lie at the bottom and the base remain horizontal; for, on hanging a chain below the base, you will observe that, on slackening the chain more or less, it bends and fits itself to the parabola; and the coincidence is more exact in proportion as the parabola is drawn with less curvature or, so to speak, more stretched; so that using parabolas described with elevations less than 45° the chain fits its parabola almost perfectly.

> Sagredo: Then with a fine chain one would be able to quickly draw many parabolic lines upon a plane surface.

> Salviati: Certainly and with no small advantage as I shall show you later.

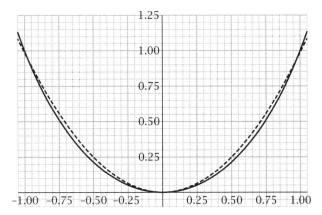

Figure 9.3. A small discrepancy.

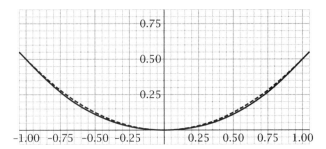

Figure 9.4. A smaller discrepancy.

There was to be no *later* for this matter but Galileo had moved from certainty to approximation: quite why he allowed both levels of conviction to remain in his dialogues we can only speculate, but it would be wonderful to know. If we take the interval as $-1 \leqslant x \leqslant 1$ once more, the parabola $y = \frac{1}{2}x^2$ is inclined at $45°$ at its ends, and is shown as the dotted curve in figure 9.4. The aspect ratio is now $2:\frac{1}{2} = 4:1$ and the hanging chain according to this new specification is again the solid line.

The great scientist certainly had a point, imprecise though that point was. Whatever Galileo thought about the shape of a hanging chain, in suggesting the shape to be a parabola he was adhering to accepted wisdom: it was generally agreed before and after him that a chain hangs as a parabola, yet (for obvious reasons) a correct proof had proved elusive. Most particularly, René Descartes had been asked by his friend and correspondent the Flemish mathematician Isaac Beeckman to confirm the suggestion, though with no evidence that Descartes responded. After all, the conic sections were very well understood and had served nature so well for so long, with the circle in many appearances, Kepler's laws involving the ellipse and, as we have seen, Galileo's own work with the parabola as the path of a projectile: the conic was the obvious candidate for purpose and the parabola the most obvious among them for the curve that a hanging chain would assume. Whatever the physical problem, the candidature of the conics for its solution would have been preeminent – a point emphasized once again in the Third Day of the *Discorsi*, where we have theorem XXII stating that the path of an arc of a circle is a faster route from a higher to a lower point on the circle than the chord joining them, and that:

> From the preceding it is possible to infer that the quickest path of all from one point to another, is not the shortest path, namely, a straight line, but the arc of a circle.

It isn't; the curve is the *brachistochrone*.

In making the mistake that a chain would hang as a projectile moved, Galileo was deceived by his eye and accepted lore, rather than being deceived by a lapse in his profound analytical mind: even Homer nods. He simply did not possess the mathematical apparatus to allow him to draw a correct conclusion, and anyway, locally, as we have seen, the catenary does look like a parabola and the parameters can be altered to make the semblance compellingly strong – at least within the limits of the length of a chain. It fell to the precocious Christiaan Huygens,[2] at the age of seventeen, to show that the curve was not a parabola and, furthermore, to provide what additional constraints were needed to make it so. In a letter of 28 October 1646 to Father Marin Mersenne, a man whom we have already mentioned and whose correspondence with Europe's thinkers is legendary, the young Huygens (1638–1656) made the promise

> to send you in another letter the demonstration that a hanging rope or chain does not make a parabola, and what must be the pressure on the mathematical chord or chain to make it so; I have found the demonstration not long ago.

Following Mersenne's enthusiastic response, Huygens fulfilled his promise in a letter dated that November, where he presented his arguments as a series of nine propositions based on Euclidean ideas, central among them the concept of similar triangles. He moved from an initial model wherein the chain is modelled by a weightless cord on which are attached evenly spaced identical weights, to the model in which the point weights are replaced by weighted line segments. In modern terms he recognized that a parabola is determined by any three non-collinear points on his chain and argued that the other points cannot lie on that parabola. As to the pressure that would cause the chain to hang as a parabola: distribute the weights evenly on the chain, not measured along the chain itself, but along the horizontal line below it, and his propositions 11 and 12 provide the argument. We will consider the important implications of this adjustment in the next section.

His proofs may be judged sound but are wordy, through a mixture of rhetoric and symbolism presenting the case at hand and leading the reader to accept it as the only reasonable avenue. But the inherent danger of an excess of rhetoric in a mathematical argument is that it can mislead. Having corrected one historical error, he made his own

[2] Using methods that he will have gleaned from his study of the works of Simon Stevin.

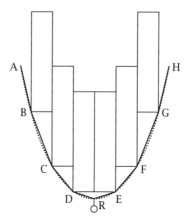

Figure 9.5. Huygens's error.

with his final statement, which he trumpets under the title *Manifestum.*
$\phi\alpha\upsilon\,\epsilon\rho\delta$; the Latin and Greek words for "evident". And this is what was
evident, referring to his own figure, which is our figure 9.5:

> Hence it is clear that if on the string ... might be placed little beams
> or parallelepipeds of equal weight size and shape, the points A, B, C
> etc. press on the string, each one on the same parabola.

Again, a predominantly verbal argument convinced Huygens, but this
time led him astray. Actually, the parallelepipeds push the string out-
wards in a normal direction at each touching corner, which will deform
the string towards an arc of a circle. Twenty-two years later, older
and much wiser, in a marginal note he admitted his mistake with the
comment "It does not follow and is not true".

As the years passed, the non-parabola proofs were clarified: the little-
known German scientist Joachim Jungius was one who provided such,
but perhaps most notably, in 1673 the Jesuit Father Ignace Gaston Par-
dies used more elegant methods to achieve the result (see Pardies 1725,
pp. 280–81). With these, the comfortable and reasonable assumption
that the parabola was the solution to the shape of the hanging chain
was put to the sword: the scientific world then knew what the shape
wasn't, but not what it was.

9.3 The Curve Identified

The problem festered. The mathematical store of curves had signifi-
cantly expanded yet it remained unknown which among them, if any,
would trace the shape of a hanging chain, even though the question

had continued to be asked by mathematicians of significance. If not a conic, then what? The vague answer was that it must be a *mechanical curve*; one not amenable to Greek construction with a straight edge and compass, but one borne of nature (see chapter 5).

It is not unusual today to broadcast a great problem in the hope that it will reach someone who will solve it or, more dramatically, to collect together some particularly choice problems and put a price on their heads, as with the Millennium Problems, each with a $1 million bounty. The same was true in the seventeenth century but with the significant difference that such broadcasts were meant as challenges, exchanged between the notable academics of the day, issued by word or letter or, commonly and more publicly, through the medium of a contemporary journal. One such journal, particularly influential since it was co-founded and regularly contributed to by the great Leibniz, was the monthly publication *Acta Eruditorum*,[3] although it is perhaps most notable for its role as the principal organ of support of Leibniz in the great controversy of primacy over the invention of the calculus.[4] It was in the June 1696 issue that Johann I Bernoulli challenged the readership to identify the curve of quickest descent (the brachistochrone and not Galileo's arc of a circle) as a particle moves freely from a higher to a lower point, and in the May 1697 issue not only did Johann I's own solution appear but also those of Leibniz, the Marquis de l'Hôpital and that of the Bernoulli sibling Jacob I.[5] A few years earlier, in the May 1690 issue of that same journal, Jacob I had presented his solution to the problem of the *isochrone*: the curve along which a body will fall in the same amount of time from any starting position; he had also issued his own challenge to the scientific community, and specifically to Leibniz and his new calculus: to identify the shape of the hanging chain (Bernoulli 1690). As with the proverbial arrival of buses, in June 1691 three solutions appeared: those of Leibniz, Johann I Bernoulli and Christiaan Huygens. Huygens had returned to the problem after a 45-year gap with methods of 45 years ago; it was not for him to embrace the newly invented calculus.

Had Leibniz, the co-founder of calculus, and Bernoulli, one of its most staunch adherents, brought its power to bear? The answer to both

[3] In translation, *Reports of Acts of the Scholars*.

[4] *Transactions of the Royal Society* played the same role for Newton in England.

[5] Newton had also solved the problem anonymously, leading to Bernoulli's famous response "tanquam ex undue leonem" (we recognize the lion by its claw).

questions is "yes", but the readers of their arguments could be forgiven for thinking otherwise. The solutions they provided were styled as that of Huygens: Euclidean, geometric, involving complex diagrams, labyrinthine arguments and, for us, rather strange notation. At that time such a problem was considered solved if a construction was provided for the solution curve and it is this fact that drove their approach. No explicit calculus appeared and none of the constructions included any connection with a chain hanging freely from two level fixed points. We will pass by Huygens's solution, explain that of Leibniz, which is an epitome of its kind, and finally detail the concealed calculus of Bernoulli's approach.

Hidden within the tangle of lines that is Leibniz's figure and our figure 9.6 there lies a catenary, so labelled, and a second curve identified as *logarithmic* but that we would label as exponential.[6] His instructions that accompanied it are:

> Given an indefinite straight line ON parallel to the horizon, given also OA, a perpendicular segment equal to O3N, and on top of 3N, a vertical segment 3N3ξ, which has with OA the ratio of D to K, find the proportional mean 1N1ξ (between OA and 3N3ξ); then, between 1N1ξ and 3N3ξ then, in turn, find the proportional mean between 1N1ξ and OA; as we go on looking for second proportional means in this way, and from them third proportionals, follow the curve 3ξ-1ξ A-1(ξ)-3(ξ) in such a way that when you take the equal intervals 3N1N, 1NO, O1(N), 1(N)3(N), etc., the ordinates 3N3ξ, 1N1ξ, OA, 1(N)1(ξ), 3(N)3(ξ), are in a continuous geometric progression, touching the curve I usually identify as logarithmic. So, by taking ON and O(N) as equal, elevate over N and (N) the segments NC and (N)(C) equal to the semi-sum of Nξ and (N)(ξ), such that C and (C) will be two points of the catenary curve FCA(C)L, on which you can determine geometrically as many points as you wish.

Transparent this is not, but unravelling what to the modern eye are the combined tangles of his diagram and supporting argument reveals his broad scheme, which involves the exponential curve we would write as $y = ar^{x/a}$ and which passes through $(-a, ar^{-1}), (0, a), (a, ar)$, where a is a constant that will later be taken as the unit, to make division by it irrelevant and its logarithm 0. The two lines, labelled K and D to the left of the figure, determine the particular exponential in that $r = d/k$, the ratio of their lengths; and there is a hidden subtlety here, as we shall later see. He noted that, given points (x_1, y_1) and (x_2, y_2)

[6] These labels are modern additions to the figure.

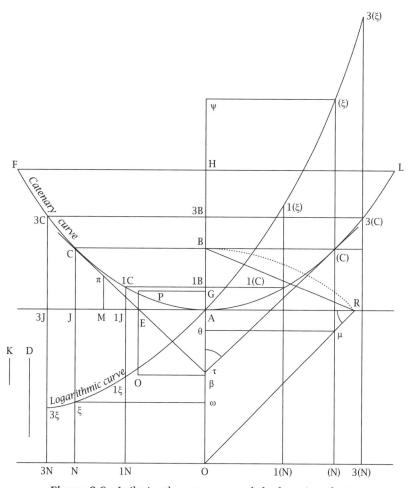

Figure 9.6. Leibniz, the catenary and the hanging chain.

lying on this curve, the point $(\frac{1}{2}(x_1 + x_2), \sqrt{y_1 y_2})$ also lies on it: a simple consequence of laws of indices. Using this fact the curve can be completed to any required extent by repeated application of the fact. From this, each pair of points on the curve $(x, ar^{x/a})$ and $(-x, ar^{-x/a})$ generate the pair of points on the catenary $(\pm x, \frac{1}{2}(ar^{x/a} + ar^{-x/a}))$ and so the catenary is constructed, point by point.

As to the connection with a hanging chain:

> This curve can be constructed, and traced very simply, by a physical type of construction, that is, by suspending a string, or better, a small chain (of variable length).

And one is left to wonder why.

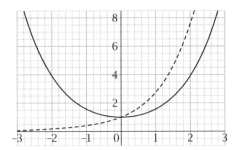

Figure 9.7. The exponential and the catenary.

Presumably tongue-in-cheek, he developed his argument into a phys-ical method of computing logarithms:

> And, as soon as you can determine its curve, you can discover all of the proportional means, and all of the logarithms that you wish to find, as well as the quadrature of the hyperbola. If the catenary curve is physically constructed, by suspending a string, or a chain, you can construct from it as many proportional means as you wish, and find the logarithms of numbers, or the numbers of logarithms. If you are looking for the logarithm of number Oω, that is to say, the logarithm of the ratio between OA and Oω, the one of OA (which I choose as the unit, and which I will also call parameter) being considered equal to zero, you must take the third proportional Oψ from Oω and OA; then, choose the abscissa as the semi-sum of OB from Oω and Oψ, the corresponding ordinate BC or ON on the catenary will be the sought-for logarithm corresponding to the proposed number.

So, let us suspend our chain against some vertical graph paper that, for reference, has drawn upon it as a dotted line the exponential func-tion $y = ar^x$, as shown in figure 9.7. For convenience we zoom in to figure 9.8, where the points labelled with capital letters are associated with the corresponding small letter: we seek the logarithm of w, located on the vertical axis below A.

To find the logarithm of w using the exponential curve, we need only move horizontally to meet the curve to yield Q on the horizon-tal axis, which is the number we seek. Yet, we must locate Q using the catenary alone and so we look for the point on the catenary vertically above Q, and to find this Leibniz instructed us to find the average of a and the *third proportional* of w and a. We have already met this term in chapter 5, but we remind the reader that this third proportional is the point Q on the vertical axis for which w, a and q are in geomet-ric sequence, which means we locate the point Q using $w/a = a/q$ and P by $p = \frac{1}{2}(w + q)$: to find the logarithm of w, compute q and

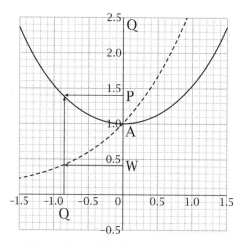

Figure 9.8. Calculating logarithms.

from this compute p, which is taken as a point on the vertical axis, and move across to meet the catenary, where the x coordinate found is the required logarithm.

Why does this prescription work? Leibniz did not mention an involved subtlety and we can expose the method and the subtlety using our previous notation. Write $w = ar^{\alpha/a}$ for some α, then we locate Q by

$$\frac{ar^{\alpha/a}}{a} = \frac{a}{q} \rightarrow q = ar^{-\alpha/a}$$

and therefore $p = \frac{1}{2}(ar^{\alpha/a} + ar^{-\alpha/a})$, with a the unit, $\alpha/a = \alpha$, which means that α is as it should be. If we revert to the exponential curve, though, Q will have been located at $\log ar^{\alpha} = \log a + \alpha \log r = 0 + \alpha \log r = \alpha \log r$ and so that ratio $r = d/k$ must be the base of his logarithms, and for the curve to a true catenary, as we have mentioned, its form must be $y = \frac{1}{2}a(e^{x/a} + e^{-x/a})$ and so that base d/k must be e. Of course, Leibniz knew this and in a subsequent detailed communication with the German baron Rudolf Christian von Bodenhausen, dated August 1691, he exposed his new calculus methods underlying the construction together with the admission that he had omitted one specification for his construction: $d/k = 2.7182818$.

So much for the solution of Leibniz. What of that of Bernoulli? As we have remarked, it was initially presented as opaquely as that of Leibniz, but his methods were to be exposed through notes made for the

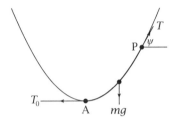

Figure 9.9. The statics of a hanging chain.

Marquis de l'Hôpital from his *Lectures on the Integral Calculus* of 1691–92, while he lived in Paris. First, the necessary elementary problem in statics, which reveals the defining equation of the catenary.

Let A be the lowest point of the hanging chain and P a point distant s along it, then the section AP is in equilibrium under the action of the three forces shown in figure 9.9: the horizontal tension, T_0 at A, its weight, mg (and since the chain is uniform, $mg = k_1 s$) and the tangential force T at P, which makes an angle ψ with the horizontal. Resolving forces accordingly, we have $T_0 = T \cos \psi$ and $k_1 s = T \sin \psi$, which immediately yield $s = k_2 \tan \psi$ to be the intrinsic equation of the curve, and with $dy/dx = \tan \psi$ we have $dy/dx = ks$.

This simple-looking differential equation will take work to solve, but before we look at Bernoulli's approach to it let us deal with the nature of Huygens "pressure", which results in the hanging chain assuming the shape of a parabola. Rather than assume the chain to be of significant weight, suppose that it is light and that equal weights are suspended from it at equal intervals measured along the horizontal; that is, the weight of the loaded chain at horizontal distance x from A is $k_1 x$. Now we have $T_0 = T \cos \psi$ and $mg = k_1 x = T \sin \psi$, which yield $x = k_2 \tan \psi$, and again with $dy/dx = \tan \psi$ we have $dy/dx = kx$ and so $y = kx^2 + c$. A parabola.

As to Bernoulli, he labelled his axes opposite to modern convention and so for him $dy/dx = a/s$. In order to construct the curve he needed to eliminate s, and to do so he proceeded as follows: $dy = a\,dx/s$ and so $(dy)^2 = a^2(dx)^2/s^2$, and since $(ds)^2 = (dx)^2 + (dy)^2$ we have

$$(ds)^2 = \frac{s^2(dx)^2 + a^2(dx)^2}{s^2}.$$

This means that

$$ds = \frac{dx\sqrt{s^2 + a^2}}{s} \quad \text{and} \quad dx = \frac{s\,ds}{\sqrt{s^2 + a^2}},$$

which when integrated yields

$$x = \sqrt{s^2 + a^2} \quad \text{and} \quad s = \sqrt{x^2 - a^2}.$$

Differentiating gives

$$ds = \frac{x\,dx}{\sqrt{x^2 - a^2}} = \sqrt{(dx)^2 + (dy)^2}.$$

Squaring and collecting terms results in $x^2(dy)^2 - a^2(dy)^2 = a^2(dx)^2$ and finally

$$dy = a\frac{dx}{\sqrt{x^2 - a^2}}.$$

For the modern mathematician, this is a differential equation which would now need solving – a stepping stone to the answer. Then, it was a formula which showed how the y increment of the curve is related to the corresponding x increment and thereby provided a method of plotting the curve point-by-point. For these seventeenth-century mathematicians, the solution had been found. What of an explicit equation of the curve? For this we have to wait 70 years and look to the efforts of another luminary.

9.4 Hyperbolic Functions

The irrationality of e had been established in 1737 by Euler (though not published until 1742) and so the nature of the considerably older important mathematical constant π pressed. It is then a justly celebrated result of the later eighteenth century that π was proved to be irrational, and it was Johann Lambert who decided the matter. One might, therefore, have forgiven him for trumpeting this result of 1761, yet it appeared merely as the first two-thirds of a paper presented to the Berlin Academy of Science (Lambert 1761).

The final third of the paper was devoted to quite different matters, ones that developed a comparison between *quantitiés circulaire* and *quantitiés transcendentes logarithmique*: what we now term circular and hyperbolic functions. His was not the first footprint in the sand: Euler (inevitably) had considered the expressions $\frac{1}{2}(e^x \pm e^{-x})$ but his interest in them was as a means to an end, using complex powers to develop infinite products for sine and cosine; the other notable contribution was from a man whose martial legacy is more significant than his contributions to mathematics. Le Chevalier François Daviet de Foncenex had

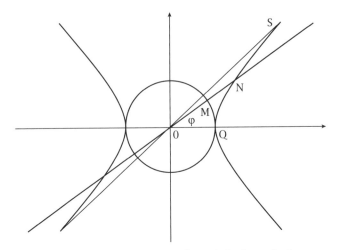

Figure 9.10. The unit circle and the hyperbola.

suggested that the connection between what are now called circular and hyperbolic functions can best be exposed by contrasting the unit circle with the unit hyperbola. His own principal interest was in the disputed meaning that could be given to logarithms of negative numbers, which inevitably led once again to complex numbers – and the uncomfortable idea of the ratio $1:\sqrt{-1}$. Lambert's interest was otherwise: he sought comparison of what we would term the natural parametrization of the circle with that of the hyperbola. So, before we immerse ourselves in some of Lambert's detail, let us be clear that in our terms its purpose was to establish the parametrization $x = \frac{1}{2}(e^u + e^{-u})$, $y = \frac{1}{2}(e^u - e^{-u})$ for the standard hyperbola $x^2 - y^2 = 1$, compare this with the standard parametrization $x = \cos u$, $y = \sin u$ for the unit circle $x^2 + y^2 = 1$, and so bring into existence the hyperbolic functions, to develop properties of them and to give them what he deemed a natural notation. We look, then, at that last third of that 1761 paper.

Since the interest is with the interrelationship between the coordinates of points on the unit circle $x^2 + y^2 = 1$ and the unit hyperbola $x^2 - y^2 = 1$, it was natural to draw a diagram including both of them and this is what we do in figure 9.10, which is extracted from Lambert's own figure. In addition to the two conics there is the line, passing through the origin (with gradient less than 1) and making an angle φ with the positive x-axis and which intersects the circle at M and the hyperbola at N. There is also a lighter line, incrementally steeper than this and intersecting the hyperbola at S, the purpose of which we shall soon see. With the coordinates of N taken by Lambert to be (ξ, η), evidently,

$\tan \varphi = \eta / \xi$, and from the hyperbola's definition,

$$1 + \eta^2 = \xi^2 = \eta^2 \cot^2 \varphi \quad \text{and} \quad \xi^2 - 1 = \eta^2 = \xi^2 \tan^2 \varphi.$$

We have, then,

$$\xi = \frac{1}{\sqrt{1 - \tan^2 \varphi}} \quad \text{and} \quad \eta = \frac{\tan \varphi}{\sqrt{1 - \tan^2 \varphi}}.$$

Here, then is a parametrization of the hyperbola in terms of the angle φ, which does not serve purpose. To move forward, call the area ONQ between the line, the hyperbola and the x-axis the letter A and define the parameter $u = 2A$.

We already have

$$\text{ON}^2 = \xi^2 + \eta^2 = \frac{1}{1 - \tan^2 \varphi} + \frac{\tan^2 \varphi}{1 - \tan^2 \varphi} = \frac{1 + \tan^2 \varphi}{1 - \tan^2 \varphi},$$

and with this Lambert took the crucial step of moving to infinitesimals. The second line, OS, is incrementally steeper than ON by the angle $d\varphi$, and ONS may be approximated by the sector of a circle of radius ON (OS). Using $\frac{1}{2} r^2 \theta$ for the area of a sector of a circle,

$$dA = \tfrac{1}{2} \text{ON}^2 d\varphi \rightarrow \tfrac{1}{2} du = \frac{1}{2} \frac{1 + \tan^2 \varphi}{1 - \tan^2 \varphi} d\varphi.$$

And so

$$du = \frac{1 + \tan^2 \varphi}{1 - \tan^2 \varphi} d\varphi.$$

From this, the chain rule gives us

$$\frac{d\xi}{du} = \frac{d\xi}{d\varphi} \frac{d\varphi}{du}$$

$$= -\frac{1}{2} \times \frac{1}{(1 - \tan^2 \varphi)^{3/2}} \times -2 \tan \varphi \sec^2 \varphi \times \frac{1 - \tan^2 \varphi}{1 + \tan^2 \varphi}$$

$$= \frac{\tan \varphi}{\sqrt{1 - \tan^2 \varphi}} = \eta.$$

Similarly, $d\eta / du = \xi$ and we have two linked differential equations. A modern approach would be to differentiate to obtain

$$\frac{d\xi}{du} = \eta \rightarrow \frac{d^2\xi}{du^2} = \frac{d\eta}{du} = \xi$$

and use the theory of differential equations to progress – which did not then exist. Instead, Lambert took infinite series forms in terms of u for each of ξ and η,

$$\xi = 1 + Au^2 + Bu^4 + Cu^6 + \cdots \quad \text{and} \quad \eta = au + bu^3 + cu^5 + du^7 + \cdots,$$

arguing that, when $u = 0$, $\xi = 1$ and $\eta = 0$. Further, that if the line is reflected in the x-axis, u becomes negative, ξ remains unchanged and η becomes negative and so the powers are as suggested. Differentiating one of the series and equating to the other results in

$$\xi = 1 + \frac{u^2}{2!} + \frac{u^4}{4!} + \frac{u^6}{6!} + \cdots \quad \text{and} \quad \eta = u + \frac{u^3}{3!} + \frac{u^5}{5!} + \frac{u^7}{7!} + \cdots.$$

With the known series for

$$e^u = 1 + u + \frac{u^2}{2!} + \frac{u^3}{3!} + \cdots$$

he could write

$$\xi = \tfrac{1}{2}(e^u + e^{-u}) \quad \text{and} \quad \eta = \tfrac{1}{2}(e^u - e^{-u}).$$

The required parametrization of the hyperbola had been achieved and two new functions had been born, ones that stood natural comparison with $\sin u$ and $\cos u$ – and ones that deserved names. Lambert christened them in a paper of 1768, when he returned to transcendental logarithmic functions and pursued their similarity with circular functions. Once again, referring to figure 9.10, if we look to the circle,

$$\tan \varphi = \frac{\text{MP}}{\text{OP}} = \frac{\sin \varphi}{\cos \varphi},$$

and to the hyperbola,

$$\tan \varphi = \frac{\text{NR}}{\text{OR}} = \frac{\xi}{\eta} = \frac{\text{sinhyp } \varphi}{\text{coshyp } \varphi}.$$

"For this reason I will call the abscissa the hyperbolic cosine and the ordinate the hyperbolic sine", wrote Lambert.

In short, tables of circular functions could be replaced by tables of hyperbolic functions. For this new tool to be useful, though, the equivalent of the list of trigonometric identities, feared by many high school students, was needed, and Lambert continued his paper by developing such. Two columns list many of the trigonometric identities, together

with the hyperbolic equivalents, many of which he noted are precisely the same and others differ simply by a minus sign: $\cos^2 y - \sin^2 y = \cos 2y$ and $\mathrm{coshyp}^2 y + \mathrm{sinhyp}^2 y = \mathrm{coshyp}\, 2y$, for example. And, he noted, the similarity extends to calculus results, with

$$\frac{\mathrm{d}}{\mathrm{d}x}\mathrm{coshyp}\, x = \mathrm{sinhyp}\, x \quad \text{and} \quad \frac{\mathrm{d}}{\mathrm{d}x}\mathrm{sinhyp}\, x = \mathrm{coshyp}\, x.$$

Time has passed and the notation has settled to $\cosh x = \frac{1}{2}(e^x + e^{-x})$ and $\sinh x = \frac{1}{2}(e^x - e^{-x})$: what has not been standardized is their pronunciation. Far from the comparative simplicity of a parabola, we have the shape of the hanging chain identified as a transcendental curve, $y = \cosh x = \frac{1}{2}(e^x + e^{-x})$, or, more generally, $y = a\cosh(x/a)$, and from it we have an important analogy with the circular functions.

We have used the name catenary a number of times, but this anglicization was yet to come about, and to achieve it we shall have to turn the curve upside down.

9.5 The Chain Inverted

The reader familiar with Hooke's law of elasticity (tension is proportional to extension) might be surprised to learn that its first appearance was in the form *ceiiinosssttuu*, a code that would be difficult enough to break today let alone in the late seventeenth century. In an era of scientific polymaths, Robert Hooke was prominent among them, and in an era of scientific curmudgeons, he was equally prominent, at least in his later years. A founding member of the Royal Society, in 1665 he was made its Curator of Experiments and was simultaneously Gresham Professor of Geometry, a surveyor and a very accomplished architect who was responsible for a number of great buildings[7] and who assisted Christopher Wren in rebuilding London after the Great Fire. A busy man, then. With these alphabetized letters he was declaring intellectual ownership of a significant result, but one that sat waiting its turn for a published, detailed explanation. And the queue of these pending disclosures was long. The coded sequence appeared at the end of a 32-page paper of 1676, written by Hooke entitled "A description of helioscopes and some other instruments". As he reached the end of his explanations of various scientific instruments he wrote:

[7] For example, the Royal College of Physicians, Montagu House and, rather less savoury, Bethlehem Hospital – known as Bedlam.

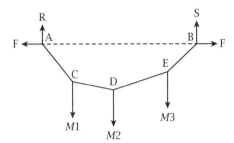

Figure 9.11. A weighted chain.

To fill the vacancy of the ensuing page, I have here added a decimate of the centesme of the Inventions I intend to publish, though possibly not in the same order, but as I can get opportunity and leasure [sic]; most of which, I hope, will be as useful to Mankind, as they are yet unknown and new.

With this philosophy, it would appear unfair that in that same year he was lampooned as the character Sir Nicholas Gimcrack in Thomas Shadwell's extremely successful comedy *The Virtuoso*; this satire on the Royal Society was a critique on the folly of intelligent men pursuing pointless scientific avenues with their associated experiments. There was nothing pointless about the third of that decimate:

The True Theory of Elasticity or Springiness, and a particular Explication thereof in several Subjects in which it is to be found: And the way of computing the velocity of bodies moved by them. Ceiiinossssttuu

It was to be two years later, in 1678, that he decoded the sequence to the Latin phrase *ut tensio, sic vis*, which translates to "as the extension, so the force", and which admits the interpretation "extension is proportional to force" and so Hooke's law as we know it. Another encoding in that 1676 paper accompanied the second of his ten space-filling teasers, with

The true Mathematical and Mechanical form of all manner of Arches for Building, with the true butment necessary to each of them. A Problem which no Architectonick writer hath ever yet attempted, much less performed. abccc ddeeeee f gg iiiiiiii llmmmmmnnnnnnooprr ssstttttuuuuuuuux

In this case Hooke was not destined to provide the solution to his riddle, a task that was left to one Richard Waller, after Hooke's death in 1703. In Waller's great tome of some 570 pages describing Hooke's

life and unpublished work (Waller 1705), we find the decipherment *Ut pendet continuum flexile, sic stabit contiguum rigidum inversum*, which translates to "As hangs a flexible cable, so inverted, stand the touching pieces of an arch" – which, as Waller comments, is the *Linear Catenaria*. That is, Hooke was suggesting that the ideal shape of an arch is that of a freely hanging chain, only upside down. With this he had observed that building materials resist compression very well but are comparatively weak in their resistance to tension, the direct opposite of the hanging rope: the rope hangs under pure tension; invert it, change the material and the structure supports itself under pure compression. The ideal moves closer to reality when the chain, hanging as a catenary, has weights placed along it to cause it to assume a shape like that in figure 9.11, with each segment of the chain under its own tension. Replace the chain segments by rods and invert the figure to achieve figure 9.12. The rods are now under thrust and the figure maps out the thrust lines of the structure: if these are contained within it, all is well – otherwise... This would have been no surprise to the Scottish mathematician David Gregory, who, in 1697 and therefore prior to Waller's revelation of the decoding, had provided his own fluent and fluxion and somewhat imprecise calculus argument to identify the catenary as the shape of a hanging chain. He also commented:

> In a vertical plane, but in an inverted situation, the chain will preserve its figure without falling, and therefore will constitute a very thin arch or fornix:[8] that is, infinitely small, rigid and polished spheres, disposed in an inverted curve of a catenaria, will form an arch, no part of which will be thrust outwards or inwards by other parts, but, the lowest parts remaining firm, it will support itself by means of its figure. ... none but the catenaria is the figure of a true and legitimate arch or fornix. And when arches of other figures are supported, it is because in their thickness some catenaria is included.

The Royal Society's records show that Hooke and, indeed, Sir Christopher Wren had promised mathematical arguments to accompany the physical demonstrations that they had performed to corroborate their beliefs, but none such were delivered. And unless some epiphany visited Hooke late in 1675 or early 1676, his inclusion of the problem of the hanging chain on a waiting list was of necessity: his most private diary includes the phrase "Riddle of arch, of pendet continuum flexile..." in its entry of Sunday 26 September 1675, suggesting that a full mathematical justification had eluded him. The theory, though, was

[8] A vaulted or arched structure.

Figure 9.12. A weighted chain inverted

of secondary importance to the practice, which was demonstrated by those "pointless" experiments in the Royal Society, to which the design of the dome (actually, one of the three domes) of St Paul's cathedral in London bears testimony.

Perhaps the most famous example of this principle being put to use is the analysis of the safety of the cracked cupola of St Peter's Basilica. The structural state of the building had been a long-term concern and, after some years of investigations and reports, in 1743 Pope Benedict XIV called the distinguished scientist Giovanni Poleni to Rome to present his views. Poleni concluded that the dome was safe by dividing it vertically into tapered lunes (orange segments), as shown in the upper part of his figure XIV, which is our figure 9.13, and taking a light chain on which he distributed 32 weights proportional to the weight of corresponding sections of that lune. The lower part of figure 9.13 shows the chain hanging as a perfect catenary, together with the weighted chain, with the weights shown as circles; the size of each circle indicates the size of the weight, and notice the largest of them near the bottom of the chain, as those sections help to support the gigantic lantern. The dotted line in the upper part of the figure is the weighted chain's position within the lune – which fits entirely within it. The cupola was safe[9] – and it still stands. This historic principle remains one of contemporary importance, embodied as one of the *reciprocal theorems* of structural analysis as *Heyman's safe theorem* of 1966 and named after the distinguished engineer Jacques Heyman.

It is not at all difficult to find examples of catenary arches, whether the choice is a consequence of structural desirability or architectural allure, but we will avoid presenting a long list of such and also the painful experience of which to choose by selecting just one example. The surrealist architect Antonio Gaudí used his familiarity with geometric forms to produce many functional yet aesthetic and eccentric designs: Barcelona's Sagrada Familia and Casa Mila are two such which

[9] Horizontal iron bands were also placed around the lower part of the dome.

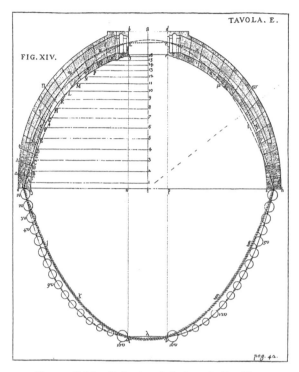

Figure 9.13. Poleni and St Peter's Basilica.

heavily feature the catenary. Another is the church of the Colònia Güell, of which only the crypt was completed. An astonishing exhibit in the Sagrada Familia Museum is his scale model of the church, constructed by hanging chains, weighted by small bags of shot, from the ceiling in a nearby shed, upon which he had drawn the floor plan of the church: a photograph was taken and inverted to reveal the overall design, which he painted to expose the proposed church in its imagined glory. The ghost of Poleni is everywhere present.

We have seen that the term *catenaria* was in use and indeed had been since 1690, when Huygens coined the word in a letter to Leibniz; not unnaturally, Huygens had extracted the word from the Latin *catena*, meaning *chain*. The shape was also known as the *chainette* or *chaine (corde) pendante* among several other variants, but the move to the modern form of *catenary*, although semantically small, was one made by a most unlikely source. Where there is an arch, there might be a bridge, and it is the catenary's role in bridge design that brought about the first mention of its modern name. In 1788 Thomas Jefferson

was the United States Minister of Finance as a preliminary to his escalation to become the country's third president in 1801. He had been sent to Europe to take part in trade negotiations and was resident in Paris: his frequent correspondent, the political activist and inventor Thomas Paine, was in England. For some time it had been Paine's view that wood and stone, the age-old materials from which bridges were built, should be replaced by iron, and he became involved in the design of an iron bridge to span the River Wear at Wearmouth, Sunderland. The investigation was of natural interest to the polymath Jefferson, whose views were of natural interest to Paine. As part of an exchange of letters between them regarding the shape the bridge should take, on 23 December 1788 Jefferson wrote from Paris:

> You hesitate between a catenary and a portion of a circle. I have lately received from Italy a treatise on the equilibrium arches, by the Abbé Mascheroni. It appears to be a very scientific work I have not yet had time to engage in it; but I find that the conclusions of his demonstrations are, that every part of the catenary is in perfect equilibrium. It is a great point, then, in a new experiment, to adopt the sole arch, where the pressure will be equally borne by every point of it.

Whether this extraordinarily busy man eventually found the time to study the communication of the Italian mathematician and cleric Lorenzo Mascheroni we know not, but *Nuove ricerche sull' equilibrio delle volte* ("New research on the equilibrium of vaults") of 1785 is some 144 pages long – and, understandably, written in Italian. It would appear, though, that through this paragraph written by a founding father of the United States and the principal author of its Declaration of Independence, the name of catenary entered the lexicon, as the shape not of a hanging chain but of the essential architecture of an iron bridge.

Mascheroni's justification for the catenary as the optimal shape of an arch appears as problem XIII of chapter 2 of his work, having carefully built a mathematical structure on which to support his argument: his final statement reads $dx : dy = s : a$, *the equation of a catenaria*.

We finish, though, on a negative note and with a second reference to Thomas Jefferson. The famous Gateway Arch in St Louis, Missouri is the main component of the winning entry in the 1947 competition for the design of the Jefferson National Expansion Memorial, in recognition of his "Louisiana Purchase" of a vast tract of land from France, which roughly doubled the size of America. The arch is commonly cited as an impressive example of the use of the inverted catenary but its shape is rather more complex than it might seem. And it does not involve a

catenary. Not a pure one, anyway. Eero Saarinen, the project's architect, contributed to the confusion with his own comments:[10]

> The arch actually is not a true parabola, nor is it a catenary curve. We worked at first with the mathematical shapes, but finally adjusted it according to the eye. I suspect, however, that a catenary curve with links of the chain graded at the same proportion as the arch thins out would come very close to the lines upon which we settled... The arch is not a true parabola, as is often stated. Instead it is a catenary curve – the curve of a hanging chain – a curve in which the forces of thrust are continuously kept within the center of the legs of the arch. ... [The Arch is] an absolutely pure shape where the compression line goes right through the center line of the structure directly to the ground. In other words, a perfect catenary.

In fact, the arch is designed as the extrusion of an equilateral triangle cross-section which diminishes in size and with the centroids lying on the curve with equation

$$y = 693.8597 - 68.7672 \cosh 0.0100333x$$

for $-299.2239 \leqslant x \leqslant 299.2239$.[11] With the multiples of cosh and of x unequal, this is not the equation of a pure catenary but of an inverted, *weighted* or *flattened* catenary, the general equation of which is

$$y = c - a \cosh \frac{x}{b} = c - \frac{a}{b}\left(b \cosh \frac{x}{b}\right);$$

an inverted catenary stretched vertically by a scale factor of a/b and flattened provided $a/b < 1$. In this case, $a/b = 68.7672 \times 0.0100333 = 0.6899619$, which means that the pure catenary has been flattened by a factor of 0.69; put another way, it has been flattened vertically by a little under a third. Pure it is not but beautiful it remains.

9.6 A Bumpy Road

Our final excursion into the world of the catenary takes us from its role in the design and implementation of an arch of great elegance and significance to its theoretical appearance as a whimsical road surface.

To elevate our centre of mass requires work, which requires energy. Better, then, not to. Understandably, we take for granted that our centre of mass remains at a constant level when we are cycling along a

[10] All of which can be found in the Saarinen archive held by Yale University.

[11] The measurements are in feet.

horizontal road, but that is to take for granted that the wheels of the
bicycle are circular; what if they are not? Suppose they are square, for
example. What then must be the shape of the road's surface that would
allow us to cycle "normally"? Of course, the answer is that it should be
in the shape of a catenary, or a sequence of them joined together. To
see this we first set down reasonable criteria for the smooth motion.

- The centre of the wheel must stay at a constant height above the
 horizontal.
- At every point of contact, the wheel must be tangent to the road's
 surface.
- The centre of the wheel should be directly above the point of
 contact.
- The distance along each segment of the surface of the road must
 be the same as the length of the side of the square wheel.

With these agreed, we summarize matters in three diagrams. Fig-
ure 9.14 shows the wheel as it completes one section of road and
starts another. It defines the x-axis, notes the square is of side $2a$
and specifies the constant height h of the centre of mass: of course,
$h = a\sqrt{2}$.

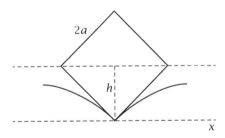

Figure 9.14. The wheel at a cusp.

Figure 9.15 shows the wheel at the top of the curve and sets up the
y-axis and the origin of coordinates.

Finally, figure 9.16 shows the general position wherein the wheel is
inclined at an angle θ to the horizontal, with the dynamic point of
contact with the curve given as (x, y).

From figure 9.16 we have

$$a = (h - y)\cos\theta = \frac{h - y}{\sec\theta} = \frac{h - y}{\sqrt{1 + \tan^2\theta}} = \frac{h - y}{\sqrt{1 + (dy/dx)^2}},$$

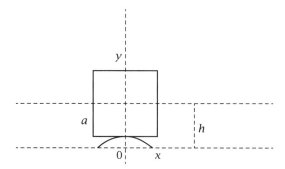

Figure 9.15. The wheel at the top.

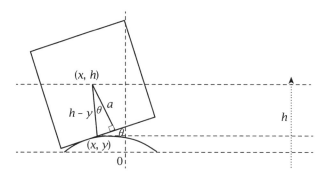

Figure 9.16. The wheel at a general position.

which means that

$$\frac{dy}{dx} = \pm\sqrt{\left(\frac{h-y}{a}\right)^2 - 1}$$

and, taking the rising component,

$$\int \frac{1}{\sqrt{(h-y)^2 - a^2}}\,dy = \frac{1}{a}\int dx,$$

$$-\cosh^{-1}\frac{y-h}{a} = \frac{x}{a} + c \rightarrow y = -a\cosh\left(\frac{x}{a} + c\right) + h.$$

From figure 9.15, when $x = 0$, $y = h - a$, which means that $\cosh c = 1$ and so $c = 0$. The equation of the road's surface is, then,

$$y = h - a\cosh\left(\frac{x}{a}\right) = a\sqrt{2} - a\cosh\left(\frac{x}{a}\right)$$

and we have our (inverted) catenary.

Note that at the join of two sections of road, $y = 0$, and with $h = a\sqrt{2}$ we have

$$\frac{\mathrm{d}y}{\mathrm{d}x} = \pm\sqrt{\left(\frac{a\sqrt{2} - 0}{a}\right)^2 - 1} = \pm 1,$$

so the wheel fits nicely.

As to the length of the section, if we integrate between $x = 0$ and $x = x_1$, where the curve meets the horizontal, we have

$$s = 2\int_0^{x_1} \sqrt{1 + \left(\frac{\mathrm{d}y}{\mathrm{d}x}\right)^2}\,\mathrm{d}x = 2\int_0^{x_1} \sqrt{1 + \left(\frac{h - y}{a}\right)^2 - 1}\,\mathrm{d}x$$

$$= 2\int_0^{x_1} \frac{h - y}{a}\,\mathrm{d}x = 2\int_0^{x_1} \cosh\frac{x}{a}\,\mathrm{d}x = 2\left[a\sinh\frac{x}{a}\right]_0^{x_1}$$

$$= 2a\sinh\frac{x_1}{a},$$

where

$$0 = a\sqrt{2} - a\cosh\left(\frac{x_1}{a}\right) \rightarrow \cosh\left(\frac{x_1}{a}\right) = \sqrt{2} \rightarrow \sinh\left(\frac{x_1}{a}\right) = 1.$$

The length of each section is precisely the length of the side of the square - and we can cycle freely. In fact, the wheels of the bicycle can be in the shape of any convex, regular polygon - apart from an equilateral triangle, as the reader may wish to investigate.

With this unconventional conveyance we reach the end of this particular journey.

Elliptic Curves

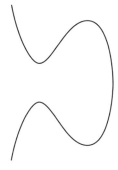

Why These Curves?

Elliptic curves have a name that is confusing and an evolution that stretches back to Ancient Greece, passes through India and Arabia to Europe, and that reaches contemporary world-wide mathematics. They appear in classical physics with the analysis of a simple pendulum (see appendix F) and in modern physics in string theory, in topology in the esoteric theory of cobordism, and in number theory, where their use ranges from the recondite inverse Galois problem through to the solution of Diophantine equations (including the famous Fermat's Last Theorem) and to the factorization of (large) integers. They form a critical component of what is the most powerful method of computer-based encryption in use today, and it is no hyperbole to suggest that their contemporary role renders them among the most significant curves of the twenty-first century. In short, they are a multi-faceted mathematical tool, the Swiss army knife of mathematical curves. Serge Lang, mathematician and prolific author, started the foreword of one of his many monographs with the comment, "It is possible to write endlessly on elliptic curves. (This is not a threat)" (Lang 1978): we have but a few pages to tell a story that might otherwise occupy volumes.

10.1 Elliptic Ambiguity

We begin this chapter by prevaricating over the definition of the curve that is its focus. What, precisely, *is* an elliptic curve? We offer three definitions, attractive only to the tutored eye.

- An elliptic curve E over a field K is a non-singular cubic curve E over K together with a given point $O \in E(K)$.

- An elliptic curve is a projective variety isomorphic to a non-singular curve of degree 3 in P^2 together with a distinguished point $O \in E$.

- An elliptic curve is a non-singular projective curve of genus 1, which is an Abelian variety under the group law.

All of which suggests that they can be quite complicated. The message is the same, although it is conveyed through slightly differing advanced vocabulary, the meaning of which need not occupy us much. Between them they tell us that an elliptic curve is a special case of a cubic curve (which is not the curve of a cubic function of x) and, more than this, it naturally lives in projective space, which allows it to be connected to "a point at infinity" and this allows a natural algebraic structure. There is more, though: it is a decidedly awkward integrand, particularly over the complex numbers, and thereby defines an *elliptic integral* whose inverse function is of fundamental importance. And to these observations we could add yet more. The central difficulty in defining the curve is that the definition is dependent on the individual who has been asked, and we will avoid all manner of subtlety by confining ourselves to one that may be described as "popular" but that is suitable to our own needs; in doing so, we will extract but a few of the tools from that Swiss army knife. We will begin, though, by looking to its misleading name, since, whatever else it is, it is not an ellipse.

The standard equation of an ellipse with (assumed) semi-major axis a and semi-minor axis b is $x^2/a^2 + y^2/b^2 = 1$ and it is a simple matter of scaling to establish its area from that of the unit circle: stretch scale factor a in the x-direction to the ellipse with area πa and then by a scale factor b in the y-direction to our ellipse with area πab. Alternatively, the problem is one of simple integration, but neither scaling nor integration can yield an elementary expression for the ellipse's circumference, with the linear stretch in the two directions now a far more complex matter to deal with. We can approximate it, of course, as Isaac Newton and, following him, John Wallis did in seventeenth century,

using infinite series. Or as Ramanujan (1962)[1] did in the twentieth century, with one of his more striking attempts giving the circumference as

$$\pi\left\{(a+b) + \frac{3(a-b)^2}{10(a+b) + \sqrt{a^2 + 14ab + b^2}} + \varepsilon\right\},$$

where $\varepsilon \sim 3ak^{20}/68719476736$. Or as many others did between these two mathematical luminaries. Yet an expression in closed form – that is, in terms of the usual combination of polynomials, rational, trigonometric, logarithmic or exponential functions – necessarily proves elusive, as it is impossible to express it as such (although it had to wait until 1883 for this fact to be rigorously established).[2] What, then, is this most difficult integral? In Cartesian coordinates, the formula for arc length is

$$\int\sqrt{1 + \left(\frac{dy}{dx}\right)^2}\, dx$$

and with a little algebraic manipulation we arrive at the circumference of the ellipse as

$$4\int_0^a \frac{\sqrt{a^2 - k^2x^2}}{\sqrt{a^2 - x^2}}\, dx,$$

with $k = \sqrt{a^2 - b^2}/a$ the ellipse's eccentricity; this k is independent of the size of the ellipse and describes its shape, it is left to the a to describe its size. The substitution $x = at$ produces the form

$$4a\int_0^1 \frac{\sqrt{1 - k^2t^2}}{\sqrt{1 - t^2}}\, dt$$

and if we write

$$\pi(k) = 2\int_0^1 \frac{\sqrt{1 - k^2t^2}}{\sqrt{1 - t^2}}\, dt,$$

the circumference of the ellipse with semi-major axis a and eccentricity k is $2\pi(k)a$, generalizing the $2\pi r$ of the circle. If we rationalize the numerator, the integrand becomes $(1 - k^2t^2)/\sqrt{(1 - t^2)(1 - k^2t^2)}$, an expression that can be recognized to be of a type with its form usually written as $R(t, \sqrt{(1 - t^2)(1 - k^2t^2)})$; that is, it is an example of a rational expression obtained from t and the square root by adding, subtracting,

[1] An exact derivation appears in Villain (2008).

[2] Proved by Liouville (1833).

multiplying and dividing, which is itself an example of the general form $R(t, \sqrt{at^4 + bt^3 + ct^2 + dt + e})$. The quartic under the root sign (which by change of variable is equivalent to a cubic) stands in contrast to any expression of the form $R(t, \sqrt{at^2 + bt + c})$, which can always be integrated (often with the use of the sneaky $u = \tan \frac{1}{2}t$ substitution): it is testament to the serendipitous nature of integration that we can integrate in elementary terms[3]

$$\frac{t^2 + t + 1 - (t^6 + t^5 + 2)\sqrt{t^2 + 2t + 1}}{t^4 - 6\sqrt{t^2 + 2t + 1}}$$

but not $1/\sqrt{t^3 - 1}$. So, how can these more complicated integrals be attacked? The names of a long list of luminaries attach themselves to the question, but it is the Frenchman Adrien-Marie Legendre who is most prominent among them. An encyclopaedic three-volume work of 1811–1816, the culmination of 40 years of study, included the fact that all cases of the form can be reduced to a combination of rational functions, elementary transcendental functions and the three additional *elliptic integrals* of

- the first kind, $\displaystyle\int \frac{1}{\sqrt{(1 - t^2)(1 - k^2t^2)}}\, dt$;

- the second kind, $\displaystyle\int \sqrt{\frac{1 - k^2t^2}{1 - t^2}}\, dt$; and

- the third kind, $\displaystyle\int \frac{1}{(1 - nt^2)\sqrt{(1 - t^2)(1 - k^2t^2)}}\, dt$.

With their close association, it is understandable that these three have been assigned a collective name and, with the second of them the integral for the rectification of the ellipse, it is equally understandable that the name for them is what it is, confusing though it may be.[4] We have, then, the concept of *elliptic integrals*, but not yet of *elliptic curves*. For us, these lie concealed within the integrands. Consider our integral for the perimeter of an ellipse in its rationalized form and the term inside the square root and write

$$v^2 = (1 - t^2)(1 - k^2t^2) = (t - 1)(t + 1)(kt - 1)(kt + 1)$$

$$= k^2(t - 1)(t + 1)\left(t - \frac{1}{k}\right)\left(t + \frac{1}{k}\right).$$

[3] Although it is best left to a computer to do so.

[4] For example, Count Fagnano (1682–1766) discovered that the arc length of the lemniscate can be expressed in terms of the elliptic integral of the first kind.

The right-hand side is a quartic in t having distinct roots $t = \pm 1, \pm 1/k$ (since $k \neq \pm 1$). If we now divide both sides by $(t-1)^4$, we have

$$\left(\frac{v}{(t-1)^2}\right)^2 = k^2 \frac{(t+1)(t-1/k)(t+1/k)}{(t-1)(t-1)(t-1)}$$
$$= k^2 \left(\frac{t-1+2}{t-1}\right)\left(\frac{t-1+1-1/k}{t-1}\right)\left(\frac{t-1+1+1/k}{t-1}\right)$$
$$= k^2 \left(1 - \frac{\alpha}{t-1}\right)\left(1 - \frac{\beta}{t-1}\right)\left(1 - \frac{\gamma}{t-1}\right).$$

If we reframe this in terms of $x = 1/(t-1)$ and $y = v/(t-1)^2$, we have the appearance of an equation of the form $y^2 = ax^3 + bx^2 + cx + d$ with three distinct real roots; the quartic has been reduced to a cubic and we are near to the definition of the elliptic curve we wish to adopt.

There is also a natural hierarchy to polynomial plane curves, expressed in terms of the degree of their Cartesian equations: that is, the maximum power of any term, or product of terms when the powers in that product are added. With all other than x and y constants, the straight line, of degree 1, $hx + iy + j = 0$, extends to the conic sections of degree 2, $ex^2 + fy^2 + gxy + hx + iy + j = 0$, and this to the degree-3 cubic curves,

$$ax^3 + by^3 + cx^2 y + dxy^2 + ex^2 + fy^2 + gxy + hx + iy + j = 0,$$

which is where we will stop. Isaac Newton, in a comprehensive study of such cubic curves (Newton 1667), showed that by imaginative choice of axes and without loss of generality this general form can be reduced to just four types, later to be compacted by Karl Weierstrass into what has become known as the *Weierstrass (long) form* $y^2 + axy + by = x^3 + cx^2 + dx + e$, the four essentially different examples of which are shown in figure 10.1: non-singular with three distinct real roots, non-singular with one real root, singular with a self-intersection and singular with a cusp. So, in our terms, a cubic curve is not that of high school mathematics, with dependent variable y, but must include the term y^2 in its equation. This Weierstrass long form is generally capable of further simplification, first by completing the square in y on the left and invoking the change of variable $y \rightarrow y + \frac{1}{2}(ax + b)$, which results in the form $y^2 = x^3 + ax^2 + bx + c$; second, the cubic on the right can be "depressed" to one in which the squared term vanishes using the substitution $x \rightarrow x + \frac{1}{3}a$,[5] which completes to the pleasant

[5] A trick bequeathed to us by Niccolò Tartaglia, whose (literally) poetic form of the solution of the cubic equation may be of interest.

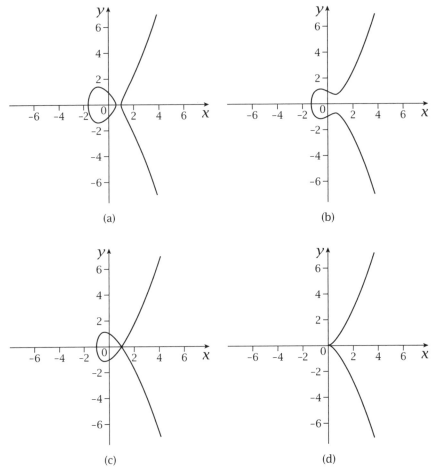

Figure 10.1. Four types of cubic curve.

form $y^2 = x^3 + ax + b$, the *Weierstrass short form* and the one that
Newton confusingly termed "diverging parabolas". We will require that
the curve is non-singular (which means that that its discriminant $4a^3 +
27b^2 \neq 0$), and with this we move another step closer to our definition
of an elliptic curve: it is a cubic curve with equation $y^2 = x^3 + ax + b$,
where $4a^3 + 27b^2 \neq 0$. Figure 10.1(a) and (b) typify the form, with (c)
and (d) denied by the condition of non-singularity.

To complete our definition of an elliptic curve we need a final compo-
nent, and by way of motivation for this, and also to expose the curve's
typical appearances in elementary number theory, we allow ourselves
a little digression.

10.2 **Problems, Problems, Problems**

Number theory is a branch of mathematics that, in both its analytic and algebraic forms, is apt to pose deceptively difficult questions. Indeed, two of the remaining unsolved Millennium Problems stem from these branches, and at this chapter's end we will mention them once more. Two names in particular from the subject's long history force themselves into any treatment of early questions: Diophantus, whom we can infer lived in the third century CE; and Pierre de Fermat, a seventeenth-century reader of Diophantus, solver of some problems and poser of many others. Diophantus's name is given permanence through its attachment to the often difficult and sometimes terrifying search for integral or rational solutions of equations with integral or rational coefficients: *Diophantine equations*, with their study proving a fertile breeding ground for mathematical techniques and a recognized proving ground for their practitioners. Diophantus's legacy is the thirteen "books" of his *Arithmetica*, six of which have survived in their original Greek with four more have been discovered written in Arabic, and, of course, there are now numerous translations of them all. From these we consider just two problems.

Arithmetica, **book 4, problem 24.** To divide a given number into two parts such that their product is a cube minus its side.

Arithmetica, **book 6, problem 18.** To find a right-angled triangle such that the area added to the hypotenuse gives a cube, while the perimeter is a square.

In approaching such questions and the many like them, Diophantus was given to taking what he no doubt considered as representative cases and producing an argument that by assumption can be generalized. In problem 24 this amounted to the following.

Suppose the given number is 6, the first part m, and therefore the second part $6 - m$; the product is, then, $m(6 - m)$ and we are required to solve the equation

$$m(6 - m) = n^3 - n.$$

Now make the assumption of a linear relationship between m and n. His first guess of $n = 2m - 1$ results in the cubic equation $8m^3 - 11m^2 - 2m = 0$; denied $m = 0$, this reduces to a quadratic equation with irrational roots, which were not acceptable. The second-guess relationship of $n = 3m - 1$ yields the far more agreeable $27m^3 - 26m^2 = 0$; with

$m = 0$ again a discarded possibility, this leaves $m = \frac{26}{27}$ and the two parts into which 6 is divided the rational pair $(\frac{26}{27}, \frac{136}{27})$.

In problem 18, Diophantus denoted the area of the triangle by a, say, and, since the two perpendicular sides have a product of $2a$, he assigned one of them to be 2 and the other a. The hypotenuse is a cube minus a; the condition on the perimeter requires that $2 + \text{cube} = \text{square}$. The cube is written as $(m - 1)^3$ and the square as $(1\frac{1}{2}m + 1)^2$, ensuring that the term in m and the constant term vanish in the equation

$$2 + (m - 1)^3 = (1\tfrac{1}{2}m + 1)^2.$$

This easily yields the solution $m = \frac{21}{4}$ and the sides of the triangle the impressive rational triplet

$$(2, \frac{24121185}{628864}, \frac{24153953}{628864}).$$

Now move to the French Jesuit Claude Bachet (1581–1638), who is perhaps most famous for his 1621 translation of the original six books of *Arithmetica* from Greek into Latin, since it was in a copy of this translation that Fermat wrote his famous marginal note that was to spawn his vaunted Last Theorem. The problem of interest that he has bequeathed to us is as follows.

For a given integer c, what are the rational solutions of the equation $y^2 - x^3 = c$?

In that same year Bachet produced an answer of sorts with the impressive *Bachet duplication formula*:

$$\left(\frac{a^4 - 8ac}{4b^2}, \frac{-a^6 - 20a^3c + 8c^2}{8b^3} \right),$$

which generates a further rational solution given an initial one (a, b) to seed the process. Of course, this immediately poses two questions: for any given c, is there a rational seed point, and if there is, will the process continue to generate new solutions as it is repeated? This latter question has particular bite if we apply the formula to the curve $y^2 = x^3 + 1$ with seed point $(2, 3)$ and $y^2 = x^3 - 432$ with seed point $(12, 36)$, as the reader can verify.

We now move further forward in time to a problem that may have originated with the French mathematician Édouard Lucas. In 1875 he posed the challenge to prove that the only occasion in which the sum of the squares of consecutive positive integers is itself a perfect square is when 24 of them are summed to yield 70^2; that is, $\sum_{r=1}^{24} r^2 = 70^2$.

Figure 10.2. A pile of cannonballs.

With the visualization of the sum as the addition of the square layers of a stack of cannonballs, as shown in figure 10.2, and the square on the right-hand side as the area of a square containing the balls when they are arranged flat on the floor, the *cannonball problem* came into existence.

With n layers in the pyramid, there will be $1^2 + 2^2 + 3^3 + \cdots + n^2 = \frac{1}{6}n(n+1)(2n+1)$ cannonballs, and for these to be formed into a square we require a positive integer m such that $m^2 = \frac{1}{6}n(n+1)(2n+1)$. Of course, there is the trivial solution $m = n = 1$, and it is a simple matter to have a computer search for a further solution, with $n = 24$, $m = 70$ an almost instant outcome from such. The wait for a second pair is quite another matter and, after waiting a long time, the possibility of there being no other integral solutions will present itself.

Lastly, we return to more ancient times to consider one final problem, one which might seem a matter of little moment but in reality is one of profound and enduring difficulty. For its early appearance we could look to Diophantus once more, or to the early Arab or Hindu scholars; we will, though, concentrate on the man who is responsible for its first significant popularization – and also for bequeathing to us another rather confusing piece of nomenclature: Leonardo of Pisa, otherwise known as Fibonacci. In 1225, when the peripatetic court of Stupor Mundi, the Wonder of the World, the Holy Roman Emperor, Frederick II visited Pisa, the emperor had specifically asked to meet the renowned Pisan mathematician Fibonacci. The audience was to prove more than a transient honour since during its course, Master John of Palermo, a court mathematician, had offered a challenge of three problems to Fibonacci, their purpose to test this famous mathematician's credentials. One of these problems was to

find a square number from which when 5 is added or subtracted, always arises a square number,

which may be rephrased as: find an arithmetic sequence of three consecutive perfect squares (assumed rational or integral) and for which the common difference is 5.

For the sake of clarity we offer such a sequence of integers with a common difference of 840 with the triplet

$$\{529, 1369, 2209\} = \{23^2, 37^2, 47^2\},$$

but, given the question's purpose, it was always likely to be more subtle than it might at first appear, and Fibonacci's impressive solution was the sequence of rationals (see appendix G)

$$\left\{\frac{961}{144}, \frac{1681}{144}, \frac{2401}{144}\right\} = \left\{\left(\frac{31}{12}\right)^2, \left(\frac{41}{12}\right)^2, \left(\frac{49}{12}\right)^2\right\},$$

which he communicated (together with the solutions to the two other problems) to the emperor later that year in a document entitled *Flos* ("Flower"). His interest had been aroused and his deeper thoughts would be disclosed in a subsequent booklet of the same year, *Liber Quadratorum* ("Book of squares"), where the result appears as proposition 17. And it is here that he bequeathed to us what is today a rather confusing piece of mathematical nomenclature: whenever such a triplet exists, he termed the common difference a *congruous number*, since it causes the triplet to be a *congruum*, from the latin "to meet together"; subsequently, the term for the common difference has been transmuted to *congruent number*. As Richard Guy commented, "Congruent numbers are perhaps confusingly named", but Fibonacci long preceded the English translations of Euclid with his equivalent triangles and also the number-theoretic work of Gauss with the idea of congruence modulo some prime number, although we shall call on this later in the chapter. An essential result from *Quadratorum* was that an integral congruous number is equivalent to an integer of the form $pq(p + q)(p - q)$ when $p + q$ is even and $4pq(p + q)(p - q)$ when $p + q$ is odd; from this, Fibonacci correctly adduced that such a number must be divisible by 24 and incorrectly adduced that it cannot be a perfect square – a fact that had to wait 400 years until Pierre Fermat supplied a proof in 1659. With the necessary divisibility by 24, the solution to the challenge must necessarily involve fractions, and the extremely clever device Fibonacci brought to bear could be used to deal with myriad common differences, that is, myriad congruous or congruent numbers.

These five problems occupy their place in the long history of (algebraic) number theory, arbitrary though they may seem. There is,

though, a cord that binds them and a weapon sharper than has been brought to bear to attack them. And that weapon is elliptic curves.

10.3 Common Ground

A change of letters to the standard variables x and y renders the equation of problem 24 of Diophantus to the curve $y(6 - y) = x^3 - x$, on which we seek rational points; the equation of problem 18 asks the same question of the curve $y^2 = (x - 1)^3 + 2$. With the Bachet problem, the curve is provided; the mystery lies with the generating formula for rational points on it. The equation arising from the cannonball problem becomes the curve $y^2 = \frac{1}{6}x(x + 1)(2x + 1)$, on which we seek integer points, which leaves the problem of congruent numbers. With the common difference of 5, Fibonacci was being asked for a rational number m such that the sequence of squares $m^2 - 5, m^2, m^2 + 5$ exists. If such does exist, we can form the product $(m^2 - 5)m^2(m^2 + 5) = m^2(m^4 - 25)$, which must itself be a perfect square; with this we are led to the search for rational points on the curve $y^2 = x(x^2 - 25) = x^3 - 25x$, where $x = m^2$. The correspondence is one way, though: a rational m for which the sequence exists will necessarily yield a rational point on the curve, whereas a point on the curve with x coordinate a rational square need not yield a rational y coordinate. Nonetheless, in every case we are led to a cubic curve without singularities and so to our present concept of an elliptic curve, albeit in Weierstrass long, rather than short, form.

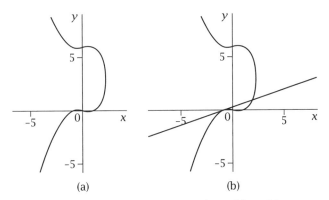

Figure 10.3. (a) Diophantus's problem 24.
(b) Further intersection of the tangent.

Having framed the problems in terms of elliptic curves, we can also frame their solutions:

For Diophantus's problem 24, he chose the substitution equivalent to $x = 3y - 1$, and a little calculus shows that this line is the tangent to $y(6 - y) = x^3 - x$ at the point $(-1, 0)$, with the curve shown in figure 10.3(a) and the further intersection with this tangent in figure 10.3(b). Solving the simultaneous equations for intersection leads to $y^2(27y - 26) = 0$ and, of course, the solution: the first part is $y = \frac{26}{27}$ and $6 - y = 6 - \frac{26}{27} = \frac{136}{27}$ is the second.

For problem 18, the line $y = \frac{3}{2}x + 1$ is the tangent to $y^2 = (x - 1)^3 + 2$ at the point $(0, 1)$, with the curve shown in figure 10.4(a) and the further intersection in figure 10.4(b), and again algebra quickly yields the intersection at $x = \frac{21}{4}$ and the required answer again follows.

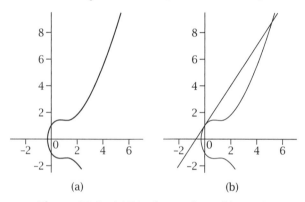

(a) (b)

Figure 10.4. (a) Diophantus's problem 18.
(b) Further intersection of the tangent.

The Bachet duplication formula arises as the further point of intersection of the tangent to $y^2 = x^3 + c$ at the point (a, b). The details of this are these: differentiate the equation to yield the gradient of the tangent to be $3x^2/2y$ and so the equation of the tangent at (a, b) is

$$y - b = \frac{3a^2}{2b}(x - a).$$

Intersect this once more with the curve to yield the cubic equation

$$x^3 + c - \left(b + \frac{3a^2}{2b}(x - a)\right)^2 = 0,$$

which we know has repeated root $x = a$. Identify $-9a^4/4b^2$, the

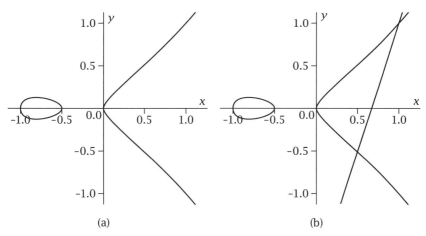

Figure 10.5. (a) The cannonball curve and
(b) its intersection with $y = 3x - 2$.

coefficient of x^2 in the equation, and elementary theory tells us that

$$a + a + \alpha = \frac{9a^4}{4b^2}$$

$$\rightarrow \alpha = \frac{9a^4}{4b^2} - 2a = \frac{9a^4 - 8ab^2}{4b^2} = \frac{9a^4 - 8a(a^3 + c)}{4b^2} = \frac{a^4 - 8ac}{4b^2}.$$

The y coordinate follows by substitution.

With the cannonball problem there is no guide for our use of the elliptic curve $y^2 = \frac{1}{6}x(x+1)(2x+1)$, which is shown in figure 10.5(a), with no tangent line provided or immediately obvious; the three conspicuous points on the curve $\{(-1,0), (-\frac{1}{2},0), (0,0)\}$ have vertical tangents, which do not intersect the curve again,[6] yet we know that $(1,1)$ lies on the curve and we can adapt our strategy of looking at tangent lines (although with $(1,1)$ we could pursue it) and argue that the chord joining two rational points on the curve must itself intersect it once more at a third rational point.

This line joining $(0,0)$ to $(1,1)$ has the equation $y = x$ and its intersection with the cubic leads to the equation $x^2 = \frac{1}{6}x(x+1)(2x+1)$ or $x^3 - \frac{3}{2}x^2 + \frac{1}{2}x = 0$ with third root $x = \frac{1}{2}$, and so a third third point on the curve is $(\frac{1}{2}, \frac{1}{2})$, which is not integral. The exact process does not bear useful repetition since all three points of course lie on $y = x$, yet we can leave this line by dint of the symmetry of the graph and to the point $(\frac{1}{2}, -\frac{1}{2})$, which must lie on it. Joining this to $(1,1)$ yields the

[6] Actually, they will do after we have completed the definition of an elliptic curve.

straight line $y = 3x - 2$, as shown in figure 10.5(b), and to the equation $(3x - 2)^2 = \frac{1}{6}x(x + 1)(2x + 1)$ or $2x^3 - 51x^2 + 73x - 24 = 0$. We know two of its roots and again elementary theory tells us that the sum of all three is $\frac{51}{2}$, making the third root $x = 24$ which leads to our sought-after point $(24, 70)$, far off the scale of our figure. We have our solution, which tells us that $1^2 + 2^2 + 3^3 + \cdots + 24^2 = 70^2$. Is this, though, the only solution? Can this process be usefully continued? Would the tangent alternative have been fruitful? We shall soon see.

Finally, from the challenge to Fibonacci we extracted the elliptic curve $y^2 = x(x^2 - 25)$, shown in figure 10.6(a).

The only obvious integral points on the curve are $(0, 0)$, $(5, 0)$, $(-5, 0)$, and again none of these is of any use as a tangent. We engage, though, in a fortuitous integer search for points on the curve and quickly see that $x = 4$ yields a negative perfect square and so $x = -4$ supplies the point $(-4, 6)$ on the curve. If we revert to the calculation of the further intersection of the tangent at this point with the curve, again elementary calculus and algebra yield the tangent to have equation $y = \frac{23}{12}x + \frac{41}{3}$ and its further point of intersection with the curve as

$$\left(\frac{1681}{144}, \frac{62279}{1728}\right),$$

shown in figure 10.6(b); it so happens that $\frac{1681}{144} \pm 5$ are each perfect squares, and with

$$\frac{1681}{144} = \left(\frac{41}{12}\right)^2$$

we have precisely Fibonacci's solution.

It is with this last question that we pause, since it is worthy of considerable development and provides an opportunity to experience the power of elliptic curves in elementary but important terms.

10.4 The Congruent Number Problem

It is with Fibonacci's last problem that we are led from puzzles to matters of profound difficulty, and here we make an observation that was made long before and far away from the court of the Stupor Mundi. We have the statement that if, for rational m and positive integer n, the sequence of perfect squares $m^2 - n$, m^2, $m^2 + n$ exists, then n is termed a congruent number. The mathematicians of Arabia and India had framed another formulation: the existence of rational numbers such that $a^2 + b^2 = c^2$ and $\frac{1}{2}ab = n$, where the n was permitted to

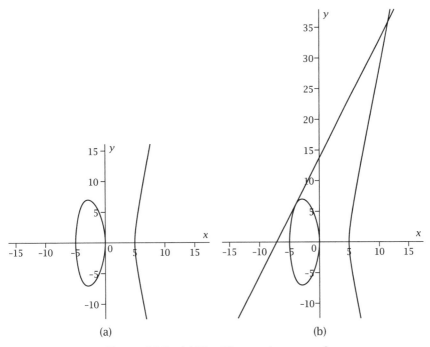

Figure 10.6. (a) The Fibonacci curve and
(b) its intersection with $y = \frac{23}{12}x + \frac{41}{3}$.

be rational. Geometrically, the search moves to the rational areas, n, of right-angled triangles with rational sides: triangles that are reasonably termed *rational triangles*. The algebraic identity underlying the equivalence is

$$a^2 \pm 2ab + b^2 = c^2 \pm 4n$$
$$\Leftrightarrow (a \pm b)^2 = c^2 \pm 4n$$
$$\Leftrightarrow (\tfrac{1}{2}(a \pm b))^2 = (\tfrac{1}{2}c)^2 \pm n = m^2 \pm n,$$

which can be put to use by noting that, if n is a rational number, there is a one-to-one correspondence between the two sets

$$\{(a, b, c) \in \mathbb{Q}^3 : a^2 + b^2 = c^2, \tfrac{1}{2}ab = n\}$$

and

$$\{(m^2 - n, m^2, m^2 + n) : (m, n) \in \mathbb{Q}^2\}$$

given by

$$(a, b, c) \to ((\tfrac{1}{2}c)^2 - n, (\tfrac{1}{2}c)^2, (\tfrac{1}{2}c)^2 + n),$$

and conversely,

$$(m^2 - n, m^2, m^2 + n) \rightarrow (\sqrt{m^2 + n} - \sqrt{m^2 - n}, \sqrt{m^2 + n} + \sqrt{m^2 - n}, 2m).$$

Specific cases of the equivalence of sequences of rational squares S and rational triangles Δ are

$$n = 5: \quad S = \left\{ \left(\frac{31}{12}\right)^2, \left(\frac{41}{12}\right)^2, \left(\frac{49}{12}\right)^2 \right\} \quad \text{and} \quad \Delta = \left(\frac{3}{2}, \frac{20}{3}, \frac{41}{6}\right),$$

$$n = 6: \quad S = \{ (\tfrac{1}{2})^2, (\tfrac{5}{2})^2, (\tfrac{7}{2})^2 \} \quad \text{and} \quad \Delta = \{3, 4, 5\},$$

$$n = 7: \quad S = \left\{ \left(\frac{113}{120}\right)^2, \left(\frac{337}{120}\right)^2, \left(\frac{463}{120}\right)^2 \right\} \quad \text{and} \quad \Delta = \left\{ \frac{35}{12}, \frac{24}{5}, \frac{337}{60} \right\}.$$

The search for congruent numbers has been transformed to the question: for what rational numbers n does a rational triangle exist with area n? And their identification has become known as the *congruent number problem*, with the elusive nature of such numbers making the problem one of the most difficult and important problems in modern number theory. In fact, Fibonacci's test had long before been passed by those ancient Arab mathematicians, with the contents of the tenth-century manuscripts declaring that 5, 6, 14, 15, 21, 30, 34, 65, 70, 110, 154, 190 – and 10374 – are all congruent (numbers).

 There is an important observation to make, and one that helps to remove redundancy from the definition of a congruent number. The Arabs had allowed the area of a rational triangle to be rational rather than integral, but through scaling we can see that there is no essential difference between the two. If such an area is written as n, then $k^2 n$ is also such an area for any rational number k, and vice versa (scaling the triangle by a factor k or $1/k$). This means that if we have a rational area, we can extract the square part from it and from this reach a more primitive rational area and then reverse the process by multiplying this by the square of its denominator to finish with a primitive square-free integer that generates the whole family. Many words for a simple process; for example, if we manage to generate a rational triangle with area $\frac{18}{175}$, then $\frac{18}{175} = (\frac{3}{5})^2 \times \frac{2}{7}$ and so $\frac{2}{7}$ must also be such an area, and we now multiply this by 7^2 to finish with 14, the primitive square-free congruent integer. So, in the quest for rational areas of rational triangles, we need only search among (positive) square-free integers, which gives rise to this final definition: a *congruent number* is a positive, square-free integer that is the area of some rational triangle. With this formulation, all we have to do is generate rational triangles,

and for a systematic approach to this we can invoke Euclid's method of generating primitive[7] Pythagorean triples:[8] Take two positive integers a, b such that

- $a > b$,
- one of them is even and the other odd,
- the numbers are coprime,

then $(a^2 - b^2, 2ab, a^2 + b^2)$ is a primitive Pythagorean triple.

For example, take $(a, b) = (5, 4)$ to generate the primitive rational triangle $(9, 40, 41)$ with area $180 = 6^2 \times 5$, which makes 5 a congruent number through the triangle with sides $(\frac{9}{6}, \frac{40}{6}, \frac{41}{6})$, as we had before. So, let us apply our systematic method: fix an a, take each b subject to the restrictions and use the expression to generate the triples and factor out the square as necessary.

The first list below was generated by increasing a and for each of these values computing the area of the triangle for the allowed values of b:

{6, 30, 60, 84, 210, 180, 210, 330, 630, 924, 546, 504, 1320, 1560, 840, 1386, 2340, 1224, 990, 2730, 3570, 1710, 2574, 4620, 5610, 5016, 2310, 1716, 7140, 7980, 3036, 4290, 7956, 10374, 10920, 8970, 3900, 2730, 7854, 11970, 14490, 11550, 4914, 6630, 12540, ...}

We now extract the square-free parts to achieve, in the same order,

{6, 30, 15, 21, 210, 5, 210, 330, 70, 231, 546, 14, 330,3 90,210, 154, 65, 34, 110, 2730, 3570, 190, 286, 1155, 5610, 1254, 2310, 429, 1785, 1995, 759, 4290, 221, 10374, 2730, 8970, 39, 2730, 7854, 1330, 1610, 462, 546, 6630, 3135, ...}

And then arrange the list in increasing order and remove redundancy to finish with

{5, 6, 14, 15, 21, 30, 34, 39, 65, 70, 110, 154, 190, 210, 221, 231, 286, 330, 390, 429, 462, 546, 759, 1155, 1254, 1330, 1610, 1785, 1995, 2310, 2730, 3135, 3570, 4290, 5610, 6630, 7854, 8970, 10374, ...}

All congruent numbers, yet, the process is fraught. Not only is the original enumeration unordered, there is repetition and there are suspicious gaps. We might first note that 1, 2 and 3 are all missing from the final list, and for good reason as none of them is congruent; 7 is missing

[7] Triples having no common factor.

[8] Book X, lemma 1; a preliminary to proposition 29.

but it is congruent, as we have noted earlier; 11 is missing and is not congruent; 13 is missing yet is congruent; 17 is missing and is not, The procedure, and any like it, is hopeless for generating congruent numbers in any useful way: 13 will appear when $a = 325$ and $b = 36$, which yield the area as $1220649300 = 13 \times 9690^2$ and the resulting rational triangle with area 13 as the impressive

$$\left(\frac{323}{30}, \frac{780}{323}, \frac{106921}{9690} \right);$$

23 will appear when $a = 24336$ and $b = 17689$, which yield the area as $2861397263088 = 23 \times 352716^2$ and the rational triangle with area 13 is the more impressive

$$\left(\frac{391}{20748}, \frac{41496}{17}, \frac{42025}{352716} \right).$$

Waiting for the congruent number 157 to appear would have been fruitless as the rational triangle having this area has side lengths

$$\left(\frac{6803298487826435051217540}{411340519227716149383203}, \frac{411340519227716149383203}{21666555693714761309610} \right)$$

with the hypotenuse

$$\frac{2244035177043369699245575130906674863160948472041}{8912332268928859588025533178967163570016480830}.$$

The values of the search variables are

$$a = 443624018997429899709925$$

and

$$b = 16613623166818185267540804.$$

A calculation performed by Dr Carmen Bruni of the University of Waterloo has it that at a search rate of 100000 numbers a second it would take about 5.89×10^{34} years to find this solution. The German mathematician Don Zagier did find it[9] but, unsurprisingly, not by this method of (literal) exhaustion. Perhaps surprisingly, he did so through the use of elliptic curves; to be precise, he found a rational point on the elliptic curve $y^2 = x^3 - 157^2x$.

[9] http://people.mpim-bonn.mpg.de/zagier/files/mpim/89-23/fulltext.pdf (in German).

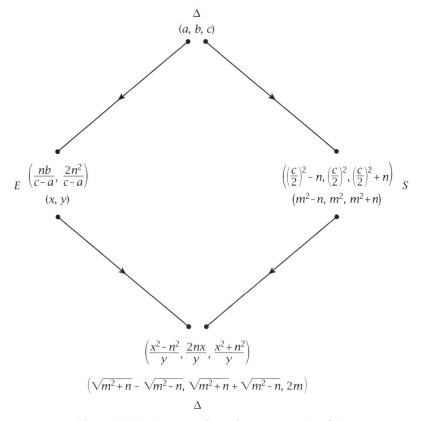

Figure 10.7. An equivalence between Δ, E and S.

We have already moved from a sequence of squares to a special type of elliptic curve in a convenient but somewhat clumsy manner, but fortunately there exists a more convincing association similar to one we have already exposed: let n be a positive integer, then there is a one-to-one correspondence between the two sets

$$\{(a, b, c) \in \mathbb{Q}^3 : a^2 + b^2 = c^2, \tfrac{1}{2}ab = n\}$$

and

$$\{(x, y) \in \mathbb{Q}^2 : y^2 = x^3 - n^2x, \ y \neq 0\}$$

given by (there are others too)

$$(a, b, c) \rightarrow \left(\frac{nb}{c - a}, \frac{2n^2}{c - a}\right) \quad \text{and} \quad (x, y) \rightarrow \left(\frac{x^2 - n^2}{y}, \frac{2nx}{y}, \frac{x^2 + n^2}{y}\right).$$

The proof is again straightforward and achieved through direct substitution. If we meld the three interpretations together: the sequence of squares, S, the rational triangle, Δ, and the elliptic curve, E, we finish with figure 10.7, which allows faithful movement between the three interpretations.

To see how productive this association can be, we start with the regulation rational $(3, 4, 5)$ triangle, which establishes $n = 6$ to be a congruent number. The above association links this to the elliptic curve $y^2 = x^3 - 36x$ and to the point $(12, 36)$ on it, and we may repeatedly use the tangent process from the previous section together with these associations to generate sequences of squares and further rational triangles. The equation of the tangent to this elliptic curve at this point is easily seen to be $y = \frac{11}{2}x - 30$, and again it is easy to see that this meets the curve again at the point $(\frac{25}{4}, \frac{35}{8})$; this generates another rational triangle

$$\left(\frac{7}{10}, \frac{120}{7}, \frac{1201}{70} \right)$$

of area 6, which corresponds to the three-term arithmetic sequence of squares

$$\left\{ \left(\frac{1151}{140} \right)^2, \left(\frac{1201}{140} \right)^2, \left(\frac{1249}{140} \right)^2 \right\}$$

with common difference 6. And we have (it transpires) an infinitely repeatable process. The equation of the tangent to the elliptic curve at $(\frac{25}{4}, \frac{35}{8})$ is

$$y = \frac{1299}{140}x - \frac{6005}{112},$$

and this meets the curve again at the point

$$\left(\frac{1442401}{19600}, \frac{1726556399}{2744000} \right),$$

which corresponds to the rational triangle

$$\left(\frac{1437599}{168140}, \frac{2017680}{1437599}, \frac{2094350404801}{241717895860} \right)$$

of area 6 and another three-term arithmetic sequence of squares with common difference 6

$$\left\{ \left(\frac{1727438169601}{483435791720} \right)^2, \left(\frac{2094350404801}{483435791720} \right)^2, \left(\frac{77611083871}{483435791720} \right)^2 \right\},$$

and so on.

Finally, as we have mentioned, although Fibonacci had stated the non-congruence of 1, it was to be Fermat who first proved the fact (as he did for 2 and 3) using the triangle interpretation and his acclaimed method of "infinite descent". The non-congruence of 1 carries with it perhaps surprising implications, three of which are as follows.

- No square number can be congruent: were there such, we could scale back to 1 by division.
- The product of three consecutive integers can never be a perfect square: otherwise there would be integers such that

$$y^2 = (x - 1)x(x + 1) = x^3 - 1x.$$

- $\sqrt{2}$ is irrational: if $\sqrt{2}$ is rational, there would be a rational triangle $(\sqrt{2}, \sqrt{2}, 2)$ with area 1.

With the geometry of the elliptic curve established and some number-theoretic applications of it discussed, we move to an arithmetic on it – and finally to its complete definition.

10.5 An Arithmetic

We have already commented that Richard Guy judged elliptic curves to be confusingly named. A particular mathematical convention can also add to the general confusion of the non-specialist, with the subject's practitioners given to recycling everyday words for technical use: *derivative, integral, rational, transcendental, ...*, and *group*. Henri Poincaré summarized matters nicely with his comment that "mathematics is the art of giving the same name to different things". This last term, *group*, is reserved for a set of elements together with a way of combining them (a binary operation) that provide all that is needed for elementary arithmetic, algebra and, in particular, equation-solving to be accomplished. These requirements are that for a set E and a binary operation (which for the avoidance of inventing a new symbol and in accordance with the recycling philosophy we write as +) the following hold.

- For all $A, B \in E$, $A + B \in E$: the operation is "closed".
- There exists $O \in E$ such that, for all $A \in E$, $A + O = O + A = A$: there is an "identity".
- For all $A \in E$ there exists $-A \in E$ such that $A + (-A) = (-A) + A = O$: each element has its inverse.

- For all $A, B, C \in E$, $A + (B + C) = (A + B) + C$: the operation is "associative".
- For all $A, B \in E$, $A + B = B + A$: the operation is "commutative".

The last condition is a convenience rather than a necessity, and with it the group becomes Abelian.[10]

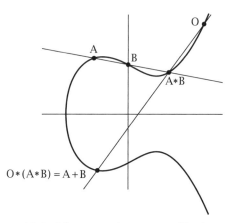

Figure 10.8. The group law on an elliptic curve.

This seeming non sequitur to our discussion of elliptic curves is in reality central to their importance, since what has so far been realized as a purely geometric object with geometric constructions applied to it has a parallel existence in the world of algebra; that is, it can be interpreted as a group and with this interpretation elementary arithmetic can be performed. Provided, that is, we have an interpretation of the sum of two points on the curve for which the earlier tangent and secant process can now be seen to have a greater cause, since any non-vertical straight line that intersects the curve twice must necessarily intersect it a third time. With the two general points A and B in figure 10.8, the third intersection point, labelled $A * B$, is then the obvious candidate for their sum; yet there are obstacles. The (Abelian) group axioms may be collected into two types: the two that mention the identity element and inverses on the one hand, and the three that deal with closure, associativity and commutativity on the other. And our nascent definition of addition fails in both categories: there can be no identity element since the condition $A * O = A$ would mean that O must be the further point of intersection of the tangent to the curve at

[10] Named after Neils Abel.

A, which depends on A, and this brings with it the further implication that $O * B = (A * A) * B = A * (A * B) = B$, which is evidently nonsense and associativity fails.

Although at first it seems remarkable,[11] we can adapt this failed construct to fulfil the group axioms in their entirety, and by the simple expedient of involving a further, arbitrary but fixed point of the curve. Suppose that O (with suggestive notation) is that fixed point, again shown in figure 10.8, and define the addition of two arbitrary points on the curve by $A + B = O * (A * B)$, that is, as the further intersection with the curve of the line joining O to $A * B$, once more as illustrated in figure 10.8. The fixed point O is easily seen to be the identity element since the collinearity of O, A, $O * A$ ensure that $O + A = O * (O * A) = A$. Moreover, $A' = (O * O) * A$ is the inverse of A, since $A' + A = O * (A' * A) = O * (((O * O) * A) * A) = O * (O * O) = O$, again because of collinearity of the points: we may write, then, $-A = (O * O) * A$. Associativity is now satisfied but it is a most tedious process to confirm this to be the case, so we will ask the reader for trust here.

All is done – apart from the crucial matter of vertical lines.

If we fix A and B (and therefore $A * B$) and move O ever further up the curve, the variable line determining $A + B$ will pivot about $A * B$ and move ever closer to the vertical without ever reaching it. We can cause the line to be vertical by adding to the cubic curve a "point at infinity" and choosing this to be our identity point O; with this, vertical lines meet the curve in three points, the two finite of which are $A * B$ and $A + B$, one vertically above the other, and the inverse of a point is its reflection in the horizontal.

With this we are finally in a position to give our complete definition of an elliptic curve (defined over the real numbers). An elliptic curve is the set

$$\{(x, y) \in \mathbb{R}^2 : y^2 = x^3 + ax + b; \; 4a^3 + 27b^2 \neq 0\} \cup \{O\}.$$

The inclusion of the point at infinity can be given full rigour at the considerable price of moving to the abstract space of the projective plane, which fortunately is beyond our remit and more fortunately still is quite unnecessary for our needs.

Before we continue, we glance at the (somewhat tedious) detail that accompanies the calculation of the sum of two points on the curve,

[11] Although considered through the general theory of Abelian groups, the surprise disappears.

given their coordinates. When all of the elementary algebra regarding various types of intersection is done with, we are left with the following.

For two points $P_1 = (x_1, y_1)$ and $P_2 = (x_2, y_2)$ on the elliptic curve $y^2 = x^3 + ax + b$, the sum is given by:

- If $x_1 \neq x_2$, then $P_1 + P_2 = (x_3, y_3)$, where

$$\begin{cases} x_3 = \left(\dfrac{y_2 - y_1}{x_2 - x_1}\right)^2 - x_1 - x_2 \\ y_3 = -y_1 + \left(\dfrac{y_2 - y_1}{x_2 - x_1}\right)(x_1 - x_3) \end{cases}$$

- If $x_1 = x_2$, then
 - If $y_1 = -y_2$, then $P_1 + P_2 = O$.
 - If $y_1 \neq -y_2$, then $P_1 + P_2 = 2P_1 = (x_3, y_3)$, where

$$\begin{cases} x_3 = \left(\dfrac{3x_1^2 + a}{2y_1}\right)^2 - 2x_1 \\ y_3 = -y_1 + \left(\dfrac{3x_1^2 + a}{2y_1}\right)(x_1 - x_3) \end{cases}$$

The first major bullet point deals with a general intersection, the second with the intersecting line being vertical or a tangent to the curve.

Note that the arithmetic group laws ensure the absence of ambiguity. For example, $4P = P+P+P+P = 2P+2P = P+3P$ seems obvious in terms of symbols but conceals subtlety regarding the various intersections of lines with the curve, with figure 10.9 demonstrating the equivalence.

The calculative formulae allow us to take any elliptic curve and any starting point(s) on it and perform the calculations as we please. For example, for the curve $y^2 = x^3 - 5x + 8$ with its point $P(1, 2)$ we may consider multiples generated by the process. These begin with

$$2P = \left(-\frac{7}{4}, -\frac{27}{8}\right), \quad 3P = P + 2P = \left(\frac{553}{121}, -\frac{11950}{1331}\right), \quad \ldots$$

The fractions that constitute the coordinates of the multiples become progressively more messy, with table 10.1 listing (somewhat artistically) the numerators and denominators of the x coordinates of $\{P, 2P, 3P, \ldots, 15P\}$, and table 10.2 doing the same for the y coordinates (in each case we assign any negative to the numerator). Such a process generates necessarily rational points on the curve with progressively greater complexity.

Table 10.1. x coordinates of multiples of P(1, 2).

```
1
−7
553
45313
−19035719
20238131321
49242784704696l
28701039923220433393
−60507200806269581569732
40962326395046617130934614753
90109321810264925204490410796325401
−30629171246657402111935049943240003688319
965233375794603743977205966597800178984956273563
14700290498471411257116332999632902694714765252395127883513
18635682378057088525757609331345728096310687785722037463624121153313
```

```
2952791287107120438668850759573253040271925628375176639961272609441
11172733331684514306947905124320043169760918542492309216
72076267683725311280022064313064365223932818287961
13373165024713309118563593855026673201000
2686328884057950874893240495929801
7477485548545062739932434
417378228875619582894961
34950386552770535043
93570604776
17279102500
9357481
11664
121
4
1
```

Table 10.2. y coordinates of multiples of P(1, 2).

2
−27
−11950
8655103
89393659342
−4398722004568869
10927727837185280995618
13780060468451643045994142977
−9419028616616397551136830734845 3150
−2462189899294568674092988574207561320461 2187
749408538852682868281496355818767882775253776 236288398
421753748163243373465805319003557833809900068358623155 284366079
−117795549845372503473529981993998199397807311419604587485832173947247868 259012882
17820788323232092771088551705235452718363838509387801849503975685655842260 4550693 65585253
114539278787694823827969528153787439855662073867320947549810696409970422473 9142729364161319 41650 85250
50739848140656127037992037298129597043559031088369592357822042158551254502689625081298310721 786511
118097077344864393599236566720878132627452013012429534372583447808484562835849 199288
611911245100951122446830161033855390061547624099374042290161215377202343459
1546504919115271304471319627734916346924181525654134980 1000000
132319073504842587656671401615199204840867464449 09701
204483644800282978998194384755845216360843752
269646438028348861920971568936899209
653398262887348585442762599
90512623841412759 0
2271338023625000
2862453 4379
1259712
1331
8
1

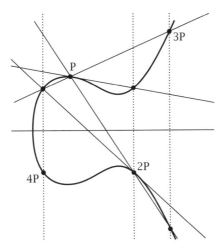

Figure 10.9. A well-defined arithmetic.

Now we have attached to our geometric realization of an elliptic curve an algebraic structure. We next look to the worlds in which the curve can be caused to exist – and in doing so mention another of those deceptively named mathematical constructs.

10.6 Fertile Fields

We have drawn pictures of elliptic curves and in doing so there is the implicit assumption that the curve comprises a continuous infinity of points the coordinates of which are ordered pairs of real numbers. If we look, though, at the calculations for the coordinates of the sum of two points or the multiple of a point on an elliptic curve with rational coefficients, we see that if we start with rational coordinates, the process necessarily generates rational coordinates and so another rational point on the curve. Not all the curve can possibly be reached by the process, and the set of rational points is seen as a subgroup of the totality of points on the curve. This observation is important, but so is the generalization of which it is part, and for this we need the abstraction of a mathematical *field*; another common word used for an uncommon purpose. This concept may be thought to distinguish between the integers, \mathbb{Z}, which form a group under addition, and the rationals, \mathbb{Q}, which do the same but also under multiplication (save for the inverse of the additive identity 0) and for which the two binary operations of addition and multiplication interact, as they should, through the law

of distributivity of multiplication over addition (that is, we can multiply out brackets). With this background, it was Henri Poincaré in about 1900 who established the following result.

Let K be a field and suppose that an elliptic curve E is given by an equation of the form $y^2 = x^3 + ax + b$, where $a, b \in K$. Let $E(K)$ denote the set of points of E with coordinates in K. Then $E(K)$ is a subgroup of all points of E.

For example, if we have an elliptic curve with $a, b \in \mathbb{Q}$ and take a point on the curve with rational x coordinate, it is clear that the corresponding value of y^2 will be rational but not at all certain that the same can be said for y. Poincaré's result tells us that all points on the curve that have both coordinates rational form a group in their own right under the chord and tangent law of addition, as we intuitively claimed above. There is, though, much more. Poincaré had conjectured and in 1922 Louis Mordell proved the following result.

Let E be an elliptic curve given by the equation $y^2 = x^3 + ax + b$, with $a, b \in \mathbb{Q}$. Then the group of rational points $E(\mathbb{Q})$ is finitely generated.

In other words, there is a finite set of points $P_1, P_2, P_3, \ldots, P_t \in E(\mathbb{Q})$ such that every point $P \in E(\mathbb{Q})$ can be written in the form

$$P = n_1 P_1 + n_2 P_2 + n_3 P_3 + \cdots + n_t P_t \quad \text{for some } n_1, n_2, n_3, \ldots, n_t \in \mathbb{Z}.$$

From this stems so very much, and far, far too much to even begin contemplating inclusion here. Results and conjectures abound, as does extremely difficult mathematics, and we will be content with the statement of but one result, due to Barry Mazur in 1977, which bears interpretation as follows.

If we take a rational point P on a rational elliptic curve and take ever bigger multiples of it and if we have not reached O by 16P, then we never will reach it with this point.

Our example (tables 10.1 and 10.2) computes the multiple to 15, and the reader may wish to test whether or not the next multiple is 0! With this, we can, in particular, hope to generate infinite numbers of rational points on a rational curve from a judiciously chosen seed point. Something that is denied us if we move from the field of rationals \mathbb{Q} back to the not-field \mathbb{Z}.[12] Integer points on an elliptic curve with integer coefficients are a far rarer breed, which cannot be surprising since, given two points on the curve with integer coordinates and given the arithmetic, it is hardly likely that their sum or multiples will have integer coordinates.

[12] Actually, it is a *ring*.

Table 10.3. Addition modulo 7.

+	0	1	2	3	4	5	6
0	0	1	2	3	4	5	6
1	1	2	3	4	5	6	0
2	2	3	4	5	6	0	1
3	3	4	5	6	0	1	2
4	4	5	6	0	1	2	3
5	5	6	0	1	2	3	4
6	6	0	1	2	3	4	5

This was made precise in 1928 when the German Carl Siegel proved the following result.

Let E be an elliptic curve given by the equation $y^2 = x^3 + ax + b$, with $a, b \in \mathbb{Z}$. Then E has only finitely many points $P = (x, y)$ with $x, y \in \mathbb{Z}$. That is, $E(\mathbb{Z})$ is finite.

So, the cannonball problem can have only finitely many solutions, and it was first proved (Watson 1918) (using elliptic functions)[13] in 1918 that the only solutions are the two that have been mentioned. The puzzle is solved, but its connection with the *Leech lattice* of sphere packing in 24 dimensions renders it a significant contributor to the *Golay 24 bit error correcting code*, and through this to the integrity of electronic data transmission. All of which we put to one side to look at a very different kind of numeric field over which an elliptic curve can be defined and, deriving from this, a contribution to cryptography: the secret transmission of messages.

Our interest will be in the finite field $F_p = \{0, 1, 2, 3, \ldots, p - 1\}$, where p is a prime number[14] and all arithmetic is reduced modulo p. This mathematical term describes nothing more than the "clock arithmetic" that we meet in elementary school and that is implicit in the uses of both the 12- and 24-hour clocks: simply reduce any arithmetic result to the remainder after division by the appropriate modulus. Table 10.3 shows the composition table for addition modulo 7, and table 10.4 the same for multiplication.

For our application, the elliptic curve defined over the finite field F_p, $y^2 = x^3 + ax + b$, has $a, b, x \in F_p$, and the right-hand side reduced modulo p, with the only permissible values of y those for which $y^2 \in F_p \Rightarrow y \in F_p$.

[13] The result has subsequently been established by several using "elementary" means.

[14] And it is necessarily prime for multiplication to behave as it should.

Table 10.4. Multiplication modulo 7.

×	1	2	3	4	5	6
1	1	2	3	4	5	6
2	2	4	6	1	3	5
3	3	6	2	5	1	4
4	4	1	5	2	6	3
5	5	3	1	6	4	2
6	6	5	4	3	2	1

And it is in this context that we were necessarily a little guarded when we transformed the Weierstrass long to the short form of the equation of an elliptic curve (see pages 187 and 188). The two-stage process of completing the square in y and depressing the cubic in x requires division by 2 and 3, respectively, which is not defined in the fields $F_2 = \{0, 1\}$ and $F_3 = \{0, 1, 2\}$, respectively. If the field on which the curve is defined is one of these, we must be content, then, with the long form, a problem of detail rather than anything intrinsic to the curve's properties. The arithmetic that we have previously performed is perfectly well defined over any field, and the only difference now is that we perform all calculations modulo some prime p and realize division in its proper role as multiplying by the inverse.

To develop the idea we will take a single elliptic curve $y^2 = x^3 + x + 1$ but consider it defined over three such fields, with $p = 5, 7, 11$, respectively.

First, $p = 5$ and so $F_5 = \{0, 1, 2, 3, 4\}$. For each $x \in F_5$ we seek a corresponding $y \in F_5$ whose square satisfies the cubic, and to this end we first construct the table of squares in F_5 as shown in table 10.5.

For each of the five possible values of x we compute the value of the cubic and determine which of the results is a square, as shown in table 10.6.

We have, then, eight (finite) points, which are shown plotted in figure 10.10, as well as the original elliptic curve: there is not much to relate them visually, and here and later we are rather stretching the concept of something being a "curve".

Next we take $p = 7$ and so F_7 to arrive at tables 10.7 and 10.8 and figure 10.11, with its disappointing four points.

And finally, $p = 11$ and so F_{11}, with the results shown in tables 10.9 and 10.10 and figure 10.12, with its 13 points.

We see that very few (if any) points lie on the original curve and that they are naturally listed in the tables as inverse pairs, which appear

Table 10.5. Squares modulo 5.

n	0	1	2	3	4
n^2	0	1	4	4	1

Table 10.6. Points on the curve modulo 5.

x	$x^3 + x + 1 \overset{?}{=} n^2$	n	(x, y)
0	1	1,4	(0,1),(0,4)
1	3	—	—
2	1	1,4	(2,1), (2,4)
3	1	1,4	(3,1), (3,4)
4	4	2,3	(4,2), (4,3)

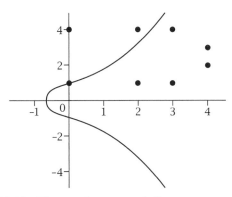

Figure 10.10. The continuous and discrete curves over F_5.

in the graphs as vertical pairs symmetrically placed about the horizontal line $x = \frac{1}{2}p$, save any that are self-inverse: the point $(2,0)$ in figure 10.12.

Our approach to identifying squares modulo a prime p is, we hope, illuminating, but it is also ad hoc. A vastly more systematic aid is to use one of the great theorems of number theory, unsurprisingly provided by one of its greatest practitioners in the person of Gauss. The theorem has its infancy in a lemma of Fermat, which appeared in the mid 1600s, to reappear as an unproven conjecture of Euler in 1744, then again with an incomplete proof by Legendre in the late 1700s: the 19-year-old Gauss provided the full statement and the first complete proof in 1797. So proud was he of the result that eventually he was to provide eight proofs in all. Termed by Gauss the *aureus theorema* (golden theorem), it

Table 10.7. Squares modulo 7.

n	0	1	2	3	4	5	6
n^2	0	1	4	2	2	4	1

Table 10.8. Points on the curve modulo 7.

x	$x^3 + x + 1 \overset{?}{=} n^2$	n	(x, y)
0	1	1,6	(0,1), (0,6)
1	3	—	—
2	4	2,5	(2,2), (2,5)
3	3	—	—
4	6	—	—
5	5	—	—
6	6	—	—

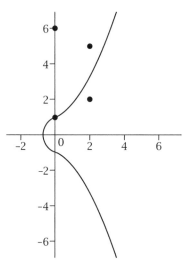

Figure 10.11. The continuous and discrete curves over F_7.

is now universally known as *Gauss's Theorem of Quadratic Reciprocity*, the main statement of which is:

Let $p \neq q$ be odd primes. Then:

(i) If $p \equiv 1 \bmod 4$ or $q \equiv 1 \bmod 4$, p is a square mod q if and only if q is a square mod p.

(ii) If $p \equiv q \equiv 3 \bmod 4$, p is a square mod q if and only if q is not a square mod p.

To this have been added the two supplements:

Table 10.9. Squares modulo 11.

n	0	1	2	3	4	5	6	7	8	9	10
n^2	0	1	4	9	5	3	3	5	9	4	1

Table 10.10. Points on the curve modulo 11.

x	$x^3 + x + 1 \overset{?}{=} n^2$	n	(x, y)
0	1	1,10	(0,1), (0,10)
0	3	5,6	(1,5), (1,6)
2	0	0	(2,0)
3	9	3,8	(3,3), (3,8)
4	3	5,6	(4,5), (4,6)
5	10	—	—
6	3	5,6	(6,5), (6,6)
7	10	—	—
8	4	2,9	(8,2), (8,9)
9	2	—	—
10	10	—	—

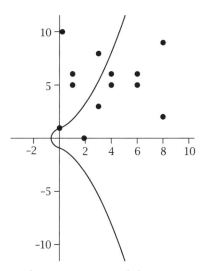

Figure 10.12. The continuous and discrete curves over F_{11}.

- If p is an odd prime, then -1 is a square mod p if and only if $p \equiv 1 \bmod 4$.
- If p is an odd prime, then 2 is a square mod p if and only if $p \equiv 1, 7 \bmod 8$.

There are clear indications of the potential usefulness of this great

result, yet space forces our hand in developing them. Instead, we move towards our major application of elliptic curves.

With the elements of each mathematical universe identified, we should look to the arithmetic through which we can combine them, and this is, of course, that which we have already defined, although we should take care with the way in which we write the expressions. The notational variant follows.

Over the field F_p, for two points $P_1 = (x_1, y_1)$ and $P_2 = (x_2, y_2)$ on the elliptic curve $y^2 = x^3 + ax + b$, the sum $P_1 + P_2$ is given by:

- If $x_1 \neq x_2$, then $P_1 + P_2 = (x_3, y_3)$, where

$$x_3 = [(y_2 - y_1)(x_2 - x_1)^{-1}]^2 - x_1 - x_2,$$
$$y_3 = -y_1 + (y_2 - y_1)(x_2 - x_1)^{-1}(x_1 - x_3).$$

- If $x_1 = x_2$, then

 ○ if $y_1 = -y_2$, then $P_1 + P_2 = O$;

 ○ if $y_1 \neq -y_2$, then $P_1 + P_2 = 2P_1 = (x_3, y_3)$, where

$$x_3 = ((3x_1^2 + a)(2y_1)^{-1})^2 - 2x_1,$$
$$y_3 = -y_1 + (3x_1^2 + a)(2y_1)^{-1}(x_1 - x_3);$$

where all arithmetic is assumed modulo p.

To elucidate matters, a typical calculation with $p = 11$ is

$$(8,2) + (6,6) \rightarrow \begin{cases} x_3 = [(6-2)(6-8)^{-1}]^2 - 8 - 6 \\ \quad = [4 \times 9^{-1}]^2 + 8 = (4 \times 5)^2 + 8 = 9^2 + 8 = 1, \\ y_3 = -2 + (6-2)(6-8)^{-1}(8-1) \\ \quad = 9 + 4 \times 5 \times 7 = 6. \end{cases}$$

So,

$$(8,2) + (6,6) = (1,6).$$

For interest, we include the full table of additions of all pairs of points for this curve defined over this field as table 10.11.

Our graphical representation of the group has contrasted the elliptic curve defined over real numbers with the elliptic "curve" defined only on the positive integer grid; more appropriate for purpose (in the case of F_{11}) are the representations that are figure 10.13(a), with figure 10.13(b) demonstrating the above addition process. To add two

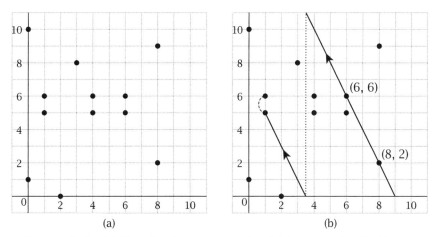

Figure 10.13. (a) The elliptic curve over F_{11}. (b) An example of addition.

different points, join them by a straight line that continues by wrapping discontinuously around the horizontal and vertical extremities until it passes through a further point, the reflection of this in the horizontal line of symmetry will be their sum; greybeards, like the author, might remember the computer game Asteroids and so will have experienced the phenomenon before; we imagine that there might be an equivalent for those of more tender years.

We see, then, that depending on the underlying field (and the curve), the number of points generated varies a great deal. The obvious question to ask is, for a given prime p and a given elliptic curve, E, how many points, $\#E(F_p)$, are there?

In general this remains an open problem, and the best that can be done is to establish estimates, the first of which is easy. If we consider the extreme case, if every integer from 1 to $p - 1$ generated a point on the graph with none of the points self-inverse, there would be $2p$ points, and also the zero point at infinity. We can conclude that

$$\#E(F_p) \leqslant 2p + 1.$$

To improve upon this gross estimate requires one of the fundamental results of the associated theory, which we can point to in the following intuitive manner. If we look a little more closely at the tables 10.5, 10.7, 10.9, notice that, for each n, the numbers n^2 and $(p - n)^2$ are the same modulo p, as expanding $(p - n)^2$ to $p^2 - 2np + n^2$ makes clear, and we have a natural distinction between the elements of the field, leading to an important definition.

Table 10.11. Addition table of points on $y^2 = x^3 + x + 1$ over F_{11}.

+	0	(0,1)	(0,10)	(1,5)	(1,6)	(2,0)	(3,3)	(3,8)	(4,5)	(4,6)	(6,5)	(6,6)	(8,2)	(8,9)
0	0	(0,1)	(0,10)	(1,5)	(1,6)	(2,0)	(3,3)	(3,8)	(4,5)	(4,6)	(6,5)	(6,6)	(8,2)	(8,9)
(0,1)	(0,1)	(3,3)	0	(4,5)	(2,0)	(1,5)	(6,6)	(0,10)	(8,2)	(1,6)	(3,8)	(6,5)	(8,9)	(4,6)
(0,10)	(0,10)	0	(3,8)	(2,0)	(4,6)	(1,6)	(0,1)	(6,5)	(1,5)	(8,9)	(6,6)	(3,3)	(4,5)	(8,2)
(1,5)	(1,5)	(4,5)	(2,0)	(3,3)	0	(0,1)	(8,2)	(1,6)	(6,6)	(0,10)	(4,6)	(8,9)	(6,5)	(3,8)
(1,6)	(1,6)	(2,0)	(4,6)	0	(3,8)	(0,10)	(1,5)	(8,9)	(0,1)	(6,5)	(8,2)	(4,5)	(3,3)	(6,6)
(2,0)	(2,0)	(1,5)	(1,6)	(0,1)	(0,10)	0	(4,5)	(4,6)	(3,3)	(3,8)	(8,9)	(8,2)	(6,6)	(6,5)
(3,3)	(3,3)	(6,6)	(0,1)	(8,2)	(1,5)	(4,5)	(6,5)	0	(8,9)	(2,0)	(0,10)	(3,8)	(4,6)	(1,6)
(3,8)	(3,8)	(0,10)	(6,5)	(1,6)	(8,9)	(4,6)	0	(6,6)	(2,0)	(8,2)	(3,3)	(0,1)	(1,5)	(4,5)
(4,5)	(4,5)	(8,2)	(1,5)	(6,6)	(0,1)	(3,3)	(8,9)	(2,0)	(6,5)	0	(1,6)	(4,6)	(3,8)	(0,10)
(4,6)	(4,6)	(1,6)	(8,9)	(0,10)	(6,5)	(3,8)	(2,0)	(8,2)	0	(6,6)	(4,5)	(1,5)	(0,1)	(3,3)
(6,5)	(6,5)	(3,8)	(6,6)	(4,6)	(8,2)	(8,9)	(0,10)	(3,3)	(1,6)	(4,5)	(0,1)	0	(2,0)	(1,5)
(6,6)	(6,6)	(6,5)	(3,3)	(8,9)	(4,5)	(8,2)	(3,8)	(0,1)	(4,6)	(1,5)	0	(0,10)	(1,6)	(2,0)
(8,2)	(8,2)	(8,9)	(4,5)	(6,5)	(3,3)	(6,6)	(4,6)	(1,5)	(3,8)	(0,1)	(2,0)	(1,6)	(0,10)	0
(8,9)	(8,9)	(4,6)	(8,2)	(3,8)	(6,6)	(6,5)	(1,6)	(4,5)	(0,10)	(3,3)	(1,5)	(2,0)	0	(0,1)

A non-zero number that is congruent to a square modulo p is called a *quadratic residue* (QR) modulo p, whereas one that is not so is called a *quadratic nonresidue* (NR) modulo p. From table 10.5, we have that $\{1,4\}$ are QR and $\{2,3\}$ are NR modulo 5; from table 10.7, we have that $\{1,2,4\}$ are QR and $\{3,5,6\}$ are NR modulo 7; from table 10.9, $\{1,3,4,5,9\}$ are QR and $\{2,6,7,8,10\}$ are NR modulo 11. In fact it is easy to prove that

if $p > 2$ is prime, there are exactly
$$\tfrac{1}{2}(p-1) \text{ QR and } \tfrac{1}{2}(p-1) \text{ NR modulo } p.$$

With this at hand we can develop the heuristic that, in the long term, the values of the cubic expression will be distributed uniformly across the possibilities, half of which will be QR; when there is a QR we will, in general, generate two values of the quadratic expression; and then there is the point at infinity. That is,

$$\#E(F_p) \approx \tfrac{1}{2} \times p \times 2 + 1 = p + 1.$$

A suspicion given rigour by the following 1922 result of the German mathematician Helmut Hasse.

The number of points on the elliptic curve $y^2 = x^3 + ax + b$ over the finite field F_p satisfies $|\#E(F_p) - (p+1)| \leqslant 2\sqrt{p}$, which gives rise to the *Hasse interval*

$$p + 1 - 2\sqrt{p} \leqslant \#E(F_p) \leqslant p + 1 + 2\sqrt{p}.$$

That is, for p large, the number of points on the curve is $\sim p$.

As a (rather large) example (Morain 2006), with $p = 10^{2499} + 7131$ (which is, indeed, prime) and the curve $y^2 = x^3 + 4589x + 91128$, $\#E(F_p) = p + 1 - t$, where t is the number listed below – a rather small number compared with p:

```
74311991522324244885259324275360356018387099873453
52419033712773474261605295745613934784827303221928
19633683575685731860633308594723133404633701650347
64260993170876499703763557640712637346542861635530
24856068874723077656097078238737234927413045213588
59651283907037798537461442323235045275340826091926
29061252451509422146798642464551793004805487116360
04743137665795329380558601618835834198796868893391
29320412135366200684013620964493358889632073987400
```

880836072043167819435435301254203874045015052903 92
000068495427393032914624220033239147926141945021 24
122343595679261259560456616043839757898379281360 25
620011798249384004045008584520449871951575828394 36
057153863826221227906256608278950318938988853308 12
578313993269694618128437253459115977868025826425 29
163013628536768647749494806629480269999989548358 31
387765095297144723348697799906289840994365491033 56
974032706070675024911460474847465294209029611323 03
740576343364071957477085727098341529842061071267 56
008468304449000961288194218319933018689619850760 29
228733382357896594019878760506896270894774907173 66
754410230986360942010122625495852602530360613170

Why do we finish the section with this result and why do we choose such a large prime to serve as an example of it? This chapter's principal denouement follows and answers precisely these questions.

10.7 Cryptography

With the variant of elliptic curves defined over finite fields of prime order, we extract another of those tools from the Swiss army knife, since we now have the necessary apparatus for an application of them in the world of cryptography.

The philosophy underpinning the ancient and ever-present problem of secure communication has developed from the encryption of data using some (presumed) secret system to one in which it is assumed that the system of encryption is publicly known but that some key(s) that are central to it are protected from intrusion.

The *symmetric key* system has the standard cryptographic characters of Alice and Bob, each using a public process and a common, private key to implement it in an agreed manner to allow one to communicate with the other, with the encrypted message secure from the ever-present eavesdropper, Eve. Schematically, encrypting a message M using a key K resulting in an encrypted message C can be represented as $E_K(M) = C$, and the decryption process as $D_K(C) = M$. Quite how the key is used to encrypt and decrypt is determined by whatever algorithm is chosen. The current accepted standard uses a 128-bit key and is known by the initialism AES (Advanced Encryption Standard) and, more personally, by the name Rijndael, a concatenation of the surnames of

the two Belgian cryptographers who devised it: Vincent Rijmen and Joan Daemen. Its involved set of procedures are widely available on the internet and we will not trouble to repeat them here, but with an encryption/decryption algorithm chosen, the problem remains one of choosing a key that is known only to A and B. And perhaps to communicate that key in a secure manner, one to the other.

An alternative scheme to the symmetric key is the *public key*, in which Alice and Bob each have a key known only to themselves; schematically, $E_{K_1}(M) = C$ and $D_{K_2}(C) = M$. The first implementation of public key encryption came about in 1976,[15] when Walt Diffie and Martin Hellman devised a method (known as DH) and an implementation of it; this was followed in 1977 by an alternative approach of Ron Rivest, Adi Shamir and Leonard Adleman (known as RSA) – the principle behind both approaches is computational infeasibility. With RSA the observation that although multiplying two large prime numbers is a trivial matter for modern computers, factorizing back the composite number can be impractical; with DH the computational infeasibility centred around what has become known as the *discrete logarithm problem* (DLP). Any statement of the DLP is contingent upon environment, but its principle is that if $a = b^n$ (or $a = nb$) for known a and b, it can be contrived to be extremely difficult to find the value of n. We will not consider its manifestation with the DH protocol, but its variant in terms of points on elliptic curves over finite fields is at the heart of this section and, rather than repeatedly writing "elliptic curve discrete logarithm problem", we use the unfriendly but standard initialism ECDLP: if on our elliptic curve we take a starting point P and add it to itself repeatedly using the tangent method to reach nP, and if the curve, the point and the prime number are carefully chosen and n is large, it is currently extremely difficult to determine n from knowledge of P and nP. From this belief simple methods have been devised to pass information securely over an insecure electronic channel, although much-repeated implementation can be impractically demanding of processing time.

First, let us suppose that Alice wishes to communicate a message, M, to Bob, with M encoded as an integer: this is easy. Second, the integer has to be embedded as a point on some appropriate elliptic curve, which is far easier than one might imagine.[16] So, let us imagine this to be done

[15] If we ignore the priority of three members of British GCHQ, whose work was kept secret until 1997.

[16] Of many alternatives: Steef *et al.* (2017) and King (2009).

with, for illustrative purposes, M(10, 12) located on the elliptic curve $y^2 = x^3 + 7742x + 734$, defined over the finite field with prime $p = 7901$. The two decide on a second point on the elliptic curve, P(5, 8), which need not be private. So far, the only private information is M, but Alice secretly chooses a large positive integer, a, and Bob does the same with b and they proceed as follows.

- Bob computes the point bP and sends it to Alice.
- Alice computes the points aP and M + $a(b$P) = M + abP and sends them to Bob.
- Knowing aP, Bob computes $b(a$P) = abP and subtracts this from the received M + abP to recover M.

The process is deceptively simple, with its security relying on the assumption that, to calculate abP = $a(b$P) = $b(a$P) from a knowledge of P and a bracketed term, Eve must discover either a or b: a manifestation of the ECDLP.

For example, let us suppose that $a = 27$ and $b = 83$.

- Bob computes bP = 83(5, 8) = (6602, 7629) and sends this to Alice.
- Alice computes aP = 27(5, 8) = (213, 1529) and M + $a(b$P) = (10, 12) + 27(6602, 7629) = (10, 12) + (734, 475) = (4790, 5356) and sends these to Bob.
- Bob computes $b(a$P) = 83(213, 1529) = (734, 475) and subtracts this from (4790, 5356) to yield the message (10, 12).

We should note that calculations undertaken by Alice and Bob are of a different magnitude to those that must be undertaken by Eve. The two can make use of "doubling"; for example, to compute 83P they would generate the sequence

$$P + P = 2P \rightarrow 2P + 2P = 4P \rightarrow 4P + 4P = 8P \rightarrow 8P + 8P = 16P$$
$$\rightarrow 16P + 16P = 32P \rightarrow 32P + 32P = 64P$$

and then form the composite sum

$$83P = ((64P + 16P) + 2P) + P.$$

In total, $6 + 3 = 9$, rather than the extreme of 82 additions and a short-cut denied to Eve. This said, there are significant shortcuts available to

Eve, but by careful choice of the system components, these can be rendered relatively harmless; all Alice and Bob have to do is write the multiple in binary and double and add accordingly, operations for which a computer is extremely amenable.

ECC and RSA can be melded, with the former method used to communicate the common key to be used with the latter. This key exchange is a straightforward variant of the above method, wherein

- Alice computes the point aP and sends it to Bob;
- Bob computes the point bP and sends it to Alice;
- knowing bP, Alice computes $a(b$P$)$;
- knowing aP, Bob computes $b(a$P$)$ to arrive at the same point abP on the curve;
- Alice and Bob extract the key from abP using a method already agreed: perhaps the final 256 bits of its x coordinate.

Once again, suppose that $a = 27$ and $b = 83$:

- Alice computes aP $= 27(5,8) = (213, 1529)$ and sends it to Bob;
- Bob computes bP $= 83(5,8) = (6602, 7629)$ and sends it to Alice;
- Alice computes $a(b$P$) = 27(6602, 7629) = (734, 475)$;
- Bob computes $b(a$P$) = 83(213, 1529) = (734, 475)$;
- the key is extracted by agreed means.

With these simple examples, we hope that the principle and the method of its implementation are clear, but to gain a perspective on the complexity involved in real-world communication, we mention the details of two elliptic curves in common use.

Microsoft Digital Rights Management Curve

Used to protect the intellectual rights of software and media ownership, the curve has equation $y^2 = x^3 + ax + b$, where

$a = 3176890812513255503476317476413827693272746955927,$

$b = 79052896607878758718120572025718535432100651934,$

with the curve defined over the finite field with prime

$p = 785963102379428822376694789446897396207498568951.$

A point on the curve is provided with coordinates

$P_x = 77150721626264982617064826856579889907769254176,$

$P_y = 390157510246556628525279469266514995562533196655.$

The curve contains

$$7859631023794288223766930248817149576126886157429$$

points.

All of the above numbers are given in base 10, whereas it is usual to write (particularly long) numbers in base 16, that is, hexadecimal. If we trouble to convert the above prime to hexadecimal, we reveal some playfulness on the part of the Microsoft employees responsible for the curve and which has mega nerd appeal with

$$p = 89|ABCDEF|01234567|27182818|31415926|14142|4F7,$$

where the vertical lines divide the central part of the number into: the extra digits needed for hexadecimal notation and the first eight digits of base 10 (both in order) followed by the start of the decimal expansions of e, π, $\sqrt{2}$, respectively.

P-384

The second elliptic curve has the name P-384, where the P does denote prime, but not the 384th such, which would be far too small for purpose (it is 2657). The designation tells us that the prime is a sort of generalized Mersenne prime, with the highest power of 2 being 384. The prime is precisely

$$p = 2^{384} - 2^{128} - 2^{96} + 2^{32} - 1$$
$$= 39402006196394479212279040100143613805079739270465446679482934042457217149687032904726608825893800186160$$
$$6973112319$$

in base 10. And it is over this prime field that the curve is defined, a curve with equation $y^2 = x^3 - 3x + b$, where

$$b = b3312fa7e23ee7e4988e056be3f82d19181d9c6efe8141120314088f5013875ac656398d8a2ed19d2a85c8edd3ec2aef.$$

The supplied point P on the curve has coordinates

$$P_x = aa87ca22be8b05378eb1c71ef320ad746e1d3b628ba79b9859f741e082542a385502f25bf55296c3a545e3872760ab7,$$
$$P_y = 3617de4a96262c6f5d9e98bf9292dc29f8f41dbd289a147ce9da3113b5f0b8c00a60b1ce1d7e819d7a431d7c90ea0e5f.$$

And since we are also informed that

$$\#E(F_p) = 3940200619639447921227904010014361380507973927046794666794660794690527962765939911$$
$$32635693989563081522949135544336539426436,$$

there are plenty of points from which to choose.

This information was gleaned from the NSA (the American National Security Agency) website and, comfortingly, we are informed that the specification protects data up to TOP SECRET level.

If we wish rather less calculation and are content merely with NSA SECRET classification, we could use $y^2 = x^3 + x + 61$ with $p = 10^{77} + 21$, where

$$\#E(F_p) = 1000000000000000000000000000006131967$$
$$2271172718781291022527780387603.$$

We leave the reader to find a point on it!

Why are governments, banks, great corporations and others content with elliptic curve encryption? Well, we suggest that they are not, but electronic communication is essential and currently this protection is deemed secure since the fastest known algorithm to solve ECDLP (*Pollard's rho algorithm*) executes in exponential time, with its expected running time proportional to \sqrt{p}; with current computing speeds this means that it is currently not feasible to solve the ECDLP for $p > 2^{160}$.

10.8 Apologia

We have come to the end of our discussion of the elliptic curve, yet have hardly touched upon its story since its reach is so much greater than we can possibly show. With the underlying field the rationals, we have not discussed the crucial measure of the number of points on an elliptic curve (its rank) and the many problems associated with measuring its size. We have omitted discussion of *Tunnell's theorem*, which supplies a computable necessary condition for a square-free integer to be congruent, and it would be sufficient too if the (weak) *Birch and Swinnerton-Dyer conjecture* is true. And this is one of the Millennium Problems, with a $1,000,000 price on its head; and there are the *L functions* and *zeta functions* of elliptic curves, which connect them to the *Riemann hypothesis*, which is another of those Millennium Problems. To develop these ideas we would need many more pages and we would have to have

become involved with complex numbers. Yet, this book's length stands as a fierce barrier and we have adhered to our self-imposed restriction to the Cartesian plane and so have avoided them, and in doing so have concealed the great body of material that the synthesis of an elliptic curve and this particular field brings with it. What does an elliptic curve "look like" when it is defined over the complex numbers? A torus. And so is the associated group $E(\mathbb{C})$. And there are complex-valued integrals to deal with and the concept of a function having two separate periods and this leads to the *Weierstrass \wp function*, which we believe is the letter "p" in his hand and which is pronounced "p" and which for some reason has stood the notational test of time. And, connected with these are *modular forms*, which brings us back to elliptic curves, since it was the conjecture of Yutaka Taniyama and Goro Shimura that the two are one and the same thing, remarkable though this seems: if Fermat's Last Theorem were to be false, and so there exist integers for which $a^n + b^n = c^n$ for $n \geqslant 3$, it is a 1986 result of Ken Ribet that the resultant elliptic curve $y^2 = x(x - a^n)(x + b^n)$ is not modular, but in 1994 (principally) Andrew Wiles showed that it is modular, and we have the necessary contradiction. In 1999 it was proved that every elliptic curve is modular.

So, we offer an apology for including a curve in this anthology whose story we cannot properly tell, but we think its omission would have been far the greater sin. Aware of Serge Lang's non-threat, we will stop here; the chapter and the book.

Perhaps the Most Important Curve of All

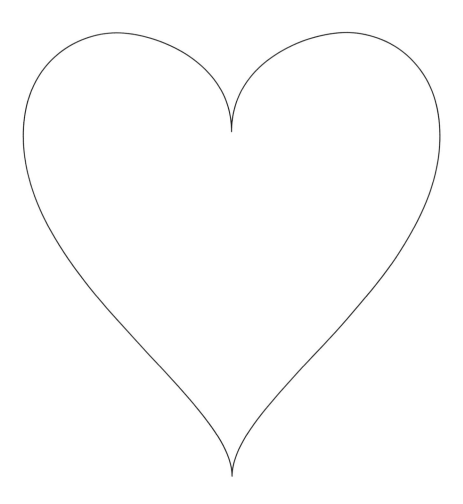

$$x^2 + (\tfrac{5}{4}y - \sqrt{|x|})^2 = 1$$

The Title Page

We imagine that the reader's curiosity will have been aroused by the two blocks of digits in the book's front matter. They occupy the first printed page (p. ii) after the title page and in doing so are appropriately placed, since the words they represent *are* those of the title page.

In a paper of 2001 Jeff Tupper of the Department of Computer Science, University of Toronto, produced the startling result that the set of all points (x, y) in the plane for which

$$\tfrac{1}{2} < \lfloor \mathrm{mod}\,(\lfloor \tfrac{1}{17}y \rfloor 2^{-17\lfloor x \rfloor - \mathrm{mod}\,(\lfloor y \rfloor, 17)}, 2) \rfloor,$$

where $0 \leqslant x < 106$ and $N \leqslant y < N + 17$, takes the form

That is, the condition generates itself in this rectangular region of the plane. For this to happen, though, the rectangle must be rather far up the y-axis: to be precise, N is the number[1]

485845063618971342358209596249420204458140058798324454948309308506193470470880992845064476986552436484999724702491511911041160573917740785691975432657185544205721044573588368182982375413963433822519945219165128434833290513119319995350241375876523926487461339490687013056229581321948111368533953556529085002387509285689269455597428154638651073004910672305893358605254409666435126534936364395712556569593681518433485760526694016125126695142155053955451915378545752575659074054015792900176596796548006442782913148854825991472124850635268663047630

[1] It need not be, but it will be large. The alternative 960...719 is frequently given, although for the mathematician this would naturally plot the image upside down.

We hope that the reader new to this phenomenon will find the fact surprising. There is much more, though. With the rectangle's dimensions of $106 \times 17 = 1802$, any of its $2^{1802} \approx 10^{542}$ pixel patterns (sometimes called Tupperware) can also be replicated by the formula if that rectangle is placed at some other appropriate distance N up the y-axis. The two large numbers in the front matter are, respectively, the values of N for which the corresponding region is occupied by "Curves for the Mathematically" and "Curious", with the allowed dimensions of the region insufficient for the text to appear as one item:

CURVES FOR THE MATHEMATICALLY
CURIOUS

Given that the defining condition relates the coordinates of points in the plane, we have allowed ourselves the dubious luxury of considering the images it generates to be curves, and in doing so we feel we owe the reader an explanation of the underlying mathematics of what might seem a mystical phenomenon, experimentation with which provides an excellent opportunity to dissipate hours of spare time. We dismantle the condition piece by piece.

First, the *floor function* features several times, defined by "$\lfloor \alpha \rfloor$ is the greatest integer less than or equal to α". In fact, its appearance as the major enclosing bracket is unnecessary, as $\frac{1}{2} < \lfloor \alpha \rfloor$ is equivalent to $\alpha \geqslant 1$: the condition therefore becomes

$$\mathrm{mod}\left(\lfloor \tfrac{1}{17}y \rfloor 2^{-17\lfloor x \rfloor - \mathrm{mod}\,(\lfloor y \rfloor, 17)}, 2\right) \geqslant 1.$$

Next (as Tupper points out in his 2001 article), $\lfloor \tfrac{1}{17}y \rfloor \equiv \lfloor \tfrac{1}{17}\lfloor y \rfloor \rfloor$, and so the relationship is between $\lfloor x \rfloor$ and $\lfloor y \rfloor$ rather than $\lfloor x \rfloor$ and y. This means that for each grid point (x, y) in the image, the whole unit pixel with it and $(x + 1, y + 1)$ as opposite corners is determined, and so we may restrict ourselves to the grid points (x, y) themselves, each of which generates the corresponding 1×1 pixel. The condition moves to

$$\mathrm{mod}\left(\lfloor \tfrac{1}{17}\lfloor y \rfloor \rfloor 2^{-17\lfloor x \rfloor - \mathrm{mod}\,(\lfloor y \rfloor, 17)}, 2\right) \geqslant 1$$

and from this to

$$\text{mod}\,(\lfloor \tfrac{1}{17}y \rfloor 2^{-17x-\,\text{mod}\,(y,17)}, 2) \geqslant 1,$$

where the variables are now assumed to be positive integers.

Next, the $\text{mod}(y, 17)$ expression is computing parlance for what mathematicians write as r in the modular identity $y = 17q + r$ – that is, the remainder after division by seventeen – and so is an integer $0 \leqslant r < 17$. With this, the condition may now be written

$$\text{mod}\,(q2^{-17x-r}, 2) = \text{mod}\left(\frac{q}{2^{17x+r}}, 2\right) \geqslant 1.$$

If we now consider the binary form of the integer q, the quotient $q/2^{17x+r}$ locates the decimal point immediately to the right of its $(17x+r)$th digit (counting from the right with the rightmost digit as the 0th) and the inequality distinguishes between that digit being 0 or 1. A grid point, and therefore a pixel, is plotted only provided that digit of q is 1. If we wish the condition to plot a particular bitmap, imagine drawing the 106×17 grid and filling in the appropriate pixels. Now replace the filled-in pixels with 1s and the others with 0s: from this pattern of digits form a large binary number in some systematic manner (for example, bottom to top, left to right; top to bottom, right to left; etc.), convert to decimal and we have q; multiply by 17 and we have N.

As with any magic trick, an explanation of its method tends to remove the magic, leaving only the trick: a mathematician is, after all, a conjurer who gives away his secrets.[2]

[2] A quotation from John Horton Conway.

Conics Encapsulated

Although we have not included conic sections as a chapter in the book, we will at least pay lip service to them by characterizing them through one differential equation.

The idea seems to originate with the French mathematician Gaspard Monge (1810).

Throughout the following lines, rather than involve ourselves with several changes of letters for the constants, we will recycle.

We begin with the general equation of a conic (with c taken as positive)

$$ax^2 + bxy + cy^2 + dx + ey + f = 0$$

and consider it as the quadratic equation in y

$$cy^2 + (e + bx)y + (ax^2 + dx + f) = 0$$

with (positive part) solution

$$y = \frac{-(e + bx) + \sqrt{(e + bx)^2 - 4c(ax^2 + dx + f)}}{2c}$$

$$= ax + b + \sqrt{Ax^2 + 2Bx + C}.$$

We now differentiate with respect to x to achieve

$$y' = a + \frac{Ax + B}{\sqrt{Ax^2 + 2Bx + C}}$$

and again to achieve

$$y'' = \frac{A\sqrt{Ax^2 + 2Bx + C} - (Ax + B)^2/\sqrt{Ax^2 + 2Bx + C}}{Ax^2 + 2Bx + C}$$

$$= \frac{A(Ax^2 + 2Bx + C) - (Ax + B)^2}{(Ax^2 + 2Bx + C)^{3/2}}$$

$$= \frac{AC - B^2}{(Ax^2 + 2Bx + C)^{3/2}} = (AC - B^2)(Ax^2 + 2Bx + C)^{-3/2}.$$

Next we raise both sides to the power $-\frac{2}{3}$ to achieve

$$(y'')^{-2/3} = (AC - B^2)^{-2/3}(Ax^2 + 2Bx + C).$$

And finally differentiate three times to achieve the result that all conics appear as solutions to the differential equation

$$((y'')^{-2/3})''' = 0.$$

Differentiating this out and simplifying results in the remarkable

$$9\left(\frac{d^2y}{dx^2}\right)^2\frac{d^5y}{dx^5} - 45\frac{d^2y}{dx^2}\frac{d^3y}{dx^3}\frac{d^4y}{dx^4} + 40\left(\frac{d^3y}{dx^3}\right)^3 = 0.$$

So, with this differential equation we have considered all variants of each of the conic sections, although of the degree of usefulness of this fact, we are unsure.

A Trigonometric Variant for the Bézier Curve

For the variant

$$f_{3,i}(t) = \alpha_i \sin \tfrac{1}{2}\pi t + \beta_i \cos \tfrac{1}{2}\pi t + \gamma_i \sin^2 \tfrac{1}{2}\pi t + \delta_i \cos^2 \tfrac{1}{2}\pi t, \quad (C.1)$$

the end points conditions result in

$$\begin{aligned}
\beta_1 + \delta_1 &= 0, & \alpha_1 + \gamma_1 &= 1, \\
\beta_2 + \delta_2 &= 0, & \alpha_2 + \gamma_2 &= 1, \\
\beta_3 + \delta_3 &= 0, & \alpha_3 + \gamma_3 &= 1.
\end{aligned}$$

The first derivative is

$$\begin{aligned}
f'_{3,i}(t) &= \tfrac{1}{2}\pi \alpha_i \cos \tfrac{1}{2}\pi t - \tfrac{1}{2}\pi \beta_i \sin \tfrac{1}{2}\pi t \\
&\quad + 2\gamma_i \sin \tfrac{1}{2}\pi t \times \tfrac{1}{2}\pi \cos \tfrac{1}{2}\pi t \\
&\quad - 2\delta_i \cos \tfrac{1}{2}\pi t \times \tfrac{1}{2}\pi \sin \tfrac{1}{2}\pi t \\
&= \tfrac{1}{2}\pi \alpha_i \cos \tfrac{1}{2}\pi t - \tfrac{1}{2}\pi \beta_i \sin \tfrac{1}{2}\pi t \\
&\quad + \tfrac{1}{2}\pi \gamma_i \sin \pi t - \tfrac{1}{2}\pi \delta_i \sin \pi t.
\end{aligned}$$

The corresponding conditions result in

$$\begin{aligned}
\alpha_2 &= 0 \rightarrow \gamma_2 = 1, \\
\alpha_3 &= 0 \rightarrow \gamma_3 = 1.
\end{aligned}$$

The second derivative is

$$\begin{aligned}
f''_{3,i}(t) &= -\tfrac{1}{4}\pi^2 \alpha_i \sin \tfrac{1}{2}\pi t - \tfrac{1}{4}\pi^2 \beta_i \cos \tfrac{1}{2}\pi t \\
&\quad + \tfrac{1}{2}\pi^2 \gamma_i \cos \pi t - \tfrac{1}{2}\pi^2 \delta_i \cos \pi t.
\end{aligned}$$

The corresponding condition simplifies to

$$\beta_3 - 2\gamma_3 + 2\delta_3 = 0.$$

These equations solve to

$$\begin{pmatrix} \alpha_1 & \alpha_2 & \alpha_3 \\ \beta_1 & \beta_2 & \beta_3 \\ \gamma_1 & \gamma_2 & \gamma_3 \\ \delta_1 & \delta_2 & \delta_3 \end{pmatrix} = \begin{pmatrix} 2 & 0 & 0 \\ 0 & 0 & -2 \\ -1 & 1 & 1 \\ 0 & 0 & 2 \end{pmatrix}.$$

Substituting these values into equation (C.1) yields the three coefficient functions

$$f_{3,1}(t) = 2\sin\tfrac{1}{2}\pi t - \sin^2\tfrac{1}{2}\pi t,$$
$$f_{3,2}(t) = \sin^2\tfrac{1}{2}\pi t,$$
$$f_{3,3}(t) = -2\cos\tfrac{1}{2}\pi t + \sin^2\tfrac{1}{2}\pi t + 2\cos^2\tfrac{1}{2}\pi t,$$

which convert in Bernstein form to the curve

$$\begin{aligned} \mathbf{r}(t) = {}& [1 - 2\sin\tfrac{1}{2}\pi t + \sin^2\tfrac{1}{2}\pi t]\mathbf{p}_0 \\ & + [2\sin\tfrac{1}{2}\pi t - 2\sin^2\tfrac{1}{2}\pi t]\mathbf{p}_1 \\ & + [2\cos\tfrac{1}{2}\pi t - 2\cos^2\tfrac{1}{2}\pi t]\mathbf{p}_2 \\ & + [-2\cos\tfrac{1}{2}\pi t + \sin^2\tfrac{1}{2}\pi t + 2\cos^2\tfrac{1}{2}\pi t]\mathbf{p}_3. \end{aligned}$$

The figure shows plots of the cubic Bézier curve (in solid line) and this trigonometric variant (in dotted line) for a particular and arbitrary set of four points: the difference here and the difference generally hardly justifies the effort!

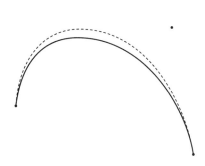

Envelopes

This book's dedication is borrowed from Edith Somervell's 67-page booklet entitled *A Rhythmic Approach to Mathematics* (Somervell 1906). It reemerged in 1975 as volume 5 of the series "Classics in Mathematical Education" under the auspices of the National Council of Teachers of Mathematics. The dedication expresses a sentiment with which we have accord, and the work is one that has relevance to us here and that must have provided excellent motivational material for some fortunate children of the time. There is a foreword too, the final paragraph of which reads:

> The method here indicated has one great advantage over many kinds of educational reform; it is a thing which women can manage entirely without agitation or public discussion. We need not wait for Acts of Parliament or the permission of School Inspectors. Any lady who will spend a few hours in practising on the lines laid down by Mrs. Somervell will then be able to teach village children in play, during the holidays. The materials are cheap, the apparatus simple, and the work interesting to nearly all children. Moreover, the lessons can be given in the open air, without desks or chairs. Little teachers and little pupils, sitting in a ring together on the ground, with a good selection of coloured cottons on the grass at their feet, all the young eyes glowing with eager curiosity to see what pattern will come out next, form a picture very pleasant to contemplate.

The writer was Mary Everest Boole. Her middle name originated from the surname of her uncle, George Everest, after whom Mount Everest is named, and her surname that of her husband, George Boole, whom we remember far more clearly, mostly in association with Boolean algebra. So, what is this educational nirvana of which Mrs Boole enraptures? It is what Mrs Somervell termed *curve sewing*, with the two praising the use of curve stitching as a means to promote both atheistic satisfaction and subconscious awareness of pattern, thereby exposing harmony and interrelationships between objects: the *rhythmic* approach to mathematics, championed by and possibly originating with Mrs Boole.

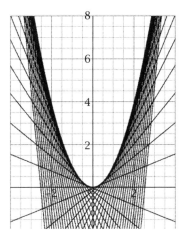

Figure D.1. The envelope of $y = x^2$.

Included with the book is a series of cards with appropriately placed holes to allow the children repeatedly to join them by straight line segments of thread to form the outline of a number of curves, including curves of pursuit and also a Reuleaux pentagon.

This curve sewing takes as its mathematical form the topic of *envelopes*, wherein we must replace the holed cards and attractive coloured threads with computer output – and mathematics far too advanced for the children Somervell had in mind.

We begin with the reverse process: given a differentiable curve, draw its tangents at many points to construct a web of straight lines that cradle the curve, as shown in figure D.1, for which the curve has equation $y = x^2$. Each tangent has the form $y - a^2 = 2a(x - a)$ and so the family of tangents may be parametrized as $y = 2ax - a^2$, and since the tangents envelop the curve it can reasonably be said to be the *envelope* of them.

Our purpose is the reverse of the above: to be given a one-parameter family of straight lines and from it derive their envelope. To that end, consider this family of tangents once more and two that are close to each other; so, the original one and a second one having equation $y = 2(a + h)x - (a + h)^2$ for small h. The intersection of these two lines must yield a point near to the point on the curve we seek and so, setting $2(a+h)x-(a+h)^2 = 2ax-a^2$ and simplifying to $h(2x-2a-h) = 0$, we have an equation the only sensible solution to which is $x = a + \frac{1}{2}h$, and substituting this back into the equation of either tangent then gives $y = a^2 + ah$. So, the point with coordinates $(a + \frac{1}{2}h, a^2 + ah)$ lies

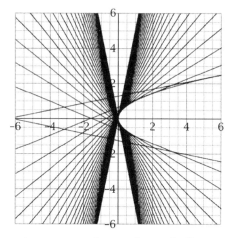

Figure D.2. The envelope of $y^2 = x$

arbitrarily near to our curve, and in the limit as $h \to 0$ it will lie on it, to yield the point (a, a^2) and the equation $y = x^2$ is recovered.

The temptation to experiment with other one-parameter families of straight lines is, of course, extremely hard to resist: if, for example, we wish to generate $y^2 = x$ we should consider $y = ax + 1/(4a)$ and so generate figure D.2.

Generalize, and the one-parameter family could itself be curves. Reversing the roles, for example, has the family of parabolas $y = ax^2 + 1/(4a)$ generating the pair of straight lines $y = \pm x$.

If the above procedure is reminiscent of differentiating from first principles with respect to the parameter, it is no surprise since that is exactly what it is. We can generalize the family of straight lines to a general family of curves $F(x, y, a) = 0$, with the nearby member of the family $F(x, y, a + h) = 0$ and so $(F(x, y, a + h) - F(x, y, a))/h = 0$. Now take the limit as $h \to 0$ and we have $\partial F(x, y, a)/\partial a = 0$. The pair of equations

$$F(x, y, a) = 0 \quad \text{and} \quad \frac{\partial F(x, y, a)}{\partial a} = 0$$

can be used to define the envelope of curves of the family $F(x, y, a) = 0$, the equations of which are found by eliminating (if possible) the parameter between the two equations.

Mrs Somervell's simplest construction for the children is what is otherwise known as the *problem of the falling ladder*: which curve is generated when a ladder of length 1 unit slides from the vertical?

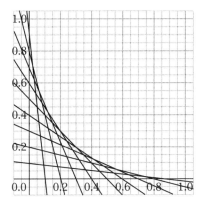

Figure D.3. The falling ladder

Figure D.3 has the ladder represented by the first quadrant segments of the family of straight lines $x/a + y/(1 - a) = 1$, joining $(a, 0)$ to $(0, 1 - a)$, which we can rewrite as $ay = (a - 1)(x - a) = ax - a^2 - x + a$. Its derivative with respect to a is $y = x - 2a + 1$, and substitute $a = \frac{1}{2}(x + 1 - y)$ into the original equation and simplify to finish with $x^2 + y^2 - 2xy - 2x - 2y + 1 = 0$, a homogeneous equation in x and y of degree 2 which therefore represents a conic. Its discriminant $(-2)^2 - 4 \times 1 \times 1 = 0$ tells us that it a parabola.

Our use of this idea in chapter 7 fails to allow the elimination of the parameter and leaves us with the parametric equations of the envelope instead.

The Mathematics of an Arch

The statement we prove is that a two-dimensional structure forming an arch subject to vertical compression alone implies that the shape of the arch is a catenary.

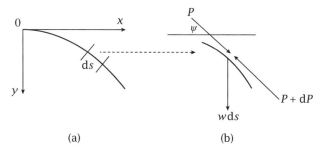

(a) (b)

Figure E.1. Internal forces on an arch.

Figure E.1(a) shows a vertical section of the arch of material of weight w per unit length, with a coordinate system set appropriate for needs and that supplies the boundary conditions that $x = 0$, $y = 0$, $dy/dx = 0$. Figure E.1(b) magnifies the element of length ds, which is subject to three forces: its weight, $w\,ds$, the upper force, P, bearing downwards and the compensating force $P + dP$. We require the shape to be such that there is no horizontal stress on the section; that is, the arch is stable under its own weight. Resolving forces horizontally, this condition results in

$$P \cos \psi + d(P \cos \psi) = P \cos \psi \rightarrow d(P \cos \psi) = 0 \rightarrow P \cos \psi = k.$$

At the top of the arch, $\psi = 0$ and $P = P_0$, which means that $P_0 \cos 0 = P_0 = k$ and so $P \cos \psi = P_0$. Also, the product rule yields $dP \cos \psi - P \sin \psi \, d\psi = 0$.

Now resolve forces vertically for equilibrium and we have

$$w\,ds + P \sin \psi = P \sin \psi + d(P \sin \psi) \rightarrow w\,ds = d(P \sin \psi).$$

The product rule yields

$$w \, ds = dP \sin \psi + P \cos \psi \, d\psi$$

$$\rightarrow w \, ds = \frac{P \sin \psi}{\cos \psi} \, d\psi + P \cos \psi \, d\psi$$

$$\rightarrow w \, ds = \frac{P_0 \sin^2 \psi}{\cos^2 \psi} \, d\psi + P_0 \, d\psi = \frac{P_0}{\cos^2 \psi} \, d\psi$$

$$\rightarrow \frac{ds}{d\psi} = \frac{P_0}{w} \sec^2 \psi$$

$$\rightarrow s = \frac{P_0}{w} \tan \psi = a \tan \psi.$$

With this we have the intrinsic equation of the longitudinal curve of the arch and we follow a standard procedure to extract its Cartesian equation:

$$\frac{dy}{dx} = \tan \psi = \frac{s}{a} \rightarrow \frac{d^2 y}{dx^2} = \frac{1}{a} \frac{ds}{dx}$$

and

$$ds^2 = dx^2 + dy^2 \rightarrow \frac{ds}{dx} = \sqrt{1 + \left(\frac{dy}{dx}\right)^2}$$

and so

$$\frac{d^2 y}{dx^2} = \frac{1}{a} \sqrt{1 + \left(\frac{dy}{dx}\right)^2} \rightarrow \frac{dy'}{dx} = \frac{1}{a} \sqrt{1 + y'^2}, \quad \text{where } y' = \frac{dy}{dx}.$$

We separate variables to

$$\int \frac{1}{\sqrt{1 + y'^2}} \, dy' = \frac{1}{a} \int 1 \, dx \rightarrow \sinh^{-1} y' = \frac{x}{a} + c.$$

The boundary condition of $x = 0$, $y' = 0$ results in $c = 0$ and so $\sinh^{-1} y' = x/a$. This makes $y' = \sinh(x/a)$ and from this $y = a \cosh(x/a) + c$, where the arbitrary constant is evaluated in terms of the height of the arch. A catenary, then.

The Simple Pendulum

As an example of elliptic integrals appearing and of the use of the world's sneakiest substitution, we mentioned that the motion of a simple pendulum involves elliptic curves and here we see why.

It is standard and elementary to prove that the pendulum's motion is governed by the differential equation $d^2\theta/dt^2 = -k^2 \sin\theta$, where θ is the angle it makes with the vertical at time t. This is commonly simplified by the assumption that θ is small and so $\sin\theta \sim \theta$ (in radians) to the differential equation $d^2\theta/dt^2 = -k^2\theta$, which is readily tractable, unlike the analysis of the general case, which yields the following:

$$\frac{d^2\theta}{dt^2} = -k^2 \sin\theta \rightarrow \int \frac{d^2\theta}{dt^2}\, d\theta = \int \frac{d^2\theta}{dt^2}\frac{d\theta}{dt}\, dt = \int -k^2 \sin\theta\, d\theta$$

$$\rightarrow \frac{1}{2}\left(\frac{d\theta}{dt}\right)^2 = k^2 \cos\theta$$

$$\rightarrow \frac{d\theta}{dt} = \sqrt{2}k\sqrt{\cos\theta}$$

$$\rightarrow \int \frac{1}{\sqrt{\cos\theta}}\, d\theta = \int \sqrt{2}k\, dt.$$

And we have an opportunity to use that half-angle substitution mentioned above, with $x = \tan\frac{1}{2}\theta$ and so

$$\cos\theta = \frac{1-x^2}{1+x^2} \quad \text{and} \quad \frac{d\theta}{dx} = \frac{2}{1+x^2},$$

and, after simplification, we are left with

$$2\int \frac{1}{\sqrt{1-x^4}}\, dx = \sqrt{2}kt,$$

an elliptic curve in the denominator and an elliptic integral to deal with.

Fibonacci's Method

Below, separated into several parts, we give a modern interpretation of Fibonacci's method of producing three-term arithmetic progressions of rational squares.

The sum of $2k$ positive odd integers centred on the even number $2a$.
Such integers may be listed as $2a \pm 1, 2a \pm 3, 2a \pm 5, \ldots, (2a \pm (2k-1))$, which sum to $4a \times k = 4ak$.

Require the lower series to contain only positive odd integers.
This means that its smallest number must be greater than or equal to 1:
$2a - (2k - 1) \geqslant 1 \Rightarrow a \geqslant k$.

Repeat twice to give the same sum.
Consider a lower series to the left, centred on $2a$ and having K terms, and an upper series on the right, centred on $2A$ and having k terms. Then, $a < A$, $K > k$ and $4aK = 4Ak \Rightarrow aK = Ak$.

Require that the two series of odd numbers are contiguous.
This means that the biggest term of the lower series is the odd number before the smallest term of the upper series. In symbols, $2a + (2K - 1) + 2 = 2A - (2k - 1)$ and so $a + K = A - k$.

Put to use the result of the sum of a series of odd integers.

$$\sum_{r=1}^{n} (2r - 1) = n^2.$$

These observations allow some given even integer of the form $4aK = 4Ak$ to be sandwiched between the consecutive odd integers that are the biggest term of the lower series and the smallest term of the upper series. And it is this fact that can be put to use.

Table G.1. A common difference of 840.

a	210	105	70	42	35	30	21	15
k	1	2	3	5	6	7	10	14
$a + k$	211	107	73	47	41	**37**	31	<u>29</u>
$a - k$	209	103	67	**37**	<u>29</u>	23	11	1

Examples

1. We first consider the number 840 to be the common difference to consider, which has the form $pq(p + q)(p - q)$ with $p = 7, q = 3$ from page 192, in which case $4aK = 4Ak = 840 \Rightarrow aK = Ak = 210$. This leads us to consider the factors of 210, interpreting whether a letter should be capital or not according to context. Table G.1 summarizes the situation.

The above penultimate condition has us seek any entry in the third row that is repeated in the fourth row, and we have two such cases: one with the lower series centred where $a = 15$ and having $K = 14$, the upper series where $A = 35$ and $k = 6$; the second case is where the lower series is centred where $a = 30$ and having $K = 7$, the upper series centred where $A = 42$ and having $k = 5$. Explicitly, the two generated series are

$$3 + \cdots + 27 + 29 + (30) + 31 + 33 + \cdots + 57$$
$$= 840$$
$$= 59 + 61 + \cdots + 67 + 69 + (70) + 71 + 73 + \cdots + 79 + 81$$

and

$$47 + \cdots + 57 + 59 + (60) + 61 + 63 + \cdots + 73$$
$$= 840$$
$$= 75 + 77 + \cdots + 81 + 83 + (84) + 85 + 87 + \cdots + 91 + 93.$$

Written in sigma notation these become

$$\sum_{r=1}^{29}(2r - 1) - \sum_{r=1}^{1}(2r - 1) = 840 = \sum_{r=1}^{41}(2r - 1) - \sum_{r=1}^{29}(2r - 1)$$
$$\rightarrow 29^2 - 1^2 = 840 = 41^2 - 29^2,$$

which means that $29^2 - 840 = 1^2$ and $29^2 + 840 = 41^2$, and we have the arithmetic sequence $\{1^2, 29^2, 41^2\}$ with a common difference of 840,

Table G.2. A common difference of 96.

a	24	12	8	6
k	1	2	3	4
$a + k$	25	14	11	10
$a - k$	23	10	5	2

and

$$\sum_{r=1}^{37}(2r-1) - \sum_{r=1}^{23}(2r-1) = 840 = \sum_{r=1}^{47}(2r-1) - \sum_{r=1}^{37}(2r-1)$$
$$\rightarrow 37^2 - 23^2 = 840 = 47^2 - 37^2,$$

which means that $37^2 - 840 = 23^2$ and $37^2 + 840 = 47^2$ and we have the arithmetic sequence $\{23^2, 37^2, 47^2\}$, also with a common difference of 840, which we have already mentioned on page 192.

2. We consider the simpler case of a common difference of 96, which again has the form $pq(p+q)(p-q)$ but with $p = 4$, $q = 2$, in which case $4aK = 4Ak = 96 \Rightarrow aK = Ak = 24$. This leads us to consider the factors of 24, again interpreting whether a letter should be capital or not according to context. Table G.2 summarizes the situation.

The only case where the entry in the third row is repeated in the fourth row is where the lower series is centred where $a = 6$ and $K = 4$ and the upper series where $A = 12$ and $k = 2$. Explicitly, the generated series is

$$5 + \cdots + 9 + 11 + (12) + 13 + 15 + \cdots + 19$$
$$= 96 = 21 + 23 + (24) + 25 + 27.$$

Written in sigma notation this becomes

$$\sum_{r=1}^{10}(2r-1) - \sum_{r=1}^{2}(2r-1) = 96 = \sum_{r=1}^{14}(2r-1) - \sum_{r=1}^{10}(2r-1),$$

which means that $10^2 - 2^2 = 96 = 14^2 - 10^2$ and we have the arithmetic sequence $\{2^2, 10^2, 14^2\}$ with common difference 96. We could, though, rewrite this common difference as 6×4^2, which means that we have

$$10^2 - 2^2 = 6 \times 4^2 = 14^2 - 10^2 \rightarrow (\tfrac{10}{4})^2 - (\tfrac{2}{4})^2 = 6 = (\tfrac{14}{4})^2 - (\tfrac{10}{4})^2.$$

And we have the three-term arithmetic sequence of square rationals

$$\{(\tfrac{1}{2})^2, (\tfrac{5}{2})^2, (\tfrac{7}{2})^2\}$$

differing by 6.

3. With Fibonacci asked to deal with the case of the common difference being 5, the sum needs to be of the form $5 \times 24 \times N$, with $24N$ a perfect square, the simplest case of which is $N = 6$, and we have the sum to be reached of 720, which has the form $4pq(p + q)(p - q)$ with $p = 5$, $q = 4$. The reader may wish to check that $a = 36$, $K = 5$ and $A = 45$, $k = 4$ yield the unique combination and which leads to

$$\sum_{r=1}^{41} (2r - 1) - \sum_{r=1}^{31} (2r - 1) = 720 = \sum_{r=1}^{49} (2r - 1) - \sum_{r=1}^{41} (2r - 1).$$

And so to Fibonacci's solution.

Finally, as to the congruence of 7, the process generates

$$227 + \cdots + 447 + 449 + (450) + 451 + 453 + \cdots + 673$$
$$= 100,800$$
$$= 675 + \cdots + 797 + 799 + (800) + 801 + 803 + \cdots + 925.$$

And this leads to the sequence

$$\left\{ \left(\frac{113}{120}\right)^2, \left(\frac{337}{120}\right)^2, \left(\frac{463}{120}\right)^2 \right\}.$$

References

Abdulle, A. and Wanner, G. 2002 200 Years of least squares method. *Elementary Mathematics* **57**:45-60.

Ames, J. S. 1902 *The Astrophysical J.* **XV**(5):299-301.

Ampère, A.-M. 1806 Elaboration of certain issues in differential calculus which enable a new demonstration of Taylor expansions and expressions thereof in closed form if the summation is limited. *Journal de L'école Polytechnique* **VI**:148-81.

Ash, A. and Gross, R. 2014 *Elliptic Tales: Curves, Counting, and Number Theory*. Princeton University Press.

Bardet, M. and Bayen, T. 2013 On the degree of the polynomial defining a planar algebraic curve of constant width, 16 December, arXiv:1312.4358v1.

Bardet, M. and Bayen, T. 2018 On the degree of the polynomial defining planar algebraic curves of constant width, 8 February, arXiv:1312.4358v1.

Barnett, J. H. 2004 Enter stage center: the early drama of the hyperbolic functions. *Math. Mag.* **77**(1):15-30.

Bellhops, D. R. and Genest, C. 2007 Maty's biography of Abraham de Moivre (translated, annotated and augmented), 29 August, arXiv:0708.3965v1.

Bernoulli, J. 1690 *Acta Eruditorum Leipzig*, pp. 217-19.

Bernoulli, J. 1694 The curvature of an elastic band. *Acta Eruditorum*, pp. 262-76.

Bernoulli, J. 2004 Lecture on the integral calculus, transl. W. A. Ferguson Jr. *21st Century Sci. Technol.* **17**(1):34-42.

Bézier, P. 1990 Interview in *Science et Vie Micro*, February.

Block, P., DeJong, M. and Ochsendorf, J. 2006 As hangs the flexible line: equilibrium of masonry arches. *Nexus Network J.* **8**(2):9-19.

Boas, M. 1962 *The Scientific Renaissance: 1450-1630*. Harper.

Bos, H. J. M. 1986 The concept of construction and representation of curves in seventeenth century mathematics. *Proc. Int. Congress of Math.*, Berkeley.

Bos, H. J. M. 1996 Johann Bernoulli on exponential curves…implicit functions. *Vierde serie Deel* **14**(1):1-19.

Boyer, C. B. and Merzbach, U. C. 2011 *A History of Mathematics*, 3rd edn. Wiley.

Bradley, R. E. and Sandifer, C. E. (eds) 2007 *Leonhard Euler: Life, Work and Legacy*. Elsevier.

Brown, E. 2000 Three Fermat trails to elliptic curves. *College Math. J.* **31**(3):162-72.

Brown, E. and Myers, B. T. 2002 Elliptic curves from Mordell to Diophantus and back. *Am. Math. Monthly* **109**(7):639-49.

Bryant, J. and Sangwin, C. 2011 *How Round Is Your Circle? Where Engineering and Mathematics Meet.* Princeton University Press.

Bukowski, J. F. 2006 *Huygens, Holland and Hanging Chains.* Bookend Seminar.

Bukowski, J. F. 2008 Christiaan Huygens and the problem of the hanging chain. *College Math. J.* **39**(1):2–11.

Burn, B. 2000 Gregory St. Vincent and the rectangular hyperbola. *Math. Gazette* **84**(501):480–85.

Butz, A. R. 1969 Convergence with Hilbert's space filling curve. *J. Comput. Syst. Sci.* **3**:128–46.

Cantor, G. 1878 Ein Beitrag zur Mannigfaltigkeitslehre. *Crelle's J.* **84**:242–58.

Cajori, F. 1913 History of the exponential and logarithmic concepts. *Am. Math. Monthly* **20**(1):5–14.

Carpenter, F. B. 1995 *The Inner Life of Abraham Lincoln.* University of Nebraska Press.

Casteljau, P. de Faget de 1999 De Casteljau's autobiography: my time at Citroën. *Computer Aided Geometric Design* **16**:583–86.

Chatterjee, N. and Nita, B. G. 2010 The hanging cable problem for practical applications. *Atlantic Electron. J. Math.* **4**(1):70–77.

Coolidge, J. L. 1963 *The Mathematics of Great Amateurs.* Dover.

Cook, T. A. 1979 *Curves of Life.* Dover.

Cotes, J. H. 2005 Congruent number problem. *Pure Appl. Math. Q.* **1**(1):14–27.

Cundy, H. M. and Rollett, A. P. 1961 *Mathematical Models.* Oxford University Press.

Dafner, R., Cohen-Or, D. and Matias, Y. 2000 Context-based space-filling curves. *Eurographics* **19**(3):209–18.

Dauben, J. W. 1975 The importance of dimension: problems in the early development of set theory. *Historia Mathematica* **2**:273–88.

Davis, P. J. 2001 *Spirals from Theodorus to Chaos.* A. K. Peters.

Davis, P. J. 2014 *Interpolation and Approximation.* Dover.

de Moivre, A. 1730 *Miscellanea Analytica de Seribus et Quadraturis.* London.

de Moivre, A. 1756 *The Doctrine of Chances,* reprinted for A. Millar, London.

Diaconis, P. and Zabell, S. 1991 Closed form summation for classical distributions: variations on a theme of de Moivre. *Statist. Sci.* **6**(3):284–302.

Dickson, L. E. 1920 *History of the Theory of Numbers,* vol. II. Carnegie Institute of Washington.

Dirichlet, L. 1829 Sur la convergence des séries trigonométriques qui servent à représenter une fonction arbitraire entre des limites données. *Crelle's J.* **4**:157–69.

Dorodnov, A. W. 1947 On circular lunes quadrable with the use of ruler and compass. *Dokl. Akad. Nauk SSSR* **58**:965–68.

du Bois-Reymond, P. 1875 An attempt to classify arbitrary functions of real arguments according to their changes in the smallest intervals (Versuch einer Classification der willkürlichen Funktionen reeller Argumente nach ihren Äenderungen in den kleinsten Intervallen). *Borchardt's J.* **79**:21–37.

Duncan, D. D. 2006 *Lump: The Dog Who Ate a Picasso,* 2nd edn. Thames and Hudson.

Eknoyan, G. 2008 Adolphe Quetelet 1796–1874 – the average man and indices of obesity. *Nephrol Dial Transplant* **23**:47–51.

Euler, L. 1744 *De Curvis Elasticis*, Additamentum I. (Translated in 1933 as *A Method for Finding Curved Lines ... Accepted Sense* (ed. W. A. Oldfather, C. A. Ellis and D. M. Brown). *Isis* **20**(1):72–160.)

Euler, L. 2007 On the values of integrals extended from the variable term $x = 0$ up to $x =$ infinity (transl.), 31 May, arXiv:0705.4640v1.

Eves, H. 1983 *Great Moments in Mathematics: Before 1650.* Mathematical Association of America.

Eves, H. 1983 *Great Moments in Mathematics: After 1650.* Mathematical Association of America.

Eves, H. 1990 *An Introduction to the History of Mathematics.* Brook/Cole.

Fauvel, J. and Gray, J. (eds) 1987 *The History of Mathematics: A Reader.* Palgrave Macmillan.

Feynman, R. P. 1998 *What Do You Care What Other People Think? Further Adventures of a Curious Character.* W. W. Norton.

Forrest, A. R. 1972 Interactive interpolation and approximation by Bézier polynomials. *Computer J.* **15**(1):71–79.

Forrest, A. R. 1990 Interactive interpolation and approximation by Bézier polynomials. *Computer Aided Design* **22**(9):527–37.

Galilei, G. 1914 *Two New Sciences.* Macmillan.

Gardner, M. 1991 *The Unexpected Hanging and Other Mathematical Diversions.* University of Chicago Press. (Republished as *Knote and Borromean Rings etc.* by the MMA in 2014.)

Gerver, J. 1970 The differentiability of the Riemann function at certain rational multiples of π. *Am. J. Math.* **92**:33–55.

Gil, J. B. 2005 The catenary (almost) everywhere. *Boletìn de la Asociaciòn Matemàtica Venezolana* **XII**(2):251–58.

Gillispie, C. C. 2000 *Pierre-Simon Laplace, 1749–1827: A Life in Exact Science.* Princeton University Press.

Gouvea, F. Q. 2011 Was Cantor surprised? *Am. Math. Monthly* **118**:198–209.

Gray, J. J. 2000 *The Hilbert Challenge: A Perspective on Twentieth Century Mathematics.* Oxford University Press.

Gregory, D. 1695–1697 The properties of the hanging catenaria. *Philosophical Transactions of the Royal Society of London* **19**:637–52.

Hadamard, J. 1921 L'oeuvre mathématique de Henri Poincaré. *Acta* **38**:203–87.

Hahn, A. J. 2012 *Mathematical Excursions to the World's Great Buildings.* Princeton University Press.

Hald, A. 1990 *History of Probability and Statistics and Their Applications before 1750.* Wiley.

Hardy, G. H. 1916 Weierstrass's non-differentiable function. *Trans. Am. Math. Soc.* **17**(3):301–25.

Havil, J. 2014 *John Napier: Life, Logarithms, and Legacy.* Princeton University Press.

Heath, T. 1910 *Diophantus of Alexandria.* Cambridge University Press.

Heath, T. 1981 *A History of Greek Mathematics*, Vol. 1: *From Thales to Euclid.* Dover.

Heilberg, J. L. 2007 *Euclid's Elements of Geometry*, Greek text edited and translated by R. Fitzpatrick (https://archive.org/stream/JL_Heiberg___EUCLIDS _ELEMENTS_OF_GEOMETRY/Elements_djvu.txt).

Herschel, J. 1850 *Edin. Rev.* **XCII**:1-57.

Hermite, C. 1905 *Correspondance d'Hermite et de Stieltjes*, vol. II. Paris: Gauthier-Villars.

Heyman, J. 1982 *The Masonry Arch.* Wiley.

Hilbert, D. 1891 Über die stetige Abbildung einer Linie auf ein Flächenstück. *Math. Annln*, pp. 459-60.

Huygens, C. 1638-1656 *Oeuvres Complétes Correspondence of Christiaan Huygens* tome 1, no. 14.

Jesseph, D. M. 2000 *Squaring the Circle: The War between Hobbes and Wallis.* Chicago University Press.

Johnson, D. M. 1979 The problems of invariance of dimension in the growth of modern topology, Part I (communicated by H. Freudenthal). *Archive for History of Exact Sciences* **20**(2):97-188.

Johnson, D. M. 1981 The problems of invariance of dimension in the growth of modern topology, Part II (communicated by H. Freudenthal). *Archive for History of Exact Sciences* **25**(2-3):85-266.

Jones, W. 1706 *Synopsis Palmariorum Mathesios.*

Joy, K. I. 2000 Bernstein polynomials. Visualization and Graphics Research Group, Department of Computer Science, University of California, Davis.

King, B. 2009 Mapping an arbitrary message. *Int. J. Net Security* **8**(2):169-76.

Klein, F. 1958 *On Mathematics* (ed. R. Moritz). Dover.

Kline, M. 1990 *Mathematical Thought from Ancient to Modern Times*, vols 1-3. Oxford University Press.

Kolwankar, K. M. and Gangal, A. D. 1996 Fractional differentiability of nowhere differentiable functions and dimensions, 21 November 1996 (arXiv:chao-dyn/9609016v2).

Lambert, J. 1761 Mémoire sur quelques propriétés remarquable des quantitiés transcendantes circulaires et logarithmique. *Mémoires de l'Académie royale des sciences de Berlin* **17**:265-322.

Lambert, J. 1768-1770 Observations trigonométrique. *Mémoires de l'Académie royale des sciences de Berlin* **24**:327-54.

Landau, E. 2001 *Differential and Integral Calculus.* American Mathematical Society.

Lang, S. 1978 *Elliptic Curves, Diophantine Analysis.* Springer.

Laplace, P. S. 1986 Memoir on the probability of the causes of events (transl. S. M. Stigler). *Statist. Sci.* **1**(3):364-78.

Lazarov, B. 2001 Teaching envelopes in secondary school. *The Teaching of Mathematics* **XIII**(1):45-55.

Leibniz, W. W. 1691 Concerning the curve formed by a heavy flexible chord ... mean proportionals and logarithms. *Actis Erudit. Lips.*, June.

Levien, R. 2009 From spiral to spline: optimal techniques in interactive curve design. PhD thesis.

Liouville, J. 1833 Mémoire sur les transcendantes elliptiques de premiere et de seconde espace considérées comme fonctions de leur amplitude. *Journal de l'Ecole Polytechnique* **23**:37-83.

Lockwood, E. H. 1961 *A Book of Curves*. Cambridge University Press.

Lopez, G. M. 1998 Poleni's manuscripts about the dome of St. Peter's. PhD thesis.

Mahoney, M. S. 1994 *The Mathematical Career of Pierre de Fermat: 1601-1665*. Princeton University Press.

Mainstone, R. 2003 Saving the dome of St. Peter's. *Construction History* **19**:3-18.

Mascheroni, L. 1785 *Nuove Ricerche Sull' Equilibrio Delle Volte*. Bergamo: Francesco Locatelli.

Mazur, J. 2010 *What's Luck Got to Do with It? The History, Mathematics, and Psychology of the Gambler's Illusion*. Princeton University Press.

Mellish, A. P. 1931 Notes on differential geometry. *Ann. Math.* **32**(1):181-90.

Milne, J. S. 2006 *Elliptic Curves*. Booksurge.

Monge, G. 1810 Sur les équations différentielles des courbes du second degré. *Bull. Soc. Philom. Paris*, pp. 87-88.

Moore, E. H. 1900 On certain crinkly curves. *Trans. Am. Math. Soc.* **1**:72-90.

Morain, F. 2006 *Proc. LIX Colloq. École Polytechnique*, Paris, 26 November.

Newman, J. (ed.) 2003 *The World of Mathematics*, vols 1-4. Dover.

Newton, I. 1667 *Enumeratio Curvarum Trium Dimensionum* ("The Enumeration of Cubics"). Mathematical Papers 12, pp. 10-89.

Ng, C. H. B. and Fan, W. Y. 2014 Reuleaux triangle disks: new shape on the block. *J. Am. Chem. Soc.* **136**(37):12,840-43.

O'Grady, P. 2003 Hippias of Elis. *Proc. Biennial Int. Conf. of Greek Studies*, Flinders University.

Osserman, R. 2010 How the gateway arch got its shape. *Nexus Network J.* **12**:167-89.

Osserman, R. 2010 Mathematics of the gateway arch. *Notices AMS* **57**(2):220-29.

Pardies, I. G. 1725 *La Statique, ou la Science des Forces Mouvantes*. Paris.

Peano, G. 1890 Sur une courbe, qui rempli toute une aire plane. *Math. Annln* **36**(1):157-60.

Poincaré, H. 1899 La Logique et l'intuition dans la science mathématique et dans l'enseignement. *L'enseignement mathématique* **1**:157-61.

Rabut, C. 2002 On Pierre Bézier's life and motivations. *Computer-Aided Design* **34**:493-510.

Ramanujan, S. 1962 *Modular Equations and Approximations to π. Ramanujan's Collected Works*. New York: Chelsea.

Reissmann, N. and Meyer, J. C. 2016 A study of energy and locality effects using space-filling curves, 20 June, arXiv:1606.06133v1.

Resnikoff, H. L. 2015 On curves and surfaces of constant width, 25 April, arXiv:1504.06733v1.

Reuleaux, F. 1963 *The Kinematics of Machinery*. Dover.

Rice, R. and Brown, E. 2012 Why are ellipses not elliptic curves. *Mathematics Magazine* **85**:163–76.

Robertson, S. A. 1984 Smooth curves of constant width and transnormality. *Bull. Lond. Math. Soc.* **16**:264–74.

Rouse Ball, W. W. 2003 *A Short Account of the History of Mathematics*. Dover.

Sagan, H. 1994 *Space Filling Curves*. Springer.

Sagan, H. 1991 Some reflections on the emergence of space-filling curves: the way it could have happened and should have happened, but did not happen. *J. Franklin Inst.* **328**(4):419–30.

Scott, J. F. 1960 *A History of Mathematics; From Antiquity to the Beginning of the Nineteenth Century*. Barnes & Noble.

Server, J. 1971 More on the differentiability of the Riemann function. *Am. J. Math.* **93**:33–41.

Shoesmith, E. 1985 Thomas Simpson and the arithmetic mean. *Historia Mathematica* **12**:352–55.

Simpson, T. 1755 A letter to the Rt. Hon. George Macclesfield. On the advantage of taking the mean of a number of observations in practical astronomy. *Phil. Trans. R. Soc. Lond.* **49**:82–93.

Smith, D. E. 1985 *A Source Book in Mathematics*. Dover.

Somervell, E. L. 1906 *A Rhythmic Approach to Mathematics*. London: George Philip and Son.

Stahl, S. 2006 The evolution of the normal distribution. *Mathematics Magazine* **79**(2):96–113.

Steef, A., Shamma, M. N. and Alkhatib, A. 2017 A secure approach for embedding message text on an elliptic curve defined over prime fields, and building "EC-RSA-ELGamal" Cryptographic System. *Int. J. Comput. Sci. Inform. Security* **15**(6).

Stigler, S. M. 1990 *The History of Statistics: The Measurement of Uncertainty before 1900*. The Belknap Press of Harvard University Press.

Stigler, S. M. 2002 *Statistics on the Table: The History of Statistical Concepts and Methods*. Harvard University Press.

Stillwell, J. 1995 Elliptic curves. *Am. Math. Monthly* **102**(9):831–37.

Swetz, F. J. 2013 *The European Mathematical Awakening*. Dover.

Talbot, A. N. 1890–91 *The Railway Transition Spiral*, vol. 5, p. 96. University of Illinois Technograph.

Teets, D. and Whitehead, K. 1999 The discovery of Ceres: how Gauss became famous. *Mathematics Magazine* **72**(2):83–93.

Thomas, I. 2018 *Selections Illustrating the History of Greek Mathematics. I. From Thales to Euclid*. Harvard University Press.

Timmerman, G. 2014 Approximating continuous functions and curves using Bernstein polynomials. *Math* 336, 2 June.

Todhunter, I. 1865 *History of the Theory of Probability from the Time of Pascal to that of Laplace*. Macmillan.

Tupper, J. 2001 Reliable two-dimensional graphing methods for mathematical formulae with two free variables. *Proc. 28th Ann. Conf. Computer Graphics and Interactive Techniques*, pp. 77–86. ACM Press.

Vilenkin, N. Ya. 1995 *In Search of Infinity*. Birkhäuser.

Villain, M. B. 2008 Ramanujan's perimeter of an ellipse, 1 February, arXiv .math/0506384v1.

Waller, R. 1705 *The Posthumous Works of Dr. Robert Hooke*. The Royal Society.

Washington, L. C. 2008 *Elliptic Curves Number Theory and Cryptography*. Chapman and Hall.

Watson, G. N. 1918 The problem of the square pyramid. *Messenger of Mathematics* **48**:1–22.

Wells Jr, R. O. 2015 Geometry in the age of Enlightenment, 30 June, arXiv:1507 .00060v1.

Yaglom, I. M. and Boltyanskii, V. G. 1961 *Convex Figures*, transl. P. J. Kelly and L. F. Walton. Holt, Rinehart and Winston.

Index